Promoting Civic Engagement Through Art Education

This textbook equips students and educators committed to understanding how art and creative practice work as powerful communicative tools and have a substantial role in advancing civic participation. Alongside promoting educational practices with learners' civic engagement in mind, this book is a call to action, inviting creative educators to explore the potential of art for developing critical perspectives, articulating voices and diverse points of view, and engaging in dialogue across difference.

Chapters assist students and educators in understanding critical concepts ranging from the protections afforded art under the constitution, to the role of civic institutions such as museums, community arts centers, and schools in advancing civic participation. They also present the relationship between art, education, and civic engagement using watershed political moments such as voter suppression initiatives, xenophobic reactions to the COVID-19 pandemic, and widespread national Black Lives Matter protests. Readers are guided throughout with a series of key questions at the onset of each chapter and encouraged to investigate further the issues discussed through exploration of the many resources embedded in each chapter. Coursework and participatory learning experiences that orient future and current art educators to the relationship of the arts and culture to democracy are also featured.

This book will be ideal for students in art education in both upper division undergraduate and graduate levels, with cross-curricular appeal for students of political science, social studies, sociology, public history, public anthropology, heritage studies, and public humanities. As well as this, it will be a must read for educators who are asked to respond to challenges within the political sphere, and how these political challenges are influencing educational environments.

Flávia Bastos is a Distinguished Research Professor in the Arts and Humanities at the University of Cincinnati, USA.

Doug Blandy is Professor Emeritus in the College of Design, School of Planning, Public Policy and Management at the University of Oregon, USA.

"This book is an invitation to generate networks of resistance through education through the arts to promote and imagine democracy as a common life project. It aims to prepare children, youth, and adults to be informed citizens able to engage civically in support of democracy. It does not lament and settle into impotence. Instead, it makes evident the role of arts education as a practice of resistance in the face of the current situation of discredited democracy. That is why it is a book for educators and all those who, from institutions related to art and culture, assume the transformative role of the arts."

– **Fernando Hernández-Hernández**, *Emeritus Professor of Cultural Visualities and Arts Education, University of Barcelona, Spain*

"Instructive and compelling, this edited volume brings together ideas, beliefs, and transformative actions from a wide range of artists, arts educators, designers, and activists focused on the advancement of civic engagement within a democratic society.

Written in a style and format that is engaging and often drawn from the writers' personal experience, this book challenges readers to explore deeply the decisive roles artists, art educators, and all citizens can play in confronting our world of pressing social and cultural concerns."

– **Dr. Paul E. Bolin, PhD**, *Professor Emeritus, Department of Art and Art History, The University of Texas at Austin*

"This book is an essential light in dark times. Within the pages of *Promoting Civic Engagement Through Art Education,* readers will receive both practical wisdom and philosophical food for thought. Framing democracy and civic engagement as 'future-oriented acts of being and doing with others,' Bastos, Blandy, and the contributing authors have given us a gift through which we might imagine a democratic future that is inclusive, expansive, creative, and just."

– **Kim Cosier, PhD**, *Professor Emeritus, Art Education, and Founder, Milwaukee Visionaries Project*

Promoting Civic Engagement Through Art Education

A Call to Action for Creative Educators

Edited by Flávia Bastos and Doug Blandy

NEW YORK AND LONDON

Designed cover image: © Getty Images

First published 2025
by Routledge
605 Third Avenue, New York, NY 10158

and by Routledge
4 Park Square, Milton Park, Abingdon, Oxon, OX14 4RN

Routledge is an imprint of the Taylor & Francis Group, an informa business

© 2025 selection and editorial matter, Flávia Bastos and Doug Blandy; individual chapters, the contributors

The right of Flávia Bastos and Doug Blandy to be identified as the authors of the editorial material, and of the authors for their individual chapters, has been asserted in accordance with sections 77 and 78 of the Copyright, Designs and Patents Act 1988.

All rights reserved. No part of this book may be reprinted or reproduced or utilised in any form or by any electronic, mechanical, or other means, now known or hereafter invented, including photocopying and recording, or in any information storage or retrieval system, without permission in writing from the publishers.

Trademark notice: Product or corporate names may be trademarks or registered trademarks, and are used only for identification and explanation without intent to infringe.

ISBN: 978-1-032-50580-0 (hbk)
ISBN: 978-1-032-51397-3 (pbk)
ISBN: 978-1-003-40201-5 (ebk)

DOI: 10.4324/9781003402015

Typeset in Sabon
by KnowledgeWorks Global Ltd.

Contents

List of Figures	*viii*
Acknowledgments	*xi*
About the Authors	*xii*
Foreword	*xv*
Liora Bresler	

Introduction: Promoting Civic Engagement through Art
 Education: A Call to Action for Creative Educators 1
 Flávia Bastos and Doug Blandy

Introduction to Section I 7

Section I: Theory: Developing a Democratic Imagination 11

1 Civics and the Arts: Developing Cultural Citizenship within
 Art Education 13
 Rachel Fendler and Sara Scott Shields

2 Limit Acts and Constructed Situations as Curriculum: Paulo
 Freire and the Situationist International 26
 Olivia Gude

3 Transformative Learning toward Socio-Ecological
 Consciousness and Civic Engagement: The Creative Potential
 of Nature Connection 43
 Mira C. Johnson

4 Reproductive Justice as Feminist Art Education 56
 Karen T. Keifer-Boyd

5 An Affective and Sensory Civic Encounter: Examining Ableism
 and Civic Education through Arts Based Policy Research 75
 jt Eisenhauer Richardson

6 Encountering the *I Can't Breathe Mural:* Antiracism, the
 Material Culture of Protest, and Art Education 95
 Erica Rife and Doug Blandy

7 Making Common Ground for Living: Strategies for
 Meaningful Intervention into Systemic and Structural
 Inequities 109
 James Haywood Rolling, Jr.

8 Art Education for Democracy: Insights from *Who Is
 American Today?* Project 123
 Flávia Bastos

9 Global Music Communities and Civic Engagement in the
 Digital Age 140
 David G. Hebert and David Thorarinn Johnson

Introduction to Section II 155
Flávia Bastos and Doug Blandy

Section II: Engagement: Creating as if Communities Matter 159

10 We Make the Road by Walking: Exploring Art Activist
 Pedagogy 161
 Dipti Desai

11 Reimagining YAAAS: Supporting the Well-being and Civic
 Potential of Resettled Refugee Youth through Collaborative
 Artmaking 172
 Kate Collins

12 AMP!ify | Agitate | Disrupt: Civic Engagement and Political
 Clarity in Art Education 186
 Joni Boyd Acuff, Courtnie Wolfgang, and Mindi Rhoades

13 The Landscape is Turning: Narrative Collage as Sites of Civic
 Engagement 201
 Amy Pfeiler-Wunder

14 Engaging the Next Generation of Citizen Artists: How a
 Museum of Contemporary Art and Chicago Public High
 School Partnered to Foster Informed and Activated Youth 215
 *Lynne Pace Green, Damon Locks, Maria Scandariato,
 and Andrew Breen*

15	Reflective Conversations between Two Experienced Women Art Educators and Their Life-Long Involvement through Civic Engagement	239
	Sharon Greenleaf LaPierre and Enid Zimmerman	
16	Utilizing Fugitive Pedagogies to Promote Civic Education in *De Facto* Segregated Schools	252
	Debra A. Hardy	
17	Combating Racial Pandemic and Advocating for the Invisible through Art	264
	Kevin Hsieh	
18	(Un)learning on the Sidewalk: Personal Reflections on Reclaiming Civic Engagement and Democracy in Public Art Making	278
	William Estrada	
19	Engaging Circles of Relation: Indigenous Methodologies in Community-based Theatre	291
	Theresa J. May	
	Conclusion and Final Remarks	303
	Flávia Bastos and Doug Blandy	

Index 306

Figures

1.1 Student mood boards (left two images) and images of students reflecting on the walking tours (right two images). 19
1.2 Images of student work from Somerville High School. 22
2.1 Generative Theme Investigation by Nicole Abandor, 2020. Permission of the artist, Olivia Gude. 28
2.2 I'm an Evil Child. Who Knew? Punishment Autobiographical Comic by Maria Lopez, 2008. Spiral Workshop Archive. 29
2.3 Getting Lindsay Linton, photograph in *Understanding Joshua* series, Lightjet c-print mounted on Plexiglas 30.5 × 152.4 cm Ed. 3/3, Selvage Collection, by Charlie White, 2020. Permission of the artist. 31
2.4 Power of Advertising project as taught by Madilyn Strentz at Back of the Yards College Preparatory High School, 2016. Contemporary Community Curriculum Archive. 33
2.5 Sell Out Détournement by Mercedes Jones, 2007. Spiral Workshop Archive. 37
2.6 Live Without Deadtime installation, Spiral Workshop, 2011. Spiral Workshop Archive. 40
2.7 Détourning the Elements & Principles Curriculum, artwork by Olivia Gude, 2012. 41
4.1 Laura Feierman's room installation *Vulnerability, Humility, Insecurity, Tenacity* is part of the collaborative project, Wo/Manhouse 2022. 60
4.2a Olivia Jane's (2022) *Moon Womb* can be worn as public pedagogy for reproductive justice. 61
4.2b Artist Olivia Jane (2022) wears her embroidery design, *Moon Womb*. 62
4.3 *Pro-choice Activism: Today and in 1989 with Merle Hoffman 968* is a 23″ × 29.5″ × .5″ collage by feminist art activist Linda Stein created in 2019. 63
4.4 *Mr's.' Nirbhaya*, comprised monotype prints as backdrop for tangled red threads in which six rag doll-like ceramic figures dangle is the 36″ × 68″ × 6″ sculptural work by Ian Kaur created in 2022. 65
4.5 The chart is a compilation of works discussed in this chapter, prepared by the author. 68
5.1 My grandmother-in-law and mother-in-law's handwritten recipe notebook. 76

5.2	Book cover, *Student's Textbook*, United States Department of Labor's Bureau of Naturalization, 1918.	77
5.3	Dough rolled on my mother's countertop. 2022. Domestic labor.	81
5.4	Creating cut-out cookies from the US Constitution. 2023. Domestic Labor.	82
5.5	Erasure of letters in ableist words in the 1882 Immigration Act.	86
5.6	Text from the *United States Constitution* cut from dough.	87
5.7	Cut-out sugar dough letter cookies organized alphabetically and by frequency cooling on a metal rack.	88
5.8	A line from the State of Ohio's Constitution cut from sugar cookie dough. *To Form a More Perfect*.	89
5.9	Crumbling cut-out letter cookies. To Form a More Perfect.	89
5.10	Cut-out cookie dough pushed across the countertop (top), a mound of dough baking in the oven (bottom).	90
6.1	*I Can't Breath* Mural, Photography by Erica Rife.	97
6.2	Antiracism Lenses for Social Justice Education.	101
8.1	*Who Is American Today?* Exhibition poster.	127
8.2	Tania, Provo High School, still from digital story.	130
8.3	Cameron, Provo High School, still from digital story.	131
8.4	Data table by cohort, prepared by Flávia Bastos.	134
8.5	The relationship between digital making skills and citizenship types.	136
9.1	Ukrainian violinist performs a folk song from a bomb shelter in a "virtual concert".	145
9.2	Ukrainian pianist performs Chopin in a bombed-out house.	145
9.3	Ukrainian violinist performing for others in a bomb shelter.	146
10.1	Pages of *Passport to the Past* booklet given during walking tour, 2018.	164
10.2	Pages of *Passport to the Past* booklet given during walking tour, 2018.	164
10.3	Pages of *Passport to the Past* booklet given during walking tour, 2018.	165
10.4	Map of Sites in booklet, Photography by Dipti Desai.	165
10.5	Walking Tour, Photography by Dipti Desai.	166
10.6	Public Art Installation of *Passport to the Past* at Kimmel Window, NY 2021, Photography Pamela Jan Tinnen.	169
10.7	Public Art Installation of *Passport to the Past* at Kimmel Window, NY. 2021, Photography by Pamela Jan Tinnen.	170
12.1	*AMP! Critical Race Theory* (Issue 1).	190
12.2	*AMP!* Planning FORMAT document shared with students and *AMP!* Participants.	191
12.3	Cover art and page 1 of *AMP! Culturally Relevant Pedagogy*.	194
12.4	Pages 2 and 7 of *AMP! Culturally Relevant Pedagogy*.	195
12.5	Cover page and page 8 of *AMP! Afrofuturism*.	196
13.1	Anthony: Paper Doll in New York City.	206
13.2	Rosie's Doll: "Being Myself". (1) Rosie with skinned knees, (2) Rosie with a cellphone, "Teaching in a Digital Age" and (3) Rosie with a rainbow bag.	207
13.3	Celebrating Pride: Andrea's Doll. (1) Andrea's Blank Paper Doll and (2) Celebrating Pride Clothing Choices.	209

15.1 *Pinheads*, 22″ × 16″ steel sculpture on found object, acrylics by Sharon LaPierre. 242
15.2 *White Faced Basket*, 9.5″ tall by 8″ in diameter, coiled basket with handmade paper, wool, acrylics, relief eyelashes, mixed media by Sharon LaPierre. 243
15.3 *Ties to the Past*, June 12, 2017, 9″ × 11″ mixed media work by Enid Zimmerman. 249
15.4 *Difficult Road Ahead*, September 17, 2021, November 20, 2022, and February 18, 2023, 9″ × 11″ each, mixed media works by Enid Zimmerman. 249
17.1 *Let Me Share the Sky with You*, 2021, public mural (partial) by Amanda Phingbodhipakkiya, photo taken by the author at 10th Street, Midtown Atlanta on August 31, 2022. 268
17.2 Between the Red by Arianne Peiann Chen, painting with collage on canvas board, 8″ by 11″, with poetry. 269
17.3 Sketch (Left, 17.3a) for the illustration *This Is Not Consent* (Right, 17.3b) by Courtney Escorza, poster design, 8″ × 11″, 2021. 271
18.1 Family, student-generated Arpillera created as part of the Telpochcalli Artist in Residence Program in collaboration with Dana Oesterlin-Castellon as part of a social studies lesson on Latin American history and migration. Photograph by William Estrada. 280
18.2 You Are Beauty, student-generated text using stencils and acrylic on mylar balloon in collaboration with Cognate Collective as part of a Chicago Arts Partnership in Education after-school program co-taught with Erin Franzinger Barrett. 282
18.3 People in their neighborhood making buttons through The Mobile Street Art Cart Photograph by William Estrada. 285
18.4 Families Belong Together, Natasha colored in a poster in a public workshop through the Mobile Street Art Cart Project in collaboration with the Mobilize Creative Collaborative. 286

Acknowledgments

This project would not have been possible without those authors who generously agreed to contribute to this volume. We appreciate their time, attention, and dedication to art, education, and imagining democracy and civic engagement. We are grateful to Julia Dolinger, our editor at Routledge, along with Sophie Ganesh and other members of the editorial team for their expert guidance in bringing this collection of essays to press. We are grateful for the assistance two remarkable University of Cincinnati students, Mia Morales, who served as our research assistant during the development of the prospectus for this book and for the contributions of Deependra Dehariya, our graduate research assistant who lent tremendous support during the chapter development phase of the project.

We are grateful to our students and colleagues at the University of Cincinnati and the University of Oregon for their sustained insights and responsiveness to our commitment to the focus of this book.

Thank you to our spouses, Larry Huston and Linda Beal Blandy, for their ongoing support and encouragement of our commitment to advancing democracy through art, education, and civic engagement.

About the Authors

Joni Boyd Acuff is a Professor of Art Education at The Ohio State University. She also serves as the Chair of the Department of Arts Administration, Education, and Policy. Her expertise lies in critical multiculturalism, critical race theory, Black feminist theory, and Afrofuturism in art education.

Flávia Bastos is a Distinguished Research Professor in the Arts and Humanities at the University of Cincinnati. Inspired by Paulo Freire's educational philosophy, Bastos is a Distinguished Fellow of the National Art Education Association. Her project "Who is American Today?" received the Excellence in Research in Education through Art award in 2021.

Doug Blandy is a Professor Emeritus in the College of Design, School of Planning, Public Policy and Management at the University of Oregon. His research focuses on community-based art education experiences within a lifelong learning context. He is a Distinguished Fellow of the National Art Education Association.

Andrew Breen is an art educator and photographer. Currently, he is developing a new curriculum for Graphic Arts courses at Amundsen High School in Chicago.

Liora Bresler is a Professor Emerita in Curriculum and Instruction in the College of Education at the University of Illinois Urbana-Champaign. Bresler's interdisciplinary work focuses on the arts and qualitative research methodology. She has sought to bring together intellectual communities across arts disciplines and cultures to address key areas in early childhood, curriculum and cultural context, and embodiment in education.

Kate Collins is a Visiting Associate Professor in the School of Art at The University of Arizona. Her research focuses on transformative arts-based pedagogies and collaborative arts partnerships for youth learning.

Dipti Desai is a Professor of Art and Art Education and the Director of Graduate Art + Education Programs at New York University. She is a scholar, artist-educator, and activist whose work addresses the intersection between visual art, activism, critical pedagogy, and critical race theory.

William Estrada is a faculty member at the University of Illinois at Chicago School of Art. He is also Art History and a Teaching Artist at Telpochcalli Elementary School in Chicago. His work focuses on addressing inequity, migration, and cultural recognition

through art and education. He engages in collaborative efforts with Mobilize Creative Collaborative, Chicago ACT Collective, and Justseeds Artists' Cooperative.

Rachel Fendler is an Associate Professor in the Department of Art Education at The Florida State University. Additionally, she serves as the Director of Teacher Certification. Fendler's research explores how art presents possibilities for young people to relate to each other and their city differently.

Lynne Pace Green is an artist and educator with experience in museums, public schools, universities, and arts organizations. Currently serving as the Director of the Teaching Artist Development Studio at Columbia College in Chicago, Green is also a founding member of Arts Ed Chi and a catalyst for the International Teaching Artists Collective.

Olivia Gude is a Professor Emerita of Art Education at the School of the Art Institute of Chicago and Professor Emerita at the University of Illinois at Chicago. Known for her expertise in reimagining art education curriculum and collaborative mural and mosaic projects, Gude is a Distinguished Fellow of the National Art Education Association.

Debra A. Hardy is an Assistant Professor in Art Education at the Peck School of the Arts at the University of Wisconsin, Milwaukee. Her research focuses on the histories of art education on the south side of Chicago for Black teachers and students. Utilizing critical race theory and Black feminist theory, she challenges historical narratives and Whiteness within art education.

David G. Hebert is a Professor with Western Norway University of Applied Sciences, Bergen. He is the author of several books and serves on editorial boards in music and arts education. Additionally, he manages the state-sponsored Nordic Network for Music Education.

Kevin Hsieh is a Professor of Art Education in the Ernest G. Welch School of Art & Design at Georgia State University. His research interests include interdisciplinary art education, Chinese art history, museum education, and LGBTQ+ issues.

David Johnson is a Canadian/Swedish music education researcher and an Associate Professor of Music at Western Norway University of Applied Sciences, Bergen. He is the editor of the book "Confluence: Perspectives from an Intercultural Music Exchange in Nepal".

Mira Johnson is an Adjunct Assistant Lecturer at Bronx Community College. Her research interests are associated with Adult Education and Lifelong Learning. She serves as a board member and secretary for the New York Folklore Society.

Karen T. Keifer-Boyd is a Professor of Art Education and Women's, Gender, and Sexuality Studies at The Pennsylvania State University. Her research focuses on transdisciplinary creativity, inclusion, feminist art pedagogy, and disability studies.

Sharon La Pierre is an artist and art educator specializing in fiber design, music, and curriculum research methods. She has served in various roles within professional and international research and multicultural organizations for art education.

Damon Locks is a visual artist, educator, and musician. He works with the Prisons and Neighborhood Arts/Education Project at Stateville Correctional Center near Chicago

and has received various awards, including the Helen Coburn Meier and Tim Meier Achievement Award.

Theresa May is a Professor Emerita in Theatre Arts at the University of Oregon. Specializing in Native theatre, Latinx dramatic literature, ecotheatre, and community-engaged plays, she is also a co-founder of the EMOS Ecodrama Playwrights Festival.

Amy Pfeiler-Wunder is a Professor of Art Education at Kutztown University. She serves as the Department Chair and Coordinator of the Master of Art Education Graduate program. Her research examines the impact of intersectionality on professional identity in art education.

j.t. Eisenhauer Richardson is an Associate Professor at The Ohio State University. Their research explores trans*/crip/(neuro)queer poetics and forms in art education. Richardson also exhibits artwork in various media and practices, including collage, textile, installation art, and performance.

Mindi Rhoades is an Associate Professor of Teaching and Learning in the College of Education and Human Ecology at The Ohio State University. Her research focuses on using multimedia and interdisciplinary arts-based approaches to teaching, research, and activism. Rhoades is interested in the intersections of arts and media with STEM fields.

Erica Rife is the Executive Director of the Architecture Foundation of Oregon. She is a nonprofit sector leader focused on design, innovation, and inclusion. Rife previously served as the managing director of Design Museum Portland where she led its development, program direction, and community building.

James Haywood Rolling, Jr. is a Dual Professor of Arts Education and Teaching & Leadership at Syracuse University. As the 37th President of NAEA, he shaped the field and chaired the NAEA Equity, Diversity, and Inclusion Commission. He is a National Art Education Association Distinguished Fellow.

Maria Scandariato is a Chicago Public Schools teacher with 26 years of experience. She has served as a department chair, curriculum coordinator, and mentor. Passionate about history and art, Scandariato empowers students to become agents of change.

Sara Scott Shields, Associate Professor and Chair of the Art Education Department at The Florida State University, brings 16 years of teaching experience at secondary and collegiate levels. Her research focuses on integrating arts-based research, contemporary art, and community histories for socially just educational encounters.

Courtnie Wolfgang is an Associate Professor of Art Education at the Rhode Island School of Design. Her research focuses on intersections of post-structural, post/feminist, critical race, and queer theories with arts pedagogies. Wolfgang has led collaborative arts-based workshops and edited a special issue of Visual Arts Research on Queering Art Education.

Enid Zimmerman is a Professor Emerita of Art Education and High Ability Programs at Indiana University. Her research interests include art education, creativity, talent development, history, feminism, and global art education.

Foreword

Liora Bresler

The intensified attacks on democratic institutions globally, including countries with strong democratic traditions, make this book remarkably timely. At the same time, the core issues it addresses are timeless. The buffet of ideas, frameworks, and practices presented here cultivate democratic education in imaginative, wise, and transformative ways.

The notion that education is crucial in supporting democracy was ardently voiced by John Dewey (1916) more than a century ago, in times of increased diversity and social change. According to Dewey, democracy is not simply a form of government but a way of life, present in the attitudes and values of people working with one another. Democracy as practice has to be constantly re-discovered and re-organized. Democratic processes involve conflict-resolutions that are situation-specific, seeking for contextual, rather than universal, approaches (Väkevä & Westerlund, 2007).

Democratic values, Dewey argued, don't only accommodate difference but depend on difference. A democratically oriented "new patriotism", philosopher Walter Feinberg maintains, replaces nationalism with attending to the cultural, political, and planetary life (Feinberg, 2023). Nationalism, to invoke Buber's distinctions of relationships (Buber, 1923/1971), is typically founded on "Us-Them"[1] mindset. The aesthetic principle of *diversity within unity*, I suggest, captures a democratic principle with important educational implications. Following on Buber's "I-Thou" relationship of attuned connection across differences, I envision democratic education as striving for "I-Thou-Us", where the "I" of learners and teachers attends to diverse voices with the aspiration to connect. Education for democracy requires a shift of mindset, political and educational. Our challenge is how to create a unity larger than existing tribal and national ones.

While Buber's "I-Thou" is centered on encounters with individual people, he also referred to it in relation to artworks (Buber, 1923/1971). Indeed, the arts invite us to connect in ways that honor situated interpretations and perspectives. Aspiring to democratic teaching in my aesthetic education courses, I drew on sustained engagement with artworks, connecting in this process to our inner landscapes and responses, then, to others' multiplicity of interpretations, opening a conversation (Bresler, 2021). Here, unity was facilitated by course structure and communal experiences. Class members repeatedly found that discrepant interpretations opened us for richer understanding. The power of art in inviting us to engage with and listen to conflicting perspectives, to

stay with dissonance as a productive space, has also been key pedagogy in my qualitative research courses (e.g., Bresler, 2013).

Taking connection to the next step, Philosopher Maxine Greene writes about the power of the arts to mobilize: "Most significant for me is the capacity of an art form (when attentively perceived, when authentically imagined) to overcome passivity, to awaken us to a world in need of transformation, forever incomplete" (Greene, 2007, p. 660). She suggests, "If we could attend with enough care and reflectiveness to the shapes of pain in the *Guernica* and the light bulb and the desperate mother, if we could participate against the background of our lived and lacerated lives… our own visions might call on us to reach towards a reciprocity of perspectives" (Greene, 2007, p. 659).

The capacity of the arts to evoke empathy, mobilize, and work productively with diverse interpretations gives it special educational power. The humanities, Feinberg maintains, are "critical for developing the skills required to hear and respond to complex, sometimes uncomfortable truths by probing the interpretive frames that can help understand the source of such discomfort, setting the stage for collective discussions about who we are and who we might like to become, the material for collective self-understanding and development" (Feinberg, 2023, p. 67). The arts, sharing these interpretive aspects with the humanities, add heightened experiential and expressive aspects to these discussions.

I witnessed the invitation to engage in such collective discussions, "to perceive attentively and imagine authentically against the background of students' lived and lacerated lives", in a border town in Texas in a high-school project integrating the arts into academic disciplines[2] (Bresler, 2002). Before the project started, the school was on probation with the State Board of Education because fewer than 40% of its students passed the yearly Assessment exam. Overall, 90% of the student population was identified as at-risk and below standardized grade level scores. Time spent at school was the only English-speaking part of most students' day. The idea of spending time and energy on providing arts instruction as part of the academic program in this high-school was perceived as outlandish even within the school. Still, a core group of teachers in English, drama, music, visual arts, and social studies envisioned and created a democratically oriented curriculum that aimed for relevance to students' lives.

The integrated curriculum was structured around the broad themes of class, gender, ethnicity, family, and propaganda. In lessons on class, I observed students study the Mexican, French, and Russian revolutions in history, listening to and singing songs associated with the Mexican revolution, and read literature that portrayed class differences. Discussions ranged from analysis of elements of poetry and music to broader historical and sociological contexts. In a unit on ethnicity, students read poetry and literature from the Harlem Renaissance, listened to, then wrote their own blues lyrics, and studied the role of race in conflicts from the Spanish Civil War through WWII. Responding, analyzing, and creating visual artworks and drama sketes, composing music and poetry based on their lived experience, the assignments encouraged inquiry skills and independent research, connecting broader and disciplinary issues to personal meaning and expression.

Students' responsibility and agency extended beyond contents and pedagogies to include democratic classroom management. Addressing discipline, for example,

students divided the room into two diagonal sections, with one section housing disruptive or tired students, and the other section housing the motivated students. There was a constant flow between the two sections, when the disruptive students decided to give the work a try, or the motivated students decided they wanted a break. Disruption, students, and teachers told me, stopped. Observing classes, talking with teachers and students, and reading students' works, I was struck by the vitality of engagement by both students *and* teachers. The engagement was evident in teachers' collaborative work, as they democratically created this trans-disciplinary curriculum. Teachers negotiated and learned from each other in the process of bringing their distinct disciplinary traditions, personal and professional knowledge. The vitality of democratic processes was clearly evident in students' absorbed participation in class, dramatically different, they said, from their past truancy.

While the lived experience of the curriculum was empowering and impactful, the future of the project, teachers recognized, would be judged by test-scores. I remember an early morning phone call by a social studies teacher at the end of the semester, telling me about the test-scores released that morning. This school, formerly at the bottom of the district in test-scores, now scored the highest. It was a day of celebration. The integrated curriculum could continue.[3]

I witnessed a similar spirit of collaborative democratic education in a curricular project centered around peace education in Bogota, Colombia, *Uaque* (Arcila, 2017). *Uaque* is a Muisca indigenous word conveying friendship, kinship, neighborhood, and conversation. The project, carried out by a group of 18 teachers with Jorge Arcila as the research director, was initiated by the Colombian Institute for Educational Research and Pedagogical Development and conducted in partnership with Bogotá's School Board. The UAQUE mission addresses peace through the building of curricular experiences that modeled how to connect to the "other" throughout differences and conflicts. Observing and talking with teachers of literature, arts, creative circus, and movement/yoga/martial arts, I was struck by teachers' appreciative listening to each other and to their students as they created innovative curricula, and the effect on students' trust and engagement. Here, democratic participation was also evidenced by the dedication of the whole community of displaced people who came to this area 20–30 years prior to building one of the schools. The project, I was told, still continues eight years later.

These two examples exemplify the capacity of arts education, when conducted with the intention to listen, honor, and learn from multiple perspectives, to create a vital curriculum based on democratic values. Examples of work presenting important approaches and practices to arts education for democracy involve theater (Boal,1993; McCammon, 2007; Schonmann, 1996); visual arts (Bastos, 2007; Blandy, 1994); music (Kallio et al., 2021; Saether, 2008); and dance (Green, 2000; Stinson, 1998). The chapters in this volume enlarge our vision of the possible by extending paradigms and settings, from schools and museums, to city-scape of streets and parks, YouTube, and material culture.

Arts education is not immune from common curricular problems, including repression and propaganda. Even teachings committed to democratic ideals might inadvertently reinforce policies and practices that democratic arts education intends

to rectify (Kallio, 2015; see also Väkevä & Westerlund, 2007). Structures and leadership are essential to maintain innovative systemic educational practices. Still, the arts' capacity to evoke personal resonance within aesthetic distance, allowing a space that accommodates multiplicity (including conflictual) of viewpoints, makes them powerful pedagogical tools, inviting us to engage, mind, heart, and spirit in democratic processes toward personal and communal expansion.

NOTES

1. Nested within "I versus Them" mindset in individualistic cultures.
2. The project was initiated and modestly supported by the College Board/Getty Institute.
3. For a while. My observations and involvement occurred in the funded stage. It would be important to follow projects like this to learn if they are sustained when key participants and leadership change.

REFERENCES

Arcila, J. (2017). *UAQUE: The art of coexistence: School's investigative, pedagogical and esthetic bets* (Arcila, J. & Cortes, Eds.). Instituto para la Investigación Educativa y el Desarrollo Pedagógico, IDEP. https://repositorio.idep.edu.co/handle/001/283

Bastos, F. (2007). Art in the market program: Ten years of community-based art education. *Journal of Cultural Research in Art Education, 25*, 51–63.

Blandy, D. (1994). Assuming responsibility: Disability rights and the preparation of art educators. *Studies in Art Education, 35*(3), 178–187.

Boal, A. (1993). *Theater of the oppressed* (C. McBride, trans.). Theater Communications Group.

Bresler, L. (2002). Out of the trenches: The joys (and risks) of cross-disciplinary collaborations. *Council of Research in Music Education, 152*, 17–39.

Bresler, L. (2013). The spectrum of distance: Cultivating empathic understanding in research and teaching. In B. White & T. Costantino (Eds.), *Aesthetics, empathy and education* (pp. 9–28). Peter Lang.

Bresler, L. (2021). Aesthetic and pedagogical compasses: The self in motion. *Artizein: Arts and Teaching Journal, 6*(1), Article 10. https://opensiuc.lib.siu.edu/atj/vol6/iss1/10

Buber, M. (1923/1971). *I and thou*. Simon and Schuster.

Dewey, J. (1916). *Democracy and education*. Macmillan.

Feinberg, W. (2023). *Democracy for education*. Cambridge University Press.

Green, J. (2000). Power, service, and reflexivity in a community dance project. *Research in Dance Education, 1*(1), 53–67.

Greene, M. (2007). Interlude: The arches of experience. In L. Bresler (Ed.), *International handbook of research in art education* (pp. 657–662). Springer.

Kallio, A. A. (2015). *Navigating (un)popular music in the classroom: Censure and censorship in an inclusive, democratic music education* [Doctoral thesis], Sibelius Academy of the University of the Arts Helsinki. Studia Musica 65. http://ethesis.siba.fi/files/nbnfife2015102315039.pdf

Kallio, A. A., Westerlund, H., Karlsen, S., Marsh, K., & Sæther, E.(Eds.). (2021). *The politics of diversity in music education*. Springer.

McCammon, L. (2007). Research on drama and theater for social change. In L. Bresler (Ed.), *International handbook of research in arts education* (pp. 965–982). Springer.

Saether, E. (2008). When minorities are the majority: Voices from a teacher/researcher project in a multicultural school in Sweden. *Research Studies in Music Education*, 30(1), 25–42.

Schonmann, S. (1996). Jewish-Arab encounters in the drama/theater class battlefield. *Research in Drama Education*, 1(2), 175–188.

Stinson, S. (1998). Seeking a feminist pedagogy for children's dance. In S. B. Shapiro (Ed.), *Dance, power and difference: Critical and feminist perspectives on dance education* (pp. 23–47). Human Kinetics.

Väkevä, L., & Westerlund, H. (2007). The "method" of democracy in music education. *Action, Criticism and Theory for Music Education*, 6(4), 96–108.

Introduction

Promoting Civic Engagement through Art Education: A Call to Action for Creative Educators

Flávia Bastos and Doug Blandy

This book draws upon our sustained commitment to embrace the political in art and in education. Collectively, our scholarship, teaching, and community engagement are rooted in transformative conceptions of education best articulated by Brazilian educator Paulo Freire's (2020) categorization of education as a political act. This volume seeks to unapologetically advance an educational framework (Section I) illuminated by practice (Section II) that can sustain educators' goals of preparing students for civic engagement within a democratic society.

WHY NOW?

Robert Kagan (2023), a contributing editor to the *Washington Post*, warned his readers on November 30 that a "Trump dictatorship" is within the realm of possibilities (p. 1). This opinion piece was widely referenced in other print, broadcast media, and social media. Alarming is his observation that the United States (U.S.) electorate is delusional about the impossibility of Donald Trump being the Republican nominee in 2024, given the numerous indictments of him and his co-defendants (some of whom have pled guilty and been sentenced in Georgia) associated with overturning the 2020 election. Kagan wrote,

> Like people on a riverboat, we have long known there is a waterfall ahead but assume we will somehow find our way to shore before we go over the edge. But now the actions required to get us to shore are looking harder and harder, if not downright impossible. (p. 1)

He goes on to state that

> If Trump does win the election, he will immediately become the most powerful person ever to hold that office. Not only will he wield the awesome powers of the American executive … but he will do so with the fewest constraints of any president, fewer even than in his own first term. (p. 1)

This opinion piece in the *Washington Post* appeared as we are finalizing *Promoting Civic Engagement through Art Education: A Call to Action for Creative Educators*

DOI: 10.4324/9781003402015-1

in preparation for submission to Routledge. As we worked with this volume's contributors over the past two years, a significant number of judicial, political, social, and cultural events in the U.S. and elsewhere have occurred that support the original motivations and urgency of this collection of essays. Assumptions about shared democratic values have been shaken by unrelenting events, such as Russia's invasion to and continuing war with the sovereign nation of Ukraine; the expanding conflict between Israel and Hamas in which senseless acts of violence toward Israeli civilians, including women and children, motivated a brutal invasion of Gaza, resulting in tens of thousands of civilians deaths, also including women and children, which is paving the way to expanding conflict in the Middle East and U.S.' military involvement in the region. At home, our original motivations for bringing this volume to publication continue to be prescient. These included the mounting social and political challenges associated with the January 6, 2021, attack on the U.S. Capitol to disrupt the electoral count, voter suppression initiatives before many state legislatures, xenophobic reactions to the COVID-19 pandemic leading to violence and death of Asian Americans; the humanitarian crisis on the border between the U.S. and Mexico; and widespread national Black Lives Matter protests associated with the murders of Breonna Taylor and George Floyd, a former president facing significant and unprecedented legal challenges leads the Republican party nomination, efforts to limit education's commitment to racial and social justice, and attacks to women's reproductive rights.

All these occurrences are, and have, the potential to compromise democracy, as we know and experience it in the U.S. Furthermore, they impact the mechanisms and overall quality of civic participation necessary to sustain a healthy democracy. Equally important to recognize here, as did Kagan (2023) referenced above, is the ominous displays of divisiveness and fear for the results of the upcoming 2024 Presidential election. The outcomes of this election will mean that this volume can assist in moving democracy and civic engagement forward and/or support the resistance necessary to preserve democracy and civic engagement in the aftermath of an election that results in what Kagan (2023) describes.

The rate and speed of local and global turmoil can create a sense of confusion and hopelessness, as affected people's faces haunt our memory, and the residual and future harm from these developments curb ability to imagine an end in sight. During these dire times, the question of how art and education are implicated in resisting and responding to such extraordinary conditions has not only been in our minds as editors of this volume but more importantly addressed in robust ways by all contributing authors. Our work seeks to build on art education's legacy of sustaining hope by developing creativity and imagination, as proposed by Viktor Lowenfeld in response to the atrocities he witnessed as Austrian Jewish refugee from the Nazi Holocaust. One of the most influential art educators of the twentieth century, Lowenfeld developed an approach to art education that sought to prevent the horrors of World War II through nurturing the creativity and imagination of children. In the second edition of *Creative and Mental Growth* (1952), he offers a personal perspective:

> Having experienced the devastating effect of rigid dogmatism and disrespect for individual differences, I know that force does not solve problems and that the

> basis for human relationships is usually created in homes and kindergartens. I feel strongly that without the imposed discipline common in German family lives and schools the acceptance of totalitarianism would have been impossible. (p. ix)

Reclaiming the place of art and education in promoting and imagining democracy is an urgent and needed undertaking. While questioning the role of art during times of hardship is a frequent criticism, affirming the ways in which art and education can work in tandem to restore and cultivate our shared humanity, promote solidarity and understanding, and elevate our concerns, stories, and experiences so that they can be heard and acknowledged are central to this volume's purpose.

TO WHAT END?

Peter Biro (2020) in his introduction to *Constitutional Democracy Under Stress: A Time for Heroic Citizenship* emphasizes the importance of a "sufficiently informed citizenry" as an antidote to the assaults on democracy (p. 5). The contributors to *Promoting Civic Engagement through Art Education: A Call to Action for Creative Educators* affirm, like Biro, that among the principal aims of education, including education in art, in the U.S., and those other nations aspiring to be democratic, is preparing children, youth, and adults to be informed citizens able to engage civically in support of democracy. The contributors to this volume argue that pedagogy, art curricula, and creative practice based on transformative learning assist students in understanding that art is a powerful communicative tool and as such is afforded protections under the U.S. Constitution; and it will occur within civic institutions such as museums, community arts centers, and schools. Integral to this participation is an appreciation and understanding of the relationship between art, democracy, civil society, and civic engagement.

Art education has historically responded to the needs and exigencies of the world around us. Beck's (1921) textbook, *Better Citizenship through Art Training*,[1] is an early example of educators upholding the right to know about art and examining ways in which art can promote civic engagement. As a throughline, the purpose of *Promoting Civic Engagement through Art Education: A Call to Action for Creative Educators* is to bring attention to theory and practice in art education, and related fields, that place civic engagement at the forefront. Collectively, contributors to this volume draw upon a sustained commitment to promoting educational practices rooted in the arts and to advance socially just structures within a democracy.

In this volume, we adapt the notion political turn used to characterize emerging concerns for social and political issues evident in the work of influential thinkers such as Foucault (Ferreira-Neto, 2017) and Bourdieu (Schinkel, 2003). Our intention is to galvanize the potential of art and education to engage with politics to address pressing societal needs, revisiting American's education tradition of preparing learners for democracy. However, within the U.S., there is convincing evidence that citizens are not fully informed to be able to participate civically. Shortly after the 2016 presidential election, the Century Foundation released *Putting Democracy Back in Public*

Education (Kahlenberg & Janey, 2016). Referencing multiple studies, the report brings attention to public ignorance of the roles and functions of the executive, legislative, and judicial branches of government; declining support for democratic values; an emphasis on workplace preparation in education; decline in civics instruction; a significant lack of student proficiency in civics; a public open to anti-democratic and authoritarian values; and an overall distrust in those institutions supporting and advancing democracy. We know of no subsequent publication that refutes these conclusions.

As authors in this volume, we argue that scholarship, teaching, and community engagement are embedded in transformative conceptions of education. John Dewey's (1923) *Democracy and Education: An Introduction to the Philosophy of Education* was published just over 100 years ago. This ground-breaking volume on the relationship between education and democracy was motivated at the time of its publication by concerns that democracy was being eroded by the inequitable social conditions of his time. In this volume, Dewey describes democracy as a way of life and that education should be an informed citizenry. Best articulated by Brazilian educator Paulo Freire (2020) is that education is a political act.

The contributors to *Promoting Civic Engagement through Art Education: A Call to Action for Creative Educators* assert that educating for democracy and civic engagement should be a priority for art education and affinity disciplines. They investigate the contemporary need for reinvesting education practices with a commitment to civic engagement, and the pursuit of a common good. Further, this book is a call to action, inviting creative educators, especially in the arts to explore the potential of art for developing critical perspectives, articulating voices toward diverse points of view, and engaging in dialogue across this diversity.

Contributors to this book recognize that definitions of art differ in multicultural societies such as the U.S. Within this book, art is linked with the concept of expressive culture as delineated in fields such as anthropology and folklore. Expressive culture includes sensory experiences associated with the visual, performing, literary, time-based, environmental, culinary, and heritage arts, among other expressive forms. Expressive culture also includes fine arts, traditional arts, and folk arts. Contributors also recognize that art education, or learning about art, occurs across the lifespan in informal settings, such as at home, and formal settings such as schools, museums, performing arts centers, festivals, and community arts centers, among other environments.

WHY THE ARTS AND EDUCATION?

The essays in *Promoting Civic Engagement through Art Education: A Call to Action for Creative Educators* examine questions such as:

- What is our responsibility to sustain democracy through meaningful engagement and critical activity?
- How can artists and creative citizens model an ethics of care that can foment the desire to contribute to society?

- What are students' abilities to dialogue with others in constructive and transformative ways?
- Can art and creative skills anchor contemporary education practices that promote the common good and ignite a reimagined society?

Chapters in this volume are of two types. The first section of the book, "Theory: Developing a Democratic Imagination," is primarily theoretical in focus with the second section, "Engagement: Creating as if Communities Matter" focusing on practice. Across these two sections, contributors identify and assess how much art education for children, youth, and adults addresses democracy and civic engagement historically and now. Contributors address how art educators and their students can partner with civic organizations and communities to advance the arts and education to strengthen, sustain, appreciate, understand, and participate in democracy through civic engagement. Programs and curricula that address questions associated with the intersection of culture, art, citizenship, and democracy are included. Pre-service and in-service education programs for art educators that demonstrate coursework and participatory learning experiences that orient future art educators to the relationship of the arts and culture to democracy as well as strategies for partnering with their students to advance democracy are featured.

This volume has a flexible format in which each chapter is presented with instructional questions aimed at directing readers to the critical issues discussed and expanding their own thinking about the topics raised by the authors. In this way, the book can function as a textbook, if so desired, while also appealing to a wider audience of scholars, graduate students, upper division undergraduates in the fields associated with arts, arts education, education, political science, social studies, sociology, public folklore, public history, public anthropology, heritage studies, and public humanities. Secondary audiences will include professionals and interested others associated with the arts, civic engagement, politics, public policy, community engagement, and community cultural development. Among the primary readership we anticipate that this book will stimulate and support additional scholarship.

Contributors to this collection of essays are innovative in the ways they assist readers in thinking through this specific moment in time, the urgency of the challenges being faced within the political sphere, how these political challenges and the rise of authoritarianism are influencing educational environments, and the myriad ways that educators and their students can respond and are responding, to these challenges. Responses are substantive, grounded in contemporary theoretical perspectives, optimistic, visionary, inspiring, and pragmatic. The contributors to this volume bring decades of cumulative experience to this volume's aims and are writing from a thorough understanding and appreciation for myriad educational environments and a commitment to the way that education in the arts is responsive.

All of us associated with this book recognize that, as Lummis (1997) emphasizes, democracy is more than a set of institutions within which civic engagement occurs. Democracy and civic engagement are future-oriented acts of being and doing with others, building consensus, building inclusive communities, and finding commonality on pressing social and cultural concerns. Collectively we are voicing a call for action.

We are affirming that the arts and creativity are not only central to human experience, but they are also pivotal modes of civic engagement that are uniquely positioned to promote dialogue and understanding across difference and have the potential to model critical engagement with relevant issues that can shape action and affect change.

NOTE:

1 The book was part of a collection of historical art education textbooks that Flávia received from Foster Wygant a scholar of the history of the field of art education and emeriti faculty at the University of Cincinnati where she works.

REFERENCES

Beck, M. M. (1921). *Better citizenship through art training: A syllabus for high schools, colleges, or study clubs.* A.C. McLurg & Co.

Biro, P. L. (2020). Introduction. In P. L. Biro (Ed.), *Constitutional democracy under stress: A time for heroic citizenship* (pp. xxi–xxiv). Mosaic Press.

Dewey, J. (1923). *Democracy and education: An introduction to the philosophy of education.* Macmillan.

Ferreira-Neto, J. L. (2017). The right of the governed: Foucault's theoretical political turn. *Social Change Review, 15*(1–2), 83–104.

Freire, P. (2020). *Pedagogy of the oppressed.* Continuum. (Original work published in 1970).

Kagan, R. (November 30, 2023). Opinion: A Trump dictatorship is increasingly inevitable. We should stop pretending. *The Washington Post.* https://www.washingtonpost.com/opinions/2023/11/30/trump-dictator-2024-election-robert-kagan/?utm_campaign=wp_week_in_ideas&utm_medium=email&utm_source=newsletter&wpisrc=nl_ideas

Kahlenberg, R. D., & Janey, C. (2016, November 10). *Report k-12: Putting democracy back into public education.* The Century Foundation.

Lowenfeld, V. (1952). *Creative and mental growth* (2nd ed.). Macmillan.

Lummis, C. (1997). *Radical democracy.* Cornell University.

Schinkel, W. (2003). *Pierre Bourdieus' political turn? Theory, Culture & Society, 20*(6), 69–93.

Introduction to Section I
Theory: Developing a Democratic Imagination

This volume aims to elevate art education's commitment to democracy by presenting contemporary ways to envisage civic engagement through the arts and education. The chapters in this section reflect interconnected frameworks that frame burning issues and inspire practice. The two sessions of the book are presented in dynamic relationship with each other, conceived as a call and response, with the *first section* (theory) focusing on providing a frame for the work on civic engagement that honors multiple theoretical perspectives and raises critical and timely issues. The *second section* (practice) includes experiential accounts that respond to the demands of contemporary issues, advancing the ideals of democracy through artistic and educational practices.

Two disclaimers seem important as we introduce the first section of our volume and its contributors. First, we acknowledge that theory and practice go hand in hand and mutually inform each other. We also affirm the theoretical dimensions of practice and the practical elements of theory. We curated this volume to highlight how authors in the first section prioritize conceptualizing issues and questions to which authors in the second section respond thought innovative as well as established ways to promote civic engagement. This slightly arbitrary organization is aimed at emphasizing the ongoing dialogue between problem-posing and problem-solving that is at the center of scholarly work, enabling ideas to inform action and vice versa. Second, we want to remind readers that art and education are used throughout this volume in broad and inclusive ways, reflecting broad views of both subjects. We consider the many actors, places, and purposes of art and in education. These disclaimers are important because they reflect our desire for advancing a democratic society that is inclusive, strives to overcome stale dichotomies, and is open to ongoing refinement. We consider that the process of imagining democracy requires multiple perspectives and participants to coalesce around the critical aim of engaging with the issues of our time in order to facilitate positive change. The authors in this first section of the book underscore our belief that art and creativity are fundamental in achieving this goal and that education is an avenue to disseminate such ideas to many. Therefore, we invite you to savor the issues raised by the authors of the nine chapters in this section.

Rachel Fendler and Sara Scott Shields ask how art education can serve as catalyst for reimagining and revitalizing civic engagement today. Responding to the National Academy of Education's urgent call for a more interdisciplinary approach to civic

DOI: 10.4324/9781003402015-2

education, they propose a speculative approach to civics education. Their chapter "Civics and the Arts: Developing Cultural Citizenship with Art Education" proposes that art education can build upon a legacy of community-based and socially engaged practices to offer a unique and experiential platform for supporting civic engagement. Working with teachers they co-developed curriculum that advances the notion of cultural citizenship through projects that are simultaneously rooted in art and in civics. Their chapter illuminates the transformative potential of the art classroom to become a generative site for civic engagement.

In "Limit Acts and Constructed Situations as Curriculum: Paulo Freire and the Situationist International," Olivia Gude asks about the boundaries of what is possible in art education and in social and political issues. Dovetailing the pedagogical practices associated with Paulo Freire and the artistic methods used by member of the Situationist International (a European-based revolutionary group of artists and intellectuals) that are influential in contemporary art, this chapter shares ways to investigate social and cultural issues through playful and provocative artmaking. Departing from disruptive stances, these practices originated in education and in artmaking demonstrate the possibilities of intentionally interrogating the status quo. Juxtaposing Freirean dialogical pedagogy and the Situationists' call for a more engaged, aesthetic, and activist way to live, Gude, therefore, invites us to consider the implications of this partnership between artistic and educational practices committed to energizing and promoting new forms of engagement among ourselves, and the communities to which we belong. She invites teachers to revisit what is taking place in classrooms to consider developing projects through which participants learn and utilize unfamiliar artmaking approaches that enable them to explore in new directions and develop unexpected insights. Such projects generate spaces of focused artistic experimentation, fostering creative and critical inquiry, and expanding each student's knowledge-building capacity, intrinsic motivations, and their sense of purpose and possibilities. A Freirean-Situationist-inspired educator asks, "How can I support students in making art that is relevant to the challenges of our contemporary life?"

Mira C. Johnson's "Transformative Learning Towards Socio-Ecological Consciousness and Civic Engagement: The Creative Potential of Nature Connection" raises the issue that if democracy is a "wicked problem" that is inherently unsolvable, what would be an effective approach to civic education? She proposes that consciousness toward socio-ecological connectivity for global sustainability can provide a productive frame for civic engagement, with the goal of affecting change that extends beyond the human world to include the greater ecological community. From a socio-ecological view of transformative learning, she proposes reorienting the locus of transformation away from the individual or society to the relations among actors in a larger system. Her research supports expanding civic education to recognize human interconnectedness and dependence on nature and engaging eco-conscious educators to assist in the creation of civically minded community living in reciprocity with the more-than-human world.

In "Reproductive Justice as Feminist Art Education" Karen Keifer-Boyd reacts to the Supreme Court overruling Roe v. Wade. From the perspective of a feminist scholar and activist, she offers examples of feminist coalitions that seek to educate

about reproductive rights justice. The chapter examines strategies that can support civically engaged teaching, such as data visualization, collaborative art, performance, remix videos, interventions, and peaceful resistance to injustice toward reproductive rights. Collectively, these examples facilitate learning about processes and examples of feminist coalitions that educate through art about reproductive justice, which is the same as to learn how to participate in democracy. Responding to the ongoing attacks to reproductive justice that are taking place all over the United States, Keifer-Boyd makes a case for placing civic engagement as a priority in contemporary education, and for embracing it when it involves potentially controversial and polarizing issues.

In the chapter "An Affective and Sensory Civic Encounter: Examining Ableism and Civic Education through Arts Based Policy Research" jt Eisenhauer Richardson asks how understandings of nation, democracy, and citizenship are constructed through references to ability, health, and the national body. An analysis of citizenship language as semantic, discursive, historical, rhetorical, and material reveals how references to health and the body influence our understandings of citizenship. Grounded in artistic practices, the author's reflections and examinations highlight how ableism plays a central role in shaping understandings, laws, policies, and curricula in civic education. Denouncing this relationship is critical to transform how educational opportunities, including the arts, can be made available to serve as a means of contemplation, meaning-making, and discovery that can inspire and prepare students to address critical issues in their communities with compassion.

Erica Rife and Doug Blandy examine the history, impact, and dimensions of protest as an enduring dimension of material culture and art. The chapter "Encountering the *I Can't Breathe Mural:* Antiracism, the Material Culture of Protest, and Art Education" provides a case study from which to examine the constitutional right to protest and ways in which its exercise constitutes civic engagement. The Portland, Oregon mural created as part of the nation-wide spontaneous actions in solidarity to the Black Lives Matter movement is examined through the lenses of empathy, critical self-education, and social justice education. This framework can be relevant for educators engaging with the material culture of protest within their schools and communities and adapted within these settings to enable students in responding to, interpreting, and potentially engaging with the art of protest.

In "Making Common Ground for Living: Strategies for Meaningful Intervention into Systemic and Structural Inequalities" James Haywood Rolling, Jr. asks how the creative practices that define and shape society emerge and spread from person to person. Arguing that each approach to art and design acts a methodology that frames human experience, and its possibilities, the author considers a reinterpretation of artmaking that can inspire greater social equity. Through a description of 12 adaptable artmaking interventions, Rolling's conceptual exploration seeks to expand our understanding about artworks, teasing out how they impact us and speculating ways in which they may become catalysts of development, grounding our living, and creating new possibilities and futures.

Seeking to connect the personal and political spheres of high school students, Flávia Bastos shares the motivation, frame, and outcomes of the ongoing research project *Who Is American Today*? This ongoing collaboration between a high school

teacher and a researcher is inspired by Bastos' experiences coming of age in Brazil during the military dictatorship. The project seeks to understand how developing digital making skills can advance high school students' self-perceptions as citizens and understandings of democracy. "Art Education for Democracy: Insights from of Who *Is American Today?* Project" presents ongoing research findings that support upholding digital making as a fundamental competency in contemporary education and the possibilities for creative educators to cultivate civic engagement in their classrooms.

David G. Hebert and David Johnson examine how music can work to promote behaviors that either enhance or threaten civic life in communities. Their chapter "Global Music Communities and Civic Engagement in the Digital Age" asks about the relationship between online music communities, formal music education, and civic engagement. Recognizing that throughout history music has functioned as an important medium for human communication, collective action, and maintenance of group identity, the authors inquire about the impact of new developments in music-making and listening in the digital age. As the dominance of digital streaming and social media platforms for sharing music increasingly defines a new generation of musicians and consumers, what are the consequences for music education and for civic engagement? Drawing upon findings from an ongoing European research project on civic engagement and music participation among youth, the authors suggest a theoretical model for music communities.

The nine chapters comprising the first section of this volume embody the goal of developing a democratic imagination through art and creativity. The chapters contribute to advancing two central questions framing this volume:

- What is our responsibility to sustain democracy through meaningful engagement and critical activity?
- How can artists and creative citizens model an ethics of care that can foment the desire to contribute to society?

Engaging with a variety of artistic and creative practices, the authors in this section are innovative in the ways they assist readers in thinking through this specific moment in time, the urgency of the challenges being faced within the political sphere, how these political challenges and the rise of authoritarianism are influencing educational environments, and the myriad ways that educators and their students can respond and are responding to these challenges. Their work supports our goal of advancing a democratic imagination through ideas and practices, mundane and complex, theoretical and pragmatic, innovative and established that connect us around a shared appreciation for the fragility of democracy and the robust and impactful ways in which art and creativity can support it.

SECTION I

Theory: Developing a Democratic Imagination

CHAPTER 1	Civics and the Arts: Developing Cultural Citizenship within Art Education
CHAPTER 2	Limit Acts and Constructed Situations as Curriculum: Paulo Freire and the Situationist International
CHAPTER 3	Transformative Learning toward Socio-Ecological Consciousness and Civic Engagement: The Creative Potential of Nature Connection
CHAPTER 4	Reproductive Justice as Feminist Art Education
CHAPTER 5	An Affective and Sensory Civic Encounter: Examining Ableism and Civic Education through Arts Based Policy Research
CHAPTER 6	Encountering the *I Can't Breathe Mural*: Antiracism, the Material Culture of Protest, and Art Education
CHAPTER 7	Making Common Ground for Living: Strategies for Meaningful Intervention into Systemic and Structural Inequities
CHAPTER 8	Art Education for Democracy: Insights from *Who Is American Today?* Project
CHAPTER 9	Global Music Communities and Civic Engagement in the Digital Age

CHAPTER 1

Civics and the Arts
Developing Cultural Citizenship within Art Education

Rachel Fendler and Sara Scott Shields

> **INSTRUCTIONAL QUESTIONS**
>
> 1. How can art education serve as a catalyst for reimagining and revitalizing civic engagement in today's society?
> 2. In what ways can art educators apply a model of cultural citizenship to encourage students to confront complex societal issues through creative expression?
> 3. How can educators balance the desire for tangible, measurable outcomes of civic education with the more open-ended and speculative nature of artistic practices?
> 4. How can the affective and effective outcomes of activist art help students recognize and navigate the complexities of civic life, including issues related to power, privilege, and systemic inequalities?
> 5. How can interdisciplinary collaborations between art and other academic disciplines enhance the effectiveness of civics education?

CIVICS AND THE ARTS: CULTURAL CITIZENSHIP IN ART EDUCATION

American democracy emphasizes individual liberties and civic engagement, with schools serving to educate and prepare citizens for informed participation in the democratic process. At their best, schools play a vital role in promoting critical thinking and civic values necessary for a thriving and inclusive democracy. The National Academy of Education's report on the status of civic education (Lee et al., 2021) found a school-wide, interdisciplinary approach is needed to meet today's demands for strengthening our democratic society. In their report, Lee et al. (2021) suggested

DOI: 10.4324/9781003402015-4

that civics should be taught throughout the curriculum, beyond the bounds of one disciplinary subject. Central to their report is the framing of civics through the question: *What should we do*? This question carries within it a need to determine who the collective "we" is (who is included, who is excluded?), possible methods of action and response, and moral and ethical values motivating this response. In order to respond to this question, students must be able to engage in civic discourse, a deliberative process that asks students to grapple with multiple perspectives and objectives while building a collective response with peers. In our current political and educational climate, however, this is a formidable task. In response, we feel that this moment offers an incentive and an invitation to art educators to claim civics education as integral to our field.

Drawing on the legacies of community-based and socially engaged art practices, art education has long been committed to civic engagement. In our work as curriculum developers and art educators, we have adopted the prompt *what should we do* as our essential question. We are asking how artistic inquiry and artmaking serve as dialogic processes that prompt us, together with our students, to imagine better possible futures based on equitable and just modes of relating—to each other, to our communities, and to our environment. To put this question into action in the art room, we propose a civics education that distinguishes itself from the disciplinary limits of civics instruction, which suffers under the weight of conservative constraints. We align our thinking with Mirra and Garcia's (2022, 2023) call for a speculative approach, to propose a model of civic education that builds on the visionary and hopeful practices of youth activism. We have made similar claims (Fendler et al., 2020; Shields & Fendler, 2023; Shields et al., 2020), focusing on the potential of activist art to provide a model for civic practice. In this chapter, we draw on curriculum developed by teacher teams who collaborated with us on a project aimed at developing art+civics curriculum. As a result of this work, we suggest that when the art room becomes a site where students and teachers creatively and hopefully respond to the question, *what should we do*?, the art room becomes a generative site of speculative civic potential.

CIVICS EDUCATION: STANDARDS AND ROADBLOCKS

Public education in the United States has, since its inception, been framed as a mode of citizenship education in support of democracy. Civics curriculum teaches that institutions and political processes are the pathway for creating a just society. However, like the founding ideals of this country, these objectives are stymied by biases and tensions that support rather than alleviate structural inequities. On the one hand, schools are central to civic learning, as they are "the most systematically and directly responsible for imparting citizen norms" (Center for Information & Research on Civic Learning & Engagement [CIRCLE], 2003, p. 5). On the other hand, schools continually undermine this civic mission when implementing pedagogic practices and standards incompatible with democratic participation.

If civics education aims to produce individuals who will maintain a working democracy, it must allow for difference and struggle. Empirical findings (Hansen et al.,

2018; Levine & Kawashima-Ginsberg, 2017; Lo, 2020; Malin et al., 2014; Shapiro & Brown, 2018) report that an effective civic curriculum should take up current events and controversial issues, engage in a rich multitude of diverse sources (primary documents, local events, community speakers, and so on), and use hands-on experiences to turn the classroom into a space where civic life is woven into in the very fabric of classroom proceedings. Westheimer (2020) concluded,

> [A] well-functioning democratic society benefits from classroom practices that teach students to recognize ambiguity and conflict in factual content, to see human conditions and aspirations as complex and contested, and to embrace debate and deliberation as a cornerstone of democratic societies. (p. 10)

However, roadblocks are actively being written into educational policy that dampen the integration of dialogic practices. For example, *Education Week* has been tracking new legislation impacting public education curriculum. From January 2021 to June 2023, they noted "44 states have introduced bills or taken other steps that would restrict teaching critical race theory or limit how teachers can discuss racism and sexism" (Schwartz, 2023, para. 5). There is a clear gap, in our country and schools, between the theory of democratic participation and its practice. Beadie and Burkholder (2021) argued that presenting policy and political processes in an uncontested, value-neutral way strips them of their civic character. Schools that do not recognize how young people receive an education in civics through their day-to-day interactions in the public sphere produce a curriculum that is exclusionary to many students. As Clay and Rubin (2020) noted, "the manifestations of historical and systemic inequality dramatically shape the lived experience of citizenship for many Black and Brown[1] young people. These experiences are, in themselves, 'civics lessons' that implicitly teach young people about the limitations of their citizenship" (p. 161). When schools implement "an intentional silence regarding the ongoing historical struggles that have been waged over the meaning and unrealized potentialities that underlie different conceptions of citizenship," they erase the "most dynamic political and democratic possibilities" of civic life (Giroux, 2005, p. 4). These findings, when read alongside the chronic underperformance on civic outcomes in the Nation's Report Card (Lutkus & Weiss, 2007), demonstrate that when schools and classrooms are not themselves democratic spaces, they fail at teaching democratic values and skills.

The introduction of the speculative into civics education invites educators to engender sites of civic experimentation and imagination that resonate with and expand young people's civic experiences. By incorporating speculative thinking and imaginative exploration into civic education, schools can broaden students' perspectives, encouraging them to envision alternate societal structures, engage in critical discourse, and foster a deep understanding of the complexities inherent to democratic decision-making. Building a more expansive vision for civics education means that civic engagement encompasses more than mere actions; it encompasses a series of circumstances that emerge within the interconnectedness of communal and personal lives (Holley, 2016). A focus on civic engagement environments acknowledges

that civic practices stem from specific contexts and sheds light on why a top-down approach to civics instruction does not meet students' needs. Therefore,

> [W]e must shift from a civic engagement led by techniques to an engagement environment based on inclusive principles, allowing communities to create relevant practices that manifest those principles in the engagement environment.
>
> *(Holley, 2016, pp. 17–18)*

Civics education should support young people's access to modes of participation in civic life. To achieve this goal, however, schooling must move beyond the curricular techniques of civics and develop an approach that is speculative. As art education researchers, we see the potential for art classrooms to contribute to speculative civics education by helping students envision and explore innovative imaginings of civic issues, perhaps even challenging what civics means to young people. This view expands civics in schools to not just include discussions of government systems but pushes young people to use the arts to nurture a more engaged and imaginative citizenry built on the ways that artists research, understand, and address the complex challenges our democratic society faces. Hartman (2019, 2022) introduced speculation as a methodological approach that can illuminate missing historical narratives and experiences. Her research on slavery and the constraints placed on Black freedom shed light on the need to imagine other possible subjectivities, especially those rendered invisible or impossible within institutional structures. In this framework, she suggested, a "speculative knowledge of freedom would establish the vision of *what might be*, even if unrealizable within the prevailing terms of order" (2022, p. xxxi).

Building out of Hartman's theory (2022) and methods (2019) of the speculative, Mirra and Garcia (2023) seek a "speculative civic education that centers the building of new kinds of public relationships rather than adherence to formal institutions that cultivates joyful and intentional collective praxis toward new realities" (p. 10). The speculative is a grounding gesture (Clarke, 2022) that pays attention to what could be, offering hope, indeterminacy, and openness into the structures of curriculum and schooling. Coming from the arts, we posit that the radical imagination of community-based and socially engaged arts practice is a site that can help students perform speculation as they work toward better futures.

CULTURAL CITIZENSHIP: CULTURAL PRODUCTION AS A FORM OF EPISTEMIC JUSTICE

To consider to what extent art practice is a pathway to civic participation, we turn to the framework of cultural citizenship. While a citizen can be defined legally, the act of citizenship supersedes a legal definition. Citizenship is civics at the ground level; it is a mode of participation responsive to a broader community. Cultural citizenship is a term that captures how we build a sense of ourselves within society: "cultural citizenship is a dual process of self-making and being-made within webs of power linked to the nation-state and civil society" (Ong, 1996, p. 738). Stevenson (2010, 2011) depicted cultural citizenship as a practice of living a meaningful life with others:

"to engage in deliberative argument about who we might become, and to consider how we might lead virtuous and just lives in specific cultural locations and contexts" (Stevenson, 2010, p. 289). Cultural citizenship, therefore, refers to emergent modes of action that negotiate meaning making and recognition within collectives, such as classrooms, communities, or other spaces.

Artistic practice, when framed through the lens of cultural production and tied to the work of cultural citizenship (Gaztambide-Fernández & Matute, 2021), encompasses "those practices, processes, and products involving symbolic creativity" (Gaztambide-Fernández, 2013, p. 214). When aligning cultural production with cultural citizenship, Thomson et al. (2019) framed symbolic creativity as akin to Fricker's concept of epistemic justice:

> The maintenance of heritage languages, artistic traditions, artefacts and architectures are vital to epistemic justice, but as important is the capacity to be seen to have a credible contribution to make to the processes of social meaning-making and their political, economic and legal enactment.
> *(Thomson et al., 2019, p. 37)*

Cultural producers are cultural citizens; they contribute to the public sphere by using the fabric of our cultural lives to create narratives, offer critique, and engage in the civic practice of world-building.

Taking up cultural production, Gaztambide-Fernández (2013) suggested, "rather than thinking about the arts as *doing something to people*, we should think about artistic forms as *something people do*" (p. 226). Cultural production frames artmaking within a practice of cultural citizenship, and it begs the question, what are we doing with art? Which brings us to our earlier essential question: What should we do? What can students do with art, if they want to transform themselves, and the world? How can teacher/student collectives "do" art as a speculative project, as a way to ideate, reveal, or move toward the future they want to live in? In this way, art education can become a form of speculative civics that activates modes of cultural production and draws unexpected but powerful connections between materials and events, histories and the present, schools and communities, students and the world. To illustrate this, we present a vignette of a middle school curriculum proposal using cultural citizenship to draw students into the civic sphere.

Curriculum Close-Up: Modeling Cultural Citizenship in a Middle School Classroom

In 2021, we (Rachel and Sara) received grant funding for a curriculum development project that allowed us to invite (and remunerate) teams of arts and social studies teachers who would collaborate on developing interdisciplinary art+civics curriculum. One participating team from Ron Clark Academy (RCA), a private school in Atlanta, brought together three veteran teachers: Pam Haskins, a seventh- and eighth-grade literature and composition teacher; Susan Barnes, the cultural arts teacher; and Dr. Yvette Ledford, a fourth-, fifth-, and sixth-grade writing teacher.

During the curriculum development process, the teachers noted their school had a strong global civic mission, supporting several annual international service-learning projects. Though global civic participation was at the forefront of the school's mission,

the COVID pandemic brought civics into the local sphere, as the three teachers worked to create opportunities for students to participate in local civic action. After researching South Atlanta, walking through the neighborhood where RCA is located, and thinking about how the past influences the mission of the school and its students, the team designed a unit that asked the essential question: How does the knowledge of local history affect engagement in the community? The curriculum aimed to improve students' sense of themselves as informed civic actors.

Students began their work in a history class, researching historic sites of South Atlanta and juxtaposing the past and present of the sites. This research continued when students attended a walking tour of these sites. The tour was organized by the Fulton County Remembrance Coalition to honor and remember the victims of the 1906 Atlanta Race Massacre. The tour introduced students to the Equal Justice Initiative's (EJI) Community Remembrance Project, a creative community initiative modeling how cultural citizenship and cultural production offer powerful civic lessons. For this initiative, the EJI works with local partners to "memorialize documented victims of racial violence throughout history and foster meaningful dialogue about race and justice today" (Equal Justice Initiative, n.d.). Across the country, Community Remembrance Coalition partners engage in actions of community organizing, as they work to develop official historical markers in the Historical Marker Project, symbolic remembrance, by gathering soil from lynching sites for the Community Soil Collection Project, and sometimes artistic remembering, through site-specific mural projects.

When reflecting on their learning after the tour, students shared a sense of surprise in discovering personal connections to historically significant areas. As they gained a sense of local history, they came into an understanding of the wealth of stories about events that, as one student put it, "inspired change." They began to wonder why these histories were not common knowledge, wondering what other stories were untold. Experiencing a confluence of community remembrance, public art, and public ritual was impactful. Student participants shared the following reflections about the project in a group interview during a 2021 site visit:

> My favorite part was the mural, also, and I hope I have this part right, libations? That's what we did? I do those with my family, cause my family celebrates Kwanza, so I do that with my family each year, so doing that [during the walking tour] kinda reminded me that I was surrounded by different family members or like, different members of the community.
>
> I didn't think the rain ruined it, I kinda looked at it as, that's the ancestors that were talking. So it was really fun.
>
> I think that I'm, with people talking about it, I'm a little more tuned in because I have personal experience with [the history]. Rather than just hearing about it from other people I can like, say, oh yeah I know that myself.

The unit concluded in the arts classroom (Figure 1.1), as students brought their research, walking, and reflections together to develop historic neighborhood mood boards. These mood boards consisted of a collage of images, textures, colors, materials, and other visual elements that represented the historic memory of the neighborhoods. Processing this

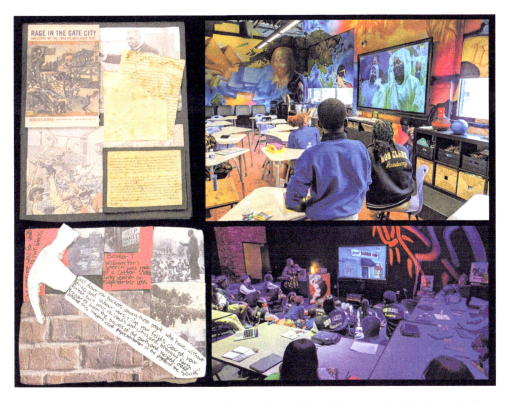

FIGURE 1.1 Student mood boards (left two images) and images of students reflecting on the walking tours (right two images).

information in mood boards allowed the production of historical narratives to maintain the subjective, experiential, and polyphonic character of the student research. Students described developing the mood boards as akin to fitting puzzle pieces together, where it was a struggle to connect all the disparate pieces of their work. At the same time, the students spoke with passion and care, understanding the importance of their work in alignment with the aims of the remembrance project. Students completed their mood boards with a strong sense of the importance of remembering; they witnessed how cities and communities hold history, and what this history means for the present and future.

Through the work of contextualizing their relationship to the city and participating in community actions, students began to identify a civic engagement environment. They also began to imagine themselves as civic actors. One student in her 2021 group interview at the school concluded,

> I know there are other places [where history was] covered up, and the people don't deserve it. They worked hard for what they had … So now that we know and we can do something about it, I would like that to happen in the future.

Through this unit, civic lessons took place through the actions of excavating lost histories, commemorating, and building community. By highlighting civic processes

that stem from cultural production, and the fight for epistemic justice, the unit suggested how classrooms and communities can engage students in the speculative work of an arts-infused civics education.

ACTIVIST ART: A MODEL FOR *ÆFFECTIVE* CIVIC PARTICIPATION

The speculative potential of the arts is key for understanding how youth engagement, imagination, and world-building might lead to civic action. By aligning cultural citizenship and cultural production, we might suggest something about the ways in which artmaking draws the maker into community. Hickey-Moody (2016) observed, "the materiality of [youth] arts practices constitutes a form of citizenship. What begins as affect, style, art practice, effects modes of community attachment that can influence community sentiment and can provide frameworks for policy and legislation" (pp. 19–20). Hickey-Moody traced the relationship between affective relations and effective civic processes. In doing so, she described the "work" of art in creating a connection between the cultural sphere and the civic one.

Throughout the art+civics curriculum workshops, we challenged the participating teachers to think expansively about the "work" of art. To do so, we introduced a list of activist art outcomes offered by Duncombe (2016). Duncombe's list of actions framed how activist art is both affective (i.e., moving, resonant, and personally transformative) and effective (i.e., has a social impact). Duncombe's neologism, *æffective*, was helpful for giving educators a vocabulary to discuss the relationship between cultural citizenship, or an affective space of belonging, and civic engagement, which can be measured in terms of effectiveness and social impact. His list includes the following actions of activist art:

- Foster dialogue
- Build community
- Make a place
- Invite participation
- Transform environment and experience
- Reveal reality
- Alter perception
- Create disruption
- Inspire dreaming
- Provide utility
- Political expression
- Encourage experimentation
- Maintain hegemony/status quo

In conversation with the teachers, this list became an organizing mechanism for their curriculum. Sitting alongside taxonomies from Fink or Bloom, we used Duncombe's list to write our objectives and orient student learning goals.

Curriculum Close-Up: High Schoolers Thinking (and Inking) with Stories of Oppression

In our curriculum development workshop, another team from Somerville High School (SHS) consisted of an art teacher, Jessica Howard, and a social studies teacher. During the summer, between design and implementation, the social studies teacher left her position at SHS, and Jessica continued into the implementation phase as the sole teacher. Jessica's art unit centered around the work *A Father's Lullaby* by Rashin Fahandej. In this work, Fahandej addressed mass incarceration through a long-term research project that drew on collaboration and co-creation with community members. As a visual artwork, the project appears as a multi-channel video work and gallery installation "centered on the marginalized voices of absent fathers while inviting all men to participate by singing lullabies and sharing memories of childhood" (Fahandej, n.d.). *A Father's Lullaby* is an example of æffective artistic activism, drawing on video, song, and the arrangement of viewers' bodies in exhibition settings to evoke intimate and personal interactions with the theme of incarceration. At the same time, this striking, multi-sensory experience informs viewers about the prevalence and impact of mass incarceration in the United States.

The unit asked the essential question: How can we tell stories of oppression and resistance to transform the future? The unit cycled through several viewings of Fahandej's piece, before moving into student artmaking. Students were asked to choose a subject, someone who had experienced oppression, and portray them in a pen portrait. The portraits centered on first-person perspectives in an effort to highlight systemic inequities; therefore, they connected thematically to Fahandej's work in spite of clear differences in material choices (Figure 1.2).

Students shared their thinking about the project during a 2022 site visit. Some students choose the subject for their portrait during a day set aside for research, working from a source image or inspiring story. For example, one student explained, "I chose Janet Collins because she caught my eye as a strong, resilient Black figure. When I read about her and saw a picture, I thought she was rather strong." Other students used the project to highlight a cause or issue they were invested in. For example, one student drew a writer they follow on social media: "Tiffany Hammond, @fidget.and.fries on Instagram, is intersectional, some of her topics include activism, being Black, being a woman, being queer, and generally how all of those overlap. I chose her because she had made me reconsider my beliefs." A smaller number of students used the project as a space to bring overlooked topics or narratives into the school or classroom, such as the student who addressed fatphobia: "I chose this subject because me, as a fat person, I've struggled since I was 10 with the way people and society treated fat people. I'm tired of it and I wanted to make art celebrating the bodies because I don't see any representation of it in school."

When students presented their work for a final critique, they questioned whether their portraits connected to the work of research and activism. Over the course of the unit, students had been able to describe the power of Fahandej's piece; they clearly recognized the depth of process required to make artwork with impact. This led to a critique of their own outcomes. In response, Jessica worked to find exhibition sites for

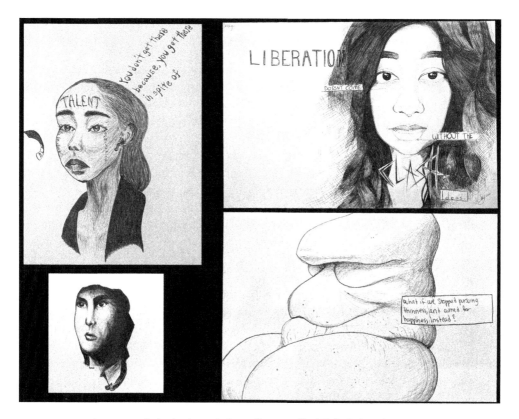

FIGURE 1.2 Images of student work from Somerville High School.

the student work within the community. And yet, at the end of a unit that was successful in terms of engagement and final products, the teacher and the students were left with questions about its impact. This outcome makes us wonder, can æffective work be assigned in schools?

This unit reveals the complexity of originating artistic activism in the classroom. Curriculum is not, necessarily, the origin of the youth arts practices that draw young people into relation (Hickey-Moody, 2016). Observing the outcomes in Somerville, we return to the need for speculation. We can encourage students to make art in the mode of artistic activism, yet we will not always know what becomes of their engagement with the æffective possibilities of art. Thus, the curriculum and its final impact remain speculative.

DISCUSSION: SPECULATING ON THE POTENTIAL OF CULTURAL CITIZENSHIP AS A MODEL FOR EMERGENT CIVIC PRACTICE

In the realm of cultural citizenship, the relationship between cultural production and politics must be a relation of futurity, of potentiality, of speculation. Hall (2016) suggested that participation in cultural movements, specifically youth subcultures, is a

way through which collective identity is developed, offering to young people the ability to articulate

> a sense of themselves in the world; they have a pride of their place; they have a capacity to resist; they know when they are being abused by the dominant culture; and they have begun to know how to hold it at bay. But above all, they have a sense of some other person that they really are. They have become visible to themselves. (p. 204)

Symbolic practices define cultural participation, in the sense that being part of a collective allows people to participate in a shared project. Such cultural production is not one of recognition but one of becoming, of joining in, of creating yourself anew with others. Because cultural production operates through modes of affect, it captivates participants in unexpected and potentially unarticulated ways. Hall theorized,

> people have to have a language to speak about where they are and what other possible futures are available to them. These futures may not be real; if you try to concretise them immediately, you may find there is nothing there. But what is there, what is real, is the possibility of being someone else, of being in some other social space from the one in which you have already been placed. (p. 205)

Culture production is not equivalent to politics. However, political action relies on it to generate motivations and responses. As Hickey-Moody (2016) concluded, "taste and culture are forms of affective pedagogy that young people mobilize to make social and political possibilities" (p. 120). Rather than finding the unpredictable potential of cultural forms as suspect, we find that this is precisely what makes the cultural realm so powerful. The cultural realm is the site of speculation and invention. Because it is captivating, desiring, and fluid in a way that policy can never hope to be, it opens up possibilities for transformation and allows us to speculate on the possibility of politicization.

In suggesting that art education can become a site for speculative civics education, we have mapped the civic possibilities of artmaking as tied to cultural production and the æffective power of activist art. Working with interdisciplinary teacher teams, we found that to bring the civics curriculum into the art room, we must hold on to the speculative. By inviting students to discover their own ties and relationships to their community, the potential for civics to take place in the classroom is enhanced. Working from an arts-informed, speculative approach does not leave teachers ungrounded. We have guides from critical pedagogy, from contemporary art, and from the practices of community organizing that offer a vision of what engaged cultural citizenship looks like. When leaning on processes of cultural production that invite modes of participation and community attachment, curriculum should ask students to transform themselves into civic actors as they simultaneously move into and become part of civic spaces. When we accomplish this, students may reveal to us, and themselves, new possibilities of civic life.

NOTE:

1 In line with contemporary discussions on racial and ethnic identity, our choice to capitalize "Black," "White," and "Brown" when referring to racial and ethnic groups has been influenced by a commitment to recognizing and respecting the cultural and historical significance of these identities. Capitalizing these terms aligns with principles of equity and inclusivity in language use and acknowledges the complex social and historical contexts associated with race and ethnicity in the United States.

REFERENCES

Beadie, N., & Burkholder, Z. (2021). From the diffusion of knowledge to the cultivation of agency: A short history of civic education policy and practice in the United States. In C. D. Lee, G. White, D. Dong (Eds.), *Educating for civic reasoning and discourse*. National Academy of Education. https://naeducation.org/educating-for-civic-reasoning-and-discourse/

Center for Information & Research on Civic Learning & Engagement (CIRCLE). (2013). Civic learning through action: The case of generation citizen. *Tufts University*. http://www.civicyouth.org/wp-content/uploads/2013/07/Generation-Citizen-Fact-Sheet-July-1-Final.pdf

Clarke, A. (2022). Songs of school abolition. *Curriculum Inquiry*, 52(2), 108–128. https://www.tandfonline.com/doi/full/10.1080/03626784.2022.2041980

Clay, K. L., & Rubin, B. C. (2020) "I look deep into this stuff because it's a part of me": Toward a critically relevant civics education. *Theory & Research in Social Education*, 48(2), 161–181. https://doi.org/10.1080/00933104.2019.1680466

Duncombe, S. (2016). Does it work? The æffect of activist art. *Social Research*, 83(1), 115–134.

Equal Justice Initiative. (n.d.). *Community remembrance project*. https://eji.org/projects/community-remembrance-project/

Fahandej, R. (n.d.). *A father's lullaby*. http://www.rashinfahandej.com/a-fathers-lullaby

Fendler, R., Shields, S. S., & Henn, D. (2020). #thefutureisnow: A model for civically engaged art education. *Art Education*, 73(5), 10–15. https://doi.org/10.1080/00043125.2020.1766922

Gaztambide-Fernández, R. (2013). Why the arts don't "do" anything: Toward a new vision for cultural production in education. *Harvard Educational Review*, 83(1), 211–237. https://doi.org/10.17763/haer.83.1.a78q39699078ju20

Gaztambide-Fernández, R., & Matute, A. A. (Eds.). (2021). *Cultural production and participatory politics: Youth, symbolic creativity, and activism*. Routledge.

Giroux, H. (2005). *Schooling and the struggle for public life: Democracy's promise and education's challenge*. Routledge.

Hall, S. (2016). *Cultural studies 1983: A theoretical history* (J. Slack & L. Grossberg, Eds.). Duke University Press. https://doi.org/10.1515/9780822373650

Hansen, M., Levesque, E., Valant, J., & Quintero, D. (2018). *The 2018 Brown Center report on American education: How well are American students learning?* The Brown Center on Education Policy, Brookings Institute.

Hartman, S. (2019). *Wayward lives, beautiful experiments: Intimate histories of riotous Black girls, troublesome women, and queer radicals*. W.W. Norton.

Hartman, S. (2022). *Scenes of submission: Terror, self-making, and slavery in nineteenth-century America* (2nd ed.). Oxford University Press.

Hickey-Moody, A. (2016). Youth agency and adult influence: A critical revision of little publics. *Review of Education, Pedagogy, and Cultural Studies*, 38(1), 58–72. https://doi.org/10.1080/10714413.2016.1119643

Holley, K. (2016). *The principles for equitable and inclusive civic engagement*. Kirwan Institute. https://kirwaninstitute.osu.edu/sites/default/files/documents/ki-civic-engagement.pdf

Lee, C. D., White, G., & Dong, D. (Eds.). (2021). *Educating for civic reasoning and discourse*. National Academy of Education.

Levine, P., & Kawashima-Ginsberg, K. (2017). *The republic is (still) at risk—and civics is part of the solution*. Jonathan M. Tisch College of Civic Life, Tufts University. https://www.civxnow.org/sites/default/files/resources/SummitWhitePaper.pdf

Lo, J. (Ed.). (2020). *Equity in civic education* [White paper]. Generation Citizen and iCivics. https://civxnow.org/wp-content/uploads/2021/08/Equity-in-Civic-Eduation-White-Paper_Public.pdf

Lutkus, A., & Weiss, A. (2007). *The nation's report card: Civics 2006* (NCES 2007–476). National Center for Education Statistics, U.S. Department of Education. U.S. Government Printing Office.

Malin, H., Ballard, P. J., Attai, M. L., Colby, A., Damon, W., Banks, J. A., Hahn, C. L., Hess, D., Hess, F. M., Liu, E., Moran, R., & Suárez-Orozco, M. (2014). Youth civic development & education. In *Stanford Center on Adolescence conference* (pp. 1–24). Center on Adolescence and Center for Multicultural Education.

Mirra, N., & Garcia, A. (2022). Guns, schools, and democracy: Adolescents imagining social futures through speculative civic literacies. *American Educational Research Journal*, *59*(2), 345–380. https://doi.org/10.3102/00028312221074400

Mirra, N., & Garcia, A. (2023). *Civics for the world to come committing to democracy in every classroom*. W. W. Norton.

Ong, A. (1996). Cultural citizenship as subject-making. Immigrants negotiate racial and cultural boundaries in the United States. *Current Anthropology*, *37*(5), 737–762.

Schwartz, S. (2023, June 13). Map: Where critical race theory is under attack. *Education Week*. https://www.edweek.org/policy-politics/map-where-critical-race-theory-is-under-attack/2021/06

Shapiro, S., & Brown, C. (2018). *The state of civics education*. Center for American Progress.

Shields, S. S., & Fendler, R. (2023). *Developing a curriculum model for civically engaged art education: Engaging youth through artistic research*. Routledge.

Shields, S. S., Fendler, R., & Henn, D. (2020). A vision of civically engaged art education: Teens as arts-based researchers. *Studies in Art Education*, *61*(2), 123–141. https://doi.org/10.1080/00393541.2020.1740146

Stevenson, N. (2010). Cultural citizenship, education and democracy: redefining the good society. *Citizenship Studies*, *14*(3), 275–291. https://doi.org/10.1080/13621021003731823

Stevenson, N. (2011). *Education and cultural citizenship*. Sage.

Thomson, P., Hall, C., Earl, L., & Geppert, C. (2019). Towards an arts education for cultural citizenship. In S. Riddle & M. Apple (Eds.), *Re-imagining education for democracy* (pp. 174–189). Routledge.

Westheimer, J. (2020). Can education change the world? *Kappa Delta Pi Record*, *56*(1), 6–12. https://doi.org/10.1080/00228958.2020.1696085

CHAPTER 2

Limit Acts and Constructed Situations as Curriculum

Paulo Freire and the Situationist International

Olivia Gude

> **INSTRUCTIONAL QUESTIONS**
>
> 1. Are projects in which students are assigned to investigate particular social and political themes necessarily a form of propaganda, substituting an art teacher's concerns for those of an apolitical "normal art education"?
>
> 2. How does appropriating and *détourning* images differ from using images as source material for making representational art?
>
> 3. Identify some aspect of an educational setting in which you find yourself that you consider to be unfortunate or upsetting. Viewing this as a limit situation, can you brainstorm with others to imagine a limit act that pushes the boundaries of what is possible to think or do in this situation?

I have often wondered if the social and political culture in the United States (U.S.) in the early decades of the 21st century might be different if visual art curriculum as taught in most K–12 public schools during the last 50 or 100 years had introduced students to critical, utopian, or iconoclastic aspirations of modernist artmaking approaches, rather than focusing curriculum largely on creative self-expression, media techniques, and the study of formalist elements and principles of art/design. How might today's youth and adult citizens' abilities to participate in difficult contemporary cultural conversations be enhanced if, as students, they had been introduced to the cultural contexts and political concerns that motivated the making of much modern, now contemporary art? How might today's art education support students in formulating and investigating crucial societal as well as personal questions?

Deciding what to make art about is not a purely personal decision. Even acting as autonomous creative artists without externally imposed restrictions such as assessment rubrics, our students (and all of us) are always already influenced by past

DOI: 10.4324/9781003402015-5

perceptions of what is desirable, reasonable, or possible to make art about. The most strangling and stultifying restrictions on artistic and social imagination are the ones we are not even aware of. They are the ties that bind but do not chafe because, unfortunately, all-too-often we (as artists, educators, and students) have learned to restrict our movements within the spaces that these unexamined bindings allow us.

Drawing on pedagogical practices associated with Paulo Freire, artistic methods used by members of the Situationist International, and art education strategies for interpreting visual art, this chapter shares examples of collaborating with students to identify significant social and cultural issues that can then be investigated through playful artmaking. It is crucial to students' and teachers' development as contemporary artists to go beyond merely choosing and *representing* subjects and themes, instead *deconstructing* received notions of the world, thus generating new patterns and formulations for understanding and interacting with the world (Gude, 2007).

PAULO FREIRE: EDUCATION AS CULTURAL ACTION

The writings and projects of Paulo Freire, one of the most influential educators of the 20th century, continue to shape the thinking and teaching practices of educators, cultural workers, and artists throughout the world. Freire developed his educational methods as a teacher and organizer of campaigns designed to eradicate illiteracy among impoverished Brazilian peasants and workers, most the children or grandchildren of formerly enslaved people. For Freire, literacy was more than merely learning to read words, more than simply using the written word to absorb the dominant narratives that shape the world view of elites. Instead, Freire recognized that as his students learned to read that they also needed to learn methods for a "critical reading of the world" (Freire and Macedo, 1987, p. 17). They needed to develop the skills to become co-participants with their teachers in the project of decolonizing themselves and their society.

In *Pedagogy of the Oppressed,* first published in Portuguese in his native Brazil, Freire contrasts dialogical education with the banking method of education (Freire, 1968/2005). In the banking method, students are seen as empty vessels into which teachers pour knowledge. In dialogical education, using "a problem-posing participatory format, the teacher and students transform learning into a collaborative process to illuminate and act on reality. This process is situated in the thought, language, aspirations, and conditions of the students" (Shor and Freire, 1987, p. 11). Given today's understanding of how visual culture shapes our understandings of the world, we can add that the process of illuminating and then acting on reality can also be situated in the images that surround us.

IDENTIFYING GENERATIVE THEMES

Designing a Freirean-inspired project begins with identifying the generative themes of a time and place. Generative themes are not abstract concepts; they are grounded in the everyday reality of people's lives. Generative themes can be thought of as the Big Ideas and Essential Questions of an era. Considered within the educational context of

Grant Wiggins and Jay McTighe's *Understanding by Design*, Essential Questions are discipline-specific as well as transdisciplinary inquiries into Big Ideas (2005). Though the ideas and questions are big and essential, counterintuitively, as students first identify them, they may at first seem insignificant—too naïve, too unimportant in the larger scheme of things, because they are embedded in the concerns of everyday life.

Asking each participant to draw individual diagrams or write personal lists can be an effective way to begin to identify and gather generative themes that might become the basis for significant collaborative artistic investigations and actions (see Figure 2.1). Ask each participant to list things that are "currently occupying their minds." Direct them to exclude nothing—no matter how idiosyncratic or trivial it may seem—personal, home life, friends, romances, favorite video games, school, interactions with police, and politics—serious or frivolous, local or global. I tell participants to "Be aware of that which is never the 'main thing' you are concerned about, but upon consideration, is disconcertingly often there looming in the background."

I caution participants to not attempt to choose the *most* important, the *most* frightening, the *most* anything because stipulating such a hierarchy has a tendency to stifle open-ended thinking. Participants then become involved in ranking or rating, rather than holding space to perceive themselves and their surroundings curiously and with fresh eyes. I also caution participants to stay away from conventional categorizations that often encode yes/no, right/wrong, and this or that dichotomies. Because as a society our visions of the possible are often blocked by binary oppositions and their attendant, seemingly irresolvable conflicts, an artistic investigation of a generative theme is predicated upon flexible articulations and visualizations.

FIGURE 2.1 Generative Theme Investigation by Nicole Abandor, 2020. Permission of the artist, Olivia Gude.

For collaborative projects, participants need to agree on a theme. I teach participants a model of collaborative decision-making. One of the core tenets of this process is to avoid voting if at all possible because voting is not the optimal democratic process for collaborative work as it creates winners and losers. Instead, projects aim for participatory democracy, looking for yes/and solutions. It is essential to not rush the process—to hear every voice, to discuss likes and concerns, to look for similarities and overlaps, to ask "what if we…," to do further research that might reveal connections and contradictions, to take time to relax and reflect, and to defer the final decision until everyone feels comfortable with it. As facilitator, it's important to remind the group that a good theme/idea is not necessarily lost if not chosen for this project; it's carried in our hearts and minds and may be manifested and investigated in another time or place or as a sub-theme during this project.

EXPANDING AND INVESTIGATING THEMES

Even if it is a familiar issue or idea, the full complexity and significance of a chosen theme is not immediately apparent. Freire writes that "Generative themes can be located in concentric circles, moving from the general to the particular" (1968/2005, p. 103). Because as an artist, my education has emphasized beginning with the sensuous and particular, I find that it can also be helpful to turn Freire's method around—to begin with the particular and then trace wider and wider concentric circles of connections to other things and systems.

Finding a productive distance from which to begin an artistic investigation is the result of intuitive reflective practice. If a chosen theme is initially expressed too concretely or too abstractly (for example, "school detentions" or "justice"), there is a tendency to merely represent, illustrate, or symbolize what we already know and believe about a subject, rather than engage in activities that move us—emotionally, physically, and conceptually. I've conducted many workshops for teachers and teens on the theme of Punishment—creating autobiographical comics (see Figure 2.2) which afford

FIGURE 2.2 I'm an Evil Child. Who Knew? Punishment Autobiographical Comic by Maria Lopez, 2008. Spiral Workshop Archive.

surprising insights into such things as youth's conceptions of justice, disciplinary practices in homes or schools, the advisability and ethics of corporal punishment, who is likely to get punished, and who decides what deserves to be punished—often then addressing complex culminating questions such as "Does punishment work?" and "Is punishment necessary?"

CODING AND DECODING

In classic Freirean pedagogy, one of the first learning activities is the teacher and students together analyzing pictures that encapsulate the social realities of participants' economic, social, and political life world. Art teachers can initiate dialogue by choosing artworks (including artists' videos and photographs) that serve as "codified representations" that embody the generative theme under investigation (Freire, 2000, p. 23). Through the distance gained by viewing reality as image, participants discuss and decode heretofore unnoticed or taken-for-granted aspects of the situation. Visual Thinking Strategy questions work well to stimulate dialogical investigations, "What's going on in this picture? What do you see that makes you say that? What more can we find?" (Yenawine, 2013, p. 25). As a teacher, I've often found that even though I am the one who chose a given artwork for its relevance and significance, my understanding of the artwork and its implications for the theme under investigation has been greatly expanded by participants' comments and connections.

As a group investigates a theme, the power of art to communicate through visual impact and emotional affect stimulates engagement and deeper commitment to the project. Chosen images can range from literal realist depictions of a scene to data visualization. I've worked with students on analyzing Thomas Kinkade images of idyllic villages made up of separate large houses with chimneys smoking and lights blazing in every window and no discernible walking paths or streets to connect them, as part of an investigation of the growing issue of providing housing for all people. I've seen students shudder in horror seeing Chris Jordan's monumental scale photograph of 426,000 discarded cell phones (the number discarded in the U.S. each day at that time) and begin discussing sustainability even as they alternated between confronting and comforting each other about the undisputed social necessity to have individual, state-of-the-art cell phones.

Sometimes an artwork can be so disturbing that it deeply unsettles viewers and shatters conventional identifications and understandings of a situation or issue. This is a strength of using challenging contemporary art as coded representations to contemplate curriculum themes. In the Getting Lindsay Linton photograph in his *Understanding Joshua* series (see Figure 2.3), the artist Charlie White creates a dramatic image of a white woman being restrained by three angry white men in a shower room-like setting. A fifth character in the scene is Joshua, a grotesque, racially ambiguous, and vulnerable-seeming puppet-like creature who is being forced to look into the woman's face as one of the men pours a thick, white milky substance onto her head.

Observing this image closely with a group of teens led to many observations and questions—Why are the men being bullies? Why is it important to these men to force Joshua to witness what is happening while also preventing him from speaking or

LIMIT ACTS AND CONSTRUCTED SITUATIONS 31

FIGURE 2.3 Getting Lindsay Linton, photograph in *Understanding Joshua* series, Lightjet c-print mounted on Plexiglas 30.5 × 152.4 cm Ed. 3/3, Selvage Collection, by Charlie White, 2020. Permission of the artist.

calling out? Is it appropriate to mention the similarity of this image to some images found on internet porn sites? New questions, based on further nuanced observation, continued to be raised. Why does each touch of hand to body when observed apart from the open-mouthed aggression on the men's faces, feel oddly tentative and tender?

We quickly moved beyond anti-bullying sloganeering to exploring the psychological significance and possible root causes of the scene. Further questions included the following: What has happened before this coercive confrontation? Why are these men so very angry? Can we speculate on likely outcomes of this incident for each individual? Does the name Lindsay in the title connect to the cultural meme of Mean Girls and thus complicate the depiction of gendered violence?

It's no small feat for an artist to horrify today's jaded viewers with a single, highly staged still photograph that is without blood and gore or nudity. Rather than remaining passive, disengaged bystanders, our investigation of this image awakened uncomfortable memories and deepened self-reflection. We were drawn into confronting and considering possible social and psychological origins of bullying behavior, including within ourselves.

Teaching Terry Barrett's Principles of Interpretation can be useful in supporting students in decoding images, developing the capacity to analyze how meaning is generated in art and in everyday experiences, objects, and communications. Students can recognize that their understandings of the meanings of things they encounter are not given and immutable, but rather are shaped by the cultural contexts that frame their experiences. We all make interpretations all the time. "Meanings of artworks [or other cultural products} are not limited to what their artists intended them to mean … Interpretations are not so much right, but are more or less reasonable, convincing,

informative, and enlightening" (Barrett, 2003, p. 198). Considering such principles tends to disarm resistance to identifying and acknowledging how cultural products shape our understandings of what is "normal" and "natural," even as it supports students in becoming sophisticated thinkers who don't resort to believing hidden conspiracy theories of how "they" are attempting to program us when they recognize the impact of cultural products on belief systems.

LIMIT SITUATIONS

Through the distance gained by viewing reality as image, participants in a theme investigation discuss and decode heretofore taken-for-granted aspects of their lives. By understanding these as cultural constructs as opposed to inevitable, unmediated reality, participants identify concrete "limit situations." When encountering and articulating limit situations, people have a tendency to think that they are identifying the borders between what is and what is impossible. Freire reminds us that these are not the frontier between being and nothingness, but rather the border between being and being more (Pinto, 1960, as cited in Freire 1968/2005).

An investigation of a limit situation proceeds as the teacher/leader and students/participants work together to more fully understand the situation in all its complexity, details, and history. The role of a teacher at this point is to formulate a range of activities or methods by which participants can develop awareness of the multiple, interrelated aspects of a theme as embedded in concrete situations, while always allowing for new methods, activities, or themes to emerge from the participants.

The Power of Advertising project, first developed in 2000 by art teacher Tracy Van Duinen at Austin Community Academy High School on Chicago's West Side, has been taught in many settings (Van Duinen, 2001). Students identify generative themes in their school and community by responding to the directive to "Question Truth" through prompts such as "Name something your family believes is true." "Name one thing a family member told you that you know was a lie." "Identify something that you believe to be desirable, but impossible." and "Everything in my textbooks is true." As they respond to given prompts, students often suggest additional prompts—an important indicator that they are internalizing a Freirean understanding of the links and disconnects between internalized beliefs and external reality.

Working in small groups, students chose an issue that they believed ought to be promoted or advertised (locally or beyond). They wrote several advertising-type slogans (Just do it) for each theme and layered these onto close up, dynamic photos of each other, becoming enactors representing their realities.

LIMIT ACTS

Because Freirean pedagogy is a pedagogy of praxis (uniting reflection and action), limit situations are understood as then requiring "limit acts" which push against identified limits, recognizing that "beyond these situations … lies an untested feasibility" (Freire, 1968/2005, p. 102). Limit acts have the potential to transform reality.

FIGURE 2.4 Power of Advertising project as taught by Madilyn Strentz at Back of the Yards College Preparatory High School, 2016. Contemporary Community Curriculum Archive.

Often publicly sharing the results of a generative theme investigation is itself a limit act, enlarging the discursive space of a school and community. (see Figure 2.4) Invariably, when the results of the Power of Advertising project are displayed in a school's public spaces, fellow students, teachers, administrators, staff, and security guards as well as visiting family and community members notice and are quickly engaged in animated discussions, debating the relevance and significance of the depicted themes as well as identifying themes that they believe ought to have also been included. An intergenerational conversation is generated in which a "normalized" status quo becomes the object of the critical and creative thinking of a problem-posing community.

A productive site for artistic investigation can frequently be found by going to the literal limit, to the actual physical space or the institutional boundaries that divide, define, and shape life experiences. I have often reflected on a project organized by Mindy Faber, an artist and teacher at Evanston Township High School in a racially and economically diverse Chicago suburb. There had long been an intense sports rivalry between Evanston High School's students and students in another north suburban school, New Trier High School. New Trier serves the predominantly white population of some of the wealthiest suburbs in the U.S.

Faber's Freire-inspired media arts curriculum encouraged students to identify and codify limit situations and then to ask probing questions (M. Faber, personal communication, January 4, 2023). When describing differences between the two schools and their students, Ms. Faber's media arts class quickly identified economic differences and unequal educational funding. In the course of further discussion and research, other questions were raised, some quite provocative. What were the reasons that fights

often broke out at sporting events? Did the school sports rivalry mask very real racial and economic fears and resentments between the students and communities? What were the histories that had contributed to housing segregation?

Students decided that a limit act was needed. In Freirean pedagogy, a teacher uses their expertise and resources to support developing a project that furthers the investigation. Faber formed a partnership with an art teacher in the New Trier art department and together they planned an initial curriculum. The Evanston students interviewed each other, creating short videos about their stereotypes of the New Trier students and their perceptions of how New Trier students stereotyped them. These videos were sent to the New Trier students to view and discuss. New Trier students created reaction videos to send to Evanston. Fieldtrips were arranged. The Evanston students visited New Trier, each shadowing a New Trier student during their school day. At days end, all the students participated in a facilitated and videotaped conversation about race and rivalry. New Trier students then visited at Evanston High School and participated in further dialogue about stereotypes and inequality.

The brief synopsis above doesn't capture the nuances and intensity for participants (students and adults) of breaking the anti-dialogical convention of not openly discussing race, economics, and cultural differences between schools or communities. Some surprising insights were generated. The Evanston students were surprised to see that their school did have many of the same resources as (wealthy) New Trier. All these suburban students listened attentively as a student who had transferred from a very poor Chicago city neighborhood school passionately stated that going on to college was not just a personal choice, explaining how her move to Evanston had greatly expanded her imagination, support network, and actual possibilities. Faber observed that "They had their guard up, but they listened to each other."

The project culminated with a public screening of the edited videos at a theater in Evanston. The students issued an open invitation to the community and also invited others (including family members, fellow students, school administrators, and local politicians). After the screening, Evanston and New Trier students "took ownership of the project," sitting together on the edge of the stage, answering audience questions, and facilitating further conversation. Faber noted that the students had begun speaking in "a more collective voice," as fellow researchers investigating a problem. The students agreed that they had started "shifting it a little bit" and that it was important to think deeply about given limitations, not by concentrating on what you can't do within institutional limits, but by focusing on what can happen despite them. (personal communication, January 4, 2023).

Freirean pedagogy is rooted in a culture of discovery and re-imagining. Often, especially in a context where there may not be complete agreement or even sharp disagreement among the participants on the root of the problem or on how the world might be made better, it's important that the focus of the cultural action be on the participants' capacity to "name the world, to change it" (Freire, 1968/2005, p. 88). Big collective actions on a singular clearly seen path are not always possible. Recognize that sharing an effective reflection can be an effective action because "Once named, the world in its turn reappears to the namers as a problem and requires of them a new naming" (p. 88).

Paradoxically, the very possibility of making transformative change can sometimes have a tendency to stifle the creative responses of individuals or groups because they feel the pressure of the "unstated but operative assumption ... that if some single project were just potent enough, then people would run right out and commence the social revolution" (Ward, 1985, p. 156). While it's important that teachers and project leaders share inspiring examples of how cultural projects have catalyzed dramatic changes in awareness as well as new developments in political policy and practice (for example, the *Adbusters*' Occupy Wall Street campaign that became a global phenomenon or the pervasive influence of the #MeToo movement), it's also crucial to emphasize the many examples of the slow, patient, and nuanced work of shifting perspectives, changing attitudes, and building communities committed to change.

MORE THAN PITTING SLOGANS AGAINST SLOGANS

Paulo Freire affirmed that the task of progressive educators is "surely not that of pitting their slogans against the slogans of the oppressors, with the oppressed as the testing ground, 'housing' the slogans of first one group and then the other" (1968/2005, p. 95). The dialogical method of problem-posing education develops critical consciousness within students through which they become aware of and investigate aspects of their lived, concrete, historical situations.

Problem-posing art teachers develop projects through which participants learn and utilize unfamiliar artmaking approaches that enable them to explore in new directions and develop unexpected insights. Such projects generate spaces of focused artistic experimentation, fostering creative and critical inquiry, expanding each student's knowledge-building capacity, intrinsic motivations, and their sense of purpose and possibilities. Students learn that meaning comes into being in particular historic, technical, experiential, aesthetic, and cultural situations. When constructing curriculum, a Freirean art teacher asks, "How can I support students in making art that is relevant to the challenges of our contemporary life?"

SITUATIONISTS IN THE SPECTACLE

Back in the day (sometime late in the 20th century), I was surprised and intrigued when I first noticed the many overlaps in the language and concepts of two seemingly quite different movements that had greatly influenced my thinking, teaching, and artmaking over the years—Freirean dialogical pedagogy and the making practices and theoretical writings of the Situationist International. The S.I., a European-based revolutionary group of artists and intellectuals (officially active from 1957 to 1972) evolved out of and in contrast to other contemporaneous art movements, including Surrealism, Dadaism, the Lettrist International, and the International Movement for an Imaginist Bauhaus. The S.I. legacy greatly influenced avant-garde art practices in the latter half of the 20th century as well as many 21st-century artistic practices (Plant, 1992). Some notable examples of Situationist-influenced art and culture include the poetic political slogans written and plastered on the walls during May 68 in Paris, the aesthetics

and politics of Punk culture, street art, and movements such as culture jamming and subvertising.

Situationist practices are grounded in the theory that since the mid-20th century the primary means of shaping people's experiences and understanding of their lives is the ubiquitous representations that make up spectacular commodity-oriented capitalist society.[1] People are overwhelmed, unable to think, and live outside of the options provided by the never-ending society of the spectacle (Debord, 1967/2014). The S.I. identified "constructed situations," interventions in habitual experiences, and perceptions as the means by which passive spectators might be shocked into active awareness, leading to critical consciousness. "The construction of situations begins beyond the ruins of the modern spectacle. It is easy to see how much the very principle of the spectacle—nonintervention—is linked to the alienation of the old world" (Debord, 1958/2006, p. 40). Situationists encourage people to eschew being passive spectators and to instead become "livers." (Wark, 2011). This process of liberating their thinking and living can be understood as a playful, embodied, aesthetic form of the activist "decoding" work of dialogical pedagogy.

DÉTOURNEMENT AS CURRICULUM

Détournement is "the reuse of preexisting artistic elements in a new ensemble" to construct new meanings. The existence of millions and millions of internet memes (as image, text, gif, or video) that re-purpose familiar cultural artifacts to create altered meanings suggests how pervasive this strategy has become in contemporary culture. *Détournement* is the key Situationist strategy for constructing situations because it simultaneously "testifies to the wearing out and loss of importance of [past culture]" as it suggests fresh perspectives and new ways of being (Knabb, 1958/2006, p. 52). The practice of *détournement* does not require traditional artistic talents nor extensive professional training. Being made up of clearly recognizable elements of familiar culture, it is an invitation to all to participate in talking back to reified received meanings. (see Figure 2.5)

Cultural artifacts that can be *détourned* include literally all preexisting cultural products in all mediums from lowly advertisements to official documents to popular cultural phenomenon to "masterworks" of high culture (Ford, 2005).Constructed situations can be big productions—collaborative and elaborate—requiring many people and resources or they can be produced by a single person with a pen or scissors, juxtaposing disparate elements, to provoke surprise, recognition, amusement, and head-shaking reflections. Great examples of elaborate constructed situations are the many projects of the artist duo The Yes Men who with their supporters and collaborators have created projects that include false personas, events, PR releases, and websites that attract attention for promoting positions that while initially seeming to be reasonable corporate responses are then quickly seen as outrageous within the context of the values and practices of dominant ideologies.[2]

When teaching *détournement* as an artistic practice in a school setting, it is important to understand the classroom as an experimental laboratory in which each student is allowed the space to explore their own cultural/political insights and values.

LIMIT ACTS AND CONSTRUCTED SITUATIONS 37

FIGURE 2.5 Sell Out Détournement by Mercedes Jones, 2007. Spiral Workshop Archive.

When engaging students in critique as an artistic practice, it is ethically imperative that teachers not act as directors who make use of the labor of students to enact a teacher's political preferences. While groups of students or even whole classes may hold or discover common interests and beliefs and democratically decide to design and enact a collaboratively constructed situation, initially *détournement* curriculum ought to be designed to give each student the capacity to freely experiment with pre-existing elements without pre-determined outcomes.

Détournement curriculum does not require extensive scaffolding. Simply asking students to think about what ads (or other cultural products) are selling beyond the most obvious answers such as beer, household cleaners, or good careers, generates rich discussions and ideas for interventions, foregrounding how ads "sell" values, aesthetic sensibilities, and life choices. In my experiences as a teacher and community artist, youth and adults quickly respond to invitations to playfully interact with, intervene in, and alter familiar cultural artifacts, whether advertisements, signs, newspapers, Disney-themed decorations, famous paintings, or school curricular materials. "Such people are all, either spontaneously or in a conscious and organized manner, *pre-situationists*—individuals who have felt the objective need for this sort of construction through having recognized the present cultural emptiness and having participated in recent expressions of awareness" (Knabb, 1958/2006, p. 50).

Teaching *détournement* was a recurring curriculum strategy during the 18 years of the Spiral Workshop, a Saturday art program for Chicago area teens and a laboratory for designing contemporary curriculum with emerging teachers.[3] The curriculum of each Spiral group introduced youth artists to a variety of artistic practices to support their investigation of a chosen theme. To clearly see a limit situation and to generatively imagine living outside of its restrictions, teen artists must develop the capacity to question boundaries as presented by approved commercial and political culture; they need to be wary of thinking that "That's just the way things are."

The Spiral Women's Work[4] group conducted two detournement-inspired projects. After watching the classic documentary film, *Killing Us Softly: Advertising's Image of Women*, the students returned to their studio classroom to find walls covered with full-page ads torn from "women's magazines." They quickly became immersed in conversations about how many of the ads offered solutions to "problem areas," suggesting that they were not good enough "as is." With no further prompting than being asked to share their thoughts through re-combinations, interventions, and unexpected juxtapositions of image and text, the young women enthusiastically made insightful, amusing (but also achingly poignant) critiques of the demand that they make themselves into spectacles within the spectacle.

In a later project, thrift store-Barbie dolls were redesigned into newly conceived "Theme Barbies." The teachers and youth artists considered the pressure on doll industry creatives to come up with novel trendy themes in order to sell more dolls while always being careful not to disrupt the normalized binary cis-gendered social order by inadvertently identifying themes that affected and limited the lives of girls and women. Themes investigated by the group included: Teen Diet Barbie (who will need to diet for life to maintain those skinny hips); Class Action Law Suit Barbie with her portfolio from her days as a Mattel model and a portfolio of law suits she is involved in because of health problems related to beauty interventions such as breast implants and liposuction, and Border Barbie—Esperanza, Barbie's friend Teresa's distant cousin who comes with accessories to aid in border crossing so she can make it to the U.S. to the underpaid housework job awaiting her in the Barbie Mansion. Some theme dolls were downright distressing: School Shooter Cecil, whose designer's accompanying statement asked how long before distressed, angry girls become violent in ways now mostly associated with young men or Teen Mental Institute Skipper who represented the growing trend to confine non-conforming kids in healthcare facilities.

Aid students in identifying varied approaches that can be used to question spectacle conventions by engaging them in analyzing various styles of detournement. *Adbusters* magazine (and website), declaring that they are in a "guerilla information war for the future" provides many examples of "smooth infiltration" ads that at first glance look perfectly normal with their high-quality photography and tasteful typography. A nostalgia-producing photograph of two cowboys riding side by side against a backdrop of a glowing sunrise initially passes as an actual Marlboro ad until one reads the text, "I miss my lung, Bob." The magazine also showcases rough intervention strategies in which pages of polished text and photographs are interrupted with scrawled lettering or cut-and-paste elements to simultaneously present the original work and to demonstrate surprising rebuttals to its message.[5]

Not content to merely sample Situationism and Punk, one Spiral group devoted their entire curriculum to using Punk aesthetics to identify and investigate generative themes. Their mission statement announced that "Art doesn't have to look like the world to be about the world."[6]

The city kids in the Spiral Punk Process group immediately got it when their teachers pointed out examples of commercial media and manufacturers appropriating styles invented by urban youth. They were outraged to learn that professional market researchers are paid to target them in order to identify their fresh ideas and to then re-package this energy in products to sell back to kids and their communities. The Situationists were acutely aware of the danger of recuperation, the process by which manifestations of radical resistance are recycled and popularized as style, depriving them of cultural meaning, draining them of critique or resistance to dominant ideologies (Hebdige, 1979).

Deciding to see learning about recuperation as an unexpected form of career education in marketing, the punk artists founded a Punk Ad Agency whose slogan was "We've sold out to sell out your products." Not waiting for industry commissions, they did market research on each other. Recognizing that for many of them cereal was a main source of sustenance, but that most advertising for cereal was directed at children, concerned parents, or "boring old people," they decided to create campaigns for sexy cereal, resulting in products such as Naughty Toasty Crunch, Get Laid Raisins, and Honey Slut Viagrios, sold in punked out packaging often with sultry women bathing in milk. As students were searching through magazines to find imagery for their collaged packages, I heard a number of teens say things such as "I can't believe how easy it is to find this stuff (sexy pictures) ... and this is just an ad for laundry detergent!" I reflected that no amount of lecturing from their teachers could have so vividly explained how the society of the spectacle replaced life with representation.

BE REALISTIC—DEMAND THE IMPOSSIBLE!

The teachers of the Spiral Bureau of Misdirection[7] group also centered their curriculum on Situationist practices, but rather than focus on the critique of commercial culture, they focused on the Situationists exuberant demand to "Live without dead time." (Marcus, 1989, p. 427). When asked what "dead time" meant, the students were quick to offer explanations without further teacher explication. The youth artists

FIGURE 2.6 Live Without Deadtime installation, Spiral Workshop, 2011. Spiral Workshop Archive.

gave answers such as, "Time spent doing things that aren't interesting." "Not being fully engaged in an activity." or sadly, simply "School." They debated whether a world in which they were not inundated with boring, meaningless activities was possible. They considered what it meant that they were sometimes bored even when they had free, unscheduled time.

Introduced to the Situationist practice of the *dérive* in which "one or more persons during a certain period drop their usual motives for movement and actions, their relations, their work and leisure activities, and let themselves be drawn by the attractions of the terrain and the encounters they find there..." (Debord, 1958/2006, p. 62), groups wandered onto the surrounding urban streets, opening themselves to experiencing "the specific effects of the psychogeographical environment, consciously organized or not, on the emotions and behavior of individuals" (Debord, 1955/2006, p. 8).

Recognizing the ubiquitous street sign as a necessary organizer of urban life but also as a demand for social conformity, they set up an experimental studio to détourn existing signs and to imagine new ones (Gude, 2001) (see Figure 2.6). Some of the youth artists constructed situations by then installing their signs in public space and observing how passersby reacted to these surprising interventions. Would the person stop, look, and be inspired to live without dead time, even for a brief moment, or would the person walk right by, unable to see new pathways through deadened eyes, unable to live or act outside the limits?

YOUR CURRENT CURRICULUM

Teachers, survey your current curriculum. (see Figure 2.7) Does it make use of, as well as teach students about, methods (individually and collaboratively) for identifying and articulating themes and issues in their lives? Do you include activities designed

LIMIT ACTS AND CONSTRUCTED SITUATIONS 41

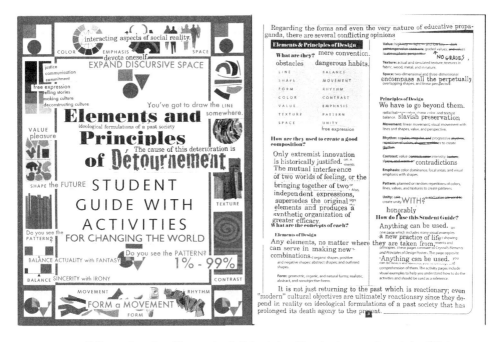

FIGURE 2.7 Détourning the Elements & Principles Curriculum, artwork by Olivia Gude, 2012.

to support students' capacities to make nuanced observations of artworks, advance grounded and imaginative interpretations, and engage in responsive conversations in which they build on each other's ideas? When incorporating art history into your curriculum do you regularly include information about the often contentious contemporaneous responses by various social groups and governments to now widely acknowledged as significant artworks? Do the artistic practices covered in your curriculum include aesthetic interventions that creatively and critically question the seamless absorption of the values of more familiar art and culture, including the familiar culture of much school-based art education?

NOTES:

1 Because the Situationists were anti-copyright and believed in the free circulation of cultural materials, there are many examples of Situationist writing available without cost on websites, including the comprehensive Bureau of Public Secrets site that contains the entire text of the *Situationist International Anthology*, compiled and edited by Ken Knabb. http://www.bopsecrets.org/
2 The Yes Men website—https://theyesmen.org/—is a rich resource for teaching about constructed situations as a collaborative artmaking process.
3 Spiral Workshop (1995–2012) at the University of Illinois of Chicago was a Saturday teen art workshop, practicum experience for teacher candidates, and a curriculum research laboratory. For more examples of Spiral curriculum, see: https://naea.digication.com/Spiral/Spiral_Workshop_Theme_Groups/edit
4 Women's Work: Make Art in Spiral Workshop 2002. Faculty: Julia Beatty, Gina Ibarra, Lauren Much. Director: Olivia Gude. https://naea.digication.com/Spiral/Women/published

5. Adbusters has created some of the most influential memes into activism events of the 21st century, including Buy Nothing Day and Occupy Wall Street. https://www.adbusters.org/
6. Drawing the Venom: Punk, Process, & Print in Spiral Workshop 2004. Faculty: Stacy DeVoney, Todd Osborne, Katy Province. Director: Olivia Gude. https://naea.digication.com/Spiral/Punk_Process_Drawing_the_Venom-working/published
7. The Bureau of Misdirection in Spiral Workshop 2011. Faculty: Erin Miller, Christian Norcross. Director: Olivia Gude. https://naea.digication.com/Spiral/Bureau_of_Misdirection–WORKING/published

REFERENCES

Barrett, T. (2003). *Interpreting Art: Reflecting, wondering, and responding.* McGraw Hill.

Debord, G. (2006). Introduction to a critique of urban geography. In K. Knabb (Ed. & Trans.). (2006), *Situationist international: Anthology.* Bureau of public secrets. (Original work published 1955).

Debord, G. (2006). Report on the construction of situations and on the International Situationist tendency's conditions of organization and action. In K. Knabb (Ed. & Trans.). (2006), *Situationist international: Anthology.* Bureau of public secrets. (Original work published 1957).

Debord, G. (2006). Theory of the dérive. In K. Knabb (Ed. & Trans.). (2006) *Situationist international: Anthology.* Bureau of public secrets. (Original work published 1958).

Debord, G. (2014). *Society of the spectacle* (K. Knabb, Trans.). Bureau of Public Secrets. (Original work published 1967).

Ford, S. (2005). *The Situationist International: A user's guide.* Black Dog.

Freire, P. (2000). *Cultural action for freedom.* Harvard Educational Review.

Freire, P. (2005). *Pedagogy of the oppressed* (M. B. Ramos, Trans.). Continuum. (Original work published 1968).

Freire, P., & Macedo, D. (1987). *Literacy: Reading the word and the world.* Taylor & Francis.

Gude, O. (2001). Psycho-aesthetic geography: A 21st century art standard for proactive art education. *Journal of Cultural Research in Art Education*, 22 (Spring), pp. 5–18.

Gude, O. (2007). Principles of possibility: Considerations for a 21st century art and culture curriculum. *Art Education*, 60(1), 6–17.

Hebdige, D. (1979). *Subculture: The meaning of style.* Methuen & Co. Ltd.

Knabb, K. (Ed. & Trans.). (2006). Preliminary problems in constructing a situation. In *Situationist International: Anthology.* Bureau of public secrets. (Original work published 1958).

Marcus, G. (1989). *Lipstick traces: A secret history of the twentieth century.* Harvard University Press.

Plant, S. (1992). *The most radical gesture: The Situationist International in a postmodern age.* Routledge.

Pinto, A.V. (1960). *Consciencia e realidade nacional*, Vol. II, Contraponto.

Shor, I., & Freire, P. (1987). What is the "dialogical method" of teaching? *The Journal of Education*, 169(3), 11–31. http://www.jstor.org/stable/42741786

Van Duinen, T. (2001). Power of advertising. *Olivia Gude NAEA Digication e-portfolio.* https://naea.digication.com/omg-archive/Power_of_Advertising/published

Ward, T. (1985). The situationists reconsidered. In D. Kahn & D. Neumaier (Eds.), *Cultures in contention.* Real Comet Press.

Wark, M. (2011). *The beach beneath the street: The everyday life and glorious times of the Situationist International.* Verso.

Wiggins G. P., & McTighe, J. (2005). *Understanding by design* (Expanded 2nd). Association for Supervision and Curriculum Development.

Yenawine, P. (2013). *Visual thinking strategies: Using art to deepen learning across school disciplines.* Harvard Educational Press.

CHAPTER 3

Transformative Learning toward Socio-Ecological Consciousness and Civic Engagement
The Creative Potential of Nature Connection

Mira C. Johnson

> **INSTRUCTIONAL QUESTIONS**
>
> 1. How might individual transformative learning impact civic engagement and transformation on a social level? How does an understanding of civic education change when reorienting the focus from the actors in the system to the relations between those actors and the larger system?
> 2. If transformative learning is not linear, how do educators best engage with it?
> 3. If democracy is a "wicked problem" that is inherently unsolvable, what would be an effective approach to civic education?
> 4. What might civic education look like if it embraced paradox and systems thinking (and rejected the uncritical acceptance of particular ideas and beliefs).
> 5. If a shared ecocentric culture and expressive traditions are an important component of developing an ecocentric perspective, how might civic education contribute to learners who do not see themselves as part of an eco-conscious culture?

We live in a time of widespread ecological disruption (Millennium Ecosystem Assessment (Program), 2005; Radchuk et al., 2019; Roe, 2019; Thiel et al., 2018). Ecologist and educator David W. Orr (2004) argues the source of the current ecological crisis "is a failure to educate people to think broadly, to perceive systems and patterns, and to live as whole persons" (p. 2). Echoing Orr's concern, researchers in adult education such as O'Sullivan (2012) and Lange (2012) have argued that achieving socio-ecological sustainability will require transformative learning experiences that lead individuals to perceive their interconnectedness with nature and all of the more-than-human world. If, as Orr, O'Sullivan, and Lange suggest, an awareness of connection to nature is essential for attaining global socio-ecological sustainability, and education should play a role in fostering this connection, then what does the process of learning to be connected to nature look like, how is it accomplished, and what role does civic education play?

In this chapter, I frame civic engagement as working to make a difference in one's greater ecological community—consisting not only of one's human community but including the "more than human world" (Abram, 1996, 2010), the interconnected web of life; the natural world that evolved prior to human life, on which the human world depends and does not include human-built constructions. Abram (1996) derived this conception of the more-than-human world through his understanding of indigenous thought and an animistic worldview. Civic education has the potential to be a transformative learning experience, and, as I have found in my research, one that can transform consciousness toward socio-ecological connectivity. Reciprocity, another indigenous idea that involves giving back to nature in gratitude (Abram, 1996; Clover, 1995, 2003; Redvers et al., 2020), plays a key role in this form of civic engagement. My research among an international group of educators learning nature connection suggests that nature connection practices can facilitate transformative learning toward a relational ontology, or an understanding of reality as "a dynamic network of relations where all things are connected as a living system" (Lange, 2018, p. 281). In the following sections I will discuss transformative learning theory, a complex systems interconnected worldview, and how these perspectives combine to foster eco-consciousness and civic action.

TRANSFORMATIVE LEARNING THEORY

My research (Johnson, 2021; Tisdell, Whalen, & Johnson, 2022) uses the framework of transformative learning theory to understand the experience of learning nature connection and the impact this learning has on educators' teaching practices. There is no unified theory of transformative learning, but instead a growing web of interrelated approaches to understanding the fundamental process of perspective change—the process of examining, questioning, and revising one's perceptions of his or her experiences (Cranton & Taylor, 2012).

Origins: Mezirow, Meaning Perspective, and Phases of Transformation

Mezirow (1978) first formulated his theory of transformative learning during a study of women returning to college and the workforce after an extended hiatus. He identified

a nonsequential nine-phase process that the women experienced, resulting ultimately in a change in "meaning perspective," what Mezirow defined as "a personal paradigm involving cognitive, conative, and affective dimensions" (Mezirow, 1985, p. 22). For Mezirow, this transformational process constituted a unique form of meaning making: "becoming critically aware of one's own tacit assumptions and expectations and those of others and assessing their relevance for making an interpretation" (Mezirow & Associates, 2000, p. 4).

Transformative Learning Theory Underlying Assumptions

Mezirow was clear in his writings that he understood the process of learning as highly personal: the learner forms meaning out of experience which is then validated or challenged through interaction with others. Rather than searching for universal truths that are independent of the knower's knowing, learning is the process of attributing meaning to experience. It is because meaning of any one experience is not universally constant that transformation is possible. By becoming aware of how past experiences and habits of mind influence their creation of meaning, the learner can become aware of the assumptions that shape how they make meaning in the world and ultimately critique and transform them (Mezirow & Associates, 2000). Transformative learning theory suggests that people regularly and uncritically make meaning using the perspective of the dominant ideology, but through critical reflection they can recognize when the assumptions of this ideology are oppressive, become aware of alternative perspectives, and ultimately pursue new actions that lead to change (Cranton & Taylor, 2012).

Socio-ecological View of Transformative Learning

In the past 20 years, a socio-ecological view of transformative learning theory has emerged that considers how individual transformation impacts social transformation: transformative learning for planetary survival (O'Sullivan, 2012) and the complexity or systems view of transformative learning (Lange, 2012, 2018).

O'Sullivan and Planetary Philosophy

O'Sullivan (2012) conceives of transformative learning as a profound change in worldview that "involves experiencing a deep, structural shift in the basic premises of thought, feelings, and actions. It is a shift of consciousness that dramatically alters our way of being in the world [...] our understanding of ourselves and our self-locations; our relationships with other humans and with the natural world" (O'Sullivan, Morrell, & O'Connor, 2002, p. 11). O'Sullivan provides a model of transformative learning that takes into account learning at the individual, cultural, and global scales, addressing critiques that transformative learning does not adequately explain how individual transformation impacts social transformation.

Lange and "New Science" or Complex Adaptive Systems

Similarly, Lange (2018) encourages a revisioning of transformative learning theory that moves beyond its original modernist epistemological, cosmological, and ontological roots and is instead grounded in the relational ontologies of New Science. Transformative learning from this perspective reorients the locus of transformation away from the individual or society and to the relations between actors within a larger system. She discourages the view of transformative learning as linear and proposes instead a process that is chaotic with many feedback cycles and that results in both epochal and incremental transformations. Because learning occurs through feedback from outside the self and "individuals often do not know their potential until a specific community brings it forth" (Lange, 2012, p. 205), relationality is central to Lange's conception of transformative learning. Lange's explicit consideration of relationship in transformative learning creates a space to consider the role of expressive culture in the transformative learning process, as well as how learning and transformation occur and influence one another across the various scales of the global system.

TRANSFORMATIVE CIVIC LEARNING FOR ECO-CONSCIOUSNESS AND CIVIC ACTION

Civic education is not inherently transformative, but it has the potential to be when it involves critical discourse and critical self-reflection that results in a change in perspective, one's understanding of self-in-relationship to others, and a greater sense of responsibility for shaping a shared social world (Hoggan-Kloubert et al., 2022). Crucial to transformative civic learning are opportunities to engage in discourse with others across lines of difference, practicing techniques of listening, reflecting, and working in concert with others (Torney-Purta et al., 2001).

A "Wicked Problem" for Civic Education: Environmental Degradation

While the United States has a long history of including civic education within formal education, adult educators Carcasson and Sprain (2012) argue that current civic education programs have not proven effective at addressing the "wicked problems" (Rittel & Webber, 1973) of democratic societies. These problems are "wicked" in that they cannot be solved using data alone, in fact, they likely cannot be "solved" at all. Instead, they require systems thinking and an appreciation of competing underlying values, paradoxes, and tradeoffs that often can be not resolved but must continually be reevaluated and re-addressed. "Wicked problems" demand adaptive responses developed through creativity and innovation in "effective collaboration and communication across multiple perspectives" (Rittel & Webber, 1973, pp. 16–17).

Civic education itself must adapt in order to respond dynamically and effectively to the complexity of social needs it is attempting to address. It must also be vigilant in restraining its own tendency to proclaim emancipatory goals while simultaneously promoting the uncritical acceptance of particular ideas and beliefs (Sears & Hughes,

2006, p. 4). History offers countless examples of the dangers of civic indoctrination, and if we understand democracy as fundamentally a "wicked problem" it becomes clear that a static set of beliefs and values reified as doctrine will never be adaptive enough to address the ever-changing complexity of most social problems. A truly democratic and transformative civic education will promote sensitivities against indoctrination through its emphasis on communicative discourse and critical self-reflection and will be dynamic enough to find collaborative and innovative approaches to managing the inescapable paradoxes of collective living. Environmental degradation is one example of a "wicked problem" that demands balancing the often-competing goals of social, economic, and environmental sustainability. To address such problems, we need a transformative civic education that can embrace paradox and systems thinking while also resulting in active social and political participation.

Nature Connection as Transformative Civic Learning

In my qualitative study of learning nature connection as a form of informal civic adult education (Johnson, 2021), I analyzed ethnographic interviews with international educators and nature connection learners to understand the transformative dimensions of learning nature connection and its relationship to developing an ecocentric worldview then enacting it in their teaching.

Defining an Ecocentric Worldview

For the purposes of research, I defined an ecocentric worldview as a perspective that views the non-human world as animated or ensouled, sees intrinsic value in the more-than-human world, and understands all beings as connected through dynamic webs of interrelationship (Johnson, 2021). Nature connection practices refer to "things people do to learn nature's ways" (Young, Haas, & McGown, 2016, p. 35). These practices include, but are not limited to, core routines of nature connection (Young et al., 2016)—deep nature immersion and observation, tracking animals, studying bird language, thanksgiving or gratitude, etc.—and Plotkin's (2021) nature-oriented developmental tasks for each stage of human development—discovering the enchantment of nature, developing social and individual authenticity, exploring the mysteries of nature and psyche, learning to embody the unique gifts of one's soul, caring for the soul of the more-than-human community. While learning nature connection practices may not appear at first glance to be civic education, my research findings demonstrate that learning to connect with nature engages crucial elements of transformative civic education, contributing to an ecocentric worldview, and manifesting in daily practices of environmental activism and an ecocentric expressive culture.

Understanding the World as Interrelated Complex System

Lange (2012) and Orr (2004) identify a complex-systems view, or systems thinking, as being crucial to learning an ecological consciousness. Such a view allows for the

existence of paradox, requires an acceptance of the unknown, and demands a recognition that the interrelationship to all things means that every individual being is part of a larger whole (Gunderson & Holling, 2002; Walker & Salt, 2006).

EXPERIENCING INTERCONNECTIONS BEYOND HUMAN CONTROL

Educators' narratives collected in my study described how deepening their connection to nature clarified their interconnectedness and interdependence with the world around them. One educator described becoming acquainted with the plants of her garden allotment, as well as the common weeds she encountered every day in the city, and slowly building an awareness of the myriad beings with whom she cohabits and who make up her world. Gradually this awareness extended to an understanding of the ways she is connected with the world around her, and that she, too, belongs to her own place in a web of interconnection.

Educators' experiences also illuminated that such a complex system can never be within humanity's control. As another educator explained, "I don't know how nature works, but it's not under our control…I can't control or even be aware of the impact of my action, I can just think in the context [in which] I have the ability to foresee or imagine the impact. But the wave goes further than I can imagine." For several educators, having a complex-system view of the world expanded beyond recognizing the interrelationship between different parts of a system. This view allowed them to see the value of different agents (Barad, 2007; Lange, 2018; O'Neil, 2018) in the system, even other humans who seemed antagonistic to their or their community's interests. These educators used the concept of human biodiversity to connect humanity back to nature and natural processes, instead of viewing these as separate but interacting entities. As they resituated humanity within nature, they were able to make sense of the more confusing or contradictory elements of both, or at the very least accept that they exist as a necessary part of the system.

Understood as civic education, nature connection helped these individuals to address the "wicked problems" that exist at the scale of societies by giving them a way to understand and accept some conflicts as inherently unresolvable and requiring adaptive responses that acknowledge the legitimacy of competing perspectives and values. One participant put it this way: "I think in a culture it's super important to have a big biodiversity, and a biodiversity that is super challenging as well. In that sense, the human biodiversity—and how that diversity is helping also the community [self-]realizing and making steps—in a way it's a gift."

PERSONAL IMPACTS, ACTIONS, AND RECIPROCITY

Educators' experiences also highlighted the tension between acknowledging that nature, as an interrelated system, is outside of humanity's control and comprehension, while at the same time, individuals have a responsibility for their actions and their

impact on the greater whole. For most participants, these systems could be best appreciated and engaged with on the local level. At the local level, an individual can most immediately recognize the impact of their actions on their surroundings, and he or she has the opportunity to form deep relationships with, and responsibility for, the beings that also live in that place. Forming connections at the local level also facilitates an appreciation for the value of other specific locations and the tangible actions required to care for them. This insight is significant in terms of civic education, suggesting that for a citizen to develop a sense of responsibility for the greater community it can be helpful to first engage deeply with a more immediate community. It is through these locally based connections that one can build relationships of reciprocity with the more-than-human world.

Enacting an Ecocentric Worldview Through Teaching

As educators and mentors, participants identified a number of ways that their deepening relationship with nature led them to incorporate critical self-reflection, an understanding of self-in-relationship to others, and a greater sense of responsibility for shaping a shared social world, elements central to transformative civic education. These appeared in their teaching practices as space-holding, modeling, questioning, and self-awareness, and through the expressive culture they cultivated in their learning environments.

AWARENESS AND ATTENDING

Educators' experiences illustrated that in order to model engaged inquiry and hold space for learners to make sense of personal experience effectively, it is necessary for the educator to have a keen awareness of oneself and the learning environment. They described applying their nature awareness skills—like paying attention to the information provided by their senses or giving gratitude to nature for natural resources—to being aware of their subjectivity in the learning environment and responding to student needs and interests in the moment in order to facilitate effective learning.

FREEDOM AND INVITATIONS

Rather than taking a prescriptive approach to education that emphasizes "knowledge dumping" and advocates for a single correct perspective, participants approached education dialogically, inviting learners to make their own meaning and remaining open to multiple perspectives. Most participants acknowledged a tension between allowing learners the freedom to make meaning for themselves—whatever form that may ultimately take—and meeting a given educational program's philosophical or behavior change goals. However, they still recognized the value of at least attempting to incorporate critical self-reflection and an engagement with divergent perspectives into their roles as educators, and they were committed to finding a way to do so. In fact,

working with these teaching practices proved central to the way they understood their responsibility as community members and roles as activists.

Eco-Conscious Teaching as Civic Action

Important goals for all the participants' educative practices were to affect positive change in the world and to inspire an ecological consciousness among learners. In this sense, they identified as activists. Yet, and perhaps surprisingly, the majority of participants did not see traditional activism, such as protesting, as useful or compatible with what they considered to be their role as an individual community member or an educator.

LIVING ONE'S BELIEFS WHILE INVITING DIVERSE CONCLUSIONS

The concept of activism evoked strong feelings from all participants, but interpretations of the term varied from a general commitment to improve the world to participating in organized activist movements with official doctrines and methods. At first glance, this disparity in responses suggested that participants had widely different views about the value of activism in their work, but through discussion it became clear that they generally agreed that activism was central to their work as educators and was grounded in living out one's own beliefs.

Rather than prescribing right actions or trying to convince her students to see the world as she does, a K–12 educator saw her activist role as providing informative experiences that allow learners to "come to their own conclusions." It is notable that these principles also make for good adult education by recognizing that each learner needs to build new learning and meaning making based on their own previous experiences and that these will vary. She accepted that these conclusions may be quite different from those she might expect, but she believed that they would be more meaningful to learners because they would be based on their own reasoning processes.

SMALL SCALE AND LOCAL THROUGH NATURE CONNECTION

Participants seemed to agree that the most effective way of promoting ecological consciousness through their teaching practice was to provide learners with opportunities to connect with themselves and the natural world around them, and to then allow them the space to make meaning about these experiences for themselves. Consequently, the form of activism participants most identified with took place on a small scale, especially locally.

Role of Supportive Community Networks

Transformative learning models acknowledge the role of the social in the transformative learning process. For Mezirow (1991; Mezirow & Associates, 2000), reflective

discourse is key to the critical assessment of assumptions necessary for perspective change. Taylor (2009) suggests that in order for dialogue to be a medium for critical reflection, it must be relational and grounded in trust, not simply rational or analytical. Lange (2012, 2015, 2018) goes further to articulate the importance of the social in transformative learning, arguing that "individuals often do not know their potential until a specific community brings it forth ... This transformation is highly participative, spontaneously emerging in connection with others" (Lange, 2012, p. 205).

INTERGENERATIONAL MENTORSHIP

A significant social component of learning nature connection was mentorship, particularly intergenerational mentorship by family members, which featured in many participants' accounts. These experiences often included expressive culture and traditions, such as keeping a Shinto shrine or taking an annual camping trip, that helped to elevate those experiences to something more meaningful.

One way that nature connection educational programs have tried to incorporate the benefits of familial mentorship into their pedagogy is by creating intergenerational community based in nature connection. These temporary "villages" provide an immersive experiential learning environment grounded in a culture of socio-ecological sustainability, complete with its own aesthetic traditions. Participants take part in experiential workshops in nature-based mentoring and community design, species identification, tracking, wilderness skills, wild harvesting and handicraft, storytelling, and ritual, with activities designed to include infants to elders (Vermont Wilderness School, 2020).

A COMMUNITY OF LIKE-MINDED SOULS

Connecting with other people was an important theme that emerged from participants' stories of developing nature connection. Many admitted that they had not always appreciated the relationship between people connection and nature connection, however, being surrounded by others who share similar values and beliefs within a shared eco-conscious culture can be a catalyst in developing one's own ecocentric perspective.

In her description of the permaculture community she belongs to, one educator mentioned the importance of working together with other people and seeing humans and nature all working beautifully together. The community also provided opportunities for mentoring. Her mentorship of children on the farm played a significant role in this process of fully appreciating human/nature connections, allowing her to access her capacity for awe and curiosity, encouraging her to view things from the different perspectives of her young students, and challenging her to articulate her own knowledge and values when confronted with their questions. Mentorship between generations within a single community provides opportunities for reflective discourse and perspective change, two key elements of transformative learning.

IMPLICATIONS AND CONCLUSION

For the educators that I interviewed, deepening their connections to nature was fundamental to their transformative civic learning for eco-consciousness and civic action. There were several transformative elements of learning nature connection (Johnson, 2021), including the two being emphasized here: critical self-reflection and critical discourse. These transformative elements facilitated transformative civic learning, in particular the development of an ecocentric perspective, an understanding of the self-in-relationship to others, and a sense of responsibility to care for the natural and social world they inhabit, as described by Hoggan-Kloubert et al. (2022).

Like transformative civic learning, transformative learning toward eco-consciousness requires self-reflection and communicative discourse; consequently, eco-consciousness encourages civic reflection. In addition, connecting to nature is crucial for developing eco-consciousness. In the following section, I will describe ways of developing nature connection that facilitate self-reflection, civic reflection, and communicative discourse, enhancing one's ability to see the interconnections underpinning a systems view of the world while attending to reciprocity.

Beginning with Embodied Nature Connection Experiences

For many people who are new to nature connection and outdoor experiences, as well as the many people who have become disconnected from the more-than-human world, forest bathing is providing an entry or re-entry point. It can be instructive to participate in a guided forest bathing or forest therapy walk, where a human guide invites participants into sensory awareness and the forest-as-therapist provides healing (Clifford, 2021). Individuals can also develop a personal practice of forest bathing or create a routine of something as simple as a sit spot at home (Young et al., 2016), regularly taking several minutes to several hours to sit in quiet observation of the natural world, using all five senses to become fully aware. Nature connection can be strengthened just by spending time in a natural landscape, be it special or mundane, to notice taken-for-granted details.

Connecting with the Land in Reciprocity

As people become aware of the personal benefits of spending time outdoors it is easy to practice extraction—taking the health benefits of being in nature without demonstrating gratitude for nature and giving back. A different approach is that of reciprocity: learning through experiences that build in gratitude, attend to natural cycles, and practice a continuous give-and-take with the land. Examples of reciprocal practices my research participants engaged in were gardening, farming, permaculture, foraging sustainably, herbalism, and low-impact living. These embodied practices are often embedded within an expressive culture of reciprocity. Whether we develop a habit of leaving a third of the berries untouched for migrating birds when berry picking, offering a drink of water to a young sapling when on a hike, or gifting a small handmade thank you to informal nature mentors, the practice of reciprocity can become a routine reminder of our interconnectedness and interdependence.

Connecting with Your Community

Just as we are interdependent with our natural environment, we are interdependent with our social environment and that needs stewardship as well. True nature connection includes people connection, purposefully maintaining connection and building relationships with people met through your nature connection learning experiences, as well as building relationship with neighbors. Through these social relationships we can find or build shared values around nature connection and an ecocentric expressive culture. Wilderness guide/depth psychologist Bill Plotkin (2021) reminds us that healthy community and culture are created in specific places after nature connection to that place has been established by individuals. For change to occur on a societal level, it is necessary for change to first occur on the local level where individuals live in connection and reciprocity with each other and the same local ecology. However, change at the community scale can be slow. Individual change can take years, with community change taking decades or longer.

Connecting Learners to Nature as Action in Your Community

Just as Orr (2004) recommends, connecting to nature in the classroom can be as simple as adding place-based lessons and making local connections to content. Doing so can help community civic educators foster transformative civic education toward eco-consciousness and civic action.

As mentioned above, participants described how they brought their growing nature connectedness to their work as educators and mentors as a form of eco-conscious civic action. As a loose educational philosophy, they were dedicated to preventing indoctrination and committed to allowing students to make their own meaning. To this end, they practiced an invitational pedagogy grounded in space-holding, open questioning, playfulness and exploration, an acceptance of uncertainty, and inviting students' past experiences as they related to present learning. These practices are consistent with methods transformative learning theorists have found effective in facilitating critical reflection, critical discourse, and perspective change (O'Sullivan, 2012). In their embodied teaching practices, participants were intentional about teaching with the awareness of a tracker: attending closely to the learning environment, alert to student needs in the moment and aware through self-reflection of their own reactions and impact on the environment. This pedagogical approach, similar to what is found in various nature connection mentoring programs (Clifford, 2021; Young et al., 2016), created learning environments that explicitly and implicitly recognize interconnectedness and reciprocity as a framework for life experience (Capra & Luisi, 2014; Lange, 2018).

Conclusion

Achieving socio-ecological sustainability requires civic education. To fully embrace its potential to be transformative, civic education will need to expand its understanding of civil society to recognize humans' interconnectedness with and dependence on

nature, call learners to become critically aware of the structures that diminish or erase these connections, and teach citizens how to live in reciprocity with nature. My hope is that the above guidance, developed from the insights of eco-conscious educators, assists others in building civically minded community and beginning a personal path of lifelong learning in reciprocity with the more-than-human world.

REFERENCES

Abram, D. (1996). *The spell of the sensuous*. Pantheon.
Abram, D. (2010). *Becoming animal*. Pantheon.
Barad, K. (2007). *Meeting the universe halfway: Quantum physics and the entanglement of matter and meaning*. Duke University Press.
Capra, F. & Luisi, P. L. (2014). *The systems view of life: A unifying vision*. Cambridge University Press.
Carcasson, M. & Sprain, L. (2012). Deliberative Democracy and Adult Civic Education. *New Directions for Adult and Continuing Education*, 2012(135), 15–23.
Clifford, M. A. (2021). *Your guide to forest bathing (expanded edition): Experience the healing power of nature*. Red Wheel Books.
Clover, D. E. (1995). Theoretical Foundations and Practice of Critical Environmental Adult Education in Canada. *Convergence*, 28(4), 44–54. http://search.proquest.com/eric/docview/62665462/abstract/A631C3E1F48E4A89PQ/30
Clover, D. E. (2003). Environmental adult education: Critique and creativity in a globalizing world. In L. H. Hill and D. E. Clover (Eds.). *New directions for adult and continuing education*, 99. *Special issue: Environmental adult education: Ecological learning, theory, and practice for socioenvironmental change* (pp. 5–15). Wiley.
Cranton, P. & Taylor, E. W. (2012). Transformative learning theory: Seeking a more unified theory. In E. W. Taylor, P. Cranton and Associates (Eds.). *The handbook of transformative learning: Theory, research, and practice* (pp. 3–20). Jossey-Bass.
Gunderson, L. H. & Holling, C. S. (Eds.). (2002). *Panarchy: Understanding transformations in human and natural systems*. Island Press.
Hoggan-Kloubert, T., Hoggan, C., Beck, E., Surak, S. & Levine, P. (2022) Developing Democratic Citizens: (Transformational) Civic Education in Times of Uncertainty. 14th Biennial International Transformative Learning Conference, April 6–9, 2022, Virtual-Online.
Johnson, M. (2021). *Growing roots: Rewilding, transformative learning, and ecological consciousness in nature connection* [Unpublished doctoral dissertation]. Penn State University.
Lange, E. A. (2012). Transforming transformative learning through sustainability and the new science. In E. W. Taylor, P. Cranton, and Associates (Eds.). *The handbook of transformative learning: Theory, research, and practice* (pp. 195–211). Jossey-Bass.
Lange, E. A. (2015). Transformative Learning and Concepts of the Self: Insights from Immigrant and Intercultural Journeys. *International Journal of Lifelong Education*, 34(6), 623–642.
Lange, E. A. (2018). Transforming Transformative Education Through Ontologies of Relationality. *Journal of Transformative Education*, 16(4), 280–301.
Mezirow, J. (1978). *Education for perspective transformation: Women's re-entry programs in community colleges*. Teacher's College, Columbia University.
Mezirow, J. (1985). A critical theory of self-directed learning. *New Directions for Continuing Education*, 25, 17–30.
Mezirow, J. (1991). *Transformative dimensions of adult learning*. Jossey-Bass.
Mezirow, J. & Associates. (Eds.). (2000). *Learning as transformation: Critical perspectives on a theory in progress*. Jossey-Bass.
Millennium Ecosystem Assessment (Program). (2005). *Ecosystems and human well-being*. Island Press.

O'Neil, J. K. (2018). Transformative Sustainability Learning within a Material-Discursive Ontology. *Journal of Transformative Education*, *16*(4), 365–387. https://doi.org/10.1177/1541344618792823
Orr, D. W. (2004). *Earth in mind: On education, environment, and the human prospect* (2nd ed.). Island Press.
O'Sullivan, E. (2012). Deep transformation: Forging a planetary worldview. In E. W. Taylor, P. Cranton, and Associates (Eds.). *The handbook of transformative learning: Theory, research, and practice* (pp. 162–177). Jossey-Bass.
O'Sullivan, E., Morrell, A. & O'Connor, M. A. (Eds.). (2002). *Expanding the boundaries of transformative learning: Essays on theory and praxis*. Palgrave Macmillan.
Plotkin, B. (2021). *The journey of soul initiation*. New World Library.
Radchuk, V., Reed, T., Teplitsky, C., van de Pol, M., Charmantier, A., Hassall, C., Adamík, P., Adriaensen, F., Ahola, M. P., Arcese, P., Miguel Avilés, J., Balbontin, J., Berg, K. S., Borras, A., Burthe, S., Clobert, J., Dehnhard, N., de Lope, F., Dhondt, A. A. ... & Kramer-Schadt, S. (2019). Adaptive Responses of Animals to Climate Change Are Most Likely Insufficient. *Nature Communications*, *10*(1), 1–14. https://doi.org/10.1038/s41467-019-10924-4
Redvers, N., Poelina, A., Schultz, C., Kobei, D., Githaiga, C., Perdrisat, M., Prince, D. & Blondin, B. (2020). Indigenous Natural and First Law in Planetary Health. *Challenges*, *11*(29). https://doi.org/10.3390/challe11020029
Rittel, H. W. J. & Webber, M. M. (1973). Dilemmas in a General Theory of Planning. *Policy Sciences*, *4*(2), 155–169.
Roe, D. (2019). Biodiversity loss—More than an environmental emergency. *The Lancet Planetary Health*, *3*(7), e287–e289. https://doi.org/10.1016/S2542-5196(19)30113-5
Sears, A. & Hughes, A. (2006). Citizenship: Education or Indoctrination? *Citizenship and Teacher Education*, *2*(1), 3–17.
Taylor, E. W. (2009). Fostering transformative learning. In J. Mezirow, E. W. Taylor and Associates (Eds.). *Transformative learning in practice: Insights from community, workplace, and higher education* (pp. 3–17). Jossey-Bass.
Thiel, M., Luna-Jorquera, G., Álvarez-Varas, R., Gallardo, C., Hinojosa, I. A., Luna, N., Miranda-Urbina, D., Morales, N., Ory, N., Pacheco, A. S., Portflitt-Toro, M. & Zavalaga, C. (2018). Impacts of Marine Plastic Pollution from Continental Coasts to Subtropical Gyres—Fish, Seabirds, and Other Vertebrates in the SE Pacific. *Frontiers in Marine Science*, *5*, 238. https://doi.org/10.3389/fmars.2018.00238
Tisdell, E. J., Whalen, G. C. & Johnson, M. (2022). The Super-Vision of Autoethnographic Dissertation Studies: Transformative Stories of the Supervisor and the Supervised Revealed. *Adult Learning*, *33*(2), 51–60.
Torney-Purta, J., Lehmann, R., Oswald, H. & Schulz, W. (2001). *Citizenship and education in twenty-eight countries*. International Association for the Evaluation of Educational Achievement.
Vermont Wilderness School. (2020). *Art of mentoring*. Retrieved May 9, 2020 from https://vermontwildernessschool.org/workshops/art-of-mentoring/
Walker, B. & Salt, D. (2006). *Resilience thinking: Sustaining ecosystems and people in a changing world*. Island Press.
Young, J., Haas, E. & McGown, E. (2016). *Coyote's guide to connecting with nature*. OWLink Media.

CHAPTER 4

Reproductive Justice as Feminist Art Education

Karen T. Keifer-Boyd

> **INSTRUCTIONAL QUESTIONS**
>
> 1. When you first learned that the Supreme Court overruled Roe v. Wade, what was your reaction?
> 2. Why are reproductive rights important?
> 3. What is the difference between reproductive rights and reproductive justice?
> 4. Who has options of when to become pregnant? Who, when, and how should people learn about rights to choose if, and when, to become pregnant?
> 5. After learning about the art discussed in this chapter, how does the art embody processes and freedom of choice with regard to reproductive justice? How do the artworks inform, inspire, or impact your sense of civic responsibility and human rights?

INTRODUCTION TO REPRODUCTIVE JUSTICE AS ART EDUCATION

Women's right to choose pregnancy and to birth a baby are "reproduction rights." Reproductive justice is access to options for reproductive health care. No person should be forced into sterilization, pregnancy, or to give birth. "Abortion is health care. Abortion is freedom. Abortion is about taking care of ourselves, our families, and our communities. ... Those harmed most are Black, Latinx, and Indigenous people and people working to make ends meet" (The National Women Law Center, October 24, 2021). The United States has the highest rate of women dying during or within 42 days of childbirth in the industrialized world (Howard, 2020; Hoyert, 2021). These deaths are preventable (Suliman, 2021). Youth, adults, privileged, marginalized—everyone needs to be involved in supporting reproductive justice, a hallmark of democracy. Through art pedagogical strategies to engage with art about reproductive justice

DOI: 10.4324/9781003402015-7

discussed in the chapter, participants in art engagement learn civic education toward social justice. Feminist collectives and coalitions (i.e., SisterSong Women of Color Reproductive Health Collective and the Feminist Art Coalition [FAC]), along with work by individual artists and their initiatives—serve as resources for reproductive justice art curriculum.

All education is political (Specia & Osman, 2019). Educators, institutions, societies, and communities decide what is important to study and from which perspectives to teach healthcare, histories, sciences, humanities, and the arts, among other fields of study. Important to democracy is to be able to make informed decisions about birth planning, and to have the social, educational, political, and health affordable access support to do so (Howard, 2020; Hoyert, 2021; Suliman, 2021). Yet, in the United States "over the past decade, state legislatures have passed more than 500 restrictions on abortion access—90 restrictions in 2021 alone" (The National Women Law Center, 2021). This chapter is about feminist activism, coalition building, and education through art about reproductive rights justice.

As a feminist scholar activist in the field of art education, who embodies commitment to addressing critical issues, which can be perceived as controversial, my strategies are to raise questions and facilitate dialogue, embodied action, and reflection in response to engaging with art and creating art. My feminist activist work spans many decades and is based in a deep belief that visual art is integral to forming subjectivity, community, agency, and enacting social change. Feminist activism in my art education practice involves pedagogy, curriculum, challenging knowledge sources, and providing a platform for knowledge creation. I equate feminist pedagogy as feminist activism because the facilitation intends to raise learner's critical consciousness by challenging heteropatriarchy (e.g., Keifer-Boyd, 2021a,b, 2023a). For example, since 2015, I have developed and made accessible as a website,[1] curricular encounters with Linda Stein's art to foster learning about significant issues today such as displacement, bullying, gaslighting, and sexism. Annually, since 2014, I have coordinated the Art+Feminism wikistorming[2] event at Penn State, joined by many others who believe in the work, to change the knowledge narratives that misrepresent or exclude the transformative work of feminist activist art and art education. As co-founders and co-editors, Deborah Smith-Shank and I conceptualized *Visual Culture & Gender*[3] *(VCG)* in 2005 as an online, international, freely accessible, and critical annual publication that focuses on the intersections of visual culture and gender. For 18 years, as of 2023, a new volume of VCG has been published on September 15, as feminist activism.

The chapter presents examples of civic engagement through art concerning reproductive rights justice. Particular attention is on collective actions and coalition-building projects such as those supported by the FAC's processes to engage, reflect, and act, among other initiatives. Learning about processes and examples of feminist coalitions to educate through art about reproductive justice is to learn how to participate in democracy. This chapter offers participatory art approaches and curricular resources for teaching civic engagement through encounters with art. Strategies include artistic data visualization, collaborative art, performance, remix videos, interventions, and peaceful resistance to injustice toward reproductive justice that could be taught in secondary public schools and higher education and are relevant to community-based

art educators. The purpose of teaching these strategies as art education within formal school environments and informal learning spaces is to empower participatory engagement in issues that impact the well-being of all in the present and future.

ART ABOUT REPRODUCTIVE JUSTICE

College campuses known for preparing "students to address the world's most challenging problems" have been the target of anti-reproductive health rights groups in setting up fake medical centers[4] near campuses (Middlebury College, para. 2). #ExposeFakeClinics is a US initiative of more than 60 partner organizations to expose "manipulative, fake reproductive health centers" (Expose Fake Clinics, 2023, para. 1). The Expose Fake Clinics website is a resource hub that maintains an interactive data visualization of locations of fake clinics and informs about the coordinated attacks by opponents to reproductive healthcare using manipulative, deceptive, and sinister tactics ranging from intercepting online searches for abortion clinics to posing as pregnancy centers that collects and shares personal data of pregnancy (uncontrolled by Health Insurance Portability and Accountability Act [HIPAA] regulations, which only apply to medical providers, and referred to as geofencing, a digital scare-tactics attack on privacy) and fraudulent contracts sent to health care providers in an attempt to stop them from providing abortion health care. The website also offers strategies on how to be visually engaging in protest actions to attract media cover that will expose fake clinics.

Middlebury is a college campus in Vermont with a fake clinic near campus, which has been permitted to have a table at the Student Involvement Fair on campus for several years.

Middlebury's Public Feminism Fellows (Kamari Williams, Isabel Perez, Alexis Welch, Elissa Asch, Luci Bryson, Emily Ribeiro, and Meg Farley) created an art exhibition titled "Visualizing Reproductive Justice: A Call to End Fake Clinics" that was shown on campus in September 2022. The Public Feminism Fellowship was formed as an "effort to translate feminist pedagogy beyond the classroom" (Pintair, 2022, para. 2). Elissa Asch, an undergraduate student active with Middlebury's Public Feminism Fellows, also founded the New England Small College Athletic Conference (NESCAC) coalition to ban crisis pregnancy centers (CPCs), which is an initiative to get the NESCACs to ban CPC advertising and involvement on the 11 NESCAC affiliated private colleges and universities located throughout New England and New York campuses.[5]

What is at stake with the unchecked proliferation of fake medical clinics is agency to make informed decisions about reproductive healthcare, pregnancy, and families. Reproductive justice as feminist art education provides strategies, resources, and examples to engage with art that exposes fake health centers.

A Long Tally Ho(p)e: From Pre-Roe 1972 to Post-Roe 2022

The Janes, a 2022 documentary film by Tia Lessin and Emma Pildes, is about a pre-Roe v. Wade era underground service for women seeking safe and affordable abortions. Supported by Gender Equity Centers and Women's, Gender, & Sexuality Studies

university programs, *The Janes* film has been shown on campuses in conjunction with panels. The one I attended included two of the Janes as well as community organizers and a lawyer for reproductive justice. Learning this history is important to organizing for reproductive justice. ReproAction (2022) provides a post-overturning of Roe v. Wade resource video to understand and advocate for self-managed abortions without putting oneself at legal risk, important information given the 20+ arrests of women in 2022 who have ended their pregnancy. Teachers and/or students can show the 2:35 minute trailer[6] of *The Janes* along with the *ReproAction* (2:34 minute video) to foster dialogue about reproductive justice, correct misinformation about abortions, and inspire artistic data visualizations of factual information as well as produce remix projects to challenge anti-choice propaganda.

The Abortion Access Front (2022) defines themselves as a "coven of hilarious badass feminists who use humor and pop culture to expose the haters fighting against reproductive rights," (para. 1). The Abortion Access Front supports abortion clinics, organize legislation reproductive justice advocacy, and produce numerous livestreamed events, daily social media updates, and videos such as "Let's Talk About Abortion and Reproductive Justice," a 31-minute reproductive justice 101 crash course, "The 2022 State of the Uterus Address" (4:40 minutes), "I'm Just a Little Pill" (4:16 minutes), "Shame of Thrones" (1:40 minutes), and "Darbi's Dream Clinic" (2:31 minutes). Showing these videos in a class could be a catalyst for art projects such as to create a remix with a reproductive justice theme using popular culture sources.[7]

Throughout the United States, artists are finding ways to draw attention to reproductive justice. Laura Feierman's (2022) room installation titled *Vulnerability, Humility, Insecurity, Tenacity*, which is part of the Wo/Manhouse 2022[8] project, is an immersive experience visited by hundreds of people during its four months exhibition (June 19 to October 9, 2022). The experience includes a soundtrack of news of the 2022 Supreme Court overturning Roe v. Wade and its devastating impact while viewing "At Home D.I.Y." instructions on paper coverings of 12 coat-hangers making a grid pattern on one of the walls of the room. In front on a bench is a purple mannequin, one of four in the room handmade by Feierman based on her proportions and poses. The mannequin sits on a bench with hangers bent as guided by the instructions. The mannequin's head is bent down between arms in which elbows rest on knees pulled close to the chest. A red-hardened acrylic drip spills from the womb to form a large pool of intense red on the plush pink carpeted floor (see Figure 4.1).

Wo/Manhouse 2022 marks the 50th anniversary of Womanhouse 1972, which was one-year pre-Roe v. Wade, and women used coat hangers and other dangerous ways to self-abort a fetus. Sadly, 50 years later the federal protection granted on January 22, 1973, for safe and legal abortions, ended on June 24, 2022, five days after Wo/Manhouse 2022 opened. The week prior to the opening of Wo/Manhouse 2022, I interviewed the artist, Laura Feierman, as we sat on the floor among the mannequins. With Maggie-Rose Condit-Summerson, we created an online teaching resource, with a 4:05 minute edited audio of the artist speaking about the work, images of the installation, and a discussion prompt: "Why is reproductive justice important?" Throughout the Fall 2022 semester in teaching undergrads and grads in art education and women's, gender, and sexuality courses, students listened to the audio and viewed

60 THEORY

FIGURE 4.1 Laura Feierman's room installation *Vulnerability, Humility, Insecurity, Tenacity* is part of the collaborative project, Wo/Manhouse 2022.

Photo by Karen Keifer-Boyd with permission by the artist to photograph.

the images prior to class discussion. Young women shared their stories of when they heard the news of the Supreme Court overturning Roe. One expressed her fear of what will be next with this attack on women, frightened that women's right to vote will be taken away as well.[9]

While at the opening of Wo/Manhouse 2022, I met Santa Fe artist Olivia Jane,[10] who gifted me and feminist artist Judy Chicago with her "Womb Moon" embroidery patches (see Figures 4.2a and 4.2b) that can be sewn to a backpack or jacket making visible, in an honoring symbolic way, the cyclical movement of monthly moments of fertility, which are reproductive rights of one's own body, not a decision another should make.

Yet, some states had "trigger" laws that quickly removed reproductive rights with the overturning of Roe v Wade. For example, Arizona's 1864 law, reworked as an abortion ban in 1901, was revived as Arizona law in 2022 forcing all abortion clinics

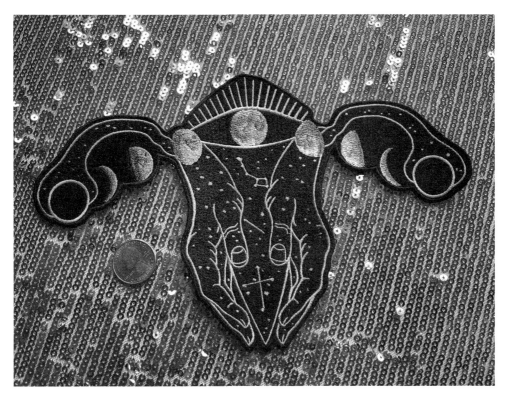

FIGURE 4.2a Olivia Jane's (2022) *Moon Womb* can be worn as public pedagogy for reproductive justice.

in the state to stop providing reproductive healthcare (American Civil Liberties Union [ACLU], 2022). The Center for Reproductive Rights (2022) maintains a dynamic map, *After Roe Fell: Abortion Laws by State*, which defines and tracks abortion access organized by five categories: expanded access, protected, not protected, hostile, and illegal. This is a useful tool to consult in developing artistic data visualizations toward reproductive justice.[11]

Comedian and American Civil Liberties Union (ACLU) Women's Rights Ambassador, Sasheer Zamata, (2021) teaches about the need for reproductive justice and the dire state of abortion access in the United States with comedic passion through a 5:51 minute video "Baking While Talking About Forced Pregnancy." Partner showing Zamata's (2021) video with Martha Rosler's (2012) "Semiotics of the Kitchen 1975," a 6:21 minute video (within an 11:25 minute video in which she introduces her desire to create art that could be widely seen and circulated) to propose student-created performances and videos of domestic task parodies for reproductive justice advocacy.

Linda Stein's (2019) collage (see Figure 4.3) juxtaposes reproductive rights protests in 1989 with protest chants and signs in 2019. While the Supreme Court passing of Roe v. Wade in 1973 legalized abortion as reproductive rights, access to safe abortions was difficult for those without financial means, racially discriminated against by healthcare professionals, and/or unable to endure the stigmatizing attacks of Christian

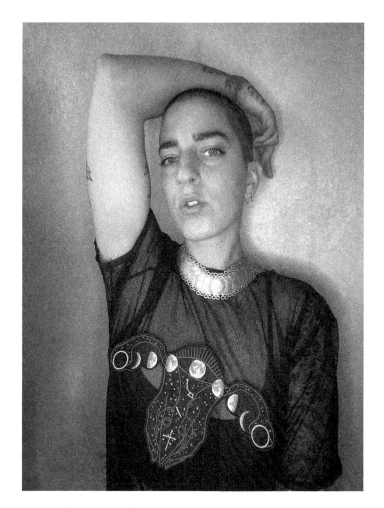

FIGURE 4.2b Artist Olivia Jane (2022) wears her embroidery design, *Moon Womb*. *Photographs courtesy of the artist @oliviajaneart and www.oliviajaneart.com.*

Nationalists, a dangerously violent movement of division based on extremist concepts of pure and impure (Stewart, 2020). Erin Grant (2022) journalist for *Ms. More Than a Magazine, a Movement* reports,

> Over the last decade, abortion clinics have been closing at an alarming rate. ... Not only do these independent clinics have less access to funding and resources, but ideologically-driven, medically unnecessary abortion restrictions make it increasingly hard for many clinics to keep their doors open and provide care. On top of that, independent providers are the most vulnerable to anti-abortion attacks and violence directed at their staff. (para. 2)

Thus, reproductive justice had not been achieved. A close study and discussion of Stein's collage, along with the *After Roe Fell: Abortion Laws by State* interactive map

FIGURE 4.3 *Pro-choice Activism: Today and in 1989 with Merle Hoffman 968* is a 23″ × 29.5″ × .5″ collage by feminist art activist Linda Stein created in 2019.

Photo courtesy of the artist.

produced by the Center for Reproductive Rights (2022), could launch a collaborative assemblage as a digital artwork or public mural that juxtaposes historical images of pre-Roe protests and strategies of underground heroes such as *The Janes* with post-Roe protests and contemporary strategies to overcome state abortion bans and achieve reproductive justice.

The reproductive justice art highlighted above shares intentions toward accessible reproductive healthcare. The criteria I set in my search for art about reproductive justice may help art educators to select art for issue-based encounters with art. Foremost, the art centers reproductive justice as its intent. Second, the art can instigate dialogue and serve as a catalyst to learn about reproductive justice.

COALITIONS AND COLLECTIVES' ART EXHIBITIONS TOWARD REPRODUCTIVE JUSTICE

"Abortion isn't a dirty word. Refusing or avoiding the word 'abortion' is not only deeply stigmatizing but othering to people who have had abortions" (Liberal Jane, 2022).

Abortion is Normal, an exhibition[12] of works by 50 artists about their abortion experience, opened in January 2020. Stigmatization, the hush-hush never to speak aloud about abortion, is challenged from stories shared (Bonow, 2022; Ruiz, 2022). Marisa Crawford (2020), *Hyperallergic* writer, describes the exhibition and works within the exhibition as follows:

> Each piece in the exhibition contributes to a rich, shame-free counter-narrative to the repressive views on reproductive rights perpetuated by Republicans in power. In Cindy Sherman's "Untitled" (2019), a pregnant woman stares the viewer dead in the eye as she clutches her stomach, a visceral reminder of how personal the experience of pregnancy is. Grandly towering over the room, Dominique Duroseau's "Mammy was here: she equally acceptable" (2019) calls attention to racial inequities in reproduction and childcare, rooted in the history of enslavement. Composed of miniature perfume bottles filled with decanted period blood that the artist collected from menstruating people of all genders, Christen Clifford's installation "I Want Your Blood" (2013–2019) juxtaposes the trappings of traditional feminine desirability with the often hidden (and shamed) bodily experience of menstruation. The blood used in Clifford's work, as well as in Portia Munson's "Menstrual Prints" (1993) series also highlights the arbitrary framing of abortion as an ending of life, since each menstrual period involves the shedding of uterine lining, which contains an egg that could have been fertilized and led to pregnancy.
>
> (Crawford, 2020, para. 3)

Further, Crawford (2020) summarizes that several artists focus on their "queer, trans, and gender nonconforming experiences of reproductive health" (para. 5).[13] The National Women's Law Center (2022), in a blog series on abortion advocacy, discusses missteps and provides guidance on destigmatizing abortion with recommendations to not reference "coat hangers, back alley abortions, The Handmaid's Tale, Sharia Law, and slavery" and instead speak to the common healthcare necessity, as conveyed in the slogan "Let's Talk About the Elephant in the Womb," given one in four women will experience an abortion in their lifetime.

Red RADs

Red RADs (RAD = Rebels against Disparity), an initiative by Ina Kaur, is a commitment to "stand against prejudice based on caste, class, race, and gender" (Kaur, 2022, para. 1). Wearing my Red Rad ceramic pin, gifted to me by Ina, initiates conversations about what freedom for all means. Her art, *Mr's.' Nirbhaya*, shown in the group exhibitions, *Artists Respond: Post-Roe Louisiana*, in June 2022, and *ROE.2* at the Woman Made Gallery in Chicago, Illinois, from January to March, 2023, references the bravery of a 22-year-old physiotherapy intern in Delhi, India, traveling on a private bus with a male friend and six other men including the driver, who all raped and murdered her, and brutally beat her male companion. *Nirbhaya* means "fearless," which became the rally chant by thousands of people

REPRODUCTIVE JUSTICE AS FEMINIST ART EDUCATION 65

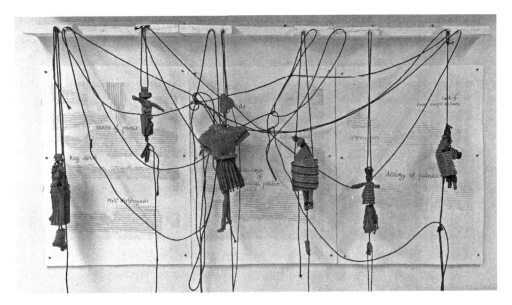

FIGURE 4.4 *Mr's.' Nirbhaya*, comprised monotype prints as backdrop for tangled red threads in which six rag doll-like ceramic figures dangle is the 36" × 68" × 6" sculptural work by Ian Kaur created in 2022.
Photo courtesy of the artist.

in India and internationally, who sought to honor the courage to call for sexual and reproductive justice. This courage is Red Rad too, a self-love to withstand the trauma of rape and to remove (i.e., abort) physical traces of the rapists' violations. The Nirbhaya protests mattered, as new laws were passed in India known as the Nirbhaya Act and courts set up to expedite the hearing of rape cases (Legal Information Institute, 2013).

In Kaur's art, *Mr's.' Nirbhaya*, there are six red figures that appear like cloth rag dolls but are ceramic forms dangling from tangled red threads in front of monoprints of text fragments with large text phrases such as "abuse of power," "miscarriage of social justice," and "ideology of patriarchy" (see Figure 4.4). Ina Kaur (2022) describes her use of rag doll symbolism in *Mr's.' Nirbhaya* as follows:

> In a world where countless nameless fearless women have no sexual and reproductive rights, they are constrained to live in terror and manhandled, similar to being treated like rag dolls. Rag Dolls, one of the oldest toys in existence, are used as comfort objects; similarly, women's role in society is that of a nurture, yet they have no agency over their bodies and are mistreated and abuse. (para. 3)

Discussion by students in my undergraduate art education course with the artist brought out a sense of collective responsibility to take action toward reproductive justice. Some noted how the dangled rag dolls referenced public race-based lynching and hanging of alleged witches suggesting the entanglement of race, caste, religion, and gender in seeking reproductive justice.

SisterSong Women of Color Reproductive Health Collective

While the legality of abortion is necessary, reproductive justice is about access as "there is no choice where there is no access" (SisterSong, n.d., para. 5). Access is a complex matter, as it is more than access to safe abortions but rather a full range of reproductive healthcare support systems such as education, adequate wages to support a family, living free from toxins in food and surroundings, free from sexual violence, free from maternal mortality and morbidity, and access to contraceptives, prenatal and pregnancy care, nearby services, transportation, childcare, and much more. The term *Reproductive Justice*, coined in 1994 by a group of Black women who met in Chicago, is based in the United Nations' Declaration of Human Rights, which holds governments responsible for protection of human rights.

SisterSong Women of Color Reproductive Health Collective, established in 1997 by 16 organizations of women of color, is a direct outcome of the Chicago group that launched the Reproductive Justice Movement in the United States. SisterSong (n.d.) identifies four critical components to achieving reproductive justice: analyze power systems, address intersecting oppressions, center the most marginalized, and join together across issues and identities. The efforts of the SisterSong Collective have been impactful such as educating on what involuntary sterilization is, where and how involuntary sterilization can happen to those incarcerated and at detention centers in the United States, and shutting down such detention centers (Registe et al., n.d.).

Feminist Art Coalition

Apsara DiQuinzio conceptualized the FAC in 2017 as a collective of institutions in the United States that would highlight feminist practices in the arts. The Feminist Art Coalition (FAC) (2021) brings together a "constellation of differences and multiplicity among feminisms" in the form of exhibitions, videos, artists, symposia, and institutions based in the premise that art can be "a catalyst for discourse and civic engagement" (para. 1–2). For example, Holly Ballard Martz's (2020) large-scale installation "Danger of Nostalgia in Wallpaper Form (in Utero)" is made of many coat-hangers, each formed into the shape of a uterus and combined to appear like ornate wallpaper. During the two-year exhibition, Martz invited people to take selfies with the wallpaper backdrop and post their image to social media. To do so, people paid a 5-dollar donation to Planned Parenthood (2021), a US national organization that provides accessible and affordable reproductive health care. The social media posts generated people sharing stories of their experiences of abortion, a taboo topic that is important to learn about beyond patriarchal fueled and funded hostile attacks that perpetuate abortion as a source of shame.

WOMB POWER (TO CHOOSE) INFORMED ACTION: REVOKING (MIS)CARRIED ABORTION BANS

It will require coalition-building and collectives to counteract attacks on reproductive rights and achieve reproductive justice. This chapter is a call to action for creative educators to recognize the urgency to protect reproductive rights, and the power of

art as education to do so. In the words of the first US National Youth Poet Laureate, Amanda Gorman (2019),

> When the penalty for rape is less than the penalty for abortion after the rape, you know this isn't about caring for women and girls. It's about controlling them.
> If the sexes and all people are to be equal, abortion has to be actually accessible and not just technically legal.
> Despite what you might hear, this right here isn't only about women and girls. This fight is about fundamental civil rights. (para. 1, 6, 7)

While some educators might feel reticent about including art about reproductive justice as curricular content, high school and university students will bring such issues to their art projects. Actipedia, "an open-access, user-generated database of creative activism," offers options to create a gallery of projects and tactics to learn from others in launching your own critically conscious art or to plan a project with a group or class (The Center for Artistic Activism, n.d., para. 1).

Moreover, given the reproductive health crisis escalated with the overturning of Roe v. Wade, there is urgent need to know how to safeguard personal reproductive health information, which is at risk with cyber-surveillance of period-tracking apps used by millions of people, most of the apps unregulated by the HIPAA, given the criminalization of abortion and "bounty hunter" laws in some states. The US Department of Health and Human Services (HHS) issued new guidance soon after the overturning of Roe, on June 29, 2022, to help protect reproductive rights for those who use period-tracking apps (Weiss-Wolf, 2022).[14] Further, states with the highest infant mortality rate have the most egregious abortion bans as documented in numerous sources and an interactive dynamic data visualization (Treisman, 2022).

It is the teacher's civic education responsibility to guide with knowledge of artists, exhibitions, coalitions, and collectives addressing the many issues of achieving reproductive justice such as brought out in the work presented in this chapter from exposing fake clinics to the necessity of reproductive rights and options for reproductive healthcare to include access to safe abortions that addresses economic, privacy, and choice precariousness. Moreover, art educators should promote civic engagement through creation and experiencing art that viscerally and factually informs about the injustice of abortion bans, those disproportionally impacted, and how to build coalitions to revoke (mis)carried abortion bans. Figure 4.5 brings together, in the form of a chart, the art, coalitions, and collections discussed in this chapter to provide a quick reference and resource for art educators to foster civic engagement with reproductive justice in their courses.

The participatory art about reproductive justice presented in this chapter engages with communities through data collected and presented as artistic data visualizations, collaborative and generative approaches, as well as stealth or direct interventions and peaceful resistance. Learning from the art selected for this chapter suggests strategies for reproductive justice art curriculum such as artistic data visualization, collaborative art, performance, remix videos, interventions, and peaceful resistance to injustice toward reproductive rights. Art pedagogy that engages with art about reproductive justice is feminist activism. The art pedagogy strategies should raise questions and

RESOURCE	WEBSITE
Abortion is Normal exhibition	https://www.arsenalcontemporary.com/ny/exhib/detail/abortion-is-normal
Data Visualizations	
Center for Data Innovation: Data visualizations of driving distances to abortion clinics	https://datainnovation.org/2022/06/visualizing-driving-distances-to-abortion-clinics/
Data Feminism and *Data + Feminism Lab*	https://doi.org/10.7551/mitpress/11805.001.0001 https://dataplusfeminism.mit.edu/
Data visualization animation of how personal data is collected and consequences for people's reproductive right	https://globalvoices.org/2023/07/25/how-companies-collect-private-data-about-reproductive-health/
FiveThirtyEight: Data visualizations of abortion restrictions in the United States	https://projects.fivethirtyeight.com/abortion-restrictions-by-state/
FlowingData: Hyperlinked list of data visualizations about reproductive justice including a data visualization that reveals how Google Maps directs searches for abortion clinics to "pregnancy crisis centers" that discourage reproductive rights.	https://flowingdata.com/tag/abortion/
Interactive Map: US Abortion Policies and Access After Roe	https://states.guttmacher.org/policies/
NAEA DVWG	http://cyberhouse.emitto.net/dataViz/
Feminist Art Coalition	https://feministartcoalition.org/
Holly Ballard Martz's 2020 installation "Danger of Nostalgia in Wallpaper Form (in Utero)"	https://www.artsy.net/artwork/holly-ballard-martz-dangers-of-nostalgia-in-wallpaper-form-in-utero
Ina Kaur's *Mr's.' Nirbhaya*	https://inakaur.com/section/516441-Mr%27s%27.%20Nirbhaya%20.html
Linda Stein's (2019) collage *Pro-choice Activism: Today and in 1989 with Merle Hoffman 968*	https://www.lindastein.com/series/armored-for-todays-events
Laura Feierman's installation: *Vulnerability, humility, insecurity, tenacity.* Wo/Manhouse 2022	https://sites.psu.edu/womanhouse/wo-manhouse-storied-prompts/vulnerability-humility-insecurity-tenacity/
Olivia Jane's (2022) *Moon Womb*	https://www.oliviajaneart.com/
Planned Parenthood	https://www.plannedparenthood.org/
Martha Rosler's (2012) "Semiotics of the Kitchen 1975"	https://www.youtube.com/watch?v=oDUDzSDA8q0
ReproAction video	https://reproaction.org/
Repro Nation Monthly: A collection of stories, analysis, and resources on the global struggle for reproductive freedom.	https://link.thenation.com/join/12x/newslettersignupverify
Sasheer Zamata's (2021) *Baking while talking about forced pregnancy* (5:51 minutes video).	https://www.youtube.com/watch?v=v9KBysDYen4
SisterSong Women of Color Reproductive Health Collective	https://www.sistersong.net/reproductive-justice
The Abortion Access Front videos: "Let's Talk About Abortion and Reproductive Justice," a 31-minute reproductive justice 101 crash course, "The 2022 State of the Uterus Address" (4:40 minutes), "I'm Just a Little Pill" (4:16 minutes), "Shame of Thrones" (1:40 minutes), and "Darbi's Dream Clinic" (2:31 minutes).	https://www.aafront.org/
The Center for Artistic Activism: Actipedia	https://actipedia.org/
The Center for Reproductive Rights	https://reproductiverights.org/
The Janes, a 2022 documentary film by Tia Lessin and Emma Pildes	https://www.hbo.com/movies/the-janes
The National Women's Law Center	https://act.nwlc.org/a/whpa?ms=takeaction

FIGURE 4.5 The chart is a compilation of works discussed in this chapter, prepared by the author.

facilitate dialogue, as well as catalyze embodied action and reflection in response to selected art and in the process of creating art.

I incorporate reproductive justice as art education in courses for undergrad students preparing to be K–12 art teachers in a variety of ways. For example, course projects inspired by the art presented in this chapter, and more than could be included in this chapter, involve learning about and creating artistic data visualization, upstander graphic narratives, and remix videos. The remix project places bioethics augmented reality avatars in transcultural dialogues with the art in the *Blood Lines* exhibition. The multimedia exhibition, *Blood Lines*, in a community gallery close to campus, was curated by Maggie-Rose Condit-Summerson, a doctoral student I work closely with in the development of reproductive justice as art education, particularly intervention art approaches in glitching digital applications and virtual environments. She describes the *Blood Lines* exhibition as follows:

> By bringing together local artists from a multiplicity of perspectives, *Blood Lines* honors, witnesses, and celebrates reproductive experiences, which are too often marginalized and stigmatized. In our current moment, conversations about reproductive rights, bodily autonomy, and access to essential care are at the forefront of political discourse. Responding to these issues, the works featured in *Blood Lines* contemplate an expansive range of reproductive histories, politics, and experiences, ranging from pregnancy, to postpartum, abortion, illness, fertility, sexuality, parenting, trauma, and beyond. The included artists share profoundly intimate documentation of bodies, stories, and lives. Throughout the gallery space, explorations of ancestral lineages, Black lesbian eroticism, transgenerational echoes of domestic violence, the nuances of sex work, and recognitions of domestic labor are put into dialogue with one another. We invite you to contribute to multiple interactive pieces in the show as an opportunity to reflect on your own perspectives surrounding reproductive histories and experiences.
>
> *(Condit-Summerson, 2023, para. 1)*

Art students at Makerere University in Kampala, Uganda, in a course taught by Dr. Richard Kabiito and art education students in my course at Penn State University in Centre County in Pennsylvania, USA, created avatars from their unique remix of more than 30 artworks of body sections each made and placed in a shared folder in which each body component communicates a bioethical issue. The students dialogue with each other to give the avatars' histories, beliefs, and personalities, and then place the avatars as augmented reality in various places in Uganda and the United States in conversation with each other and the surroundings. The bioethics narratives are recorded and included in their online exhibition. In Fall 2023, the instructions on how to participate in the generative exhibition, are as follows:

- Click on the URL or use the QR Code on each exhibition page and follow the prompt to download the free AERO app on a smartphone or tablet.
- Once you launch the AERO app, hold your device to view the avatars, and its behaviors by tapping the character, situated in places surrounding you. Interact

with the AR avatars and record. Post a link to the recording as a comment at https://sites.psu.edu/bioethics/2023/11/ and respond to the following questions:
1. Which **bioethics narratives** are new to you and/or **surprised you?**
2. Which **bioethics narratives** are concerns you hold and what are **your views?**
3. How does **place and mixed reality** of avatar and human interaction impact the bioethics narratives?
4. How would you **feel being** the avatar? How might it affect your body, thoughts, or emotions? How might it affect your relationship to others? (Keifer-Boyd, 2023b, para. 3)

Reproductive justice is necessary for a democracy to thrive and education about reproductive justice.

Civic engagement in the context of art education is multifarious. Pertinent to an art education that teaches civic engagement is to question notions of individual freedom of choice given inequities of access to education, resources, and opportunities, which typically arises from socio-economic disparities and intersectional discrimination experienced by marginalized people (Ross & Solinger, 2017). While white middle-class women art educators might assume they are encouraging choice, with "choice" being a hallmark of the creative arts (Kolk, 2023), and there may be choice of materials provided and techniques taught in art class, there also needs to be education in how to learn about complex lived realities and engage with such content in making art to be transformative arts-based inquiries. Further, collaborative art and collective endeavors provide experience in respectfully attending to different perspectives that enrich the artmaking process with nuance, specificity, and complexity given the questioning of assumptions. Reproductive justice is integral to environmental, disability, trans, queer, economic, and racial justice (Brown, 2022; DiMatteo et al., 2022; Harvey, Larson, & Warren, 2023; López, 2022; Murphy, 2017; Tam, 2021). Civic engagement in art education toward social justice must grapple with the current and looming reproductive injustices impacting all aspects of *life, liberty, and the pursuit of happiness*, as a declaration of interdependence.

NOTES:

1. See http://h2f2encounters.cyberhouse.emitto.net/
2. See https://sites.psu.edu/afwiki/
3. See https://vcg.emitto.net/
4. "Crisis Pregnancy Centers: Last Week Tonight with John Oliver (HBO)" provides a 21-minute informative video at https://www.youtube.com/watch?v=4NNpkv3Us1I on how crisis pregnancy centers (CPCs) lure and misinform girls and women. Many states use tax-payer money to fund CPCs (National Committee for Responsive Philanthropy, 2022).
5. To participate and/or support the NESCAC Coalition to Ban CPCs contact the Coalition at https://docs.google.com/forms/d/e/1FAIpQLSf47-LDB0BiBRoInvAeqRQ1zE5ZYVbRNcf9a17otoiPZ_hVZA/viewform
6. The Janes official HBO film trailer is at https://www.youtube.com/watch?v=pRbquE2BAkQ
7. See Keifer-Boyd (2021a,b) for more about feminist remix.
8. See Kate Amends (2022) film about Wo/Manhouse 2022 (9:22 minutes) at https://www.youtube.com/watch?v=VI-RhmnH4hQ and Laura Feierman speak about her installation

at https://sites.psu.edu/womanhouse/wo-manhouse-storied-prompts/vulnerability-humility-insecurity-tenacity/
9 Portuguese artist Paula Rego's series of ten large paintings of women having illegal abortions, as brave heroes rather than victims, opened public consciousness which the government attempted to quash with greater restrictions on women, including restrictions on holding bank accounts, travel, and the right to vote (Spillane, 2022).
10 Olivia Jane's website is https://www.oliviajancart.com/
11 The National Art Education Association's Research Commission established the Data Visualization Working Group (DVWG) as a viable approach to making data of current issues accessible to art educators, and in developing resources for teaching data visualization as an artform. Teaching data visualization resources are linked at http://cyberhouse.emitto.net/dataViz/ and an overview of DVWG is at https://www.arteducators.org/research/articles/240-naea-research-commission-data-visualization-working-group. Artists, scholars, software developers, and founders of the Data + Feminism Lab, Catherine D'Ignazio and Lauren F. Klein (2020), provide an open-source text to guide how to "collect, analyze, imagine, and teach" data visualization as an artform (p. 49). They advocate compiling neglected data as counterdata, exposing power differentials in consideration of who needs to become aware of the harm typically because it is not their lived experience, imagining equity with adherence to data ethics of accountability and transparency of sources of data, and teaching data visualization from a feminist intersectional lens. Their open-access online book, *Data Feminism*, provides many examples of feminist data visualizations to inspire art projects.
12 The exhibition at Arsenal Contemporary in the Lower East Side in New York was curated by Jasmine Wahi and Rebecca Pauline Jampol, and co-organized by Marilyn Minter, Gina Nanni, Laurie Simmons, and Sandy Tait. The *Hyperallergic* article states: "Proceeds raised from the show will be donated in support of voter education and advocacy on reproductive rights, as well as Planned Parenthood PAC efforts in the upcoming 2020 elections via Downtown for Democracy" (Crawford, 2020, para. 1).
13 Additional articles with images of the art in the exhibition include Cascone (2020) and Downtown for Democracy (2022).
14 Additional teaching resources are provided by the Illinois Caucus for Adolescent Health with lesson plans and curricula as an online sexual health toolkit at https://icahtoolkit.wordpress.com/category/lesson-plans-curricula/

REFERENCES

Abortion Access Front. (2022). *Who we are*. https://www.aafront.org/
Amend, K. (2022). Wo/Manhouse 2022 (9:22 minutes). https://www.youtube.com/watch?v=VI-RhmnH4hQ
American Civil Liberties Union (ACLU). (2022, October 4). *Lawsuit filed to restore abortion access in Arizona*. https://www.aclu.org/press-releases/lawsuit-filed-restore-abortion-access-arizona
Bonow, A. (2022). *Shout your abortion*. https://shoutyourabortion.com/
Brown, L. X. Y. (2022, July 26). *Vice President Harris invites AWN's Lydia Z. Brown to speak at disability and reproductive rights roundtable*. Autistic Women & Nonbinary Network, Inc. https://awnnetwork.org/vice-president-harris-invites-awns-lydia-x-z-brown-to-speak-at-disability-and-reproductive-rights-roundtable/
Cascone, S. (2020). Cindy Sherman, Nan Goldin, and other A-list artists are raising money for reproductive rights with a provocatively titled exhibition. *Artnet News*. https://news.artnet.com/art-world/abortion-is-normal-minter-simmons-1748580
Center for Reproductive Rights. (2022). *After Roe fell: Abortion laws by state*. https://reproductiverights.org/maps/abortion-laws-by-state/

Condit-Summerson, M.-R. (2023). *Blood Lines*. …3Dots. https://3dotsdowntown.com/gallery/blood-lines/

Crawford, M. (2020). 50 artists remind us that "Abortion Is Normal". HYPOALLERGIC. https://hyperallergic.com/539075/an-art-exhibition-reminds-us-that-abortion-is-normal/

D'Ignazio, C., & Klein, L. F. (2020). *Data feminism*. The MIT Press. https://doi.org/10.7551/mitpress/11805.001.0001

DiMatteo, E., Ahmed, O., Thompson, V., & Ives-Rublee, M. (2022, April 13). *Reproductive justice for disabled women: Ending systemic discrimination*. Center for American Progress. https://www.americanprogress.org/article/reproductive-justice-for-disabled-women-ending-systemic-discrimination/

Downtown for Democracy (2022). Abortion is normal. *Artsy*. https://www.artsy.net/show/downtown-for-democracy-abortion-is-normal?sort=partner_show_position

Expose Fake Clinics (2023). *About us*. https://www.exposefakeclinics.com/about-us

Feierman, L. (2022) *Vulnerability, humility, insecurity, tenacity*. Wo/Manhouse 2022. https://sites.psu.edu/womanhouse/wo-manhouse-storied-prompts/vulnerability-humility-insecurity-tenacity/

Feminist Art Coalition (FAC). (2021). *Engage. Reflect. Act.* https://feministartcoalition.org/

Gorman, A. (2019). *8 REASONS to stand up today against abortion bans in the United States*. VitalVoices: Global Partnership. https://www.vitalvoices.org/news-articles/news/watch-national-youth-poet-and-vital-voices-board-member-amanda-gorman-on-abortion-bans/

Grant, E. (2022, March 9). Independent abortion providers are on the front lines in the assault on reproductive rights. *Ms. More than a Magazine, a Movement*. https://msmagazine.com/2022/03/09/independent-abortion-provider-clinic-roe/?omhide=true&utm_medium=email&utm_source=everyaction&emci=2da3ed61-73a1-ec11-a22a-281878b85110&emdi=33602eca-0ca2-ec11-a22a-281878b85110&ceid=355089

Harvey, S. M., Larson, A. E., & Warren, J. T. (2023). The Dobbs decision – exacerbating US health inequity. *The New England Journal of Medicine, 388*, 1444–1447. https://www.nejm.org/doi/full/10.1056/NEJMp2216698

Howard, J. (2020). Women dying from pregnancy and childbirth is still a problem in the United States, CDC report shows. *CNN*. https://www.cnn.com/2020/01/30/health/maternal-mortality-statistics-cdc-study/index.html

Hoyert, D. L. (2021). *Maternal mortality rates in the United States, 2019*. NCHS Health E-Stats. https://doi.org/10.15620/cdc:103855

Jane, O. (2022). Olivia Jane. https://www.oliviajaneart.com/

Kaur, I. (2022). *Mr's'. Nirbhava*. Ina Kaur. https://inakaur.com/section/516441-Mr%27s%27.%20Nirbhaya%20.html

Keifer-Boyd, K. (2021a). Prologue: A decade of Lobby Activism. In K. Keifer-Boyd, L. Hoeptner Poling, S. R. Klein, W. B. Knight, & A. Pérez de Miles (Eds.), *Lobby activism: Feminism(s) + art education* (pp. 3–18). National Art Education Association.

Keifer-Boyd, K. (2021b). Immersive feminist remix: An affect dissonance methodology. In E. Navas, O. Gallagher, & x. burrough (Eds.), *The Routledge Handbook of Remix Studies and Digital Humanities* (pp. 80–94). Routledge.

Keifer-Boyd, K. (2023a). Youth civic participation: Activating feminist/critical race/LGBTQ+/crip justice theories. In M. Bae-Dimitriadis & O. Ivashkevich (Eds.), *Teaching civic participation with digital media in art education: Critical approaches for classrooms and communities* (pp. 24–39). Routledge.

Keifer-Boyd, K. (2023b). Placing Bioethics AR Remix Avatars in Transcultural Dialogues: Penn State Art Education Fall 2023 Art Exhibition. https://sites.psu.edu/bioethics/

Kolk, M. (2023). 5 hallmarks of a creative project. In *Creative Educator*. Tech4Learning, Inc. https://creativeeducator.tech4learning.com/2012/articles/Creative_Projects

Legal Information Institute. (2013). *Women and justice: The criminal law (amendment) Act 2013*. https://www.law.cornell.edu/women-and-justice/resource/the_criminal_law_(amendment)_act_2013

Liberal Jane. (2022, May 11). *Abortion isn't a dirty word*. @liberaljanee. https://twitter.com/liberaljanee/status/1524449375115694080?utm_source=Sailthru&utm_medium=email&utm_campaign=Repro%20Nation:%20Launch%20not%20on%20list%20-%2005.18.2022&utm_term=repro_nation_launch_intro_send

López, Q. (2022, July 1). There's no trans healthcare without reproductive rights. *them*. https://www.them.us/story/struggle-for-trans-healthcare-and-reproductive-rights-are-the-same-fight

Martz, H. B. (2020). *Danger of nostalgia in wallpaper form (in utero)* [Installation at Bellevue Arts Museum on view through winter of 2022]. Artsy. https://www.artsy.net/artwork/holly-ballard-martz-dangers-of-nostalgia-in-wallpaper-form-in-utero

Murphy, M. K. (2017). What's in the world is in the womb: Converging environmental and reproductive justice through Synecdoche. *Women's Studies in Communication*, 40(2), 155–171. https://doi.org/10.1080/07491409.2017.1285839

National Committee for Responsive Philanthropy (2022). *The threat of crisis pregnancy centers to the future of abortion access*. https://www.ncrp.org/initiatives/movement-investment-project/our-active-movement-areas/reproductive-access-gendered-violence-movement/abortion-roadmap-intro/deceptive-cpc-track#1658340419684-f35b1df3-50ba

Pintair, O. (2022). "Visualizing reproductive justice" critiques crisis pregnancy centers through art. *The Middlebury Campus*. https://www.middleburycampus.com/article/2022/10/visualizing-reproductive-justice-critiques-crisis-pregnancy-centers-through-art

Planned Parenthood. (2021). *Better health, stronger future*. https://www.plannedparenthood.org/

Registe, A., Mack, A., Rodriguez, D., Tosto, J., & Nickelson, R. S. (n.d.). *Involuntary sterilizations continue: Response to Irwin County Detention Center allegations (amenable)*. SisterSong. https://www.sistersong.net/e-book-involuntary-sterilizations-continue

ReproAction. (2022). *Understanding and advocating for self-managed abortion* [video]. https://reproaction.org/

Rosler, M. (2012). *Martha Rosler – Semiotics of the Kitchen – West Coast Video Art – MOCAtv* (11:25 min. video). The Museum of Contemporary Art. https://www.youtube.com/watch?v=oDUDzSDA8q0

Ross, L. & Solinger, R. (2017). *Reproductive justice: An introduction*. University of California Press.

Ruiz, V. (2022). *Thank God for abortion telenovela pilot*. Creative Capital. https://creative-capital.org/projects/thank-god-for-abortion-telenovela-pilot/

SisterSong. (n.d.). *Reproductive justice*. https://www.sistersong.net/reproductive-justice

Specia, A., & Osman, A. A. (2019). Education as a practice of freedom: Reflections on bell hooks. *Journal of Education and Practice*, 6(17), 195–199.

Spillane, M. (2022, July 1). How Paula Rego's abortion pictures changed the conversation. *The Nation*. https://www.thenation.com/article/culture/paula-rego-abortion-scotus/

Stein, L. (2019). *Pro-choice activism: Today and in 1989 with Merle Hoffman 968*. https://www.lindastein.com/series/armored-for-todays-events

Stewart, K. (2020). *The power worshippers: Inside the dangerous rise of religious nationalism*. Bloomsbury Publishing.

Suliman, T. (2021). *Black maternity mortality: 'It is racism, not race.'* John Hopkins Center for Communication Programs. https://ccp.jhu.edu/2021/05/17/maternal-mortality-black-mamas-race-momnibus

Tam, M. W. (2021). Queering reproductive access: Reproductive justice in assisted reproductive technologies. *Reproductive Health Journal*, 18(164), 1–6. https://doi.org/10.1186/s12978-021-01214-8

The Center for Artistic Activism (n.d.). *Actipedia*. https://actipedia.org/about

The National Women Law Center (2021). *Tell Congress: Pass the Women's Health Protection Act today*. https://act.nwlc.org/a/whpa?ms=takeaction

The National Women's Law Center (2022, January 14). *Destigmatizing abortion: You might be doing abortion advocacy wrong!* https://nwlc.org/destigmatizing-abortion-you-might-be-doing-abortion-advocacy-wrong/?ms=aa

Treisman, R. (2022, August 18). *States with the toughest abortion laws have the weakest maternal support, data shows.* NPR Special Series: Reproductive Rights in America. https://www.npr.org/2022/08/18/1111344810/abortion-ban-states-social-safety-net-health-outcomes

Weiss-Wolf, J. (2022, June 30). HHS Issued Guidance to Protect Private Medical Information. Here Are Some Best Practices for Users of Period-Tracking Apps. *Ms., More than a Magazine, a Movement.* https://msmagazine.com/2022/06/30/period-apps-women-health-data-information/?omhide=true&utm_medium=email&utm_source=everyaction&emci=30383fbe-68fd-ec11-b47a-281878b83d8a&emdi=90df9322-77fd-ec11-b47a-281878b83d8a&ceid=355089

Zamata, S. (2021). *Baking while talking about forced pregnancy* (5:51 minute video). ACLU. https://www.youtube.com/watch?v=v9KBysDYen4

CHAPTER 5

An Affective and Sensory Civic Encounter

Examining Ableism and Civic Education through Arts Based Policy Research

jt Eisenhauer Richardson

> **INSTRUCTIONAL QUESTIONS**
>
> 1. How are understandings of nation, democracy, and citizenship constructed through references to ability, health, and the body? Consider references to civic health and the national body.
> 2. What is ableism? What examples of ableism can you identify in education, policies and law, public spaces, and popular media?
> 3. How can the arts enable an embodied, sensory, and affective engagement with policy and history?
> 4. The author describes their research as "arts-based policy research." How can artistic processes be utilized to engage with policy and history?

FOUND RECIPES AND FOUND LITERATURE

We sat on the floor of my mother-in-law's home the night after her memorial, looking at old family albums and telling stories. Family members flipped through her cookbooks, remembering special meals, rows of peanut butter and chocolate cookies in tins, and their favorite frozen mint chocolate dessert still tucked away in the freezer. She loved to cook for her family and friends. She left behind a large collection of cookbooks. There were rows of spiral-bound cookbooks made by women in the community. Each recipe was written on a typewriter and included the name of the woman who contributed it. These cookbooks were sold to raise funds for schools and women's organizations.

DOI: 10.4324/9781003402015-8

76 THEORY

FIGURE 5.1 My grandmother-in-law and mother-in-law's handwritten recipe notebook.
Photography by jt Eisenhauer Richardson.

On a high shelf in the basement, I found a small notebook with a worn red cover and pages of notes and recipes written in Dutch (see Figure 5.1). The fading cursive writing was likely written by her mother. My mother-in-law, her parents, and her brother immigrated to the United States, anticipating Hitler's occupation of Holland. Clippings from magazines from the 1930s to the 1960s and handwritten recipes sent in letters rested between the pages. I studied the handwriting as other family members helped to translate the Dutch, laughing amid the challenge. *Oh, that word is … wait, what would the English word be for that … oh yes! … grate … grated lemon!*

The visit was coming to an end. People stood lingering before saying goodbye, as every goodbye was now weighty. I looked across the room at the doorway to the kitchen and said: *Cookbooks are an important form of women's literature.* My comment blended into the murmur of simultaneous conversations. I said it again the next day to my spouse and my mother when we returned home. I did not make this comment as an academic or a historian but rather because I *took notice.* Why hadn't I noticed this before? Why did recipes seem like instructions or information passed down through the generations – as something sentimental? Why had I not recognized the relationship between women's cookbooks and their roles as narrators, storytellers, and historians? My critique of "women's work" overshadowed

AN AFFECTIVE AND SENSORY CIVIC ENCOUNTER 77

FIGURE 5.2 Book cover, *Student's Textbook*, United States Department of Labor's Bureau of Naturalization, 1918.

Photograph permission of jt Eisenhauer Richardson.

my understanding of the relationships between domestic labor, women's writing, storytelling, and making.

A few days after we returned home, I received a book I ordered in the mail. The fragile book was the United States Department of Labor's Bureau of Naturalization's 1918 publication, *Student's Textbook: A Standard Course of Instruction for use in the Public Schools of the United States for the Preparation of the Candidate for the Responsibilities of Citizenship* (see Figure 5.2). It was the government's first book to prepare immigrants for naturalization through public school night classes. The first 102 pages taught English and US government and history. The final 22 pages of the *Student's Textbook* include a detailed overview of cooking, nutrition, budgeting, shopping, and personal care titled "Fundamentals for the American Home: Some Things the Housewife Should Know." The text describes the housewife's obligation:

> In order to keep herself and her family happy, she must not waste any steps or energy... Plan your work so that you will not be laying tools down and picking them up again and again. In general, use tools that take up dust rather than those that scatter it. (p. 109)

The chapter established the relationship between women's domestic labor and civic participation, particularly in preparing food: "Feed a growing child properly, and you have helped to make a good citizen" (p. 109). The *Student's Textbook* delineated gender and ability-specific civic responsibilities locating women's[1] civic participation as energetic private domestic labor and men's informed civic participation as public service and economic contributions. The first civic education textbook for naturalization by the US government covers topics like other contemporary civics education texts, including information on US history, government, and laws. However, the *Student's Textbook* also includes what disability studies scholar Jay Dolmage (2018) refers to as the "disabling and racializing force of anti-immigration rhetoric" (p. 4). Additionally, I recognize the importance of gender within anti-immigration rhetoric including women's bodies, labor, and abilities. Dolmage encourages a deeper examination of immigration, including its spaces, technologies, discourses, hidden ideas, future actions, and intentions (p. 4).

This chapter examines the relationship among civic engagement, citizenship, ability expectations, and language. I consider how perceptions of bodies, health, and ability inform understandings of civic engagement and the rights and responsibilities attributed to citizens. As Emily Russell (2011) describes:

> The shared use of the word "body" in the common terms "physical body," "body politic," and "body of the text" is not merely a neat coincidence of language but a sign of the often-forgotten dependence of each category upon the others. (Introduction)

I explored a diverse range of literature across historical (e.g., immigration law, early civic education texts, and newspapers from the early 20th century) and contemporary policy registers (policy documents, white papers, national assessments, state standards, and civics curricula). Students engage with texts in diverse ways within civic education (e.g., learning US histories, conducting research, reading contemporary news and policies, and writing and reflection). As such, approaches to civic education place different emphases on studying US history (Stern et al., 2021) and "political participation as inventive and creative activity" (Blandy, 2011, pp. 251–222; Desai, 2010; Torney-Purta, 2015). My focus on citizenship as a language and as material led me to explore the "pathologizing language of the state itself" as identified by Jina Kim (2017) in her work "Toward a Crip-of-Color Critique" (para. 5).

At the start of my research, I understood certain things about ableism and civic education. However, I challenged myself not to begin my research as if I knew where it would end. As such, my research prioritized curiosity, reflection, and what Dónal O'Donoghue (2020) describes as *contemplation*. O'Donoghue writes,

> to contemplate is to act intentionally but without intention.... While to contemplate is to give one's attention to something and, in doing so, to slow down the impulse to assign order to it from the outside (in contemplation, order is sought within) the contemplative way requires that one holds in abeyance their previous knowledge of the thing contemplated as well as the interpretative, analytical, and meaning-making practices that they might typically apply to make sense of things they wished to figure out. (p. 104)

My artistic practice and writing fostered a "felt" sense of language and the materiality of text, setting aside the impulse to "make sense" and conform to traditional notes of research and meaning-making. I came to appreciate the power of language and the materiality of text and embrace a creative approach to research that prioritizes sensation and the unconventional over rational comprehension. Semantic, discursive, and rhetorical analyses are important when examining the power of language to constitute what citizenship means and can be. In addition to these forms of analysis, I explore an embodied, affective, and sensory encounter with citizenship language, history, and policy. I describe this as *arts-based policy research*.

ABILITY, THE GOOD CITIZEN, AND A HEALTHY DEMOCRACY

The citizen has long been defined through ability and the nation as a body susceptible to illness. In times of political, social, and cultural upheaval, critical concerns arise surrounding the preparedness of citizens to maintain the "health" of the National "body" (Atwell et al., 2014; Hansen et al., 2018; Youniss, 2011). The National Conference on Citizenship's "Civic Health Assessment" and "Civic Health Index" assess civic health by measuring communities' levels of civic engagement and community participation. Within the constructs of a participatory "healthy democracy," civic education functions as both preventative care and treatment, understood to "help strengthen the health of our nation" (Equity in Civic Education Project, 2020, p. 4). As such, the imperative of civic education focuses on the "participation of informed, effective, and responsible citizens" knowledgeable of the "rights, responsibilities, and privileges of citizenship" (National Assessment Governing Board, 2018, p. 1).

The National Assessment of Educational Progress's (NAEP) *Civics Assessment Framework* (i.e., the "National Report Card") delineates the "civic knowledge," "civic skills," and "civic dispositions" necessary for "informed, responsible participation in political life by competent citizens committed to the fundamental values and principles of American constitutional democracy" (National Assessment Governing Board, 2018, p. 7). Similar terminology and characterization of "civic skills, dispositions, and knowledge" described in NAEP's Civics Assessment Framework often recur without citing a source, raising the question: How are these civic skills, dispositions, and knowledge understood to be *civic common sense?* However, Gregor Wolbring (2012) questions how civic competencies and *civic common sense* function as a list of "ability expectations" (p. 1). Wolbring writes,

> Of particular concern is using ability to delineate who is fulfilling their role, rights, and responsibilities as citizens. The detailed list of knowledge, skills, attitudes, and values seen as necessary for active citizenship is really a list of ability expectations that one has of citizens. (p. 152)

Wolbring (2012) describes how ability expectations are embedded within civic education's goal to prepare future citizens. Can people with bodyminds presumed to

be "unhealthy" and "deficient" engage in "healthy civic participation" (Grossman et al., 2021, Educating for American Democracy)?

Throughout US history, evaluations of incompetence, disability, and illness, rooted in ableism, misogyny, and white supremacy make disabled and racialized bodies inadmissible as citizens to the "body politic" (Price, 2014; Pugliese & Stryker, 2009; Yergeau, 2018). Arts educators draw critical attention to constructs of normalcy related to disability, gender, race, and sexuality (Bae-Dimitriadis, 2023; Derby, 2011; Jenkins, 2018; Kiefer-Boyd et al., 2018; Rolling, 2009; Yoon-Ramirez & Ramirez, 2021). Alison Carey (2009) describes how in the early 20th century, "'good' citizenship was identified in part through a contrast with 'idiocy.' While the good citizen was seen as rational, autonomous, and morally upright, the "idiot" was depicted as incompetent, dependent, and deviant...." (p. 36). Idiocy, citizenship, and normativity became mutually dependent. During this period, idiocy, imbecility, and insanity were understood as diagnoses on a continuum separated by their perceived degree of impairment. Jenifer Barclay (2021) describes how shortly "before the start of the Civil War," the word "'normal' took on new meaning and variations." The terms "'normality,' 'norm,' and 'normalcy' entered the English Language between 1840 and 1857" (p. 24). Barclay (2021) writes,

> As disability intertwined with the broader metalanguage of race, it minimized or amplified specific qualities imagined as innate to whiteness or blackness, racializing and delimiting "normal" bodies. Disparaging views of blackness and disability structured definitions of national identity and freedom, demarcating who could legitimately possess citizenship just as abolitionists and women's rights advocates pressed for its expansion. (p. 24)

In recent years, references to COVID-19 as the "Kung Flu" and the "China Virus" by the US government escalated long-standing anti-Asian racism (Shin et al., 2022). Protests to *Stop Asian Hate* and the hashtag #IAmNotaVirus brought critical attention to how "contagion" reflect racist and ableist ideologies embedded within the rhetoric of protecting the nation's "health."

WRITING "MATERIAL," THE BODY, AND IMAGINING DOUGH

I texted my mother a question:

If I only use flour and water, how much surface area of rolled dough would a 50-pound bag of flour make?

As both an excellent baker and a math whiz, within 2 hours, she texted me the results of her experiment: a detailed recipe and an equation as pictured in Figure 5.3.

> I experimented and came up with a ratio of 2 cups of flour to 1/2 cup plus two tablespoons of water. This is what it made. It is 16x9 or 144 square inches area. (That would also be a 12-inch square because the square root of 144 is 12) The dough

AN AFFECTIVE AND SENSORY CIVIC ENCOUNTER 81

FIGURE 5.3 Dough rolled on my mother's countertop. 2022. Domestic labor.
Photograph permission of jt Eisenhauer Richardson.

stays together well, and you can use a cookie cutter on it. It also tastes like crap [laughing face emoji]. 😂 Because of the high gluten development it takes some muscle to roll. You need a little extra flour to roll it on but not much. It isn't fragile like regular dough.

Now how many times could you make this recipe with fifty pounds of flour? Rule of thumb is that a pint is a pound. So, fifty pounds is roughly 50 pints, and 50 pints is 100 cups. You need two cups per recipe so 100 cups divided by two = 50 times.

How much would that cover in terms of surface area? Take the 144 square inches × 50 times = 7200 square inches. Another way to think of it is that it would be 50 12 × 12 in squares. There are 12 inches in a foot so it would be 50 square feet. (50 × 12 ft. The thickness is an eighth of an inch.)

My mother's recipe fascinated me – how she navigated quantification, calculation, and the material qualities of flour and water. I imagined expanses of dough

rolling from the kitchen, through the door, across the yard – dough covering the driveway and creeping down the road. I imagined rolls of dough pressed against my skin and strapped to my back while I walked miles to the downtown capital. I wanted to experience dough taking over. To me, kneading and rolling dough weren't forms of communication, but domestic labor, a form of manual labor that demanded physical effort. When imagining dough, I anticipated exhaustion and my body's limits.

I noticed when I questioned myself about whether creating "art" in the home was "good enough" or if it was even "art." I realized how I continued to marginalize domestic labor and materials. I name working with dough *domestic labor*, not invoking art-related terms, such as performance or installation. The kitchen was not a stage.

I first prepared two "recipe cards" before rolling any dough. I wrote one sentence from the US and Ohio Constitutions on each recipe card. In anticipation of the winter holidays, I mixed pounds of sugar dough to make cut-out cookies. Kneading the dough was strenuous, causing my arms to strain and my body to ache. A neat row of alphabet cookie cutters rested on the granite countertop (see Figure 5.4).

I set the rolling pin aside, picked up a cookie cutter, and began to write.

We, the People of the United S….

FIGURE 5.4 Creating cut-out cookies from the US Constitution. 2023. Domestic Labor. *Photograph by Jack Richardson.*

THE BODY POLITIC: INADMISSIBILITY, DEPENDENCY, COMPETENCE, AND NATURALIZATION

What is "the" story of a nation?

As I explored literature on civic education, I became intrigued by the possible connection between civic education's goals for students and the naturalization criteria in immigration policy. To investigate this further, I closely studied both past and present immigration laws. Through this examination, I identified the relationship between inadmissibility determinations made based on dependency in anti-immigration policies and state laws that disenfranchise voters based on competency.

When I read the Immigration Act of 1882, I recognized the central and critical significance of a word that appears only once in the document: Idiocy. The Immigration Act of 1882 excluded "any alien afflicted with idiocy, insanity, imbecility, feeble-mindedness, epilepsy, constitutional psychopathic inferiority, chronic alcoholism, tuberculosis in any form, or a loathsome or dangerous contagious disease" (Pub. L. 47–376). For the first time, US immigration law included disability and neurodivergence as inadmissibility criteria. Only months before the Immigration Act of 1882, Congress passed the Chinese Exclusion Act of 1882, barring the immigration of Chinese citizens (8 U.S.C. § 261). Prior US laws included racist policies that refused to recognize BIPOC people as citizens, including the Naturalization Act of 1790, The Indian Removal Act of 1830, and the 1856 Supreme Court ruling in the Dred Scott v. John F. A. Sandford Case.

Immigration policy repeatedly sought to identify and exclude individuals thought to lack the means to support themselves, those described as becoming "a public charge." The phrase "public charge" first appeared in the 1882 Immigration Act. Current immigration policy also includes the "public charge rule."

> Likely at any time to become a public charge means likely at any time to become primarily dependent on the government for subsistence, as demonstrated by either the receipt of public cash assistance for income maintenance or long-term institutionalization at government expense.[2]

According to US immigration policy, the following factors can be considered "when making public charge inadmissibility determinations: age; health; family status; assets, resources, and financial status; and education and skills."[3]

Jay Dolmage (2018), in *Disabled Upon Arrival: Eugenics, Immigration, and the Construction of Race and Disability*, describes how the inspection and medical examination of immigrants at Ellis Island was not an isolated concern about economics but one entangled within the US eugenic and racist ideologies. In 1905, the commissioner general of the Bureau of Immigration, F.P. Sargent, instructed inspection officers to give "poor physique" "the most weight" when evaluating immigrants. F.P. Sargent stated,

> In admitting such aliens, not only do we increase the number of public charges by their inability to gain their bread ... but we admit likewise progenitors to this country whose offspring will reproduce, often in an exaggerated degree, the physical degeneracy of their parents.
>
> *(Sargent, 1905, as cited in Dolmage, 2018, p. 17)*

Dolmage argues that Ellis Island "became the key laboratory and operating theater for American eugenics ... and scientific racism ... the effects of which can still be felt today" (p. 11). Anti-immigration laws and the central role of eugenics in the US history continue to shape how citizens are perceived and excluded.

State constitutions and voting laws similarly disenfranchise American citizens with mental disabilities rights, including their right to vote. As an Ohio resident, I had never read Article V Section 6 of Ohio's Constitution, enacted in 1852: *No idiot or insane person shall be entitled to the privileges of an elector* (OH Const art V § 6). According to the Bazelon Center for Mental Health Law (2020), seven states' current constitutions use similar ableist language (e.g., idiot, insane) in their voting laws. Only ten states' constitutions or election laws do not deny disabled people the right to vote. Thirteen states deny citizens "under guardianship" the right to vote; 22 states and the District of Columbia bar voting if a court determines a citizen "lacks the capacity to vote" (p. 13). Four states bar individuals described as "non compos mentis" from voting. Independence, economic contribution, and competency, as stated in federal and state constitutions and laws, are central to the delineation of who has or does not have the complete rights of a citizen. However, individuals with mental disabilities also lose their right to vote when mental health service providers, poll workers, or election officials "improperly impose their own voter competence requirements" (p. 13). This includes staff in nursing homes or psychiatric hospitals denying residents and patients access to voting and poll workers refusing to allow an individual to vote at a polling station.

Civic education policy outlines the rights and duties of citizens to describe what students should know and be able to do. However, do these civic knowledge, skills, and dispositions reflect anti-immigration laws and state election laws? NAEP's *Civics Framework for the 2018 Assessment of Educational Progress* defines "civic dispositions" as including economic and parental responsibilities and independence. According to the NAEP, a citizen's responsibilities include,

> ... the dispositions to become an independent member of society; respect individual worth and human dignity; assume the personal, political, and economic responsibilities of a citizen; participate in civic affairs in an informed, thoughtful, and effective manner; and promote the healthy function of American constitutional democracy. (p. xv)

Additional civic responsibilities described in the *Civics Framework* include "taking care of oneself; supporting one's family and caring for, nurturing, and educating one's children; being informed about public issues; serving on juries; voting; paying taxes; performing public service" (p. 34).

References to civic responsibilities uncritically presume an able body through their emphasis on cognitive and intellectual skills, independence, economic contribution, taking care of a family, and public service. These civic dispositions recall the public charge inadmissibility criteria of "health; family status; assets, resources, and financial status; and education and skills."[4] Furthermore, the NAEP makes a connection between citizenship, disability, and parental rights by defining civic responsibilities as including supporting one's family and raising and educating one's children. A recent

AN AFFECTIVE AND SENSORY CIVIC ENCOUNTER 85

study by Robyn Powell (2023) scrutinized the inclusion of disability in states' "termination of parental rights laws." The study found that disabled individuals are still at risk of having their parental rights revoked in 42 states and the District of Columbia. Powell's research indicates that ableism is still prevalent in state laws, as the numbers have not changed for over a decade (p. 1).

These relationships demonstrate how critically attending to ableism and language is not simply about word usage, as is often reflected in resistance to "politically correct language." Rather, Arun Sagar (2021) describes the complex and paradoxical relationship of law, language, and justice.

> [I]t is in the theatre of law that emancipatory struggles play out and the rhetoric of law and justice ... holds out the promise of change ... it is through law ... not only state laws ... but other formal and informal practices, discourses, and normative frameworks – that inequality and injustice are maintained. (p. 228)

Through examining civic education literature in relationship to immigration law, and state constitutions, I gained a more complex understanding of citizenship, ableism, language, and civic engagement. I encountered how language is enacted on bodies and places, leaving me to ask.

How is ableist language felt, not simply understood?

LETTERS OF THE LAW AND FOUND TEXTS

My exploration of citizenship language drew my attention to words and the alphabet as a symbolic system. I experimented by challenging myself to write using each letter of the alphabet only once. As a result, letters became a limited resource, resulting in fragmented and illegible writing.

In one experiment, I spelled the words idiot, citizen, and insane in different sequences limited by using each letter only once. Figure 5.5 captures this letter-by-letter erasure using "ghost text," a tactic in erasure poetry for visualizing both erased and remaining text. Spelling the words in this order left no remaining letters to spell the word nation. This process made the alphabet strange, revealing its limitations and where the intention and desire to say "something" degraded. Silencing became an affective encounter with loss and the tenuous nature of communication systems. The symbolic system of the alphabet surfaced processes of linguistic privilege. By manipulating language as material, I encountered the interrelationship of being ineligible and illegible, between literacy and access, and the relationship between privilege, writing, and symbolic systems.

This experiment also reminded me of learning to type letters. I am sighted, yet I first learned to type letters on a Perkins Brailler rather than a typewriter. I learned to use a Brailler in elementary school along with a classmate who was blind. Braille is a tactile writing system understood to be a code used for multiple languages. Disabled, D/deaf, and neurodivergent people have diverse relationships with language. American Sign Language is recognized as a distinct language by many Deaf people. Moreover, neurodivergent people have diverse experiences of the alphabet, language, and reading.

IDIOT

C T ZEN

IN S A E

C R A Z Y

N T N

FIGURE 5.5 Erasure of letters in ableist words in the 1882 Immigration Act.
Digital artwork by jt Eisenhauer Richardson.

Erasure and Historical Documents: Traci K. Smith's Declaration

Traci K. Smith, a former poet laureate, wrote a poem titled "Declaration" in 2018. The poem is an erasure of the *Declaration of Independence*, where Smith selectively chose which text to omit and keep from the original to create her poem.

Smith (2018) explained how she wrote her poem using the tactic of erasure. Through the process, Smith understood erasure and poetry as more than "a willful act" but also a way to engage with the logic of the document. She described,

> As I got further into the poem, it seemed less like I was making these really deliberate choices and more like I was hearing a logic that was gathering force. And what I heard in my rereading of the Declaration of Independence was a story about the nature of black life in this country from the beginning … I think the fact that the poem is really announcing its relationship to the original text is a way of saying, can we talk about this?
>
> *(Smith, 2018,* The Washington Post*)*

I am reminded of Dónal O'Donoghue's (2020) description of moving beyond intentionality within Traci K. Smith's description of encountering language and text as "gathering force." Smith experiences historical texts as dynamic, sensory, material, and malleable. Similarly, I wonder how "quoting" historical documents in dough may also foster the sensory, tactile, and emergent aspects of erasure.

"TO FORM A MORE PERFECT"

The kitchen was unusually quiet – no chatter, music, or phone calls. I do not know if I had ever listened to cookie cutters before this day. In the past, I focused on wanting *to make something.* The dough's shape on the countertop was our compromise – a collaboration between the dough and me. The cookie cutters refused to let go of the cut-out letters. The tip of a knife pried the letters from their grip to form words (see Figure 5.6). The cookie cutters rested, left scattered across the countertop, as I read,

> We, the People of the United
> States in order to form a
> more *perfect*

The margins of a page do not govern enjambed lines in poetry. Rather, where poetic lines end uses a different "logic," such as rhythm, sound, surprise, breath, intuition, and discovery. The typical pauses and inflection I made when reciting the first line of the Constitution changed. The adjective "perfect" waited, suspended between breaths, ready to claim a "form." Intuition rather than intention informed my decision to stop the quote on the word perfect – *to form a more perfect* – a perfect what? Is the Constitution's limitation its assertion that perfection exists?

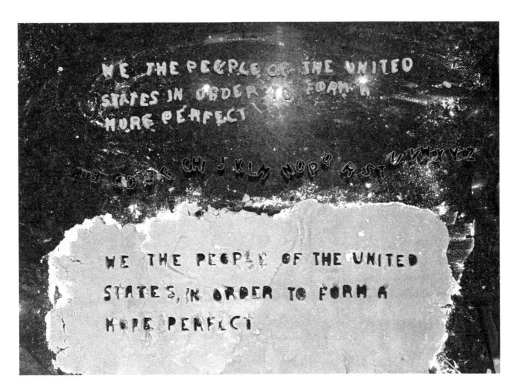

FIGURE 5.6 Text from the *United States Constitution* cut from dough.
Photograph permission of jt Eisenhauer Richardson.

I did not have a specific plan when I began quoting the Constitution in the dough. I could not predict several factors, such as the dough's thickness and elasticity. Writing in collaboration with dough enabled me to experience physically touching letters, feeling their edges, and how they bend. My writing shifted from cognition to a felt sense of the text.

I gently lifted the cut letters from the counter and placed them in the oven to bake. I pulled the hot cookies from the oven and counted how often each letter occurred. I arranged them on the cooling racks in alphabetic order. As a result, as pictured in Figure 5.7, the cookies became like a bar graph.

I did not anticipate smelling the Constitution bake in an oven or how it would surface memories of baking cookies with my family. I did not anticipate pulling policy from the oven to cool or history and policy's olfactory and tactile registers.

After baking the text from the US Constitution, I turned my attention to the recipe card for Ohio's Constitution. The sentence on the card read,

No idiot or insane person shall be entitled to the privileges of an elector.

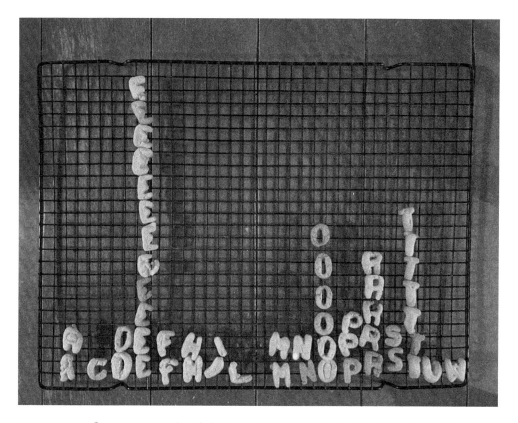

FIGURE 5.7 Cut-out sugar dough letter cookies organized alphabetically and by frequency cooling on a metal rack.

Photograph by jt Eisenhauer Richardson.

AN AFFECTIVE AND SENSORY CIVIC ENCOUNTER 89

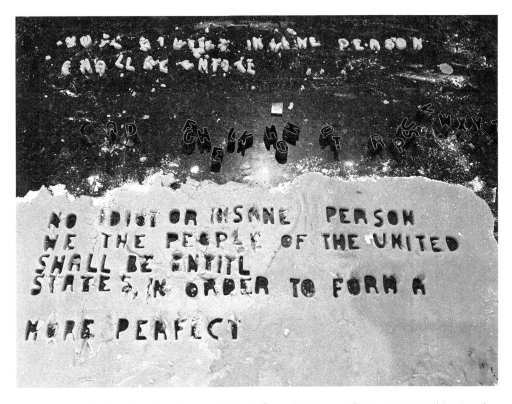

FIGURE 5.8 A line from the State of Ohio's Constitution cut from sugar cookie dough. To Form a More Perfect.

Photograph by jt Eisenhauer Richardson.

I first thought I might add the text from Ohio's Constitution after the word "perfect." However, as I ran my hands across the dough, I noticed the blank space between the lines of text I previously cut. It became a crawl space rather than the "remainder" of the page, a margin, or a footnote. As pictured in Figure 5.8, I continued to cut the letters of the Ohio Constitution from between the lines in the crawl space of the US Constitution.

However, it was over an hour before I returned to the dough to cut out the text of Ohio's Constitution. As pictured in Figure 5.9, the dry dough crumbled, leaving broken pieces and tattered edges. I looked at the rolled cookie dough, the letters, the words, and the crumbs. The sweet smell of baking cookies lingered. As pictured in Figure 5.10,

FIGURE 5.9 Crumbling cut-out letter cookies. To Form a More Perfect.

Photograph by jt Eisenhauer Richardson.

90 THEORY

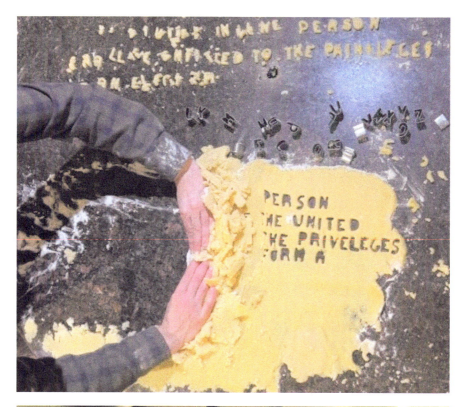

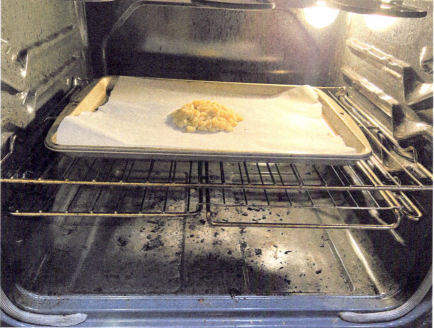

FIGURE 5.10 Cut-out cookie dough pushed across the countertop (top), a mound of dough baking in the oven (bottom).

Photographs by Jack Richardson and jt Eisenhauer Richardson.

I slowly pushed the dough on the counter. Words collapsed, the letters rippled into a mound of dough, with letters slightly still visible. I kneaded the broken letters into a ball, pressed it firmly onto a cookie sheet, and baked it in the oven (see Figure 5.10).

The dough's inherent tendencies and properties, its increasing refusal to be malleable as it dried, made me wonder why I wanted to make it legible, particularly given the pain and violence resulting from these texts and histories. I wondered about this crawl space, its sensorial aspects, and its reorientation of a written page. Can I touch a policy gap, smell it, or knead it into a ball? Moreover, if this were possible, does it pick up bits of dough that would have otherwise escaped recognition? Baking the constitutions brought me back into my body to my *felt sense* of citizenship language.

CONTEMPLATING DOUGH

At the start of my research, I posed the question, what is engagement? I identified my study as *arts-based policy research* due to the importance of arts processes as a means of contemplation, curiosity, and engagement with materials in examining policy papers, historical documents, and legislation. When examined carefully, citizenship education language reveals the need for additional forms of civic "literacies" that can attend to language as material as well as semantic, rhetorical, and discursive. I suggest that the arts make possible *civic encounters*. Civic encounters open into experiencing more than problem-solving, privileging civic curiosity to civic competency. Rather than orienting artmaking and civic engagement as communicative and representational, I was drawn to artmaking's material, affective, sensory, and embodied aspects as civic engagement. Sara Shields et al. (2020) describe the forms of sensory engagement inherent to their students' artistic forms of civic engagement. Civic encounters encourage an exploratory engagement with history, not as an unchanging record, but as a living material.

In this chapter, I present research that highlights how ableism has played a central role in shaping current understandings of citizenship, democracy, and nation. The interconnectedness of ableism, racism, and misogyny informs our understanding of civic education. The most significant impact of ableism is that it often goes unrecognized. Civic education policies and curricula play a crucial role in identifying how educational opportunities, including the arts, can inspire and prepare students to address critical issues in their communities with compassion. Identifying how ableism, racism, and misogyny inform past and present policies, laws, and education remains critical work if the potential of civic education is to be fully realized. The arts play a central role in this work, serving as a means of contemplation, meaning-making, and discovery.

Drifting Flour

I remember a psychiatric hospital on election day and how the patients lingered at the tables after breakfast. A woman walked around with a clipboard, calling out names, crouching next to people to ask if they wanted to vote. *Did she whisper?* Later in the

day, a nurse swiped her badge, opened the locked door to the unit, and led a short line of patients to a nearby room where two polling stations were set up. The patients crawled inside the booths, transported beyond the hospital by memories of familiar school cafeterias and churches. Years later, I find myself returning again and again to my memory of the woman who walked around the breakfast tables. Did she ask everyone if they wanted to vote? *Did she?*

NOTES:

1. This paper does not support the incorrect conflation of gender and sex. Rather, historical references to "women" and "men" reference those-identified as women and men within histories and policies.
2. The following reference information is provided in the 2022 Public Charge Grounds of Inadmissibility. See INA sec. 212(a)(4)(A), 8 U.S.C. 1182(a)(4)(A). Congress has by statute exempted certain categories of noncitizens, such as asylees and refugees, from the public charge ground of inadmissibility. See, e.g., INA secs. 207(c)(3) and 209(c), 8 U.S.C. 1157(c)(3) and 1159(c). A full list of exemptions is included in this rule.
3. See INA sec. 212(a)(4)(B)(i), 8 U.S.C. 1182(a)(4)(B)(i)
4. Ibid.

REFERENCES

Atwell, M., Levine, P., & Bridgeland, J. (2014). Civic deserts: National civic health challenge. *National Conference on Citizenship*. https://www.unr.edu/main/pdfs/verified-accessible/divisions-offices/student-services/student-life-services/student-engagement/civic-deserts-health-challenge.pdf

Barclay, J. L. (2021). *The mark of slavery*. University of Illinois Press.

Bazelon Center for Disability Law. (2020). *It's Your Right. A Guide to the Voting Rights of People with Mental Disabilities*. https://www.bazelon.org/wp-content/uploads/2020/10/Bazelon-2020-Voter-Guide-Full.pdf

Bae-Dimitriadis, M. S. (2023). Decolonizing intervention for Asian racial justice: Advancing antiracist art inquiry through contemporary Asian immigrant art practice. *Studies in Art Education*, 64(2), 132–149.

Blandy, D. (2011). Sustainability, participatory culture, and the performance of democracy: Ascendant sites of theory and practice in art education. *Studies in Art Education*, 52(3), 243–255. https://doi.org/10.1080/00393541.2011.11518838

Carey, A. C. (2009). *On the margins of citizenship: Intellectual disability and civil rights in twentieth-century America*. Temple University Press.

Derby, J. (2011). Disability Studies and Art Education. *Studies in Art Education*, 52(2), 94–111. https://doi-org.proxy.lib.ohio-state.edu/10.1080/00393541.2011.11518827

Desai, D. (2010). Unframing immigration: Looking through the educational space of contemporary art. *Peabody Journal of Education*, 85(4), 425–442.

Dolmage, J. (2018). *Disabled upon arrival: Eugenics, immigration, and the construction of race and disability*. The Ohio State University Press.

Equity in Civic Education Project. (2020). Equity in civic education [White paper]. J. C. Lo (Ed.). *Generation Citizen and iCivics*.

Grossman, H., Hammack, F. M., & Mirochnik, O. (2021). *Educating for American democracy: A roadmap for excellence in history and civics education for all learners*. The Educating for American Democracy Initiative.

Jenkins, K. (2018). Which Way Did He Go, George? A Phenomenology of Public Bathroom Use. In *Pedagogies in the Flesh: Case Studies on the Embodiment of Sociocultural Differences in Education* (pp. 55). Springer Berlin Heidelberg. https://doi.org/10.1007/978-3-319-59599-3_8

Keifer-Boyd, K., Bastos, F., Richardson, J., & Wexler, A. (2018). Disability justice: Rethinking "inclusion" in arts education research. *Studies in Art Education*, 59(3), 267–271.

Kim, Jina (2017). Toward a crip-of-color critique: Thinking with Minich's "Enabling Whom" emergent critical analytics for alternative humanities. *Responses*, Issue 6.1 (Spring 2017).

National Assessment Governing Board. (2018). *Civics framework for the 2018 National Assessment of Educational Progress*. https://www.nagb.gov/content/dam/nagb/en/documents/publications/frameworks/civics/2018-civics-framework.pdf

O'Donoghue, D. (2020). Contemplating art education. *Studies in Art Education*, 61(2), 99–105. https://doi.org/10.1080/00393541.2020.1753452

Powell, R. (2023, March 4). Legal Ableism: A systematic review of state termination of parental rights laws. *Washington University Law Review*, forthcoming. http://dx.doi.org/10.2139/ssrn.4378408

Price, M. (2014). *Mad at school: Rhetorics of mental disability and academic life*. University of Michigan Press.

Pugliese, J., & Stryker, S. (2009). The somatechnics of race and whiteness. *Social Semiotics*, 19(1), 1–8. https://doi.org/10.1080/10350330802632741

Rolling, J. H. (2009). Invisibility and in/di/visuality: The relevance of art education in curriculum theorizing. *Power and Education*, 1(1), 94–110. https://doi.org/10.2304/power.2009.1.1.94

Russell, E. (2011). *Reading embodied citizenship*. The American Literatures Initiative. (Kindle Locations 56–58). Kindle Edition.

Sagar, A. (2021). Law and dis/abilities. *Jindal Global Law Review*, 12(2), 227–231. https://doi.org/10.1007/s41020-021-00160-7

Sargent, F. P. (1905, April 17). Dept. of Commerce and Labor, Bureau of Immigration Correspondence with Immigration Restriction League. BMS Am 2245 (916) US Immigration and Naturalization Service. Correspondence with IRL, 1896–1920. Houghton Library, Harvard College Library, Harvard University.

Shields, S., Fendler, R., & Henn, D. (2020). A vision of civically engaged art education: Teens as arts-based researchers. *Studies in Art Education*, 61(2), 123–141. https://doi.org/10.1080/00393541.2020.1740146

Shin, R., Bae, J., Gu, M., Hsieh, K., Koo, A., Lee, O., & Lim, M. (2022). Asian critical theory and counternarratives of Asian American art educators in U.S. higher education. *Studies in Art Education*, 63(4), 313–329. https://doi.org/10.1080/00393541.2022.2116680

Smith, T. K. (2018, May 29). Traci K. Smith: 'Staying human: Poetry in the age of technology.' *The Washington Post*. https://www.washingtonpost.com/entertainment/books/tracy-k-smith-staying-human-poetry-in-the-age-of-technology/2018/05/29/890b6df2-629b-11e8-a768-ed043e33f1dc_story.html

Stern, J., Kressley, B., & Rotherham, A. J. (2021). *State of State standards for civics and U.S. history in 2021*. Thomas B. Fordham Institute. https://fordhaminstitute.org/national/research/state-state-standards-civics-and-us-history-2021

Torney-Purta, J., Cabrera, J. C., Roohr, K. C., Liu, O. L., & Rios, J. A. (2015). *Assessing civic competency and engagement in higher education: Research background, frameworks, and directions for next-generation assessment* (Research Report No. RR-15-34). Educational Testing Service. http://dx.doi.org/10.1002/ets2.12081

United States Department of Labor. (1918). *Student's textbook: A standard course of instruction for use in the public schools of the United States for the preparation of the candidate for the responsibilities of citizenship*.

Wolbring, G. (2012). Citizenship education through an ability expectation and "ableism" lens: The challenge of science and technology and disabled people. *Education Sciences*, 2(3), 150–164. https://doi.org/10.3390/educsci2030150

Yergeau, R. (2018). *Authoring autism: On rhetoric and neurological queerness.* Duke University Press.

Yoon-Ramirez, I & Ramirez, B. (2021) Unsettling settler colonial feelings through contemporary indigenous art practice, *Studies in Art Education*, 62(2), 114–129, https://doi.org/10.1080/00393541.2021.1896416

Youniss, J. (2011). Civic education: What schools can do to encourage civic identity and action. *Applied Developmental Science*, 15(2), 98–103. https://doi.org/10.1080/10888691.2011.560814

CHAPTER 6

Encountering the *I Can't Breathe Mural*

Antiracism, the Material Culture of Protest, and Art Education

Erica Rife and Doug Blandy

> **INSTRUCTIONAL QUESTIONS**
>
> 1. What is the history of protest in your community? What material culture is associated with this history?
> 2. How does protest relate to, and support, other forms of civic engagement such as voting, participation in social justice organizations, and the opportunity to participate in public forums in which public policy is discussed and debated?
> 3. Choose an example of "art" that has been used to protest. Use the framework presented in this chapter to respond to your example. Does the framework enhance your understanding of the protest movement that the art is associated with it?
> 4. Has an artwork or artifact stimulated an action on your part in a relationship to protest?

CHAPTER TEXT

During the Summer of 2020, tens of thousands of United States (U.S.) citizens participated in nationwide largely nonviolent Black Lives Matter (BLM) protests associated with the murders, by police, of George Floyd, Breonna Taylor, and other Black Americans.[1] BLM, originating following the killing of Trayvon Martin in 2012 and gaining momentum after the killing of Michael Brown in 2014, as a social movement is now indisputable (Eligon, 2020).

In the two weeks following the murder of George Floyd on May 25, 2000 BLM protests occurred in all 50 states (Eligon, 2020). An abundance of public images,

DOI: 10.4324/9781003402015-9

including murals, were created in the wake of the murder of Floyd by white police officer Derek Chauvin. The widely publicized murder sparked outrage in a nation that had been on lockdown since March of that year due to the COVID-19 pandemic. The pandemic had brought inequities of age, labor, class, and healthcare to the surface, and the murder of yet another Black life similarly resurfaced inequities in policing. Amidst the lockdown associated with the pandemic, a nationwide social uprising ensued, featuring months of nightly protests and prolific emotional expression among those who united, revolted, and grieved.

Across the U.S. plywood barriers were installed by businesses and property owners to ostensibly protect their premises. Many murals were initiated without permission on these barriers. Once businesses began to reopen, the question of preservation and ownership of these works surfaced. This proliferation of murals during the protests was watched closely by the "art world" and motivated questions of who the murals belonged to and how they should be protected preserved, experienced, and interpreted. These questions intersected with how to best maintain the power of these murals over time to identify injustice and spur actions in response.

Museums and community arts centers were among those organizations identified as possible repositories for these murals. For example, in Oakland, California (CA), organizers worked to track down over a thousand muralists to ensure consent and proper coordination with museums. Though many looked to institutions like the Oakland Museum and Oakland Art Murmur, leaders took a step back to let the muralist community take the lead. Jean Durant, the board president of Oakland Art Murmur, "hopes the preservation process will become a model for how white-led arts organizations can step back and let Black organizations lead the way forward" (Clayton, 2020, p. 1).

Within this context, consider, for example, the mural erected in proximity to us outside of the Apple store in Portland, Oregon's city center. Hereafter this mural will be referred to as the *I Can't Breathe Mural* (see Figure 6.1).

Portland experienced daily protests for three months during the Summer of 2020 and continuing intermittently to the present day.[2] Just days after Floyd's death, Portland protests resulted in businesses in Portland's city center erecting plywood barriers along their walls and windows, including the Apple store. These plywood barriers were quickly covered with protest murals. Emma Berger initiated the *I Can't Breathe Mural* on June 1, 2020. Over time the mural included the faces of George Floyd, Ahmaud Arbery, and Breonna Taylor along with text associated with BLM. While initiated by Berger, a white mural artist residing in Portland, Berger is recognized as one of the primary voices of the spontaneous protest movement due to her fast-acting work amidst Portland's reaction to the death of Floyd. While initiated by Berger, the mural on the Apple store, during the summer and fall of 2020, became a massive community board, filled with poems, art, messages of hope, demands for justice, and a memorial to the deceased. The mural quickly became a memorial site where protesters and others placed flowers, candles, pictures, and signs. Sadly, late in the summer of 2020, the mural was vandalized and Berger took responsibility for initiating repairs. Eventually, to protect the mural, Apple Inc. covered it for protection

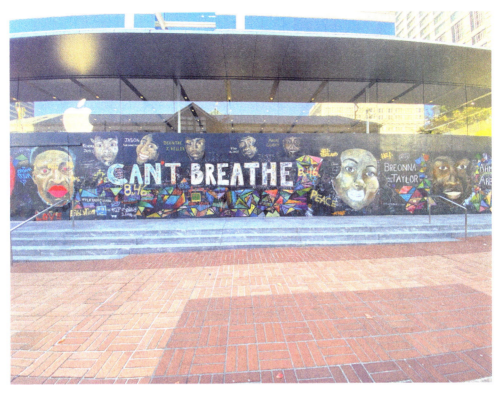

FIGURE 6.1 *I Can't Breath Mural*, Photography by Erica Rife.

and referred to it as "a monumental art piece honoring the ongoing fight for justice" (Singer, 2021, paragraph 3).

In Portland, the size and impact of the *I Can't Breathe Mural* drew the attention of many as the Apple store prepared to reopen. Instead of donating the piece to the Portland Art Museum or another arts-related institution, the mural was instead given to the nonprofit organization *Don't Shoot PDX*. The mission of *Don't Shoot PDX*

> promotes social justice and civic participation … for community members facing racism and discrimination by providing legal representation and direct advocacy …. The art proponent of our work acts as a communicative tool to facilitate discussions about race in America while providing educational assets to those most affected by discrimination in public policy.
>
> *(Don't Shoot PDX, n. d.)*

As part of their advocacy work, *Don't Shoot PDX* includes an archive of Black lives and regularly produces and participates in educational events and exhibitions that focus on the importance of documenting the experiences and histories of Black people living in Portland and elsewhere in the U.S.

Don't Shoot PDX founder Teresa Raiford declared that the moment the community began to visit the *I Can't Breathe Mural* to leave flowers and candles and mourn community members lost to police and others, she was adamant that it should not be exploited by the art world but exist to serve the community as they work to heal from the collective trauma that has plagued them for generations (personal communication, April 19, 2021). On Instagram, *Don't Shoot PDX* wrote that it considers the responsibility for preserving the paintings an honor, and that the panels "reflect the responses of so many that were witnesses to last summer's uprisings, answering the joint call to action against institutionalized violence and white nationalism" (Singer, 2021, paragraph 5). *Don't Shoot PDX* crated the mural for an anticipated three years while they track down and connect with as many people who had contributed to the mural as possible (personal communication, April 19, 2021). The panels of the piece are stored along with items left at the site to preserve the full impact of the work. This highly publicized acquisition drew attention to the mission and work of *Don't Shoot PDX* and illustrated the importance of archival preservation by and for communities that experience oppression.

Our purpose in this chapter is to consider the *I Can't Breathe Mural*, as a case example within the context of the material culture of protest.[3] In anticipation of bringing attention to this protest mural and others in schools and community-based organizations, we will propose a framework that educators can adapt within their own settings to assist students in responding to the material culture of protest such as the *I Can't Breathe Mural*. In this regard, we will consider how youth and adults in community-based education programs can consider the intrinsic and extrinsic *agency* of protest images without diluting the original intent. We recognize "protest" as intrinsic to the rights that citizens are afforded under the U.S. Constitution that it can result in significant social progress, and as such should be considered within educational contexts toward a full understanding and appreciation of "protest" as an option associated with civic engagement. Our proposed framework should not be considered prescriptive, but as a possible contribution to how those experiencing murals, like the *I Can't Breathe Mural*, can sustain their relevance in the communities of which they are a part.

ART AND THE MATERIAL CULTURE OF PROTEST

Bolin and Blandy (2003) define material culture as "all human-mediated sights, sounds, smells, tastes, objects, forms, and expressions …. When there is purposeful human intervention, based on cultural activity, there is material culture" (p. 250). In the case of the BLM movement and protests, material culture can be seen in murals, protest signage, graffiti, social media posts, videos, photography, slogans, music, theatre, chants, and oral histories, among others. Such examples of the material culture of protest are often referred to as "art" or "socially engaged art" because of the materials and formats used; their connection to creativity and imagination; and the public purpose motivating the work. Blandy (2012) describes the importance of material culture in social justice movements: "… material culture supports solidarity within a

movement while simultaneously communicating the values, attitudes, and beliefs of the movement to those outside" (p. 30).

Reed (2005) identifies social movements, such as BLM, as "unauthorized, unofficial, anti-institutional, collective action of ordinary citizens trying to change the world" (p. xiii). Such movements, according to Reed, "have shaped our politics, our culture, and our political culture as much as any other single force" (p. xiii). The protests associated with such movements include myriad forms of public display like those examples cited above. Reed (2005) refers to this material culture of protest as representative of "Aesthetic ideologies" referring "to the politics of forms, styles, genres, and conventions that emerge to embody the cultural politics" (p. 302). Using AIDS "activist art" as a point of reference, he sees such material culture as

> grounded in the accumulated knowledge and political analysis of the AIDS crisis produced collectively by the entire movement. The graphics not only reflect that knowledge, but actively contribute to its articulations as well …. They function as an organizing tool, by conveying, in compressed form, information and political positions to others affected by the epidemic, to onlookers at demonstrations, and to the dominant media. (p. 209)

The material culture of protest was also on full display during the 2017 Women's March taking place in Washington, DC, and in every U.S. state. This march is described in *Pussy Hats, Politics and Public Protest*, edited by Rachelle Hope Saltzman (2020),

> as a qualitatively different kind of protest" due to "the sheer numbers of women and their allies who joined together as a seemingly united intersectional whole to say 'hell, no' to incursions on their bodies, their rights, and those other women, children, Native American sovereignty, Black and Brown bodies, and a host of others who had been violated by the 2016 presidential election and what its results might portend. (p. xiii)

About the material culture of protest on full display during this nationwide march, including the "pussy hat," Saltzman (2020) observed that "The women involved have created and maintained opportunities for storytelling, advocacy, and community building. Making, sharing, and displaying material culture, particularly handmade hats and signs" (p. xv). In creating this material culture of protest, this was in keeping with how women have "used color, pins and ribbon to express support of causes" as the American Suffragette Movement, LGBTQ+ rights, and Planned Parenthood (p. xiv).

ANTIRACISM AND ANTIRACISM ART EDUCATION

The BLM movement was founded in 2013 after the murder of Trayvon Martin, a Black teenager, and the subsequent acquittal of George Zimmerman, the man who killed Martin. Zimmerman's acquittal was emblematic of responding to a system of justice in the U.S. that devalues and oppresses Black people inspiring the creation of

the BLM. BLM has become increasingly recognized in the mainstream after the death of Martin and accelerated in 2020 with the murder of Floyd. As stated by the founders, "We firmly believed our movement, which would later become an organization, needed to be a contributing voice for Black folks and our allies to support changing the material conditions for Black people" (Black Lives Matter Founders, 2020, p. 1).

Antiracism, a concept popularized by Ibram X. Kendi (2019) in his book *How to Be an Antiracist*, reframes the position of an individual who believes themselves to be against racism. As described by Singh (2019), "The term 'antiracist' refers to people who are actively seeking not only to raise their consciousness about race and racism, but also to take action when they see racial power inequities in everyday life" (p. 98). Kendi's (2019) conception of antiracism is that of a call to action, stating that "the opposite of racist isn't not racist" (p. 9). He argues that it is not enough to consider oneself as not racist, but one must be actively working against racist policies and beliefs in order to be antiracist. Kendi (2019) expands: "to be antiracist is a radical choice in the face of history, requiring a radical reorientation of our consciousness" (p. 23). As such, being antiracist requires a knowledge of past and present systems of injustice as well as a deep self-reflection in order to make informed and critically conscious decisions about our actions.

Within the field of visual arts education, there is a history of addressing civic engagement, social justice, and antiracism. Leadership in this regard has been provided by members of the National Art Education Association (NAEA) Committee on Multiethnic Concerns (COMC), (established 1971), among others. Most recently this history, as well as pedagogical strategies addressing the needs and interests of students and teachers, is exemplified in *Race and Art Education* by Amelia M. Kraehe and Joni B. Acuff (2021). These authors acknowledge that within the field, "there remains a third rail for many art educators – topics that are too emotionally and politically charged to go near" such as "race and racial hierarchies" (p. 5). To this end, their book provides students and teachers with an accessible guide to exploring and implementing creative actions associated with race, racism, identity, and antiracism.

ENCOUNTERING THE *I CAN'T BREATHE MURAL* AND OTHER EXAMPLES OF PROTEST

To create an antiracist framework for engaging with the material culture of protest, referencing the *I Can't Breathe Mural* as a means to explore antiracism, we propose three lenses: empathy, critical self-education, and social justice education. The proposed framework suggests that an agent of antiracism should depict human suffering, historical and cultural information, and elements of celebration.[4] Figure 6.2 is an encapsulation of this framework.

In considering how the *I Can't Breathe Mural* embraces and evokes antiracism, one must consider what the experience of a person might be by viewing and engaging with the collective content contributed by community members inspired by and allied with the BLM. No one person is going to have the same experience as another because each person brings their individual biases and previous experiences to the mural. Each

Antiracism Lenses for Social Justice Artwork

Empathy	Critical Self-Education	Social Justice Education	*I Can't Breathe* mural elements
Emotional — Ability to feel for someone else	**Deconstructionist** — Facilitate unlearning	**Connecting** — Foundational, attentive, extended	**Suffering** — References specific instances of violence and oppression towards individuals of an oppressed community
Cognitive — Understanding the thoughts, behaviors, and emotions of others	**Reconstructionist** — Devise new ways of learning	**Questioning** — Structural analysis of systems	**Informational** — References the history and culture of oppressed communities that are commonly excluded from dominant education and institutions
Behavioral — Taking action to make the lives of others better	**Constructionist** — Develop new strategies to pursue equity	**Translating** — Repackaging an idea for communication	**Celebratory** — Depict oppressed communities in a proud or even joyful light, rejecting the narrative that the entire lived experience of the community is limited to suffering.

FIGURE 6.2 Antiracism Lenses for Social Justice Education.

person will also determine their own subsequent actions after experiencing the mural. As such, it is important to identify how individuals approach antiracism through their relationship to themselves, to others, and to the systems of oppression within society. The following sections will explore these elements of antiracism through empathy, critical self-education, and social justice education.

Empathy

The study of empathy is extensive. The concept of empathy stems from the German term *Einfuhlung*, which translates to "feeling into" (Stueber, 2019, paragraph 2). For example, art and empathy have been paired in programs to assist medical students in establishing richer and non-judgment connections with their patients. Artworks serve as a "third space" with which both the counselor and the client can have an imaginative dialogue with the object (Ziff et al., 2017). In the case of social justice movements, artwork can serve as this third space for a viewer to dialogue with as they work through their own biases and perceptions in a world that advantages some and disadvantages others. The *I Can't Breathe Mural* creates a space providing the viewer with the opportunity to explore their empathetic responses without causing harm, whether intentional or not, to a person experiencing social injustices by directing their questions, assumptions, or biases inward and toward the systems themselves.[5]

Anastasiou (2015) posits emotional, cognitive, and behavioral empathy as three dimensions of empathy for self-reflection and awareness of the self in relation to others. Anastasiou defines emotional empathy as "the ability of an individual to feel for someone else, to have a similar emotional response" (p. 78). The BLM is, at its core, targeting this empathetic response by imploring people to recognize that BLM for the purpose of motivating engagement. On a perhaps deeper level, cognitive empathy is described by Anastasiou as "the intellectual ability to understand the thoughts, emotions, and behaviors of another person or group" (p. 78). This allows a person to not just feel *for* someone but to make connections to internal or external influences on a person's sense of self. This is key when viewing artworks produced by individuals whose identities may be different than one's own, or in understanding the intersectionality of race, ethnicity, gender, social class, etc. in the lives of others and oneself. Finally, Anastasiou describes behavioral empathy as "actions that people take to make things better for someone else" (p. 78). When examining experiences or material culture that is part of a greater antiracist social justice movement like BLM, this dimension is crucial to ensure that empathetic responses are not only internalized and understood but acted upon. Ward (2017) amplifies this phenomenon through Simulation Theory, where we "come to understand and empathize with others by recreating their actions, feelings, and sensations on our own neural architecture for experiencing those states (either implicitly or consciously)" (p. 61). In other words, when we feel emotional states like sadness, fear, anger, and happiness based on another person's expression of these emotional states, we are activating our own brain's perception of these emotions.

One must look at the emotional, cognitive, and behavioral dimensions of empathy with the understanding that one is connecting to another's experience through one's

own lens. It is reckless and inconsiderate to believe that one feels the way that another feels when the breadth of each of our experiences is far too complex to replicate in someone else (Jahner, 2019). For example, when a white person encounters the *I Can't Breathe Mural* and has an emotional and cognitive empathetic response to an image depicting Black suffering, they are applying their perceptions of pain without knowing the complex lived trauma of a Black person. Understanding empathetic responses when interpreting antiracist images is therefore just one component of the experience and must be accompanied by additional reflection and education to ensure that behavioral responses are informed and respectful.

Critical Self-Reflection

Anastasiou's (2015) dimensions of empathy primarily center on the experience of the self relating to another person. To engage in antiracism, one must also focus on one's perception and understanding of the world. Griffith and Semlow (2020) argue that antiracism also requires the three-step process of critical self-education created by Akbar (1998): deconstructionist, reconstructionist, and constructionist. Griffith and Semlow (2020) describe the deconstructionist phase as "helping people to critically analyze and challenge their social world, not adapt to it" (p. 377). Individuals, especially those in hegemonic groups, must learn to look at their position in the world through a critical lens to understand how systems are designed to privilege certain groups and discriminate against others. The deconstructionist phase encourages individuals not to accept injustices as unchangeable facts of the world but to recognize the harm that such narratives cause. As a collaborative and community work, the *I Can't Breathe Mural* importantly includes content that illustrates and addresses systemic inequities as groundwork toward dismantling those systems.

To reconstruct requires "considering alternative perspectives ... and propose strategies to address the limitations or errors in the way a problem has been conceptualized, examined, or addressed" (Griffith & Semlow, 2020, p. 377). Key to reconstruction is listening to and learning from individuals from a marginalized group to address the problematic narratives addressed through deconstruction. The *I Can't Breathe Mural* encourages viewers to learn directly from marginalized individuals through their creative and expressive cultural production.

The third phase of Akbar's (1998) critical self-education process is the constructionist phase, which Griffith and Semlow (2020) describe as "the creation of ways of thinking for the purpose of action and expectation that insights from action will help to refine how we think about the problem and potential solutions" (p. 377). This may also be described as rewriting the narrative or being actively involved in taking the lessons learned from the deconstructionist and reconstructionist phases and turning them into antiracist work.

Griffith and Semlow (2020) argue for the use of art to illustrate and evoke the three phases of critical self-education. In their words, "art and the arts can facilitate processing of and connection to information that can be the foundation of efforts to pursue change…" (p. 376). Griffith and Semlow have identified individual artworks that accomplish each of the three phases. These include The National Memorial for Peace

and Justice/*Lynching in America: Confronting the Legacy of Racial Terror* created by Elizabeth Alexander, Kwame Akoto-Bamfo, Toni Morrison, Hank Willis Thomas, and others; the film *Watermelon Man* directed by Melvin Van Peebles and Billie Grace Lynn's American Mask consisting of KKK style hoods created from American flags among others. A mural, such as the *I Can't Breathe Mural*, contains community-contributed content that is consistent with Griffith and Semlow's examples.

Social Justice Art Education

Critical to the antiracist framework is education and learning. Building on the concept of critical self-education and connecting it to the power of protest images is social justice education. Dewhurst (2011) argues that social justice education is "a practice of investigating and deconstructing the world around us, with the aim of rebuilding it in such a way that all people can have equal access to their full human potential" (p. 366). We see direct parallels with this practice and the critical self-education phases of the deconstructionist, reconstructionist, and constructionist process. Dewhurst applies her orientation to social justice art, which she defines as "the artistic cultural practices through which an artist analyzes structures of oppression and identifies a specific strategy to impact those structures through aesthetic means" (p. 366). Though Dewhurst's work is primarily in educating students through art-making, rather than observation, the same principles can be applied to the role of the viewer and how observation may lead to action.

Viewers of social justice artworks are being asked by the artist(s) or by the institution displaying the piece to approach their experience with critical analysis and, importantly, to leave with a greater sense of responsibility in taking action against social injustices. This critical analysis of social justice as described by Dewhurst (2011) consists of three main processes: connecting, questioning, and translating. The first process, connecting, consists of multiple stages: foundational (self-reflection and finding one's personal connection to the subject), attentive (connecting the subject to real-life experiences), and extended (connecting the subject of injustice to greater societal and systems of oppression) (Dewhurst, 2011). An example of the connecting process might be when a viewer sees an artwork that depicts a person of color experiencing police violence. The image may evoke an emotional empathetic response by connecting them to their own memories and feelings of seeing news coverage of police murdering a Black person (foundational), which then heightens their awareness when another instance of this kind happens and receives media coverage (attentive). This awareness then draws their attention on debates of police budgets and discussions of the history of policing in the U.S. (extended). This process can also be cyclical, as the viewer may approach another social justice artwork with this extended understanding and, as a result, experience a different reaction to their new knowledge.

The next process that Dewhurst describes in social justice education is questioning or investigating. This process goes beyond awareness of injustice and oppression and requires the viewer to proactively seek further information. Some of the questions that Dewhurst (2014) identifies as impactful include "what is associated with

this injustice?" (p. 60), "how does one issue of injustice compare to another?" (p. 62), "what additional information is available about this issue of injustice?" (p. 63), and "what do people think about this issue?" (p. 66). In considering these questions while viewing the *I Can't Breathe Mural*, the viewer may interrogate the complexity of the placement and materials used for the piece and how it exemplified or, perhaps, contradicts the message, and what connections might be drawn between artworks that appear to depict different subjects. The viewer might leave with questions to research themselves, such as the historical information presented in the piece, the implications of graffiti and street art, or what the public and media are saying about the work. Questioning takes place while viewing the artwork but also extends beyond the visit.

The third process described by Dewhurst (2011) is translating, or creating an object or message to convey an idea. Though Dewhurst primarily describes this step in terms of the artist, we may apply it to the experience of the viewer by analyzing subsequent action or newfound perspectives prompted by engagement with social justice art. It becomes the viewer's responsibility to translate the ideas presented in the art, as well as the independent research and connections, into antiracism work. As described in the behavioral empathetic dimension and the constructionist self-education phase, the viewer must identify the ways in which they can partake in rewriting the narrative about oppressed populations and become actively engaged in that work. In the example of connecting awareness to police violence against Black individuals, a viewer might translate this newfound knowledge into action by attending police budget community meetings or donating to a nonprofit whose work in dismantling the current policing system resonates with the viewer, including *Don't Shoot PDX* after learning of the nonprofit's acquisition of the mural. Much like empathy and critical self-education, action is crucial to social justice education.

CONCLUSION: EXPERIENCING THE MATERIAL CULTURE OF PROTEST AND THE *I CAN'T BREATHE MURAL*

It should be evident that there are many similarities across antiracism lenses of empathy, critical self-education, and social justice art education. These lenses can be applied to the wide array of content that was added by the community to the *I Can't Breathe Mural* to provide a rich understanding of the impact that such a mural can have. The *I Can't Breathe Mural* spanned the full city block of the Apple storefront and wrapped around the north wall of the store with countless contributions from individuals, including professional artists and non-artists. Each contributor brought their unique perspective, experience, and message to their additions. The diversity of subject matter and messaging, while vast, can generally be divided into contributions that fall into at least one of the following categories: depictions of Black suffering, information, and celebration. Depictions of Black suffering include references to slavery, police violence, and the Jim Crow era. Informational pieces reference the history and culture of Black Americans that may not be known to non-Black audiences. Celebratory contributions are those that depict Blackness in a proud or even joyful light, rejecting the narrative

that the entire Black experience is limited to suffering. Often, celebratory messaging comes in the form of calls to action such as voting and protest.

The *I Can't Breathe Mural* accomplishes a great deal as an agent for antiracism. Viewers are exposed to societal norms and systems of injustice and they are asked to identify where they envision their past, present, and future selves in relationship to what is depicted and advancing social justice. When considering antiracism images through empathy, critical self-education, and social justice education, each lens calls for action by individuals. The *I Can't Breathe Mural* implores viewers to be active in ensuring a just future for Black Americans. The mural succeeds in presenting opportunities for visitors to reflect and imagine and makes a deafening call to action, though what viewers do in their antiracism work upon departure is unknown. The acquisition of *I Can't Breathe Mural* by *Don't Shoot PDX* will eventually allow for programming and community engagement to accompany the future display of the mural to ensure that antiracism does not begin and end at the center of protest. Educational institutions, cities, corporations, property owners, arts institutions, and nonprofits should consider the *I Can't Breathe Mural*, and other examples of protest art, as vehicles for antiracism and the identification of ways in which they too might support community-based works that serve as agents of antiracism through empathy, critical self-education, and social justice education.

NOTES:

1 According to the Washington Post, 96.3% of nationwide protests were without injury or property damage (Chenoweth & Pressman, 2020).
2 For a timeline of the Portland protests, see the syllabus and timeline Portland State University professor Francheka Cannone (Cannone et al., 2020) and their students compiled.
3 The authors of this article, both white, cis-gender, middle-class individuals, recognize our inherent privilege in accessing the research and material for this exploration. We do not claim to understand the lived experiences of those from oppressed communities in our interpretation but seek to administer academic inquisition that may be used by others seeking to deepen their antiracist and social justice practices.
4 This framework was developed by Erica Rife during her graduate studies at the University of Oregon. While conducting research about how the Black Lives Matter movement impacted public art and museum exhibitions, she studied the Black Lives Matter grant competition and exhibition produced by the Jordan Schnitzer Museums of Art at the University of Oregon and Portland State University in 2021 and 2022. Her analysis determined that there were three prominent categories of artwork present in both exhibitions: depictions of Black suffering, informative, and celebratory. Further analysis of other exhibitions and public artworks, including the *I Can't Breathe Mural*, confirmed that these categories are oftentimes present when presenting a holistic experience encouraging Black liberation and antiracism. To view the Portland State BLM exhibit site, go to https://www.jordanschnitzer.org/exhibition/black-lives-matter-artist-grant-exhibition-3/. In addition, Christopher Paul Harris (2023) recently published *To Build a Black Future: The Radical Politics of Joy, Pain, and Care* aligns with the analysis and observation above.
5 To fully grasp the cultural complexities of a show like the BLM Exhibition, it is essential to understand that emotional, cognitive, and behavioral empathetic responses are rooted in a neurological response in the brain. Empathy is directly connected to feeling

sensations and neurobiologists have studied exactly how this response is ignited in our minds. A study of monkeys in Parma, Italy, found that the same set of neurons were fired in a monkey's brain both when they were performing a specific action and when they were watching another perform that action without performing it themselves (Gallese, 2017; Jahner, 2019; Martin, 2018; Ward, 2017). This study has shown a neurological basis for empathy and thus spawned further study into the extent of this response. Jahner (2019) identifies that such a response is still limited to the experience and repertoire of the viewer themselves, showing that we are not able to create an entirely new understanding of another's experience without bringing our own biases and modes of understanding to our empathy. Jahner (2019) writes: "Popular definitions of empathy suggest a shared emotional experience, but the idea of 'shared' misses a central idea found in the study of the neurobiology of empathy: I perceive you through me. We cannot directly experience the other; our body must be used as an interpreter of what we see. To do this, we have the power of narratives; our cultures and experiences write the narratives into our biology from which new narratives are written affording new perceptual experiences" (p. 32).

REFERENCES

Akbar, N. (1998). *Know thyself*. Mind Productions & Associates.

Anastasiou, A. (2015). The communication of empathy through art: Implications for conflict resolution and social justice. In Hajimichael, M. (Ed.), *Art and social justice: The media connection* (pp. 7–16). Cambridge Scholars Publishing.

Black Lives Matter Founders. (2020). *Black economics*. https://blackeconomics.co.uk/2020/06/07/black-lives-matter/

Blandy, D. (2012). Experience, discover, interpret, and communicate: Material culture studies and social justice in art education. In Quinn, T., Ploof, J., & Hochtritt, L. (Eds.), *Art and social justice education: Culture as commons* (pp. 28–34). Routledge.

Bolin, P. E. & Blandy, D. (2003). Beyond visual culture: Seven statements of support for material culture studies in art educations. *Studies in Art Education*, 44(3), 246–263.

Cannone, F., Belcik, M., Franken, M., Green, K., Harris, S., Kerstens, P., White, V. & Barber, K. (2020). *PDX protests, summer 2020: A syllabus & timeline*. https://pdxscholar.library.pdx.edu/cgi/viewcontent.cgi?article=1044&context=pdxopen

Chenoweth, E. & Pressman, J. (2020, October 16). This summer's Black Lives Matter protesters were overwhelmingly peaceful our research finds. *Washington Post*. https://www.washingtonpost.com/politics/2020/10/16/this-summers-black-lives-matter-protesters-were-overwhelming-peaceful-our-research-finds/

Clayton, A. (2020, June 27). Open-air art museum: Will Oakland's protest murals have a life beyond the street? *The Guardian*. https://www.theguardian.com/us-news/2020/jun/27/oakland-murals-george-floyd-protests-street-art

Dewhurst, M. (2011). Where is the action? Three lenses to analyze social justice art education. *Equity & Excellence in Education*, 44(3), 364–378. DOI: 10.1080/10665684.2011.591261

Dewhurst, M. (2014). *Social justice art: A framework for activist art pedagogy*. Harvard.

Don't Shoot PDX. (n.d.). *Who we are*. https://www.dontshootpdx.org/about

Eligon, J. (2020, August 28). Black Lives Matter grows a movement while facing new challenges. *The New York Times*. https://www.nytimes.com/2020/08/28/us/black-lives-matter-protest.html

Gallese, V. (2017). Visions of the body: Embodied simulation and aesthetic experience. *Aisthesis*, 1(1): 41–50. DOI: 10.13128/Aisthesis-20902

Griffith, D. & Semlow, A. (2020). Art, anti-racism and health equity: "Don't ask me why, ask me how!" *Ethnicity & Disease*, 30(3), 373–380. DOI: 10.18865/ed.30.3.373

Harris, C. P. (2023). *To build a Black future: The radical politics of joy, pain, and care.* Princeton University.

Jahner, E. (2019). Living narratives: Neurobiology of empathy. In Gokcigdem, E. M. (Ed.), *Designing for empathy: Perspectives on the museum experience* (pp. 31–46). Rowman & Littlefield.

Kendi, I. X. (2019). *How to be an antiracist.* Random House.

Kraehe, A. M. & Acuff, J. B. (2021). *Race and art education.* Davis.

Martin, D. (2018). *Mirror-touch synaesthesia: Thresholds of empathy with art* (pp. 3–36). Oxford University Press.

Reed, T. V. (2005). *The art of protest: Culture and activism from the Civil Rights Movement to the streets of Seattle.* University of Minnesota.

Saltzman, R. H. (2020). *Pussy hats, politics, and public protest.* University of Mississippi.

Singer, M. (2021). Apple has donated the Black Lives Matter Mural painted outside its downtown store to Don't Shoot PDX. *Willamette Week.* https://www.wweek.com/arts/visual-arts/2021/01/23/apple-has-donated-the-black-lives-matter-mural-painted-outside-its-downtown-store-to-dont-shoot-pdx/

Singh, A. A. (2019). *The racial healing handbook: Practical activities to help you challenge privilege, confront systemic racism, and engage in collective healing.* New Harbinger Publications.

Stueber, K. (2019). Empathy. In E. N. Zalta (Ed.), *The Stanford encyclopedia of philosophy.* Stanford University. https://plato.stanford.edu/entries/empathy/

Ward, J. (2017). The vicarious perception of touch and pain: Embodied empathy. In Martin, D. (Ed.), *Mirror-touch synaesthesia: Thresholds of empathy with art* (pp. 55–65). Oxford University.

Ziff, K., Ivers, N. & Hutton, K. (2017). "There's beauty in brokenness": Teaching empathy through dialogue with art. *Journal of Creativity in Mental Health, 12*(2), 249–261.

CHAPTER 7

Making Common Ground for Living

Strategies for Meaningful Intervention into Systemic and Structural Inequities

James Haywood Rolling, Jr.

> **INSTRUCTIONAL QUESTIONS**
>
> 1. How do the making practices that constitute our discipline-based and culturally based art + design systems spread from person to person? What is the fundamental work of art + design in the imagination and generation of new creative futures?
> 2. How are the individual creative leaps that irreversibly alter a society proliferated to neighboring societies as well?
> 3. Under what circumstances are human change-making practices resisted and interrupted by the establishment of systemic and structural inequities? When met with such resistance, what are some strategies for successfully marshaling our art + design practices and change-making energies to intervene in the reinauguration of human development?

RETHINKING THE FUNDAMENTAL *WORK* OF ART

Human beings invent and innovate—we make useful things and then pass those tools along. We either make stuff which never existed under the sun, or we make the stuff we already possess work better than it ever has before. Until about 12,000 years ago, humans were largely hunters and gatherers—foraging for enough to sustain our lives (Harari, 2014). We subsisted—it was all we had time to do. Today, we produce and refine what we need—we cultivate and collect what we desire. And if not that, we appropriate or adapt what others have produced, refined, cultivated, and collected. Human history is replete with the evidence of our collective-making practices.

DOI: 10.4324/9781003402015-10

From civilization to civilization, there have been numerous artistic and industrial revolutions (Schildgen, Zhou, & Gilman, 2006). How do making practices spread? How do creative activities proliferate from person to person? How are individual creative leaps generated that irreversibly alter a society and neighboring societies as well? Moreover, under what circumstances are these making practices resisted? And, when met with such resistance, how are making practices successfully marshaled to intervene?

Some define the art + design practices very narrowly as discipline-based systems for production of technically proficient hand-crafted artifacts, manufactured objects, or mediated forms (Rolling, 2019). Some define art + design as culturally based systems for the communication of the symbols and motifs telling the stories and the values that inform our lives (Rolling, 2019). For others, the purpose of their practice of art + design is to challenge power structures, interrogate belief systems, make inequities visible, or simply to transform a world out of balance for the better.

Whatever way you choose to define your own lane on the superhighway of our collective human creative practices, in aggregate these art + design practices have served as a major artery for the trucking routes of *human development*, and a primary means for generating, modeling, and adapting new cultural patterns and achievements—the stuff our civilizations are made of.

Each approach to art or design practice acts as a methodology for organizing sensory, experiential, and cultural data *about* the full human experience—modeling our most advantageous ideas, not for the sake of the "survival of the fittest," but for the "survival of the patterns" that have long sustained us all (Rolling, 2013a). In his book *The Accursed Share* (1949/1991), French intellectual Georges Bataille elaborated a unique meta-economic theory of consumption theorizing that the natural social interaction between human beings generates an *excess* of energy that *must* be expended and consumed one way or the other—either toward the seemingly profitless exercise of helping one another be more human, or by instead using one another for profit, solely, and most often brutally, for personal or private gain. Diverting and capturing human surplus for personal gain, rather than allowing it to flow toward the common good, is the accursed share.

I extend Bataille's argument by framing our collective art-making processes as a natural engine for human possibilities—one that draws upon precedent and neighboring bodies of knowledge to prosthetically aggregate all this surplus energy and accelerate the mass and momentum of the human superorganism (Rolling, 2015). Following from Bataille, our arts practices arguably serve no lesser purpose than the common good, generating what philosopher Jacques Derrida defines as a surplus, "a plenitude enriching another plenitude" (Derrida, 1976, p. 144), superseding personal or private gain. Ultimately, the creation of these surplus energies, designs, and ideas is manifested in the human conundrum of whether to apply one's excess energy toward the desirable exercise of helping one another be more human, or the undesirable use of one another for personal or private gain. Herein we can begin to see the fundamental *work* of art illuminated as it interrupts the caustic effects of systemic forms of inequity like racism.

The creation of surplus human energy is a phenomenon that emerges through interactions between members of a sociocultural swarm, a reminder that our deepest and richest achievements are not merely the product of single individuals, but of cultural systems proliferating our capacity to transmit and spread of ideas and behaviors that aid our collective resilience, thereby ensuring the survival of the patterns that sustain us (Rolling, 2013b). The management of these myriad interactions requires a sort of swarm intelligence (Rolling, 2013a)—our shared capacity to *behave together* for the common good, manifested as the production of a generative differential space, a multitudinous theater of possibilities wherein we "create and open spaces into which existing knowledge can extend, interrelate, coexist, and where new ideas and relationships can emerge prosthetically" (Garoian, 2013, p. 6).

Ultimately, the surplus energy described by Bataille (1949/1991) is manifested as the choice of whether to apply one's excess energy toward the exercise of helping one another be more human, or to use one another for personal or private gain. When our choice is to be or become a more contributive citizen of the world, at our most altruistic we give little bits of ourselves away because such are the actions that hold us together: we *form* beautifully crafted reflections of the world we've experienced; we *inform* new ideas emerging from ongoing and complicated conversations; we *transform* present conditions into future questions and possibilities because such are the objects, expressions, and sacred interventions we grasp along our journey; and we *perform* our best for the sake of the common good.

There is no privatized claim to be gained from any of these creative activities, and yet each painstakingly crafted form, each additional bit of information about the human experience, each transformation of nagging questions into new solutions, and each performance of charity or benefaction solely promoting someone else's growth of welfare ultimately increases the capacity of the entire swarm and the world we all share. The social work of art has aptly been characterized not only as the economic force first described by Bataille (1949/1991) but as the generative and reciprocating "gift" of our surplus human energies and a "prime determinant in human history" (Kosalka, 1999, p. 1).

If human development is systemic, then such development naturally generates system-wide variations in society's possible trajectories, encoding new futures with each variant. In the effort to make new futures, one of the urgent necessities of our day is to leverage these life-sustaining systems to generate greater common ground and better social worlds.

The purpose of this chapter is to expand our general understanding of the work that art has the potential to accomplish in the course of human interactions and relations which are fundamentally systemic in nature. This writing rethinks artmaking as an engine not only for producing deeply remembered *forms* but for organizing and preserving vital cultural *information*, provoking social *transformation*, and presenting emotionally resonant *performances* that reinforce our common humanity. Readers should come away with a strong argument that these same creative practices are also available to us as interventions and catalysts when human development is being impeded or foreclosed, either by design or for lack of imagination of the futures that are possible.

ART AND THE MULTIVERSE OF SURPLUS ENERGY SYSTEMS

Human beings are immersed in, sustained through, and sometimes imperiled by systems. Research tells us this. For example, the term *systemic racism* is redundant. According to environmental scientist and systems expert Donella H. Meadows (2008), "a system is a set of things—people, cells, molecules, or whatever—interconnected in such a way that they produce their own pattern of behavior over time" (p. 2). Racism, all by itself, is systemic. That is its nature. It does not require a grammatical modifier. Humans, both as living, individual organisms and in our network of social relationships with one another, are also systemic. In her influential book *Thinking in Systems*, Meadows (2008) defined a system as a "set of elements or parts that is coherently organized and interconnected in a pattern or structure" (p. 188) that becomes more than the sum of its parts.

Every oppressive system produces structures and behaviors to perpetuate itself. That's the reproductive nature of systems. For example, racist systems produce racist individuals, racist institutions, and racist policies as their necessary byproduct. Racism, as practiced in the United States for centuries, has long distorted racial differences into divisions to systemize the collection of wealth, the plundering of land, and the accumulation of social power, effectively sustaining the status quo of white supremacy present at the birth of this nation from generation to generation. That is the nature of racism. Public and private education are examples of a modern social institution that preserves our nation's status quo through the highly "socializing experiences it offers the young" (Meyer, 1977, p. 55).

Whether oppressive or liberatory and generative of surplus energies for creation, our dominant mental models matter because these models tend to inhere and endure as the prevailing social constructs and contracts until they are either invalidated, are replaced as they become obsolete, or are fundamentally reinterpreted. Cognitive scientists have long argued that "model construction and deployment…[are] activities [that] extend to all sorts of human endeavors" (Gentner & Stevens, 1983). For example, a story is a model. A hypothesis is a model. A work of art is model. So is a memory or a metaphor. Models are the stuff that paradigms and practices are made of. According to an exploration of mediated modeling in science education by Ibrahim A. Halloun (2007), a paradigmatic model is "a conceptual system that governs explicitly a person's conscious experience in a given situation" and which also "supplies appropriate mnemonics for consciously retrieving necessary means and method from memory" (p. 692). A famous example of this was the geocentric model of the universe, a long-prevailing paradigm that fixed a stationary Earth at the center of the cosmos and governed an entire school of thought featuring humankind as the center of that universe—until Copernicus proposed a new cosmology with the Earth as just one planet within a far-flung system of orbiting objects in motion, a theory that opened the door to subsequent new discoveries by Galileo, Kepler, and Newton which would radically alter humankind's means and methods for understanding and interacting with nature (Kuhn, 1962/1996).

Human beings generate such models because of their cognitive utility in making knowledge visible. *In other words, our systems of thinking generate both simple and*

complex structures to model and perpetuate them. These models coalesce and aid our recollection of valued understandings or observations, making it easier to negotiate divergent bodies of knowledge in a convoluted world wherein new information cannot always "be integrated into the existing paradigm" and problems sometimes emerge or "persist which cannot be resolved" (Carroll, 1997, p. 174). In such cases, new models for negotiating both the known and still undiscovered or unmapped bodies of knowledge orbiting the human experience can collide with, supplant, or replace paradigmatic models that are fast becoming either obsolete or problematic points of connection within the evolving framework of human knowledge. In these ways, our models constitute and represent our truths—while also allowing us to reinterpret them freely.

Across the annals of human social history, the reason why oppressive systems consistently disassociate from, diminish, devalue, demolish, and destroy works of art—often while demonizing the creative practitioners and practices that produce them—is because surplus human social energy is a finite resource. Like a yes-no flowchart, if this surplus is not diverted to produce individualized profit and private gain for a select few, then it will instead produce creative leaps and common ground for all. That is the fundamental nature of surplus. As a product of surplus human social energy, all oppressive systems share these characteristic deviances from the common good: they are divisive, curtained, monocultural, and/or prescribed to produce models that are most identifiable by their almost molecular resistance to change.

According to Meadows (2008), a system "produces a characteristic set of behaviors" classified as its "function" or "purpose" (p. 188). Until it deteriorates or is overcome, a system of knowledge, like all systems, works to maintain the survival of its own characteristic relationships and functions over time—whether through growth, contraction, periods of equilibrium, or evolutionary leaps. This suggests that the effort of futurists to generate greater diversity, equity, and inclusion in human relations continues to *be* an effort precisely because there are dominant mental models and derivative practices in place which systemically work to *resist* greater diversity, equity, and inclusion out of sheer self-preservation. So, in an effort to develop a surreptitious argument for the continued incursion of models that appear effective in yielding greater diversity, equity, and inclusion against systemic forms of resistance, this chapter offers a brief account of the dominant archetypes of the status quo in oppressive and uncreative knowledge systems—the change-resistance of divisive knowledge, the anti-information of curtained knowledge, the inbred frailty of homogenous knowledge, and the rigidity of prescribed knowledge. What follows are four examples of liberatory and generative knowledge models derived from the oppressive and nullifying knowledge systems they must effectively counteract. For each systemic inequity, I will contextualize some potentially liberatory points of intervention.

Models of Constructive Creative Practice

There is clearly no one definition of art. Art-making systems are adaptable practices that naturally lend themselves toward the generation of knowledge models that are easily reinterpreted, diverting surplus human energy toward where it is most needed

at any given moment. Constructive practices for making art and innovation may be hybrid or alternately *formative* and solutions-oriented toward the production of a final product; *informative* and expressive-communicative; *transformative* and critical-activist; and/or *performative* and either improvisatory or repertory (Rolling, 2013c). One way to create common ground for living is through knowledge systems that focus on thinking through observation, experience, and/or experiment, toward mastery of the properties of mediums and materials.

> Viewing the arts as a system of production invites…collaboration with other disciplines that teach [citizens] to think empirically in a medium or material. [Creative practitioners] with an affinity for techniques and practices that generate beautiful forms, structures, and singular solutions will likely find…kinship with industrial and interactive designers, with architects, poets, filmmakers, and scientists.
>
> *(Rolling, 2011a, p. 10)*

Systems of inequity may work to resist liberatory and surplus formative energies by generating divisive models of *privileged* practice for the private gain of a select few, while others are either segregated into creative deserts or relegated to pipelines or prisons for exploiting their energies. Instead of the creation of surplus forms, new ideas, and openly accessible knowledge constructs, privileged practices are inherently nonconstructive and unavailable for community access. For example, racism privileges whiteness, relegating people of color into roles where their labor, lands, and energies are converted to the building of white wealth. Likewise, patriarchy privileges men, relegating women, and children into roles where their labor and energies are converted to the building of male power. Divisive human knowledge systems are nonconstructive, disintegrating the ties that bind us together by favoring the few over the many.

Models of Communicative Creative Practice

Another way to create common ground for living is through knowledge systems that focus on thinking expressively through a symbolic language.

> Viewing the arts as a system of communication invites…collaboration with other disciplines that teach [citizens] to think expressively in a language. [Creative practitioners] with an affinity for more interpretive practices that navigate the signs and symbols humans make in order to convey valued signifiers will likely find…kinship with [storytellers] of all kinds, mathematicians, musicians, dancers, and a multicultural array of ethnic, religious, and social communities.
>
> *(Rolling, 2011a, p. 10)*

Systems of inequity may work to resist liberatory and surplus informative energies by generating intransigent models of *normative* practice featuring an overwrought adherence to the tenets of Western-centric storytelling as the basis for validity in the

known world. Instead of the communication of surplus information, normative practices cancel out non-conforming information. This intransigence is exemplified in the following passage by Herbert Spencer (1896) in his book *Education: Intellectual, Moral, and Physical*:

> What knowledge is of the most worth?—the uniform reply is—Science. This is the verdict on all the counts. For direct self-preservation, or the maintenance of life and health, the all-important knowledge is—Science. For that indirect self-preservation which we call gaining a livelihood, the knowledge of greatest value is—Science. For the due discharge of parental functions, the proper guidance is to be found only in—Science. For that interpretation of national life, past and present, without which the citizen cannot rightly regulate his conduct, the indispensable key is—Science. Alike for the most perfect production and highest enjoyment of art in all its forms, the needful preparation is still—Science. And for the purposes of discipline—intellectual, moral, religious—the most efficient study is, once more—Science.
>
> *(Spencer, 1896, pp. 93–94)*

However, this particular story of science cannot be the full story of knowledge-creation since Western scientific methods for providing "an organized account of whatever knowledge we can obtain about the universe" are only several centuries old (Purtill, 1970, p. 306), while human beings have been acquiring, organizing, re-organizing, and transferring new surplus creative energies to one another for a great deal longer than that. Our museums are stocked with evidence that *artistic methods*—from the visual to the architectural to the performative to the literary—have likewise been systematically codified into meaningful organizations of our personal and social knowledge bases so that our shared discourses can grow. Intransigent human knowledge practices, no matter how bombastically pronounced, are inherently noncommunicative. Eurocentrism leaves too many story systems out of consideration, effectively bringing down an iron curtain of misinformation to encircle a self-made ghetto of impoverished stories—obscuring the validity of a multiverse of alternative norms and realities.

Models of Heterogeneous Creative Practice

Common ground for living is also created through knowledge systems that focus on thinking critically about the stories and ideas we choose to live by, interrogating the status quo.

> Viewing the arts as a system of critical reflection invites…collaboration with other disciplines that teach [citizens] to question their contexts, confront injustice, and seek to understand the gaps in given knowledge. [Creative practitioners] with an affinity for more critical practices that question situated or embodied contexts will likely find…kinship with feminists, iconoclasts, revolutionaries, cultural theorists, mass media dissenters, political activists, and environmentalists.
>
> *(Rolling, 2011a, p. 10)*

Systems of inequity may work to resist liberatory and surplus transformative energies by generating non-diverse models of *monocultural* practice that are dangerously inbred, identical, and vulnerable to the rapid spread of diseased mentalities seeking, for example, to oppress, exploit, or do harm to others for sport. Instead of generating sustainable and transformative change from surplus interactions within a diverse ecosystem of lived experiences and exchanged ideas, monocultural practices are practically unsustainable. Non-diverse human knowledge systems are unstable and as susceptible to a catastrophic failure to thrive or survive as a natural ecosystem that is not biologically diverse.

Models of Flexible Creative Practice

Finally, common ground for living is also created through knowledge systems that focus on thinking improvisationally, flexibly utilizing systems for making art and innovation that are alternately *formative* and solutions-oriented, *informative*, and expressive-communicative, *transformative* and critical-activist, or a hybrid *performance* exhibiting structures derived from all of these processes.

> Improvisational [knowledge-making] practices offer combinatory approaches for [surplus creative energies] that may include material-specific, language-specific, and/or critical-activist theory-building strategies—constituting arts-based bodies of knowledge "across" idiosyncratic modes of inquiry.
>
> (Rolling, 2013c, p. 147)

Systems of inequity may work to resist liberatory and surplus performative energies by generating non-flexible models of *prescribed* practice that fundamentally misunderstands and delimits the definition and purposes of art to decoration, entertainment, and investment property. Instead of the creation of surplus performative energies, prescribed practices are non-flexible. Non-flexible human knowledge systems foreclose the possibility of unexpected and mutually beneficial creative outcomes.

A SYSTEMIC APPROACH TO CREATIVE FUTURES

According to systems theory (Meadows, 2008), separate and distinct systems can sometimes be nested within one another—either parasitically like an infestation of fleas on a dog, or symbiotically like clownfish seeking protection among the stinging tentacles of a cluster of sea anemone. There is another such relationship directly relevant to this writing—*one system can also be a catalyst for change within a larger system that it nests within, working from the inside out*. For example, while racism is a system for structuring white supremacy and rendering Black lives as inveterate monstrosities, the arts have surreptitiously offered up counternarrative meaning-making systems reinterpreting the Black body as a beautiful form through the dance choreography of Alvin Ailey, for example in his masterpiece *Revelations*; the arts

have communicated life-affirming personal and cultural information about enduring the terrorism of random lynchings through Billie Holiday's urgent jazz soliloquy *Strange Fruit*; the arts have laid bare questions about racial injustice in America that have been hidden by the "answers," instigating urgent transformation through James Baldwin's literary call to action titled *The Fire Next Time*; likewise, the arts have improvised new storytelling inventions documenting the ongoing saga of African American communities in the United States through Jacob Lawrence's epic 60-panel painted visual narrative titled *The Migration Series*.

Given that systems will naturally resist change unless systematic interventions are undertaken, the remainder of this chapter cites specific examples of activists and innovators utilizing leverage points suggested by Meadows to "change the structure of systems to produce more of what we want and less of that which is undesirable" (p. 145), in a framework of anti-oppressive actions and outcomes I have developed in response. Below I have numerated my framework of proposed interventions *in reverse order* just as Meadows (2008) first presented them in her book *Thinking in Systems* (p. 147)—from those more basic, attainable, and likely to leverage only modest changes within a complex system, to the hardest kinds to engineer yet which are likely to yield the most enduring and widespread effect. Utilizing this framework, readers are invited to adapt any of the 12 following interventions as appropriate to context and purpose.

Altering Parameters as an Intervention for Nonconstructive Models

One can activate the de/re/construction of any prevailing social architecture that resists new creative futures, power-sharing, and greater equity, diversity, or inclusion in a number of ways. *At the very least, you can alter the parameters that mark the boundaries of the prevailing status quo, allowing it to diverge from its prior limits.* For example, one can practice and teach *art for social change*, not just self-expression, like Brazil's legendary theater artist and theorist Augusto Boal who, once elected to city government by Bogotá's mayor Antanas Mockus, "staged public coproductions of urban life," including "legislative theater," ultimately "training facilitators for non-actors who perform their worst problems and then improvise solutions for conflicts, mental illness, and unfair laws" (Sommer, 2014, p. 2).

12. *Constants*

According to Meadows (2008), a constant defines the rate at which something happens in a system. For example, change the constant rate of fuel consumption per mile in a car, and you fundamentally change the way that the vehicle operates in traffic. Through his art-making Michael Ray Charles offers a model of intervention in opposition to a prevailing social architecture that binges on a constant of attractive popular culture distractions, influence-peddling snippets and soundbites, and reality TV artificialities. Instead, Charles recalibrates the parameters of prevailing social constructs by reintroducing an old constant—the ugliest misanthropic stereotypes from America's past which were once rampant throughout this nation's popular culture, always ready

to erupt into virulence no matter how long dormant. Instead of perpetuating an impoverished notion of art merely as a medium for expressing beauty in the world, Charles inoculates the public with its own history of oppression, boosting its immunity against its worst inhumanity for the sake of its greater development (Charles, 2001).

11. Buffer Sizes

According to Meadows (2008), buffers are stabilizing elements within a system. Big buffers make the system more stable, and small buffers make it more subject to change. For example, the larger the amount you have in your savings account, the more likely your lifestyle will remain unchanged when faced with unexpected or exceptional expenses. During the influential artistic and intellectual movement known as the Harlem Renaissance, which bloomed in the United States from about 1918 to the mid-1930s, the immense buffer of racist imagery and buffoonish iconography in the United States was eroded and disrupted by a groundswell of figures, symbols, and artifacts celebrating the identities and cultures of persons of color in everyday life (Powell & Bailey, 1997).

10. Physical Structures

According to Meadows (2008), reconfiguring a system's physical infrastructure and the way it incorporates the elements it needs to sustain its functioning can have an enormous effect on its operations. For example, museums and galleries are architectural enclosures for the preservation and exhibition of art; they also serve a gatekeeping function regarding what works of art are preferred, purchased, and accessioned for inclusion in that institution's collections as well as what audiences have access to its canon of artifacts. Street art, on the other hand, is positioned well outside the boundaries of gatekeeping cultural institutions with classical facades and welcomes all members of the public as its audiences, free of charge or social distinctions (Sweeny, 2013).

Altering Feedback as an Intervention for Noncommunicative Models

One can also alter the feedback that informs how the prevailing status quo acts upon the individuals, institutions, and elements that constitute it. For example, one can simply portray Black lives as lives that fundamentally matter, like the contagious Detroit musical hit factory known as Motown founded by Berry Gordy in collaboration with a small network of Black businessmen and women that included numerous musicians, songwriters, performers, producers, and recording engineers, many of whose names remain obscure even today (Rolling, 2013a).

9. Delays

A system's functioning is determined by how much lag time passes between the summoning of new resources and the intake of that regulating inflow. For example, imagine stepping into a shower in an old hotel where the water temperature takes at least a minute to respond to each faucet twist, oscillating between an overcapacity of hot water and an under-capacity. Krzysztof Wodiczko employs a strategy to counteract delays in humanity's response to inhumanity through his creation of large-scale video

projections on architectural façades and monuments, thus serving as sites of collective memory and dialogue through the public presentation of acts of confession, trauma, grief, fear, anger, and mourning (Rolling, 2013c). Wodiczko solicits these brave acts while participants are most vulnerable, and their raw emotions are key elements of the art-making process.

8. Negative Feedback Loops

A negative feedback loop *slows down* a process to preserve the optimal functioning of that system. An example is when a thermostat calls for more heat in a room, and the boiler responds by sending hot water to the room's baseboard heaters, which in turn begins to heat up the air in that space over a period of time. The slow loop will keep the system's functioning optimal and keeps the room from getting overheated too quickly depending on established parameters of the boiler and the accuracy and speed of the feedback. James Brown defiantly *sped up* the process of disrupting racism's malignant stereotypes with his musical anthem "Say It Loud—I'm Black and I'm Proud," informing US citizens of beliefs rarely given public expression (Rolling, 2011b).

7. Positive Feedback Loops

A positive feedback loop *speeds up* a process that regulates the optimal functioning of that system—the more it works, the more it gains power to work more. For example, the success of pyramid schemes depends on the ability to recruit more and more investors. Since there are only a limited number of people in a given community, after the initial rush of success, all pyramid schemes will ultimately collapse. The only people who make money are those few initial investors who are at the top of the pyramid. Meadows (2008) suggests that in most interventions, it's preferable to slow down a positive loop rather than speeding up a negative one. To slow down the capitalist inertia toward inhumane labor practices, the documentary photographs of Lewis Wickes Hine were activist texts and catalysts for the transformation of workplace policies allowing the use and abuse of child labor in industry (Rolling, 2011b).

Altering Design as an Intervention for Non-Heterogeneous Models

One can also alter the sustainability of a prevailing status quo's design so that it damages its own ability to replicate or reproduce itself. For example, given that cinema is an iterative medium wherein films borrow the tropes, archetypes, and visual metaphors of previous films, the use of Black characters in films only as sidekicks or one-dimensional caricatures was forever changed simply by introducing Black characters who were the main protagonists in stories that were written and/or directed by African Americans, incorporating the Black power ideology that was reshaping race relations in the United States.

6. Information Access

It is easier to change the flow of information about what is happening within a system and where it is happening, than it is to change the structures that constitute that

system. For example, it was at first easier to intervene in the widespread oppressive practice of slavery through the publication of intimate, first-hand slave narratives and other forms of abolitionist literature, art, and poetry.

5. Rules

The rules by which a system operates define the relationship of the elements that constitute it, its boundaries for growth, and its viability within certain habitats or contexts. For example, Afrofuturism is a cultural aesthetic that decodes and recodes the rules of popular culture, generating new points of access into story genres that otherwise excluded the presence of the African diaspora, such as science fiction, superheroes, and horror.

4. Evolution

This is the power to insert rogue elements into a system which can then mutate, evolve, or self-organize—just like a virus—in a way that radically changes the functioning and constitution of that system. In the few decades since its origins in the 1970s, the hip-hop music genre—born out of the culture of urban, minoritized, disenfranchised youth—has insinuated itself globally throughout the canon of traditional contemporary Western music, popular culture, and fashion (Rolling, 2011b).

Altering Intent as an Intervention for Non-Flexible Models

First and foremost, one can fundamentally alter the intent of a prevailing status quo so that it achieves an entirely different output and outcome. For example, in the storied Kansas City "cutting contests" of yesteryear, up-and-coming jazz artists entered late-night jam sessions and were expected to copy the complex riffs of the region's most masterful musicians—and yet adapt and improvise flourishes all their own.

3. Goals

Changing the goals of a system changes its parameters, its feedback loops, and the inherent design of its information flows and self-organization. In response to the visual argument of racial inferiority, the Harlem Renaissance inaugurated the performance and presentation of the "New Negro" archetype in order to relocate the African American experience and identity within a new locus of self-imagery (Willis, 2000).

2. Remodeling Paradigms

A paradigm is a model or a pattern to live by. Paradigms are the sources of systems. Goals, mindsets, values, beliefs, and social contracts for ethical interactions all arise from the prevailing communal paradigm. For example, the Marvel superhero movie *Black Panther* marked a monumental shift in cinema history not only by being nominated for seven Academy Awards and bringing Afrofuturist aesthetics into the mainstream but also by proving that a predominantly Black cast can draw huge audiences and break box office records globally, across cultural boundaries.

1. Transcendence

Like being born-again into newfound purpose, this is an intervention which elevates an individual to a state of "enlightenment" that changes everything (Meadows, 2008, p. 164). It is akin to an eruption, an earthquake, or a revolution. For example, from Frederick Douglas to LeVar Burton, African Americans have always experienced and fostered the acquisition of literacy as akin to a renaissance of identity that no other person could dispute or despoil. Creative leaps also have a transcendent property, capable of changing everything and establishing unexpected futures.

CONCLUSION

The purpose of this chapter was to expand our general understanding of the work of art in systemic human social relations when that work is purposed not only to give shape to our best ideas and *form* new aesthetic achievements but also to *inform* ourselves, *transform* ourselves, and *perform* our best selves, making common ground for living. In this writing I have explained four models of art + design practiced not for art's sake but rather for humanity's sake, as surplus energy systems. I have also presented 12 adaptable interventions for igniting these surplus engines for the generation of new possibilities, thereby leveraging the emergence of new futures even when resisted by intransigent systems for preserving status quo inequities. Localized adaptations for introducing new interventions toward achieving greater equity are essential for human development, just as I encouraged in my open letter to fellow creatives who similarly understand that Black lives matter no less than any other life (Rolling, 2020). Given the rampant increase in political polarization and divisive rhetoric over recent years, adapting the arts and design as leverage points for uprooting inequities and promoting civic engagement is also timely. Now go and do likewise.

REFERENCES

Bataille, G. (1949/1991). *The accursed share: An essay on general economy. Vol. 1: Consumption* [Hurley, R., Trans.]. Zone.

Carroll, K. L. (1997). Researching paradigms in art education. In S. D. La Pierre & E. Zimmerman (Eds.) *Research methods and methodologies for art education* (pp. 171–192). National Art Education Association.

Charles, M. R. (2001). *Michael Ray Charles in "Consumption" | Art21 | Segment from Season 1 of "Art in the Twenty-First Century."* Available at: https://art21.org/watch/art-in-the-twenty-first-century/s1/michael-ray-charles-in-consumption-segment [Accessed 5 January 2023].

Derrida, J. (1976). *Of grammatology.* John Hopkins University.

Garoian, C. R. (2013). *The prosthetic pedagogy of art: Embodied research and practice.* State University of New York.

Gentner, D., & Stevens, A. L. (Eds.) (1983). *Mental models.* Lawrence Erlbaum.

Halloun, I. A. (2007). Mediated modeling in science education. *Science & Education, 16*(7), 653–697.

Harari, Y. N. (2014). *Sapiens: A brief history of humankind.* Random House.

Kosalka, D. (1999). George Bataille and the notion of gift. *Online article.*

Kuhn, T. S. (1962/1996). *The structure of scientific revolutions* (3rd ed.). The University of Chicago Press.

Meadows, D. H. (2008). *Thinking in systems: A primer*. Chelsea Green Publishing Company.

Meyer, J. W. (1977). The effects of education as an institution. *The American Journal of Sociology*, 83(1), 55–77.

Powell, R. J., & Bailey, D. A. (Eds.) (1997). *Rhapsodies in black: Art of the Harlem renaissance*. University of California Press.

Purtill, R. (1970). The purpose of science. *Philosophy of Science*, 37(2), 301–306.

Rolling, J. H. (2011a). Art education as a network for curriculum innovation and adaptable learning. In *Advocacy white papers for art education, section 1: What high-quality art education provides*. National Art Education Association.

Rolling, J. H. (2011b). Arts practice as agency: The right to represent and reinterpret personal and social significance. *Journal of Cultural Research in Art Education*, 29, 11–24.

Rolling, J. H. (2013a). *Swarm intelligence: What nature teaches us about shaping creative leadership*. Palgrave Macmillan.

Rolling, J. H. (2013b). Art as social response and responsibility: Reframing critical thinking in art education as a basis for altruistic intent. *Art Education*, 66(2), 6–12.

Rolling, J. H. (2013c). *Arts-based research primer*. Peter Lang.

Rolling, J. H. (2015). Swarm intelligence as a prosthetic capacity. In C. Garoian (Ed.) Special issue: The prosthetic pedagogy of art. *Qualitative Inquiry*, 21(6), 539–545.

Rolling, J. H. (2019). Philosophies of creative leadership in historical context: Paradigms and practices in art & design education. In *The international encyclopedia of art and design education (Vol. 1)* (pp. 533–549). Wiley-Blackwell.

Rolling, J. H. (2020, July 10). *Black lives matter: An open letter to art educators on constructing an anti-racist agenda*. National Art Education Association, Advocacy & Policy Links. Retrieved September 9, 2023, from https://www.arteducators.org/advocacy-policy/articles/692-black-lives-matter

Schildgen, B. D., Zhou, G., & Gilman, S. L.(Eds.) (2006). *Other renaissances: A new approach to world literature*. Palgrave Macmillan.

Sommer, D. (2014). *The work of art in the world: Civic agency and public humanities*. Duke University Press.

Spencer, H. (1896). *Education: Intellectual, moral, and physical*. D. Appleton and Company.

Sweeny, R. W. (2013). Street art. *Art Education*, 66(5), 4–5.

Willis, D. (2000). *Reflections in black: A history of black photographers 1840 to present*. W. W. Norton & Company.

Art Education for Democracy

Insights from Who Is American Today? *Project*

Flávia Bastos

> **INSTRUCTIONAL QUESTIONS**
>
> 1. How can educators, in particular art educators, engage with political topics, current events, and identity issues in today's classrooms?
> 2. What can digital media and contemporary technologies (videos, podcasts, social media) offer to foment civic engagement and promote critical digital citizenship?
> 3. What is the relationship between developing digital making skills and preparing students to become critical and transformative citizens?
> 4. What is the responsibility of creative educators to teach to sustain democracy? And what barriers do they encounter?
> 5. How do contemporary ways of teaching and learning ignite desire for civic dialogue, social justice, and democracy?

In the small office adjacent to James Rees art room, Cameron showed me the story board he was developing to in response to the project's prompt: "Who is American Today?" Displaying all the expected jadedness of a high school senior, Cameron demeanor was edgy and seemingly uncomfortable. His storyboard was empty, except for a few minor and unrecognizable sketches. The concept for his digital story was so elusive that he could not clearly explain it. He avoided my questions about the project, instead looking out the window into the spectacular Utah mountain views and blue skies surrounding the school. He was angry about President Trump's ban on transgender military

DOI: 10.4324/9781003402015-11

officers, he was questioning the value of his education, and the state of the country. I played the teacher's card and encouraged him to finish the project by the deadline. When our conversation ended, I fully expected Cameron not to come through. Nonetheless, to our surprise, a week or so later he finished one of the most compelling digital stories in our data set—a stop-motion hand-drawn animation giving voice to the perspective of a transgender high school student who powerfully stated he did not belong in American society.

(Research notes, October 10, 2017)

This chapter is about the power of digital making tools to engage students with the issues around them, therefore advancing their capacity for civic engagement. Proposing a pragmatic approach for *critical digital making*, defined here as the intentional synergy between learning about digital making strategies (or the process of developing multimedia works using digital tools) to connect the students' personal and political spheres, I examine how our research project *Who Is American Today?* provides a robust rational for the role of art education in promoting democracy.

Artistic practices are uniquely positioned to facilitate reflection and expression of one's lived experiences as evidenced in Cameron's story, which illustrates how critical digital making can provide avenues for all students to communicate their situated perspectives and positions in society. *Who Is American Today?* inquires about the connection between art and civic engagement, while affirming that the creative process offers a method for reflection, expression, and engagement that can create the necessary conditions for coalition building and provide a road map for fomenting change. Articulating the findings and lessons derived from the project's seven-year history, this chapter provides (a) a rationale for education as political practice that can be activated through art, and (b) a discussion of insights derived from the project, including a description of the project's structure, key results, and an examination of outcomes and lessons learned. *Who Is American Today?* is a collaboration with James Rees, a master art educator of national reputation who taught at Provo High School in Utah for many years. James and I conceived of this project together and have partnered since its inception contributing to it our complimentary perspectives of a classroom teacher and researcher (www.whoisamerican.org). I write this chapter as primary author, incorporating input and suggestions from James.

(ART) EDUCATION IS POLITICAL

I embrace Freire's (1971/2000) notion that education is a political act that either reinforces the status quo or promotes critical consciousness with the goal of promoting social justice. Freire conceived of education as a praxis of aligned theory and methods with the goal of preparing students to engage in the promotion of freedom. His methods emerged during a time when more than half of Brazilian adults were illiterate and therefore more susceptive to political manipulation and oppression. Mid-1960s Brazil was a time of civil unrest that reflected widespread social justice movements taking place across Latin America seeking to achieve greater social

opportunity, inclusion, and justice. In response to this, with help from the Central Intelligence Agency (CIA) a coup displaced the elected government, and a military junta established a dictatorship, curtailing civil rights, including the right to vote, censoring the media and the arts, and imprisoning and torturing those who opposed the regime. I was born at that time and came of age in a country that earned for democracy, the right of free expression, and the return of the artists and intellectuals who went into exile, but whose ideas and artworks fueled a robust creative resistance movement.

Freire's educational philosophy and methodology are grounded on the notion that education is a political process that connects students to civic engagement. I have pioneered employing Freire's ideas to art education in my early work on the topic of community-based art education. Doing research in a rural school in Southern Indiana, I was curious about the potential of facilitating engagement between students and the local art of the primarily White and economically underprivileged town of Orleans, population 2,000 as means to raise awareness of their circumstances and appreciation for the local culture and heritage. Applying Freire's literacy methods designed to empower Brazilian adults to become critical citizens through learning to read and write to the art education context in rural Indiana yielded surprising outcomes. Adults in Freire's literacy circles re-discovered their connections to the places where they lived, worked, and socialized by unpacking the meaning of words and texts derived from their everyday work and community experiences. More than coding and decoding words and learning the conventions of language, literacy was a process of making meaning of a learner's circumstances. Seeing teaching adults to read and write as a political act that connected acquiring knowledge and at the same time nurturing creativity, Freire (1983) affirms that "reading the world always precedes reading the word, and reading the word implies continually reading the world" (p. 10). He articulated a fundamentally political premise that education must provide tools and skills to critically examine, shape, and transform one's experience. Consequentially for me and others (Bastos, 2016; hooks, 1994; McLaren, 2010), art and politics are intertwined and connected to transformative approaches to education.

In a Freirean tradition, the students, and teachers I worked with in Orleans, Indiana, were invited to revisit their established conceptions of art, making room for bringing local art forms into their awareness. This process of gradually recognizing the art production that existed in the surrounding community and to begin to engage with it as educational content led to the acknowledgment of the network of makers in the local community, who have been excluded from educational consideration. I coined the term *making the familiar strange* (Bastos, 2002) to capture the process of consciousness raising that resulted from examining everyday experiences within the local culture and enabled a broader and more inclusive definition of art to emerge. Learning with, about, and through the local community transformed the way teachers and students in Orleans saw themselves, and their culture. This re-writing of their world demanded a new, re-envisaged, narrative about the community and its people, which was broader and more inclusive, validating, honoring, and celebrating the local culture and the peoples' concerns, values, and modes of expression.

Tucker (1996) denounces that more inclusive understandings of art, in which rigid boundaries between what is and is not considered art, are contested because they correspond to more democratic views of society. She goes on to caution that rigid categorizations between high and low art reflect a conservative societal project. In contrast, the process of *making the familiar strange* has the potential to re-signify connections among students, teachers, and their own community and to prepare them to engage civically in more informed, critical, and interested ways. Centering art and education practice upon the immediate circumstances of learners can provide a meaningful pathway from the personal to the political.

One of the key concerns for today's educators is how to support students in learning to articulate their own voices to foster democratic dialogue (Kinlock, 2011). Recognizing culture has shifted from primarily communicating with text-based language to the image as the dominant tool of expression, teachers and educational researchers must consider how the prevalence of digital media in students' lives can be effectively integrated to shape learning, exploration, and self-expression (Greene, 2020; Johnson et al., 2014; Ritzer & Jurgenson, 2010). Furthermore, as the United States grows more diverse and divided, public schools find greater challenges to effectively promote democracy (Blandy & Congdon, 1987; Kozol, 2005). Certain types of classrooms can create conditions whereby students have an opportunity to exercise their citizenship and begin to build their own public spheres (Calhoun, 1992). Young people are often alienated and disenfranchised from politics because they "are not defined in our society as political subjects, let alone as political agents" (Buckingham, 2000, p. 219). According to Gutmann (2004), culturally responsive teaching promotes structural inclusion because it gives students an experience of recognition and civic equality. Further, teachers must "find ways of establishing the relevance of politics and connecting the 'micro-politics' of personal experience with the 'macro-politics' of the public sphere" (p. 221). A core belief in my work is that creative engagement must integrate critical thinking and making. My career as an art education researcher, and in particular my role in the *Who Is American Today?* project, leverages this Freirean-inspired commitment to education practices that sustain our democratic imagination while at the same time developing skills for civic engagement. Central to the vision of *Who Is American Today?* (see Figure 8.1) is the investigation of how digital making, defined as the creative practice of critically interpreting and making digital media texts, can promote and advance civic engagement with high school students.

WHO IS AMERICAN TODAY?

Who Is American Today? is an ongoing research project that seeks to understand how critical digital making can advance notions of citizenship in visual art classrooms. This project incorporates elements of traditional qualitative inquiry and arts-based research (Barone & Eisner, 2012; Leavy, 2015; LeCopmte & Preissle, 1993). Digital making is conceptualized as utilizing digital tools to produce visual art that can "create knowledge to help us understand in a profound way the world in which we live" (Sullivan, 2010, p. x). This project is loosely inspired in the European study

ART EDUCATION FOR DEMOCRACY 127

FIGURE 8.1 *Who Is American Today?* Exhibition poster.
Photo by James Rees with permission.

"Creative Connections," designed to encourage the voices of young people in exploring European identities. According to Richardson (2016), the project facilitated representations of identity and belonging through a range of media, unveiling the effect of economic and political decisions, and challenging notions about experiences of European citizenship. To some extent, the current political and social upheavals in the United States parallel those taking place in Europe and around the globe raising questions about the role and responsibility of education in general and art education in particular to promote or engage with issues of citizenship. Global migration, the rise of populist nationalism, and the quest for legal recognition, visibility, civic equality, and structural inclusion of diverse racial, ethnic, cultural, linguistic, and religious

groups have complicated the attainment of citizenship in countries around the world, including France, Canada, England, and the United States. More recently, the war in Ukraine and the Palestinian-Israeli war have challenged a presumption of world peace. Western nations are facing increasing challenges to civic values illustrated by violent conflicts between police officers and communities of color (Taylor, 2016), large numbers of immigrants from nations such as Syria and Iraq seeking refuge in Europe, and terrorist attacks taking place in cities such as Paris and San Bernardino, California, and London, to cite a few. Further, xenophobia and intolerance have led to anti-immigrant positions behind the passage of the Brexit referendum for the United Kingdom to leave the European Union, the popularity of conservative political leaders in Europe (Banks, 2017), and the election (and potential re-election) of Donald J. Trump as President of the United States. These developments and events have stimulated renewed contentious and polarized political discussions and debates about the extent to which Western nations can and should structurally integrate diverse ethnic, cultural, linguistic, and religious groups into their nation-states and provide opportunities for them to become fully integrated and participatory citizens in society (Bawer, 2006; Murray, 2017).

Who Is American Today? represents an activist and pragmatic way to lean into these issues, leveraging the potential of digital tools to capture, articulate, and disseminate the experiences of high school students across the country. Students are asked to respond the prompt "Who is American today?" through a short, 1–2 minute video. Each student's digital story unveiled critical connections between students' experiences with digital making and citizenship.

The analyses of these videos unlock our understandings about the relationship between digital making and citizenship. The central questions informing this ongoing research are as follows: (a) How can art education prepare students to be critical citizens engaged in our national community? (b) How do contemporary instructional strategies help students articulate their own experiences and desire for social justice and democracy? (c) How can digital media making promote critical digital citizenship?

Structure

Since the project's inception in 2017, five cohorts of students (see data table) have contributed to the investigation, totaling 96 participants. The project's website provides a platform to disseminate outcomes and invite participation (www.whoisamerican.org). Information about core values and objectives, a lesson plan, digital media galleries featuring the work of participants, events, social media links, and contact information is provided in English and Spanish. During the pandemic, many teachers utilized the resources and lesson plans to develop meaningful lessons. Each cohort completes consent forms, engages in planning with the research team, and collects data in the form of interviews, work in development, and finished videos.

Data analysis focuses on two variables: (a) students' digital making skills and (b) students' understandings of citizenship. Based on the strategies used for creating the video, the research team developed a rubric that outlines a progression of digital making skills, ranging from *underveloped* to *competent +*. A typology proposed

by James Banks (2017) provided a lens to distinguish among students' perspectives regarding citizenship. According to Banks, citizens have rights and privileges within a nation-state and are, therefore, entitled to protection by the nation-state. However, increasingly today we witness many racial, ethnic, cultural, linguistic, and religious groups are denied structural inclusion into their nation-state. Consequently, they do not fully internalize the values and symbols of the nation-state, develop a strong identity with it, or acquire political efficacy. They focus primarily on specific group needs and goals rather than the overarching goals of the nation-state. This process is described as *failed* citizenship. Banks proposes four approximate overlapping categories useful to think about citizenship socialization and citizenship education:

1. *Failed citizenship* relates to persons who do not internalize the values and ethos of the nation-state, feel structurally excluded within it, and have highly ambivalent feelings toward it.
2. *Recognized citizenship* exists when the nation-state publicly recognizes an individual or group as a legitimate, legal, and valued member of the polity.
3. *Participatory citizenship* involves individuals with citizenship rights taking actions as minimal as voting to influence political decisions in their communities, nations, and the world to actualize existing laws and conventions.
4. *Transformative citizenship* requires citizens to take action to implement and promote policies, actions, and changes that are consistent with values such as human rights, social justice, and equality. The actions that transformative citizens take might—and sometimes do—violate existing local, state, and national laws.

Although these categories are distinct, they overlap and intersect dynamically. For example, individuals must be recognized by the nation-state as legal and legitimate citizens before they can become participatory citizens who can take actions such as voting. However, failed, recognized, and participatory citizens can all take transformative actions to make fundamental changes aimed at promoting social justice and equality.

Our research focuses on understanding the relationship between the citizenship types, the process of digital making, and civic engagement. Gleaning from each cohort's data, including observations, interviews, and final videos, the research team identified the level of digital making skills and citizenship type for each participant. Banks' model was utilized to interpret the content of each student's videos to identify the citizenship type represented and our digital making rubric helped determine digital making skills. To offer a glimpse of the types of digital stories created and what we can learn from them as educators and researchers, we will examine the work of two students from Provo High School—Tania and Cameron. Their backgrounds are representative of the diversity of American classrooms regarding age, gender identity, socio-economic status, and ethnicity.

According to 17-year-old Tania (see Figure 8.2), "nobody is the same, we all have a story to tell." She sees Americans are caring and independent and aspire for better opportunities. Her position illustrates the stance of a *recognized citizen*; she talks about her parents coming to the United States from Mexico 25 years ago and

FIGURE 8.2 Tania, Provo High School, still from digital story.
Photo by James Rees with permission.

traveling between the two countries. Born in Mexico and raised in the United States, she considers herself an American. Her digital story was created proficiently, utilizing primarily family images depicting landmarks of her personal history—celebrations, graduations, sports events, family gatherings—and conveyed a sense of connection and pride. She concludes by saying, "it doesn't matter where you are from, or how you look, you can be an American just as everybody else. Be the person you are meant to be" (https://www.youtube.com/watch?v=U0UW35VRAmo).

Cameron offers a critical view. His video developed from the incomplete work we discussed in the vignette at the beginning of the chapter into a powerful narrative (see Figure 8.3). Distancing himself from Americans, Cameron's digital story powerfully expresses his feelings of a citizen who does not fit in. As a transgender 18-year-old, Cameron voices the experience of not feeling recognized. His hand-drawn animated story transcends the narrative of a *failed* citizen through *advanced* digital making skills. In fact, Cameron's skill leading the viewer to consider carefully and thoroughly what is being said makes him a *transformative* citizen. As a counter-storyteller, Cameron defies mainstream narratives of America, inviting us to consider the problems of not embracing diversity, and the implications of narrowly conceived policies resulting in closing social opportunities and civic participation (https://www.youtube.com/watch?v=zgKZZa14V-w&t=5s).

Results

Interviews and videos offered insights into students' perspectives. These results help us understand how students conceptualized (a) American identity, (b) digital making, their experiences with articulating, (c) personal voice, and their (d) views of citizenship.

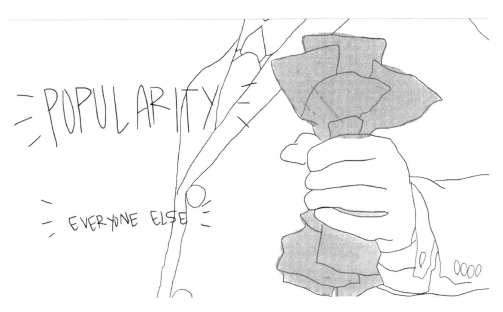

FIGURE 8.3 Cameron, Provo High School, still from digital story.
Photo by James Rees with permission.

American Identity

Overall, students considered it difficult and complex to examine the topic of who is American today because it could bring about controversy and anger. Some students recognized significant gaps between ideas typically associated with being an American, such as patriotism and love of country, and the current socio-political reality laced with dissent and controversy. Students underscored that democratic collaboration required positive shared understandings about how to belong to a community and participate in civic society. Many students seemed surprised that there were so many different opinions among their peers. The diversity of students' experiences, particularly their status as immigrants (or not), had strong influence in their experiences in and views of America. The interplay of social economic status, race and ethnicity, and experiences with diversity, including recent arrival in the United States, resulted in a rich spectrum of positions among the students that mirrors opinions in the country at large (Bastos & Rees, 2021a). Both students and researchers were surprised that the range of views expressed ranged from intolerance bordering White supremacy, to very inclusive and liberal perspectives. The range of opinions about what it means to be American was often expressed through ideologized imagery, such as the military, the flag, and even sports teams' insignias and sporting events. Alternatively, some students' videos reflected their personal values, family experiences, and identity, which were visualized through creative strategies such as family sourced photographs and memorabilia, images of their home and community surroundings, and student-generated images such a photographs and drawings. An interesting observation is that after students shared their digital making practice through critiques during the making process, many refined their choices

moving away from stock photos and ideologized images toward more personal and student-created imagery.

Digital Making

Students did not initially consider the video assignment to be an art project. Most students interviewed thought art is a good way to express a variety of opinions. Many students believed "art can give people a voice" and "can help examine what it is to be a citizen" (personal communications, October 10, 2017). These interviews suggest that students struggle to include digital media within their definition of art. However, once they were able to discuss art more broadly, as to include digital media tools, they were more positive regarding the process of developing digital media skills and saw their emerging digital media literacy more favorably. This shift in understanding is significant because it can support a richer engagement with digital media in education and greater consideration for art's role in engaging with current topics to articulate and share delicate, persuasive, and poetic perspectives.

Despite reported avid consumption of digital media, students did have not many experiences producing media content, such as films or digital stories, especially if it involved personal experiences and opinions. Most of their reported digital media interactions involved *liking*, and sharing content posted by others, and they did not see their own social media posting as content for other's consumption. In responding to the video prompt, the most utilized approach to structure the video's narrative was to create videos as a narrated slide presentation. However, through exposure to different approaches including examples from artists using digital media and from the work created by peers, and critical reflection, students were able to expand their storytelling strategies to include, in addition to still images, animation, music, and visual effects that emulated and, in some cases, borrowed from what they have seen in film, media, games, television, and advertising. Data across all five cohorts confirms that regardless of students' daily exposure to digital tools, most students are at the beginning of their development as *competent* digital makers. The digital making skills of about two-thirds of high school students in this study are at the emerging stage or below. This trend underscores the opportunity that digital making presents in education to infuse student's relationship with digital media with criticality, reflection, and to unleash its potential to articulate voice toward greater dialogue, interactivity, and engagement.

Personal Voice

Increasingly, teachers and students are tentative about or outright avoid examining and sharing their personal experiences and perspectives, especially when related to difficult topics. In our engagement with this project, students have hesitated to express and in some case refused to communicate their own opinions. Oyler High School students, for example, asked pointed questions about who was going to have access to the videos and seemed to be evaluating the consequences of speaking freely. Upon reflection, such a cautious stance from a group of mostly Black students participating in an after-school media literacy program in an underprivileged community in Cincinnati makes sense considering the daily threats that are part of their

lived experiences. Nonetheless, it seems important to take stock of the current educational climate across the country and to consider how it might impact the experiences of students and teachers. For example, Alexa a student from Miami Valley High School explicitly remarked that "I have never done something like this before. I have done class projects before, but I have never been able to express my opinion before" (personal communication, November 13, 2020). Rather than considering this to the isolated perspective of a single student, this comment is a warning about the directions that are evident in contemporary education and the risks of suppressing the exploration of personal opinions and positions in educational spaces perhaps to avoid the risks that might be associated with free exploration of ideas for both teachers and students.

In fact, one of the questions teachers often ask when they consider participation in this study is about how they can safely and appropriately engage with potentially volatile contemporary topics. Our guidance to educators points out that an important purpose of education is prepared for democratic participation, and that safeguarding space for student voice in classroom is essential. We have also offer practical strategies for teachers to engage with difficult topics (Bastos & Rees, 2021b) negotiating the increasingly politicized relationship with administration and creating a culture committed to keeping students safe. We recognize that while it is important to promote a space for free speech and dialogue in classrooms, there are many constraining factors and risks that teachers must consider. Overall, the experience of *Who Is American Today?* underscores the need to encourage and expand the critical investigation of current issues and the development of personal voice rather than avoiding them for fear of consequences.

Citizenship

Unsurprisingly, approximately 70% of students participating in this project are considered *recognized* citizens. Just the fact of being registered in school would have required recognized citizenship status. At the same time, the lack of opportunity to engage with current events and explore personal opinions in educational settings may have an effect in preventing students from developing more advanced concepts of citizenship. Additionally, it is of concern that 13% of participants identify as *failed* citizens, reflecting their general malaise and feelings of exclusion from American society. If follows that only 13% of participants position themselves as *participatory* citizens who are able and equipped to engage with civic life. This raises many concerns about education's effectiveness in preparing youths to participate in a democratic society. Nonetheless, our data thus far indicates a positive and beneficial relationship between achieving competence in digital making skills and becoming a transformative citizen (see data visualization). We observed that regardless of citizenship type, from identifying as a *failed*, *recognized*, or *participatory* citizens, engaging in digital making had a positive impact in augmenting students' communication and reflection skills. The emerging finding of our study is that the development of digital making tools when applied to the personal spheres of students may facilitate civic engagement and lead to transformative action. *Who Is American Today?* validates the notion that critical approaches to digital making in which media analysis and production are

connected facilitate the understanding that learning about the world is directly linked to the possibility of changing it and become a "prerequisite for self-representation and autonomous citizenship" (Goodman, 2003, p. 3). We encountered strong and sustained evidence that engaging in critical digital making has the potential to engender productive, creative, and even political acts; therefore, enabling students to locate and express their own voices, and use them to inform participation in their own communities and beyond, with the potential of affecting change. In this way learning about making with the tools and about the issues of today provides a methodology for civic engagement and transformation.

The experience of the *Who Is American Today* unveils a pragmatic and productive approach to digital making in which students investigate the timely issue of American identity through widely available digital tools. According to one student, creating and sharing through this project could be described as a three-step process: "first you see it, then you understand it, and later you do it at a deeper level" (student interview, October 11, 2017). In the words of another student, digital stories are "a great way to express one's perspective and avoid the white noise that conversations tend to become" (student interview, October 11, 2017). Ninety-six students have wrestled with the question of "Who is American today?" from their own situated perspectives, expressing their ideas through evolving digital making skills (see Figure 8.4). True to media literacy goals, the project seeks to articulate student voice to promote

Who is American Today? Project
Data by cohort

	Provo HS 2017 (n=37)		Provo HS 2016 (n=23)		Miami Valley HS 2020 (n=22)		Kennedy Heights 2020 (n=5)		Oyler HS 2021 (n=9)		TOTALS (n=96)	
DIGITAL MAKING												
Undeveloped	4	11%	2	9%	2	9%	2	40%	2	22%	12	13%
Emerging	27	73%	20	86%	14	64%	1	20%	7	78%	69	72%
Emerging +	3	8%			4	18%					7	7%
Competent	2	5%	1	5%	1	4.5%	2	40%			6	6%
Competent +	1	3%			1	4.5%					2	2%
CITIZENSHIP TYPES												
Failed	2	5%	3	12%	3	14%			4	44%	12	13%
Recognized	25	68%	17	74%	16	73%	4	80%	5	56%	67	70%
Participatory	8	22%	2	9%	1	4.%	1	20%			12	13%
Transformative	2	5%	1	5%	2	9%					5	4%

FIGURE 8.4 Data table by cohort, prepared by Flávia Bastos.

understanding and dialogue about students' experiences and perspectives. By creating and circulating original videos, students can experience how digital making can create possibilities for surpassing polarizing issues, engender shared understandings, and foster awareness of the relationship between digital making, voice, and the pursuit of a common good.

Outcomes and Lessons Learned

Developing digital making skills integrates critical thinking and making, while preparing and encouraging students to actively participate in their communities as cultural producers (Mattson, 2017, McGillivray, 2016). Responding to the unique conditions of our times, which involve unprecedented access to digital tools, increasing political intolerance, a reckoning of American society's racist structure (DiAngelo, 2018), and a global pandemic that disrupted conventional ways of teaching and learning (Dehner, 2020), digital making can provide an integrative approach from which to examine these burning issues while creating opportunities to advance education's critical goal of promoting social justice. However, one potential barrier to this work is the fact that students are seldom asked for their opinions and in some cases are afraid of expressing their ideas to authority figures. This suggests that education is out step with fundamental democratic principles such as developing citizens who are willing and able to participate in the democratic process, promoting tolerance and understanding, and supporting human rights, including the right to voice. Digital media literacy encompasses digital making in an effort to advance contemporary education toward greater meaning and impact. Simultaneously, digital media literacy advances students' right to and exercise of free speech. Share (2002) suggests that "critical media literacy pedagogy provides the students and teachers an opportunity to embrace the changes in society and technology not as threats to education but as opportunities to rethink teaching and learning as political acts of consciousness raising and empowerment" (p. 4). The experience of *Who Is American Today?* underscores the transformative power of critical digital making to support young peoples' process of seeing themselves as civic agents capable of starting and sustaining change.

Developing critical digital making skills moved students from a narrow and individualistic relationship with social media that traded on the allure of popularity and promoted disinformation about, to an evolving understanding, how digital media is created and utilized, and most importantly, it allowed for firsthand experiences creating and disseminating digital content applied to expressing, amplifying, and organize voice. This trajectory toward more nuanced knowledge of digital tools and their potential, witnessed with research participants, advances the social meaning of creativity, in which when makers exercise agency, and criticality they become able to explore their surroundings and make informed decisions. According to Gauntlett (2011), intentionally developing this kind of everyday creativity is important for society and therefore is political. This project facilitated reflection about the impact of learning to use digital technologies to express opinions and perspectives in ways that are individually conceptualized and developed and its value in creating meaning in a networked culture (Jenkins, Ford, & Green, 2013) and promoting conversations that can lead to

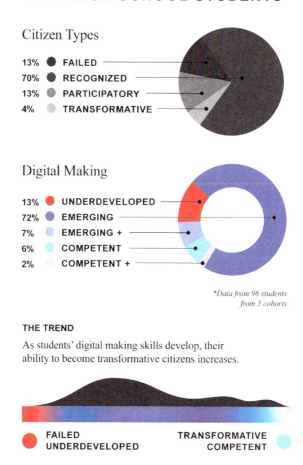

FIGURE 8.5 The relationship between digital making skills and citizenship types.

Data visualization by Annie Nall, Communication Design Student, College of Design Architecture Art and Planning, University of Cincinnati, 2024.

participation. The ability to critically interpret one's circumstances, while also being able to effectively translate this understanding into communication through written, visual, or digital creative text, is the basis of Freire's transformative literacy and education practice. This study demonstrated that developing into competent digital makers may also have an impact in developing students into participatory and transformative citizens who are capable of greater levels of civic engagement (see Figure 8.5).

CONCLUDING INSIGHTS

I expect this project can inspire many approaches to digital making in which the perspectives, interests, and capabilities of today's students are engaged and developed. Because I believe that in a genuine democracy, schools provide spaces for deliberation,

consideration for bolstering the common good, and democratic decision-making, engaging with creative strategies such as digital making can provide flexible, robust, and student-centered ways to realign education and democracy. In closing, I reflect upon my own civic engagement journey, through my immigrant experience. I came to the United States in the pursuit of a graduate education and subsequently stayed and built a rewarding career in higher education. I treasure the handheld American flag I received during the naturalization ceremony a few years ago because it is a marker of my own process of belonging. I anguished about applying for citizenship even after living in the United States for more than two decades. I made my decision the night I saw the live performance of the musical Hamilton and I felt a surge of emotions about the possibilities embedded in origin story of the United States enacted by a diverse cast who embraced an inclusive notion of art that honored multiple musical and movement traditions. I realized then that I loved this country, accepted the complicated ways in which I belonged, and embraced the opportunities to contribute. My experience of being a conditional and sometimes ambivalent citizen finds resonance in Lalami's (2020) description:

> The existing limitations to citizenship stand in sharp contrast to the civic ideals that Americans are taught. Every morning in this country, schoolchildren recite a pledge of allegiance that promises them one nation under God, indivisible, with liberty and justice for all. Then they grow up to find that depending on the lottery of their birth, the state might actively or passively deny them equal rights equal status, equal participation in the electoral process, equal rights, or an equal sense of belonging in the community. Conditional citizens are people who know what it's like for a country to embrace you with one arm and to push you away with the other.
>
> Yet I'm still here. When I arrived in the United States as a foreign student, I had no idea that someday it would become my home. I fell in love with America at the same time as I fell in love with an American. (p. 27)

My career in art education, in particular the research *Who Is American Today?*, underscores the interdependent relationship between education and democracy. This project illuminates the ways in which education is neglecting its responsibility to safeguard democratic values curtailing opportunities for students articulate and express their own voices, develop critical thinking skills, and reflect about the events and circumstances surrounding them. Further, this study provides persuasive evidence that proficiency with creative tools such as digital making can provide avenues to encourage and nurture civic engagement. I have personally experienced how the arts can foster, sustain, and inspire democracy. As citizen and educator, I am committed to upholding democracy as a central goal in education and deeply engaged in continue to understand how art and creativity can promote civic engagement and social justice.

You are invited to join in this movement. This chapter seeks to inspire educators to embrace their responsibility for preparing students to be active and conscientious participants in the political sphere, while underlying the robust ways in which art and creativity can promote such goals. Recognizing education's implicit political project, this chapter offers a model for creative civic engagement derived from the experience of the *Who Is American Today?* project and offers ways to engage with the realities

of today's students while harnessing the transformational potential of widely available digital tools. The findings of this study strongly suggest that supporting, developing, and refining students' digital making skills have a positive impact in advancing how students see themselves as citizens and political agents.

REFERENCES

Banks, J. A. (2017). Failed citizenship and transformative civic education. *Educational Researcher, 47* (7), 366–377.

Barone, T., & Eisner, E. W. (2012). *Arts based research*. Sage Publications.

Bastos, F. M. C. (2002). Making the familiar strange: A community-based art education framework. In Y. Gaudelius, & P. Speirs (Eds.). *Contemporary issues in art education*. Prentice-Hall.

Bastos, F. M. C. (2016). Can latitudes become forms? Unveiling purpose in higher education practice. *Visual Inquiry: Learning & Teaching Art, 5* (1), 37–44.

Bastos, F. M. C., & Rees, J. (2021a). Who is American today? Promoting critical digital citizenship with high school students. In A. D. Knochel, C. Liao, R. M. Patton (Eds.). *Critical digital making* (pp.137–151). Peter Lang.

Bastos, F.M. C., & Rees, J. (2021b). Can art address difficult topics? *School arts magazine* (pp. 11, 41). Davis Publications.

Bawer, B. (2006). *While Europe slept: How radical Islam is destroying the West from within*. Broadway Books.

Blandy, D., & Congdon, K. G. (Eds.). (1987). *Art in a democracy*. Teachers College Press.

Buckingham, D. (2000). *After the death of childhood: Growing up in the age of electronic med* Polity.

Calhoun, C. (1992). *Habermas and the public sphere*. MIT Press.

Dehner, M. (March 15, 2020). The best apps to help you teach art remotely. *The Art of Education*. Retrieved from https://theartofeducation.edu/2020/03/15/the-best-apps-to-help-you-teach-art-remotely/.

DiAngelo, R. (2018). *White fragility: Why it's so hard for white people to talk about racism?* Beacon Press.

Freire, P. (1971/2000). *Pedagogy of the oppressed*. Seabury Press.

Freire, P. (1983). The importance of the act of reading. *The Journal of Education, 165* (1), 5–11.

Gauntlett, D. (2011). *Making is connecting: The social meaning of creativity from DIY and knitting to YouTube and Web 2.0*. Polity.

Goodman, S. (2003). *Teaching youth media: A critical guide to literacy*. Teachers College Press.

Greene, J. (March 17, 2020). Shifting unexpectedly to remote instruction requires as many human solutions as tech solutions. *Inside Higher Education*. Retrieved from https://www.insidehighered.com/print/advice/2020/03/17/shifting-unexpectedly-remote-instruction-requires-many-human-solutions-tech.

Gutmann, A. (2004). Unity and diversity in democratic multicultural education: Creative and destructive tensions. In J. Banks (Ed.). *Diversity, and citizenship education: Global perspectives* (pp. 71–96). Jossey-Bass.

hooks, B. (1994). *Teaching to transgress: Education as the practice of freedom*. Routledge.

Jenkins, H., Ford, S., & Green, J. (2013). *Spreadable media: Creating value and meaning in a networked culture*. New York University Press.

Johnson, L., Adams Beeker, S., Estrada, V., Freeman, A., Kampylis, P., Vuorikari, R., et al. (2014). *Horizon report Europe: 2014 Schools edition*. Publication Office of the European Union/The New Media Consortium.

Kinlock, V. (2011). *Urban literacies: Critical perspectives on language, learning and community.* Teachers College Press.

Kozol, J. (2005). *Shame of the nation: The restoration of apartheid schooling in America.* Three Rivers Press.

Lalami. L. (2020). *Conditional citizens: On belonging in America.* Pantheon books.

Leavy, P. (2015). *Method meets art: Arts-based research practice* (2nd ed.). The Guilford Press.

LcCopmtc, M. D., & Prcissle, J. (1993). *Ethnography and qualitative design in educational research.* Academic Press.

Mattson, K. (2017). *Digital citizenship in action: Empowering students to engage in online communities.* International Society for Technology in Education.

McGillivray, D. (2016). Young people, digital media making and critical citizenship. *Leisure Studies*, 35 (6), 724–29.

McLaren, P. (2010). Revolutionary critical pedagogy. *Inter Actions: UCLA Journal of Education and Information Studies*, 7, 1–11.

Murray, D. (2017). *The strange death of Europe: Immigration, identity, Islam.* Bloomsbury.

Richardson, M. (2016). "The cuts, they trimmed the people" – School children, precarity and European citizenship. *European Educational Research Journal*, 15 (6), 714–735.

Ritzer, G., & Jurgenson, N. (2010). Production, consumption, prosumption: The nature of capitalism in the age of the digital 'prosumer.' *Journal of Consumer Culture*, 10, 13–36.

Share, J. (2002). *Media literacy is elementary: Teaching youth to critically read and create media* (2nd ed.). Peter Lang.

Sullivan, G. (2010). *Art practice as research: Inquiry in visual arts.* Sage.

Taylor, K.-Y. (2016). *#Black lives matter to Black liberation.* Haymaker Books.

Tucker, M. (1996). *A labor of love.* The New Museum of Contemporary Art.

CHAPTER 9

Global Music Communities and Civic Engagement in the Digital Age

David G. Hebert and David Thorarinn Johnson

> **INSTRUCTIONAL QUESTIONS**
>
> 1. What are some specific examples of how music is sometimes used to promote behaviors that either enhance or threaten the civic life of communities?
> 2. How can online music learning communities be used as a resource to strengthen formal music education?
> 3. In what ways are online music learning communities likely to challenge the music teaching profession over the coming years?

GLOBAL MUSIC COMMUNITIES AND CIVIC ENGAGEMENT IN THE DIGITAL AGE

While leading a music workshop for teenagers in North Macedonia in 2022, facilitators found the participants showed a clear understanding of both public heroism—such as King Marko Mrnjavčević (1335-1395), a local hero celebrated in Slavic folklore and oral tradition and depicted in statues—and *private heroism*, which they described as including family members, teachers, and close friends. The Macedonian teenagers mentioned "saving lives" as an obvious sign of heroism, but also promoting peace, and even simply "being there for someone" as an individual. Still, one noted that "everything is a game of chance, and you could end up needing a hero instead of being one." The song "Heroes"– popularized by a Swedish singer Måns Zelmerlöw at the 2015 Eurovision contest–was mentioned in their discussion. One explained, "It says something … we are the heroes of the time!" They discussed the meaning of the first verse, about both accepting imperfections one cannot fix and living in the moment, and how it says to "sing it like a hummingbird,

DOI: 10.4324/9781003402015-12

the greatest anthem ever heard" (signifying that profound feelings are sometimes expressed subtly, like a hummingbird's soft sound). Then, the song's chorus: "We are the heroes of our time, but we're dancing with the demons in our minds." One participant, a teenage girl with pink hair, passionately explained with a bit of stuttering, "maybe it's because the… there are these… thoughts that are bringing us down so we can't accomplish something that we want." "Yeah!" several others encouraged her. She continued, "Because I think that being a hero is also, not always being a hero to someone, but is sometimes being a hero to yourself." More of the teenagers nodded, and one girl sitting on the other side of the circle added, "Explaining problems through music makes people feel less lonely." Another said "I think that music says a lot about people, and writing music or poems … I think you can express yourself most like that."

(personal communication, September 20, 2022)

It has long been understood that music listening is deeply meaningful to youth, particularly as part of their socializing activities, but just *how important is music for young people*? The example described above illustrates how notions of heroism and civic engagement are understood among young Europeans, and that music is one important way they are communicated. Still, can we safely assume that, for instance, more than 80% of European youth find music to be important in their lives, or is music's importance diminishing with the rise of new media? Might this vary depending on which part of Europe is surveyed, whether in Scandinavia, the Baltic countries, or the Balkans, for instance? Moreover, to what extent is music participation connected with civic engagement among European youth? As we will explain, the EU's Erasmus Plus-funded Music Talks project enabled the authors of this chapter to obtain a more precise and updated understanding of youth attitudes toward – and participation in – *music* as a basis for future innovations to non-formal education programs. Our role within the Music Talks partnership was as academic researchers coming from the field of music education to support the work of NGOs and music schools in the project. New insights were achieved through our analysis of responses from a total of 377 completed questionnaires from Norway, Latvia, and North Macedonia, along with 20 Music Leader Profiles generated from qualitative interviews among 30 prominent leaders of diverse urban youth music activities in Bergen, Riga, and Prilep.

Music Talks was an EU Erasmus Plus-funded partnership between educational institutions and NGOs in Latvia, Norway, and North Macedonia with the aim of developing innovative teaching materials for working with youth (ages 15–25) in non-formal education, with a focus on developing young people's skills to discuss important issues through music as a tool for civic participation. A 20-month project implemented in 2021–2022, Music Talks enabled four European institutions with backgrounds in music education and youth work to join their missions to develop an innovative approach to boost social skills and facilitate inclusion through meaningful discussions about music and civic engagement among young people. In this chapter, we will refer to findings from the Music Talks project as a basis for our discussion of the following themes: global virtual music communities, music in youth political and civic engagement, and educational implications of the changing nature of musical experience in a digital age.

GLOBAL VIRTUAL MUSIC COMMUNITIES

Since the first decade of the 21st century, online virtual music learning communities have been heralded as revolutionizing both music learning and the professional music industry (Hebert, 2009; Whiteley & Rambarran, 2016). While online communities by their nature are mercurial and constantly evolving, one may begin by distinguishing between two main species of platforms where online music learning occurs.

TikTokin' Bout a Revolution

Scholars have proposed a taxonomy distinguishing between platforms aimed at a specific genre or instrument (such as Banjo Hangout), and general-interest social networking sites (SNS) such as Instagram, YouTube, TikTok, or Twitter, where music, although in many cases being a dominant dimension of the site, is only one of several possible subjects of interest for platform users (Waldron, 2020). While more successful dedicated music learning platforms can have tens of thousands of subscribers worldwide – notable ones have included "Noteflight, Mikseri, Aviary, and Indaba" (Ruthmann & Hebert, 2018, p. 11) – they are dwarfed in scale by general-interest SNS such as YouTube, Reddit, Facebook, Twitter, and TikTok, which have millions of users. Waldron (2020) suggests however that the defining dimensions of virtual music learning are common to both categories of web forum: namely, the use of uploaded tutorials and the ability to leave comments and pursue dialogue with others from the online community via comment boards. This twin focus on "content and comment" (Waldron, 2020, p. 35) is a radical and defining dimension of virtual music learning. Waldron (2020) writes,

> YouTube videos are of particular interest because they serve a dual purpose; their most apparent and pragmatic function being useful straightforward music teaching and learning aids. However, YouTube videos also act as vehicles of agency to promote and engage participatory culture through discourse in online community, thus also fulfilling a significant teaching role, albeit in a more nuanced manner than as a direct but informal music learning resource. (pp. 34–35)

The hypertext and hypermedia attached to tutorials represent a novel peer-to-peer format where the initial post of a song or tutorial becomes a collaborative platform for discussion, discovery, and creation (Tobias, 2014). Abramo (2020) takes viral video phenomena – such as parody versions of the Carly Rae Jepsen song "Call Me Maybe" – to illustrate connections between creation, comment, and community in online fora. He writes, "Access to social media allows people the ability to create their interpretations, send it out to the world, and let others partake" (Abramo, 2020, p. 554). In other words, online responses to musical materials can be just as important a learning resource as the original content itself. This new mode of learning blurs the conventional lines between teacher/student, expert/novice, and essentially nullifies the "pro-ams" dichotomy between professional and amateur users (Tobias, 2014). As Gouzouasis (2010) observed, "the meanings and hierarchical relationships of these terms and concepts need to be reexamined and called into question" (p.12).

Defining what sort of community these global music networks create is complex. Waldron (2012) asserts that in some regards participation in online music communities should be seen as comparable to non-virtual communities for participants: "For people who regularly participate in online community, the experience derived from belonging to a virtual group is as meaningful as being part of an offline community" (Waldron, 2012, p. 190). One possible theoretical perspective, then, stresses the similarities between online musical communities and traditional face-to-face communities. In this vein, a large share of recent research into online music learning is grounded in Lave and Wenger's (1991) theory of "communities of practice", a model of learning based on traditional apprenticeship (for example, Krause et al., 2020; Kinsella, 2021; Tobias, 2014). Another theoretical touchstone is Jenkin's (2006) concept of "participatory culture" to conceptualize the interaction between learners in online fora (see, for example, Abramo, 2020; Jones, 2008; Tobias, 2014; Waldron, 2020). Today's cocktail of handheld devices, big data, and social networks arguably makes global virtual music communities fundamentally different from music learning communities that have come before. Consequently, newer theories of affinity groups, imagined communities and networked publics have been proposed to fill in the gaps and make sense of emergent activities and possibilities (Hebert, 2018; Kenny, 2016, Ruthmann & Hebert, 2018).

SOCIAL CAPITAL, CIVIC ENGAGEMENT, AND MUSIC

Civic engagement can be defined as "working to make a difference in the civic life of our communities and developing the combination of knowledge, skills, values and motivation to make that difference. It means promoting the quality of life in a community, through both political and non-political processes" (Ehrlich, 2000, vi). Music is recognized as a potent force for political mobilization and as an agent of social change, with scholarship investigating the historical ties between music and civic engagement, including with respect to patriotism, nationalism, and social justice (Hebert & Kertz-Welzel, 2016). However, music is used not only to instill patriotism but also "has long played a role in activism and resistance" (Hess, 2019, p. 1). In a large literature review, Hallam (2015) describes civic engagement as a "transfer effect" of music making, citing research that concludes that music contributed to civic engagement through "pro-social behavior and teamwork in children across the age range and adults" (p. 15). Hill also considers the musician's unique training as ideal for engendering leadership qualities. He states, "The [unique] relationship [in terms of focus and creativity] between a musician's motivation and commitment to their craft, contribute to musicians being inherently equipped to not only lead themselves but others as well" (Hill, 2022, p. 165). Others, such as Jones (2008) and Bucura (2022), appeal to Bourdieu's theory of social capital to conceptualize music's political potential. Bucura (2022), for example, argues that music can build social capital by supporting both bonding – bringing like-minded people of similar backgrounds closer together – and also bridging – making connections between groups with dissimilar backgrounds and perspectives.

Music educators in recent years have sought to harness formal music education to better serve civic goals. In *The Oxford Handbook of Social Justice in Music Education*, Benedict (2015) writes, "The call for a renewed educational emphasis on

the development of critical thought and awareness of music among pre-service teachers and children is especially important in this age of casino-capitalism and hyper-commercialism" (p. xiv). Jones (2008) argues that "music educators and community musicians should consciously make helping students develop intercultural understanding and skills and dispositions for civic engagement a goal of school and community music offerings" (138). He continues,

> Music educators and community musicians can focus their efforts not simply on the sonic sphere and cultural contexts of musics, but also the development of social capital through helping students develop the knowledge, dispositions, habits, and musicianship skills necessary to engage musically in a variety of social settings with a variety of other people throughout life.
>
> (Jones, 2008, p. 138)

Social justice and developing social capital, networks, and community have in this manner become a central theme within music education research. Ultimately, Jones argues that "Instead of social capital being a byproduct of musicing, music educators and community musicians should make it an implied goal" (Jones, 2008, p. 132). In other words, by harnessing the psychological and social processes inherent in music, music educators and musicians can use music education as a unique force for social change.

It is possible to regard Web 2.0 digital technology and online musical communities as having the potential to increase the power of music as an agent for social change and civic engagement. This engenders what Partti and Karlsen (2010) dub "transcultural cosmopolitanism" in which "digital users are connected through digital and social media in ways that allow for the exploration and the development of connections between people and ideas that are geographically disparate" (p. 496). Examples of millennial musical subcultures such as Japanese tango and Siberian beatboxing speak evocatively to the potential of virtual community to bring together new groups of people in novel ways with music that is geographically, historically, and culturally distant. In this manner, online music learning facilitates community-building on a global scale that would previously have been impossible, allowing contemporary learners to "access knowledge not available in his local geographically situated community of musicians" (Waldron, 2020, p. 31). This power to spread musical practices globally facilitates access to music of their homeland for diasporic populations as well, potentially sustaining musical cultures among migrant populations.

MUSIC IN YOUTH POLITICAL AND CIVIC ENGAGEMENT

Perhaps no recent development more vividly demonstrates the powerful relationship between music and political thought as the ongoing war in Ukraine, which has served as the backdrop for an array of videos disseminated via social media that depict music performances in wartime contexts (Figure 9.1). For instance, pianist Karina Manyukina was featured playing Chopin in a video disseminated on Radio Free Europe (Figure 9.2). According to the accompanying explanation, "A Ukrainian

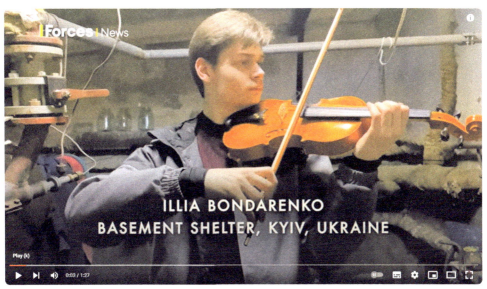

FIGURE 9.1 Ukrainian violinist performs a folk song from a bomb shelter in a "virtual concert".

Screenshot taken from YouTube by the authors.

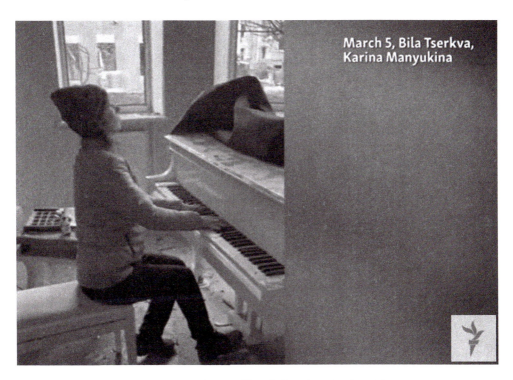

FIGURE 9.2 Ukrainian pianist performs Chopin in a bombed-out house.

Screenshot taken from YouTube by the authors.

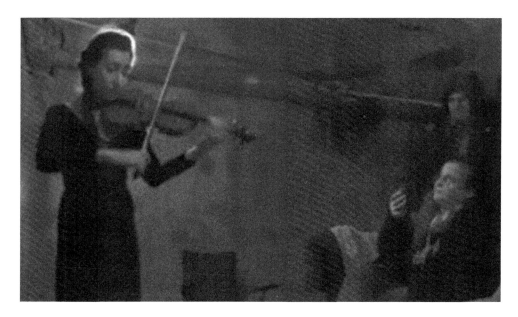

FIGURE 9.3 Ukrainian violinist performing for others in a bomb shelter.
Screenshot taken from YouTube by the authors.

pianist has been filmed playing a final rendition of Chopin in the ruins of her house after it was badly damaged by Russian shelling. In a video recorded by her daughter, Iryna Manyukina is seen playing the piano in their home in Bila Tserkva, some 80 kilometers from Kyiv" (Radio Free Europe, 2022).

Other viral videos have shown, for instance, a young Ukrainian violinist playing music from a Kyiv bomb shelter (Forces News, 2022) (Figure 9.3) and a Ukrainian refugee girl singing the theme song from the Disney movie *Frozen* (5 News UK, 2022). However, an entirely different take on the role of music during wartime can be seen from how death metal and other aggressive sounds are used as a backdrop for provocative videos produced by far-right Ukrainian military units (Azov Battalion, 2022). Indeed, these examples illustrate how music can be used to either unite or divide.

Political instability, migration, economic uncertainty, and war have challenged European unity in these first two decades of the new millennium. Music has been proposed as a European cultural expression that can bind nations together and promote peace and understanding. In 2017, responding to the Brexit referendum, Israeli-Argentinian conductor Daniel Barenboim took a moment during his leading of a German orchestra, which was performing British works on the BBC Proms program, to offer the following explanation of the unique role of music in a unified European identity:

> Our profession, the musical profession, is the only one that is not national. No German musician will tell you, 'I am a German musician and I will only play Brahms, Schumann and Beethoven'. If a French citizen wants to learn Goethe, he has to have a translation, but he doesn't need a translation for the Beethoven symphonies.
>
> *(Cleaver, 2017)*

Recent initiatives such as the European Choral Association's "Sing me in" program (also funded by Erasmus+) make explicit use of European musical heritage to promote integration and intercultural understanding. Europe is certainly united in some ways by culture, particularly as seen in music, even while there is significant diversity between its different regions. With this in mind, it is useful to very briefly compare the three nations in the Music Talks project to be discussed as cases in this chapter, located in different regions of Europe: Nordic (Norway), Baltic (Latvia), and Balkan (North Macedonia) countries (Music Talks, 2022). All three are rather small nation-states, but the population of Norway, at 5.5 million, is more than twice that of the others: Latvia with 1.8 million and North Macedonia with 2.1 million (World Factbook, 2022). The latter two countries are more ethnically diverse, with the majority ethnic group comprising only around 60% of the populations of Latvia (e.g. Latvian 62.7%, Russian 24.5%, Belarusian 3.1%, Ukrainian 2.2%, etc.) and North Macedonia (e.g. Macedonian 58.4%, Albanian 24.3%, Turkish 3.9%, Romani 2.5%, etc.), while Norway is more than 80% Norwegian. The three countries are also rather different in terms of religious diversity. Norway is nearly 68% Evangelical Lutheran, while Latvia (Lutheran 36.2%, Roman Catholic 19.5%, Orthodox 19.1%), and North Macedonia (Macedonian Orthodox 46.1%, Muslim 32.2%, other Christian 13.8%) are far more religiously diverse. There is also an enormous disparity between these countries in terms of average annual income and cost of living, as well as in terms of inequalities within each country. Currently, Latvia has some of the highest levels of income inequality in the EU. In terms of real GDP per capita, Latvia (US $29,900) is about twice that of North Macedonia (US $15,800), but less than half that of Norway (US $63,600). A distinctive feature of Norway relative to other nations is the wealth of its state government, bolstered by the world's largest sovereign wealth fund (valued at over 1 trillion US dollars), despite its small population (5.5 million people). This is partly because Norway has become Europe's main supplier of oil and gas (especially during the war between Russia and Ukraine) and is the world's second-largest exporter of seafood (World Factbook, 2022).

What did the Music Talks project discover from a comparative study of music and youth civic engagement in these three contrasting states of Norway, Latvia, and North Macedonia? As Barenboim might expect, we found more that unites than divides contemporary European youth. In terms of overall degree of civic engagement, 43.8% of participants reported "I am politically active and concerned about my community" and 55.7% reportedly make an effort to stay informed, but only 31.6% considered themselves more politically engaged than their peers. Age did not appear to impact this issue, and overall, the survey determined that the 15–18-year-olds were not any less politically engaged than 19–25-year-olds, and none of these findings differed significantly across the three countries. Unsurprisingly, young people who have received advanced musical training were twice as likely as those without musical training to "strongly agree" with the statement "some of my heroes are musicians", but the statement was relevant to all categories of participants. Among our participants, 73% reported that "music inspires me to be a better person", and 66.8% agreed that "some of my favorite public figures and heroes are musicians".

We anticipated that a high frequency of music listening, more developed music listening skills, or preference for certain genres might be associated with a high degree

of civic engagement. Results indeed determined that frequently discussing music with friends is associated with a high degree of political engagement. Specifically, 50.7% of participants who frequently discuss music with friends reported being politically active and concerned about issues affecting their community compared to the 43.8% of all participants who reported political engagement. We also found an association between political engagement and enjoying traditional music of one's own country: 52.6% of participants who reported enjoying traditional music of their country also reported being politically engaged compared to the 43.8% of all participants who reported political engagement. Additionally, world music and political engagement were also found to be associated: 57.0% of those who listen to world music are also reportedly politically engaged compared to 43.8% of the total population that reported political engagement.

To summarize, our findings depict a European youth that are to a large degree unengaged in civic and political thinking and activity; in survey responses, young people reported low interest in keeping informed of current events and sharing political views, as well as emotional detachment from social issues. They are however emphatic in their engagement with music listening and music sharing with peers, although the majority continue to engage with each other face to face rather than in online fora. Finally, results point to connections between certain music genres and civic engagement. Taken together, these results invite us to speculate on whether it might be possible to more effectively harness music education to promote civic engagement among European youth. But is it more effective to pursue civic engagement through online communities or through more traditional music education approaches? The future of music education, musical communities, and civic engagement is an issue of increasingly greater relevance to our field, and the findings of Music Talks present an opportunity to reconsider current thinking within music education about the nature and uses of online learning. With music bringing people together in novel ways in global online learning communities, it is relevant to consider how we understand the power of music to build communities, and how music education might best engage with emergent media.

THE NATURE OF MUSICAL EXPERIENCE IN THE DIGITAL AGE

It has long been known that music plays an important role when it comes to emotional well-being among adolescents (Miranda & Gaudreau, 2011). Recent studies have suggested that youth engagement with music has changed during the time of the Covid-19 pandemic (Vidas, Larwood, Nelson, & Dingle, 2021). Music Talks was among the first international-comparative studies of youth music attitudes in Europe since the start of the Covid-19 pandemic, which is regarded as the most socially disruptive event since WWII. Under these conditions, we aimed to explore how much young people listen to music, how important it is to them, and how they share music with peers (Music Talks, 2022).

Among the more significant findings from this study were that across all three European countries youths report similar ways of sharing music with peers, favoring face-to-face over other methods. Additionally, over 80% of respondents indicated

either "agree" or "strongly agree" in response to the statement "Music listening is an important and meaningful activity for me personally". This result indicates a remarkably strong consensus, and overall youth respondents indicated much more certainty about music mattering to them personally than their political activities or concern for their community. Still, we also note that those youth who frequently discuss music with peers are statistically more likely to be politically active and concerned about issues affecting their community. Over 57% of respondents indicate they discuss music with friends "a few times per week". When it comes to listening to traditional music from their own country, Norwegian respondents were *least likely* to indicate that they "strongly agree" with the prompt that they "listen to traditional music from your country", comprising only 15.5% (versus 26.9% in Latvia and 26.4% in North Macedonia).

EDUCATIONAL IMPLICATIONS

Perhaps more important than the scale of online communities is the challenge that the online paradigm poses to the hierarchical model associated with traditional, formal music education. As Tobias (2014) states, digital technology offers "relatively low barriers to artistic expression and civic engagement" (p. 206), thereby engendering wider and more equal participation in music making and learning. Abramo (2020) argues that P2P music learning communities can be understood in this regard as "democratic" since social media "allows people the ability to create their interpretations, send it out to the world, and let others partake" (p. 554). Gouzouasis and Bakan (2011) stress the contrast between the level playing-field paradigm of virtual learning spaces to the exclusionary and hierarchical aspects of traditional music pedagogy, stating that the music education profession has "catered to a select minority" and now faces an existential threat from the current generation of digital natives. They write, "The vast majority of adolescents no longer need 'music educators' to acquire music skills, participate in music making activities, and create music" (Gouzouasis & Bakan, 2011, p. 10). Instead, online learners often take lessons and share resources with other learners, others who are "both like [them] and at similar stage musically in their development" (Waldron, 2020, p. 31).

Some argue that what appear to be democratizing processes through new technologies enable further de-canonization of Western classical music practices as dominant in education, thereby destabilizing "the long established practice and belief that formal, school-based music education is the main and most prominent arena for the fostering of children and adolescents" (Partti & Karlsen, 2010, p. 373). In its stead – at least in *theory* – web-based remote learning offers the promise of access to a broad array of musical cultures, cultures which may have been neglected or even actively repressed within national formal music education contexts. This is the promise of the "long tail" of the internet, where learners can freely discover and pursue increasingly narrow or more specialized interests.

Enthusiasm for the emancipatory potential of Web 2.0 technology and the online music learning paradigm should nevertheless be tempered by potentially negative

effects it may also engender. In studies of the impact of Covid-19 on the move to digital learning, Kinsella (2021) and Bucura (2022) note that rapid digitalizing of music education can be blamed for weakening existing music communities and excluding disadvantaged learners who lack access to technologies. Bucura (2022) notes,

> Associating physically, however, has become difficult with the growth in popularity of virtual communications and entertainment that diminish person-to-person interactions. The loss of personal connection and association, and thus social capital, have had repercussions that can include weakened social connections. (p. 5–6)

Kinsella (2021) states that the rapid move to online teaching in the U.K. led to the greater exclusion of those suffering "digital poverty" defined in terms of lack of access to resources, technology, materials, or knowledge (p. 2). Schmidt (2020) suggests that Web 2.0 ought to be considered with "productive critical engagement" that recognizes the "overbearing force for solipsistic action, group-think, and narcissism" that inheres in SNS alongside the positive aspects and potential of online community. O'Neill (2020) suggests that virtual music learners' agency is significantly tempered by the digital medium, arguing that "young people are being positioned or 'fabricated' as youth-as-musical-resources or music entrepreneurs who are both shaping and being shaped by a heterogeneous web of political and practical objectives" (p. 490). Paradoxically, while Web 2.0 brings more and more people together, it also serves to separate us through increased reliance on distance learning, collaboration, and communication. Digital media enables people to form communities and networks around shared musical interests; at the same time, it threatens traditional face-to-face contact, networks, and experiences (Hebert, 2009). Tobias (2014) writes,

> Telepresence or telematic musicking and immersive qualities of media trouble notions of liveness, presence, virtuality and togetherness. While some are physically present at a live performance, others might feel present though they are accessing a live feed online through a computer or mobile device. In both cases, those experiencing the concert might express their perspectives and communicate with one another via a virtual communicative layer. (p. 222)

CONCLUDING REMARKS

Throughout history, music has functioned as an important medium for human communication, collective action, and the maintenance of group identity (Bader, 2018). In the digital age, new developments in music-making and listening behaviors have revolutionized musical practices, as the ways in which people socially engage with music have profoundly changed (Hebert, 2018; Hebert & Williams, 2020). As we have seen, the dominance of digital streaming and social media as platforms for sharing of music is defining a new generation of musicians and music consumers, but the broader consequences of this paradigm shift for education and civic engagement are still little appreciated. Young people tend to no longer own physical collections of

recordings, with music consumption now dominated by YouTube and Spotify, and while digital streaming challenges the record industry's business models, it has also been instrumental in connecting people globally by enabling a broadening of musical communities. These creative yet disruptive tendencies were amplified in many ways by the Covid-19 pandemic, which saw a significant impact on music making and music learning practices.

Recent studies have suggested that "A central task for comparative education researchers is to analyze civic norms with other values to understand how citizenship and identity is experienced by youth" (Kubow et al., 2023, p. 255). Here we have examined such tendencies from both theoretical and practical perspectives, drawing on our experiences and findings from a European research project on civic engagement and music participation among youth ages 15–25 in selected countries from three European regions: Scandinavia, the Baltics, and Balkan states. We began with a critical analysis of the contemporary relevance of definitions and theoretical models for "music community", with particular attention to how this phenomenon emerges and functions across time among specific online affinity groups, and also demonstrate ways that civic engagement continues to be shaped through music participation. Specifically, we may consider creative revival of "retro" technologies and formats (such as vinyl records), pastiche "mash-ups", internet pirating and hacktivism, as well as informal music learning facilitated through YouTube channels, and the increasing integration of online music learning into formal education (Ruthmann & Hebert, 2018). Much attention has been paid to social media's role in the splintering of debates and dissemination of "fake news". In the realm of music, however, social media and streaming services facilitate new media forms that may promote empathy and shared values, while strengthening social cohesion among youth (Barrett & Bond, 2014; Boer & Abubakar, 2014). Identities are redefined in social media, through "music glocalization" (Hebert, 2018), which broadens the geographic spread of specific scenes – such as Finnish tango, Japanese salsa, or Siberian beatboxing – and through construction of online "communities of musical practice" (Kenny, 2016) assembled around particular instruments, from bass guitar to didgeridoo. To align with the arguments offered in this chapter, educators would do well to carefully reflect on the role that online communities play among their students' musical identities, and how more direct engagement with them may also become an active component of their own instruction. Such an approach would empower music teachers to effectively foster civic engagement through their educational programs.

REFERENCES

Abramo, J. M. (2020). Resonating bodies online: Social justice, social media, and music learning. In J. L. Waldron et al. (Eds.). *The Oxford handbook of social media and music learning* (pp. 549–557), Oxford University Press.

Azov Battalion (2022). АЗОВ: понад вісім років військової історії. Набір відкрито! [AZOV: More than eight years of military history. The match is on!]. Retrieved from: https://www.youtube.com/watch?v=_lcyu-07aRs

Bader, R. (Ed.). (2018). *Springer handbook of systematic musicology*. Springer.

Barrett, M. & Bond, N. (2014). Connecting through music: The contribution of a music programme to fostering positive youth development. *Research Studies in Music Education*, 37(1), pp. 37–54.

Benedict, C. (2015) Why social justice and music education. In C. Benedict et al. (Eds.), *The Oxford handbook of social justice in music education* (pp. xi–xvi). Oxford University Press.

Boer, D. & Abubakar, A. (2014). Music listening in families and peer groups: Benefits for young people's social cohesion and emotional well-being across four cultures. *Frontiers in Psychology*, 5, pp. 1–15.

Bucura, E. (2022). Bonding and bridging: Perceptions of social capital in community music. *Athens Journal of Humanities & Arts*, 9, pp. 1–27.

Cleaver, M. (2017, July 19). Proms 2017 – Daniel Barenboim. YouTube. https://www.youtube.com/watch?v=0oNWpKBP6bU

Ehrlich, T. (Ed.). (2000). *Civic responsibility and higher education*. Oryx Press.

Forces News. (2022). Violinist in Kyiv bomb shelter joins in global virtual concert. Retrieved from: https://www.youtube.com/watch?v=rajsPt93lJs

Gouzouasis, P. (2010). An ethos of music education: An (im)possibility? *May Day colloquium on ethics and music education*. Montclair University. June 19, 2010. Unpublished refereed conference paper.

Gouzouasis, P. & Bakan, D. (2011). The future of music making and music education in a transformative digital world. *UNESCO Observatory Refereed E-Journal, Multi-Disciplinary Research in the Arts*, 2(2), pp. 1–21.

Hallam, S. (2015). *The power of music: A research synthesis of actively making music on the intellectual, social and personal development of children and young people*. iMERC.

Hebert, D. G. (2009). On virtuality and music education in online environments (in Hungarian translation, by Mariann Abraham). *Parlando*, 48(4). Retrieved from: https://www.parlando.hu/2009-4.html

Hebert, D. G. (2018). Music in the conditions of glocalization. In D. G. Hebert & M. Rykowski (Eds.). *Music glocalization: Heritage and innovation in a digital age* (pp. 1–19), Cambridge Scholars Publishing.

Hebert, D. G. & Kertz-Welzel, A. (Eds.). (2016). *Patriotism and nationalism in music education*. Routledge.

Hebert, D. G. & Williams, S. (2020) Ethnomusicology, music education, and the power and limitations of social media. In J. Waldron, S. Horsley & K. Veblen. (Eds.). *Oxford handbook of social media and music learning*, Oxford University Press.

Hess, J. (2019). *Music education for social change: Constructing an activist music education*. Routledge.

Hill, J. C. (2022). Activist musicians: A framework for leaders of social change. *Journal of Leadership Education*, 21(2), pp. 164–180.

Jenkins, H. (2006). *Confronting the challenges of participatory culture: Media education for the 21st century (Part 2)*. MIT Press.

Jones, P. M. (2008) Developing social capital: A role for music education and community music in fostering civic engagement and intercultural understanding. In D. D. Coffmann. (Ed.). *CMA XI: Projects, perspectives, and conversations*, Levinsky College School of Education.

Kenny, A. (2016). *Communities of musical practice*. Routledge.

Kinsella, C. (2021). The impact of COVID-19 lockdown restrictions on community music-making in the UK: Technology's potential as a replacement for face-to-face contact. *Journal of Music, Health & Well-Being*. pp. 1–19.

Krause, A. E., North, A. C. & Heritage, B. (2020). Music-related activities on Facebook. *Psychology of Music*, 48(4), pp. 564–578.

Kubow, P. K., Webster, N., Strong, K. & Miranda, D. (2023) New directions for citizenship, democracy, and education. In P. K. Kubow, N. Webster, K. Strong & D. Miranda (Eds.).

Contestations of citizenship, education, and democracy in an era of global change: Children and youth in diverse international contexts (pp. 245–256), Routledge.

Lave, J., & Wenger, E. (1991) *Situated learning: Legitimate peripheral participation*. Cambridge University Press.

Miranda, D. & Gaudreau, P. (2011). Music listening and emotional well-being in adolescence: A person- and variable-oriented study. *Revue Européenne de Psychologie Appliquée, 61*(1), pp. 1–11. DOI: 10.1016/j.erap.2010.10.002

Music Talks. (2022). Music Talks Erasmus+ Project. Retrieved from: https://sites.google.com/view/music-talks-erasmus-project/about-us

O'Neill, S. (2020) New materiality and young people's connectedness across online and offline spaces. In J. L. Waldron et al. (Eds.). *The Oxford handbook of social media and music learning* (pp. 489–502), Oxford University Press.

Partti, H. & Karlsen, S. (2010). Reconceptualizing musical learning: New media, identity and community in music education. *Music Education Research*, 12(4), pp. 367–382.

Radio Free Europe. (2022, March 5). Ukrainian Pianist Plays A Final Rendition Of Chopin In The Ruins Of Her House. Retrieved from: https://youtu.be/DDUdK5SYa7w

Ruthmann, A. & Hebert, D. G. (2018). Music learning and new media in virtual and online environments. In G. McPherson & G. Welch (Eds.). *Creativities, technologies, and media in music learning and teaching* (pp. 254–271), Oxford University Press.

Schmidt, P. (2020). Reports from the field: Building a new social contract for community engagement through musical virtual hangouts. In J. L. Waldron et al. (Eds.). *The Oxford handbook of social media and music learning* (pp. 215–226), Oxford University Press.

Tobias, E. S. (2014). 21st century musicianship through digital media and participatory culture. In M. Kaschub & J. Smith (Eds.). *Promising practices in 21st century music teacher education* (pp. 205–226), Oxford University Press.

Vidas, D., Larwood, J. L., Nelson, N. L. & Dingle, G. A. (2021). Music listening as a strategy for managing covid-19 stress in first-year university students. *Frontiers of Psychology, 12*. DOI: 10.3389/fpsyg.2021.647065

Waldron, J. L. (2012). Conceptual frameworks, theoretical models and the role of YouTube: Investigating informal music learning and teaching in online music community. *Journal of Music, Technology and Education*, 4, pp. 189–200. 10.1386/jmte.4.2-3.189_1.

Waldron, J. L. (2020) Social media and theoretical approaches to music learning in networked music communities. In J. L. Waldron et al. (Eds.). *The Oxford handbook of social media and music learning* (pp. 21–39), Oxford University Press.

Whiteley, S. & Rambarran, S. (Eds.). (2016). *Oxford handbook of music and virtuality*. Oxford University Press.

World Factbook. (2022). Retrieved from: https://www.cia.gov/the-world-factbook/

5 News UK. (2022). Musicians in Ukraine bring heartrending performances from inside bomb shelters | 5 News. Retrieved from: https://www.youtube.com/watch?v=_wGvVJZbyOw

Introduction to Section II
Engagement: Creating as if Communities Matter

Flávia Bastos and Doug Blandy

The contributors to this second section of *Promoting Civic Engagement through Art Education: A Call to Action for Creative Educators* bring attention to practice in art education, and related fields, that place civic engagement as it supports democracy at the forefront. The authors of these chapters recognize the multiplicity of places where art education occurs: kindergarten through high schools, museums, and community arts centers among others. Also recognized is the multiplicity of types of students served within a lifelong learning context. These authors also reinforce a view that students will be representative of multiple cultures with conceptions of art that will be similar and different across cultures as emphasized in this book's introduction.

The chapters in the preceding section were largely theoretical in their focus. This second section of the book emphasizes practice. As in the first section the theoretical was often positioned with practical examples, in this section, authors will reference the theoretical as they describe practice in a variety of settings. Consider the authors in this section in dialogue with those in the first where theoretical issues are framed and, in this section, where the emphasis is on action.

Across the examples of practice described in this section, there is a common commitment to the transformative role of art education in fostering civic engagement, promoting democratic values, and addressing systemic inequalities. In addition, the contributors to this section offer diverse pedagogical approaches that collectively advance artistic activism and civic engagement, the importance of critical inquiry through and with art, the significance of personal and collective identity within democratic societies, confronting racial and ethnic stereotypes, historical context for art and civic education, addressing racial prejudices, cultural competency, and community-based educational methodologies. The chapters in this section collectively emphasize the transformative potential of art education in fostering civic engagement, promoting democratic values, challenging systemic inequalities, and amplifying marginalized voices. Educators can draw insights from these diverse perspectives to design inclusive, community-oriented, and socially conscious art education programs. An overview of the chapters in this section follow below.

Dipti Desai in "We Make the Road by Walking: Exploring Art Activist Pedagogy" delves into "Passport to the Past," an activist art project initiated within the "Artistic Activism as Radical Research" graduate course at New York University (NYU). The

project manifested as a public art installation and walking tour to illuminate the concealed histories of resistance and resilience among various marginalized groups, including Indigenous people, African Americans, Latinx, LGBTQ+, women, and Asian Americans. Students formed an art collective, drawing inspiration from Paulo Freire's democratic education principles, emphasizing critical public pedagogy. This intervention underscores the significance of civic engagement by questioning which memories and histories gain visibility in diverse educational settings, ranging from formal classrooms to public spheres.

Kate Collins in "Reimagining YAAAS: Supporting the Well-being and Civic Potential of Resettled Refugee Youth Through Collaborative Artmaking" discusses how civic engagement and well-being have been meaningfully supported for resettled refugee youth in Baltimore, Maryland, through a collaborative artmaking initiative called Youth Artist and Allies taking Action in Society (YAAAS). The chapter describes the distinct challenges and potential of refugees, along with scholarship revealing the interconnectedness of well-being, civic engagement, and the arts in youth engagement. The chapter then delves into the transformative aspects of the dynamic YAAAS project, initially launched as a university-community-engaged arts course which partnered refugee high school students with local educators pursuing a graduate degree and is now reimagined as a public art museum initiative. The chapter concludes by identifying and reimagining three particularly generative elements of the YAAAS model: how YAAAS conceives of, launches into, and sustains well-being and civic engagement for resettled refugee youth with the hopes of inspiring other similarly invested arts educators situated in university programs, art museums, and beyond.

Joni Acuff, Courtnie Wolfgang, and Mindi Rhoades in "AMP!ify | Agitate | Disrupt: Civic Engagement and Political Clarity in Art Education" detail how three higher education art educators integrated zine-making into the curriculum for undergraduate pre-service art teachers, serving as an arts-based intervention. Through this approach, students engaged deeply with critical pedagogies, producing zines to explore contemporary teaching and learning issues. The chapter addresses the current social and political challenges in education, particularly legislative actions targeting content that addresses systemic racism and homophobia.

Amy Pfeiler-Wunder in "The Landscape is Turning: Narrative Collage as Sites of Civic Engagement" explores collage narratives through paper dolls crafted by pre-service educators, serving as platforms for civic engagement within evolving educational, cultural, and political contexts. As part of their coursework, these students critically examined historical and modern paper doll representations to design dolls reflecting their own identities and perspectives. While traditionally laden with stereotypes related to gender, race, and class, this project subverted these norms, reimagining paper dolls as tools for playful resistance and storytelling. These dolls challenge dominant views of teacher identity, positioning educators as advocates for change within turbulent social and political landscapes.

Lynne Pace Green, Damon Locks, Maria Scandariato, and Andrew Breen in "Engaging the Next Generation of Citizen Artists: How a Museum of Contemporary Art and a Chicago Public High School Partnered to Foster Informed and Activated

Youth" describe the reinstatement of a civics requirement in Illinois for high school graduation and how the Museum of Contemporary Art (MCA) in Chicago initiated a pioneering project to blend art and civic education. In 2016, MCA introduced the School Partnership for Art and Civic Engagement (SPACE) to integrate social science, civics, and visual art standards aligned with Chicago Public School's civic education vision. The SPACE framework encourages students to critically analyze local issues through the perspective of contemporary artist practices, prompting them to question, research historical contexts, employ radical imagination, and take actionable steps for change. By embedding artists within Chicago public high schools for extended periods, MCA strategically leveraged its artistic resources to foster meaningful interactions among students, educators, and the broader school community.

Sharon Greenleaf La Pierre and Enid Zimmerman in "Reflective Conversations Between Two Experienced Women Art Educators and Their Life-Long Involvement Through Civic Engagement" feature a dialogue between these two seasoned art educators reflecting on their journey from co-editing a National Art Education Association's pioneering research book to their current focus on creative aging and civic engagement. With extensive experience spanning K–12 classrooms and higher education, they delve into how personal backgrounds and educational trajectories shaped their commitment to social action across various communities. The conversation touches on their identities as women and how their civic activities and artistic endeavors were propelled by social engagement. Moreover, they emphasize the potential for leveraging their life experiences to inspire older adults toward creative and civic engagement at local, regional, national, and international levels, serving as catalysts for lifelong learning and activism.

Debra Hardy in "Utilizing Fugitive Pedagogies to Promote Civic Education in *De Facto* Segregated Schools" reveals the teaching methodologies of Margaret Burroughs (1915–2010), a notable high school art teacher in Chicago from the 1940s to 1960s. Burroughs' pedagogical approach reflects the practices of Black educators who employed fugitive pedagogies, discreetly incorporating Black histories into curricula away from administrative scrutiny. The chapter illuminates the historical roots of citizenship education, tracing it back to educators like Burroughs and Woodson during the civil rights era. By connecting contemporary art education practices to their historical counterparts, the chapter underscores a longstanding tradition, especially within Black schools, of prioritizing civic engagement and holistic citizenship in art education for nearly a century.

Kevin Hsieh in "Combating Racial Pandemics and Advocating for the Invisible Through Art" addresses the significant rise of racial prejudice against Asians, Asian Americans, and Pacific Islanders in the United States, exacerbated by derogatory terms used by political leaders during the COVID-19 pandemic. Citing data from STOP AAPI Hate, the chapter underscores the urgency to combat both visible and invisible racism targeting these communities. Written by a Taiwanese American art educator, the author outlines an art project implemented within a pre-service art teacher education program and a Taiwanese youth summer initiative. The chapter includes the pedagogical approach employed, examines participants' artworks, and offers practical suggestions, emphasizing the imperative to address and counteract AAPI-related racism through art education.

William Estrada in "(Un)learning on the Sidewalk: Reclaiming Civic Engagement and Democracy in Public Art-making" reflects on the transformative potential of community-based art education, emphasizing its role in reshaping the relationship between art, individuals, and their communities. Drawing from his experiences teaching art in schools and engaging with broader community contexts, Estrada examines the impact of integrating art education with civic engagement initiatives. A focal point is the Mobile Street Art Cart Project, situated in Chicago's Latinx neighborhoods, which encourages participants to engage with hand-screen printed graphics reflecting their lived experiences. By fostering dialogues and interactions among participants of all ages, the project underscores the power of art education in addressing community needs, promoting democratic spaces, and amplifying the voices of historically marginalized communities. This chapter advocates for reclaiming art as a catalyst for collective creativity and civic empowerment.

Theresa J. May in "Engaging Circles of Reflection: Indigenous Methodologies in Community-based Theatre" articulates the vital role of applied Indigenous methodologies, emphasizing values like relationship, respect, reciprocity, and reverence for interconnectedness, particularly when artist-educators collaborate with Native American communities. "Salmon Is Everything," a theatrical production centered on the cultural importance of salmon to Indigenous communities of the Pacific Northwest in collaboration with various Northern California tribes such as the Karuk, Yurok, Hoopa Valley, and Klamath-Modoc is highlighted. The author shares insights associated with self-decolonization, community outreach, consultation protocols for handling Native stories, and the cultural competency essential for fostering meaningful and enduring partnerships.

Collectively, the authors above offer a comprehensive exploration of the multifaceted intersections between art education, democracy, and civic engagement. These chapters serve as a testament to the enduring impact of art in shaping critical consciousness, fostering social change, and nurturing inclusive communities. These authors invite readers to draw upon their insights to reimagine pedagogical approaches and embrace the transformative power of art education to contribute to a more just, equitable, and democratic society.

These chapters are substantive, grounded in contemporary theoretical perspectives, optimistic, visionary, inspiring, and pragmatic. The contributors to this section bring decades of cumulative experience to this volume's aims and are writing from a thorough understanding and appreciation for myriad educational environments and a commitment to the way that education in the arts is culturally and socially responsive. The contributors to this section are voicing a call for action.

Engagement: Creating as if Communities Matter

CHAPTER 10	We Make the Road by Walking: Exploring Art Activist Pedagogy		
CHAPTER 11	Reimagining YAAAS: Supporting the Well-being and Civic Potential of Resettled Refugee Youth through Collaborative Artmaking		
CHAPTER 12	AMP!ify	Agitate	Disrupt: Civic Engagement and Political Clarity in Art Education
CHAPTER 13	The Landscape is Turning: Narrative Collage as Sites of Civic Engagement		
CHAPTER 14	Engaging the Next Generation of Citizen Artists: How a Museum of Contemporary Art and Chicago Public High School Partnered to Foster Informed and Activated Youth		
CHAPTER 15	Reflective Conversations between Two Experienced Women Art Educators and Their Life-Long Involvement through Civic Engagement		
CHAPTER 16	Utilizing Fugitive Pedagogies to Promote Civic Education in *De Facto* Segregated Schools		
CHAPTER 17	Combating Racial Pandemic and Advocating for the Invisible through Art		
CHAPTER 18	(Un)learning on the Sidewalk: Personal Reflections on Reclaiming Civic Engagement and Democracy in Public Art Making		
CHAPTER 19	Engaging Circles of Relation: Indigenous Methodologies in Community-based Theatre		

We Make the Road by Walking
Exploring Art Activist Pedagogy

Dipti Desai

> **INSTRUCTIONAL QUESTIONS**
>
> 1. What is the role of memory in civic education?
> 2. What are the ways art classrooms shape people's memories of history?
> 3. Why is collective practice important in art education?

Myles Horton's (1990) words "we make the road by walking" continue to be a guiding force as he reminds me that "the way you really learn is to start something and learn as you go along" (p. 3). And, just as importantly, he says that we "cannot wait to create tomorrow" but "have to start creating" now (p. 56). Given the current ideological battles being fought in the United States over whose memory is remembered, the urgency of now, I believe, needs to be underscored given that memory work is always pedagogical.

Several Republican-controlled State legislatures have proposed and passed "memory laws" that defend official historical narratives about how slavery, race relations, gender, and sexuality are taught in schools and universities (Synder, 2021). Currently, 18 States have passed memory laws that restrict the way the history of slavery, critical race theory, and sexism are taught in schools in their State – all done under the guise of defending "American" education (Schwartz, 2021). The mission to restore American education was the guiding principle of the President's Advisory 1776 Commission (2021) created by Donald Trump at the end of his term in office that acknowledged slavery as a historical evil, but only as one among other "challenges to American principles," such as identity politics and progressivism.

It is this urgency of now that shaped a collective art intervention called *Passport to the Past (2018 and 2022)*, composed of an art installation and a walking tour public for freshman and new graduate students at New York University (NYU) that makes

DOI: 10.4324/9781003402015-15

visible the hidden histories of resistance and resilience of Indigenous people, African American, Latinx, LGBTQ+, women, and Asian Americans. These hidden histories are inscribed in the buildings, streets, and parks in and around NYU. In what follows, I explore this art intervention – a form of critical public pedagogy as memory work that I suggest is a vital component of civic engagement.

MEMORY, HISTORY, AND PEDAGOGY

Memories and histories are part of our daily lives and not only shape our sense of self, our identities, but are also an integral part of the public spaces in our cities that shape a collective sense of our culture, history, and national identity. Artifacts, objects, images, and spaces contain memories providing a lens into understanding the past as it relates to the present and future. How we remember our past is a site of struggle as Foucault (1975) reminds us: "since memory is actually a very important factor in the struggle, if one controls people's memory, one controls their dynamism" (p. 25). How educational institutions shape people's memories of history is critical to the ways domination maintains its power as evidenced by what is included and excluded in school curricula and textbooks and more clearly today in the creation of memory laws in several Republican-controlled States that dictate how slavery and race relations should be taught in schools.

As Timothy Synder (2021) alerts us, it is important to understand that the memory laws rely on the affective and subjective dimension of memory, calling for teachers to self-censor any lessons that cause students "discomfort, guilt, anguish or any other form of psychological distress on account of the individual's race or sex" (Synder, 2021, para. 16). The emotional texture of memory is one that art activist projects harness as it shapes our subjectivities, evoking strong reactions across the political spectrum requiring negotiations to be made across differences. It is no surprise then, as Marita Sturken (1997) contends: "cultural memory is a field of cultural negotiations through which different stories vie for a place in history" (p. 1). Therefore, which historical narratives get told in educational sites and which get silenced highlights the "politics of memory as pedagogical" (Anderson, Desai, Inez, & Spreen, 2023, p. 101). As pedagogy is always political, it follows that a pedagogy of memory is also political as it controls how people understand the past, present, and future (Anderson, Desai, Inez, & Spreen, 2023).

My understanding of memory is indebted to the work of the Popular Memory Group (2006) that suggests that it is a political practice that is always about the "past-present relation" precisely because "'the past' has this living active existence in the present that it matters so much politically" (p. 212). Moreover, memory not only configures our subjectivities, but as Toni Morrison (1995) reminds us it plays a critical role in our collective imagination as it produces and reproduces notions of national history, citizenship, and the culture of nationhood, what Benedict Anderson (1983) called an imagined community. It is this understanding of memory as a political practice that is critical to the activist art project, *Passport to the Past*.

Passport to the Past was initiated in Spring 2018 as part of a graduate-level course I teach called *Artistic Activism as Radical Research*. This course focuses on artistic

activism as a practice that is grounded in envisioning new ways of acting and thinking in our communities to create change. It deliberately challenges the notion that art practice, research, and social activism are discrete entities and in doing so is a form of radical or "militant research" (Colectivo Situaciones, 2003). Focusing on a range of different forms of artistic activism as case studies that use different research methodologies, such as public history, oral history and orality, participatory action research, ethnography, community archiving, and radical cartography to name a few, we sought to understand how artists/artist collectives engage with communities, social movements, neighborhoods, and cities. A key component of the course is to design and implement an art activist intervention in the public sphere as a collaborative project reflecting on how power, voice, and representation are enacted and to what end. The graduate students and I as their teacher decided to work as a collective on a historical art activist intervention for our university, NYU. *Passport to the Past* was the art activist intervention we designed and implemented, which was a lesson in democratic education in the Frierian sense.[1]

ART ACTIVISM, COLLECTIVE PEDAGOGY, AND DEMOCRATIC EDUCATION

I had heard that there was an underground railroad stop close to the NYU's main campus and was taken by surprise as I had no idea about this history having worked at NYU for 20 years. It was this knowledge that sparked a discussion with my students in the *Artistic Activism and Radical Research* course when we were exploring the ways activist artists/collectives use the strategy of making visible the hidden histories of marginalized groups. This discussion led to a collective decision to further explore the history of resistance and resilience of Indigenous people, African American, Latinx, LGBTQ+, women, and Asian Americans around NYU. Our historical research was conducted with students and me choosing one marginalized group to research, which was then presented to the collective. However, as a collective we created sub-groups called affinity groups based on our expertise to design and implement the art intervention. We would reconvene to share what the affinity groups had done and as a collective make suggestions, edit text and images, and/or endorse what the sub-groups had come up with.

Passport to the Past (see figures 10.1–10.5) offers a snapshot of the hidden and underrepresented histories of resistance and resilience of Indigenous people, African American, Latinx, LGBTQ+, women, and Asian Americans around NYU as well as the direct action taken by NYU students in the 1960s and 1970s. It was conceived as a walking tour for NYU freshman and new graduate students as part of their orientation. In our initial research during the course *Artistic Activism as Radical Research*, we learned that freshman orientation runs for a week at NYU and is composed of 500 events, and not one event speaks to the history of Indigenous people, African American, Latinx, LGBTQ+, women, and Asian Americans that are inscribed in the private and public spaces around NYU. Freshman and graduate students know the best bars and shops but have no idea about the long history of resistance and resilience

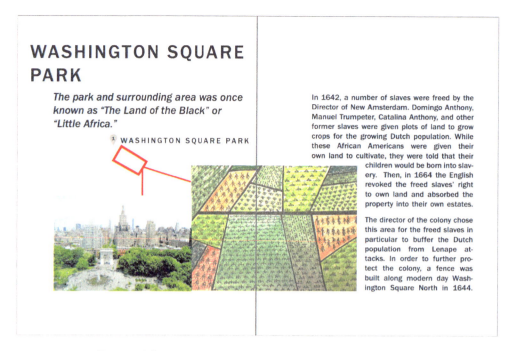

FIGURE 10.1 Pages of *Passport to the Past* booklet given during walking tour, 2018. *Photography by Dipti Desai.*

FIGURE 10.2 Pages of *Passport to the Past* booklet given during walking tour, 2018. *Photography by Dipti Desai.*

WE MAKE THE ROAD BY WALKING 165

FIGURE 10.3 Pages of *Passport to the Past* booklet given during walking tour, 2018. *Photography by Diptil Desai.*

FIGURE 10.4 Map of Sites in booklet, *Photography by Diptil Desai.*

166 ENGAGEMENT

FIGURE 10.5 Walking Tour, *Photography by Diptil Desai.*

of historically marginalized people around NYU. Designing a walking tour with a brochure that is handed out to students on the tour and/or could be given out to students during freshman orientation for self-guided tours was only the beginning of this art activist intervention. However, the primary work of this project has been and continues to be convincing first the Deans in our school (Steinhardt) and then NYU as a whole that a historical walking tour of resistance and resilience needs to be part of the experience for entering freshman and graduate students as a form of public pedagogy that actively resist the willful forgetting of marginalized histories.

Collective practice is common in contemporary art; however, it is not a customary practice in art education that is still largely driven by individual art projects. For a semester, the students and myself, their teacher, became a collective that drew inspiration from the Flash Collective created by Avram Finkelstein (Desai & Finkelstein, 2017) and the Critical Art Ensemble collective (1998). The Critical Art Ensemble describes their way of working collectively as "solidarity through difference" (p. 66), which focuses on the assets each member of a collective brings to

the project that shapes the process of working together. Our collective process was guided by the range and depth of interdisciplinary knowledge within the collective that meant that we each brought a different set of skills or assets to the class, which we drew upon. Consensus was achieved through a process of discussion, debate, and dialogue where our differences were respected and it structured our power relations in class in a more horizontal manner, but this did not mean we were always equal, and the amount of work done by each member was equal (Desai, 2020). The notion that every member of the collective should equally contribute to the project is as the Critical Art Ensemble (1998) reminds us, "a form of rigid equality" that can be a "perverse and destructive type of Fordism" (p. 67) as it measures work in terms of quantity and not quality.

Working as a collective on *Passport to the Past* is a very different pedagogical process than group work, as it involves thinking together, listening, dialogue, caring, and designing every aspect of the intervention together. Group work, a key method of teaching, often organizes differences in the classroom in a cohesive manner to contribute to one project that still mimics the commodification of the individual and the colonial logic of learning grounded in modernity that is reproduced in education. Collective pedagogy instead "challenges the cultural and political neoliberal economy of education that foregrounds the modernist/colonial ideology of individuality as autonomous and marketable" (Anderson, Desai, Heras, & Spreen, 2023, p. 150). Furthermore, collective pedagogy challenges the divide between mind and body and instead draws on multi-modal ways of knowing that evoke all the senses, emotions, desire, and love (Anderson, et al., 2023).

Collective pedagogy in a graduate course was not easy because we are all conditioned to perform in particular ways as students and teachers, and when that hierarchy is dismantled, it requires not only a conceptual shift but an emotional one as well. The students and I were "teacher learners," which is a key to collective pedagogy where we were constantly teaching each other as well as learning from each other (Freire, 1985, p. 16). This process of being teacher learners required us to be equal participants in the classroom where dialogue became central to working through our differences without erasing them. Dialogue to borrow Freire's (1985) words "is not an empty instructional tactic, but a natural part of the process of knowing" (p. 15). Genuine dialogue as part of collective practice of knowing required both my students and me as their teacher to learn how to listen to each other. Learning to listen is also a way of knowing and a way of looking, which as the activist Dylan Wahbe from Sunrise suggests evokes a code of ethics (Anderson, et al., 2023): "speaking after listening, because listening is also a way of looking, and a device to create understanding as empathy, capable of becoming an element of intersubjectivity. Epistemology thus becomes an ethics" (Anderson et al., 2023, p. 129). It follows that listening is a precondition for learning collectively and as the activist sound collective, Ultra-red (2014) reminds us: "listening is a site for the organization of politics". They continue, "collective listening is not an end in itself. Rather, it is a tool among other tools available for the long haul of struggle" (p. 7). It is only through a process of listening that we can move toward political action, and in the case of our work in *Passport to the Past*, it meant listening for the sounds of marginalized histories to make these histories visible as part of the walking tour.

A collective classroom is a space of knowing where caring for each other (Held, 2006; Noddings, 1984) becomes the moral framework that guides how we participate in dialogue with each other, where we need to be conscious of how we speak and how we listen to each other. Virginia Held in her book, *Ethics of Care* (2006), reminds us that "caring relations should form the wider moral framework into which justice should be fitted. Care seems the most basic moral value ... Without care ... there would be no persons to respect and no families to improve ... Within a network of caring, we can and should demand justice, but justice should not push care to the margins" (pp. 71–72). Caring is a moral and aesthetic framework for social justice that I would suggest is integral to civic education.

This collective educational process was not without tensions and uneasiness for both my students and me as we were making the road by walking and what we did not know in relation to art, activism, history, and education outweighed what we knew. Asking questions became a central part of our educational practice where learning "how" to know that which we do not know is as Freire (1985) indicates not a methodological dimension of education, but rather an "artistic one" (p. 17). It follows that collective pedagogy is to quote Freire "simultaneously an act of knowing, a political act, and an aesthetic event" (1985, p. 17).

Creating different kinds of educational spaces (walking tour, brochure, public art installation, and in the future a website) where people can discuss, reflect upon, exchange ideas, and learn from the narratives of the past that surround us, I believe, is a critical aspect of democratic education. Pablo Freire (2014) reminds us that the essence of democratic education is the "possibility of re-learning, of exchanging" (p. 21), through the process of dialogue, which is not an "instructional tactic, but a natural part of the process of knowing" (Freire, 1985, p. 15). He goes on to say that if we understand education as a process then we need to understand that it is "something that goes beyond itself" (Freire, 2014, p. 21) as it inspires "different ways of thinking, of dreaming" that in turn opens possibilities for students to produce knowledge (p. 23). It is this Frierian spirit of democratic education that informed our collective practice.

CONCLUDING THOUGHTS

Several years later the *Passport to the Past* brochure was redesigned as a public art installation for NYU Kimmel Windows (2021) by Rhea Creado, one of the students who had graduated, but remained involved in this project and me (see Figures 10.6 and 10.7). The walking tour and brochure featured 20 sites around NYU and Kimmel's Windows featured 13 sites, which is only a small portion of the invisible histories of marginalized groups. I keep learning about more sites from other professors and the public as we have led several walking tours not only at NYU but also for the New York City-based *Creative Time*. The project continues to be reimagined, so the idea of creating a website as a living document has been discussed as it will allow us to add new sites and more information on each existing site.

As the introduction of the *Passport to the Past* brochure and the NYU website indicates: "history is part of our daily lives as we walk through public and private

FIGURE 10.6 Public Art Installation of *Passport to the Past* at Kimmel Window, NY 2021, Photography by Pamela Jan Tinnen.

spaces and therefore, any discussion of history and its enduring effect on human life must acknowledge that we can never fully separate our relationships to the past from the present and future as well from our bodies/emotions. These buildings, streets, and parks serve as an entry point into understanding the past, which is complex and not always progressive, however it shows us how power impacts our daily lives in subtle, yet profound ways" (Desai, nd). Many buildings, parks, and streets within the NYU vicinity literally hold this invisible history of everyday forms of resistance and resilience in their architectural structure and so making this invisible history visible is a form of activism, given the politics of memory as discussed in the earlier section.

Passport to the Past as a collective pedagogical project provides an opportunity to address the needs of each student in various ways as dialogue becomes a critical and central aspect of this form of teaching and learning. Dialogue as Timothy Stanley (2003) indicates is foundational to democracy: "democracy cannot survive unless people come together in dialogue to develop shared projects despite their differences and

170 ENGAGEMENT

FIGURE 10.7 Public Art Installation of *Passport to the Past* at Kimmel Window, NY. 2021, Photography by Pamela Jan Tinnen.

without unduly imposing their conceptions of the good life on others" (p. 38). As I have indicated earlier in this chapter, the construction of particular forms of public memory is critical to how a nation such as the United States imagines itself and how it shapes democracy in ways where some people feel like they belong and can participate, and some do not. In the United States this means that not all people "enter democratic spaces under the same conditions" (Stanley, 2003, p. 38) because of the ways history is represented in popular culture, media, school textbooks, and public monuments that "makes it appear as if certain people belong in certain spaces while others do not" (Stanley, 2003, p. 38). The project *Passport to the Past* opens a dialogic space in the public sphere that makes visible the history of marginalized communities in NYC who often feel they do not belong in these public spaces. As an act of civic and democratic education, the activist art project *Passport to the Past* is a political act that nudges us to think about all the other hidden histories of marginalized groups in public and private spaces in our cities. And it hopefully invites conversations about how we can reimagine democracy in our nation, which is under serious threat.

NOTE:

1 Paulo Friere, the Brazilian educator, argued that education is never neutral and advocated critical pedagogy, a philosophical of education that empowers students and communities to draw on their own experiences to see how these experiences are connected to systems of privilege and oppression and then address social inequity by becoming agents of social change.

REFERENCES

Anderson, B. (1983). *Imagined communities: Reflections on the origin and spread of nationalism.* Verso.

Anderson, G. L., Desai, D., Heras, A. I., & Spreen, C. A. (2023). *Creating third spaces for learning post-capitalism: Lessons from educators, artists, and activists.* Routledge. DOI https://doi.org/10.4324/9781003345015

Colectivo Situaciones. (2003, September). On the researcher militant. transform.APA eipcp.net http://transform.eipcp.net/transversal/0406/colectivosituaciones/en.html

Critical Art Ensemble. (1998). Observations on collective cultural action. *Art Journal*, 57(2), 73–85.

Desai, D. (2020). Educating for social change through art: A personal reckoning. *Studies in Art Education*, 61(1), 10–23.

Desai, D. (nd). NYU Kimmel Windows Presents "Passport to the Past" on View Until March 21, 2002. https://www.nyu.edu/about/news-publications/news/2021/december/nyu-kimmel-windows-presents--passport-to-the-past---on-view-unti.html

Desai, D. & Finkelstein, A. (2017). NYU flash collective: An art intervention in the public sphere. In G. Sholette, C. Bass, & J. Kasper (Eds.), *Art as social action: An introduction to the principles & practices of teaching social practice art.* Allworth Press.

Foucault, M. (1975). Film and popular memory: An interview with Michel Foucault. *Radical Philosophy*, 11(11), 24–29.

Freire, P. (1985). Reading the world and reading the word: An interview with Paulo Freire. *Language Arts*, 62(1), 15–21.

Freire, P. (2014). *Pedagogy of solidarity.* Routledge.

Held, V. (2006). *The ethics of care: Personal, political, and global.* Oxford University Press.

Horton, M. & Freire, P. (1990). *We make the road by walking: Conversations on education and social change.* Temple University Press.

Morrison, T. (1995). The site of memory. In William Zinsser (Ed.) (2nd Ed), *Inventing the truth: The art and craft of memoir* (pp. 83–102). Houghton Mifflin.

Noddings, N. (1984). *Caring: A feminine approach to ethics and moral education.* University of California Press.

Popular Memory Group. (2006). Popular memory: Theory, politics, method. In R. Johnson, R. G. McLennan, B. Schwarz, and D. Sutton (Eds.), *Making histories: Studies in history-writing and politics* (pp. 205–252). Routledge.

Schwartz, S. (2021). Map: Where critical theory is under attack. *Education Week.* https://www.edweek.org/policy-politics/map-where-critical-race-theory-is-under-attack/2021/06

Stanley, T. (2003). Creating the space for 'civic' dialogue. *Phi Delta Kappa*, 85(1), 38.

Sturken, M. (1997). *Tangled memories: The Vietnam war, the AIDS epidemic and the politics of remembering.* University of California Press.

Synder, T. (2021, June 29). The war on history is a war on democracy. *New York Times.* https://www.nytimes.com/2021/06/29/magazine/memory-laws.html

The President's Advisory 1776 Commission. (2021). *The 1776 Report.* https://trumpwhitehouse.archives.gov/wp-content/uploads/2021/01/The-Presidents-Advisory-1776-Commission-Final-Report.pdf

Ultra-red. (2014). *Ultra-red workbook 09: Practice sessions.* Koenig Press.

Reimagining YAAAS

Supporting the Well-being and Civic Potential of Resettled Refugee Youth through Collaborative Artmaking

Kate Collins

> **INSTRUCTIONAL QUESTIONS**
>
> 1. Beyond the designation of refugee, displaced people in the US, both temporary and permanent, also currently include asylum seekers (who seek refugee status only after arriving to the US), undocumented immigrants, Humanitarian Parolees from countries such as Afghanistan and Ukraine, and those who hold Special Immigrant Visas. What are the distinctions? Which organizations serve these individuals and families in your area and how might you craft a partnership with nuanced arts programming that enhances well-being and civic potential in a manner that is culturally responsive?
>
> 2. If you've been engaged in arts-based partnerships with refugee and immigrant populations in your community, how are you or can you contribute to the expansion of social networks that support well-being? Consider bonding, bridging, and linking capital in your exploration.
>
> 3. Why is it a civic and public health matter for displaced populations like refugees to have narrative control? How can you or your organization support that through the art forms you typically engage in or how might you broaden those artforms to invite further narrative control?

Do good to do well, an expression originating in the 1700s and commonly attributed to Benjamin Franklin, (Boyte, 2013)[1] is a belief that continues to thrive across many nations and bodies of scholarship today. Researchers from Canada (Li, 2020), Germany (Barreto et al., 2022), New Zealand (Carlton, 2015; Hayhurst, et al., 2019), the United Kingdom (Borgonovi, 2008), and the US (Nelson et al., 2019; Wrak-Lake et al., 2019; Ziebarth, 2021) assert this belief with specific regard to the civic

DOI: 10.4324/9781003402015-16

engagement and well-being of immigrants and refugees, some even noting a mutually reinforcing relationship (Carlton, 2015; Nelson & Chandra, 2020; Sloan et al., 2019;). Simultaneously, the world is seeing a wellspring of research from an expanding range of disciplines asserting the importance of the arts for well-being (Adnams Jones, 2018; Rollins, 2015; Sonke et al., 2019) and arts for civic engagement (Korza, et al., 2005; Rabkin, 2017; Stern & Seifert, 2009). Invested in the role of collaborative artmaking in supporting all these reciprocal relationships, this chapter explores an intergenerational arts project with a unique approach, partnering students and teachers, aimed at supporting the learning, well-being, and civic engagement of resettled refugee youth in the US. Following a literature review that encompasses the distinct challenges and potential of refugees, along with scholarship revealing the interconnectedness of well-being, civic engagement, and the arts in youth engagement, this chapter delves into the transformative aspects of a dynamic project called Youth Artists and Allies taking Action in Society (YAAAS). Finally, with an interest in reimagining YAAAS to further enhance civic potential, the chapter discusses three particularly generative aspects of the project where the design and curriculum can be extended and deepened for greater impact. These generative aspects include how YAAAS conceives of, launches into, and sustains well-being and civic engagement for resettled refugee youth. Through this reimagining process, I aim to inspire and support similarly invested arts educators and arts organizations, eager to meaningfully engage the growing population of displaced immigrants and refugees.

DEFINITIONS AND STATISTICS

To begin this exploration, some definitions and statistics provide essential context for refugee experiences and an appreciation for both the urgency and possibility of supporting refugee youth's civic potential and well-being through the arts. At the end of 2021, the United Nations High Commission on Refugees (UNHCR) reported 89.3 million displaced people forced to flee their homes across the globe (United Nations High Commission on Refugees [UNHCR], 2022). Of those, 27.1 million people were designated as refugees, and around half were under the age of 18 (UNHCR, 2022). This number has doubled from just a decade ago (UNHCR, 2022). A refugee is "someone who is unable or unwilling to return to their country of origin owing to a well-founded fear of being persecuted for reasons of race, religion, nationality, membership of a particular social group, or political opinion" (UNHCR, n.d.). Refugee status is a legal distinction whereupon individuals and families are granted permission to reside and work in a country of resettlement by the government of that country (Weng & Lee, 2016). The US is one of 29 countries that resettle refugees, but less than 1 percent of the refugee population is considered for resettlement worldwide (International Rescue Committee [IRC], n.d.). The remaining refugees take shelter in camps, rural, and urban areas of neighboring countries, often dealing with their own internal crises.

Globally, the number of refugees is alarming and continues to grow as years progress, conflicts expand, and damage caused by environmental disasters continues. No longer a temporary phenomenon, average displacement lasts 20 years for refugees

(European Commission, n.d.). Between 2018 and 2020, nearly 1 million children were born refugees, living their entire lives outside of the country their families call home (UNHCR, 2021). These growing numbers tell only a fraction of the story because they do not reflect the collective or individual experiences of trauma and poverty caused by war and displacement. Before and after resettlement, refugees have diverse experiences and do not easily "fit in" to a homogenous category (Ziaian et al., 2021). Refugees include a full spectrum of families and individuals from leaders, physicians, and attorneys to farmers, shepherds, and tradespeople. No matter their social class or profession, the triple trauma paradigm (Michultka, 2009) of (1) pre-flight, (2) in-flight, and (3) post-flight is likely to impact the vast majority at one or more phases of displacement. Pre-flight and in the country of origin, experiences of trauma may include violence, torture, family separation, poverty, malnutrition, imprisonment, and repeated relocation. While in flight, refugees experience fear of being caught and returned, detention, exploitation, sexual violence, robbery, long waits in refugee camps situated in overwhelmed bordering countries, and uncertain futures. Finally, post-flight and in the country of resettlement, relief can be mixed with guilt about those left behind, bad news from home, racial/ethnic discrimination, social and cultural isolation, unemployment, inadequate housing, and language barriers (Center for Victims of Torture, 2005). While the experiences of refugees are not uniform, they are fraught and complex, nonetheless.

CIVIC ENGAGEMENT OF REFUGEE YOUTH

Researchers highlight that refugees living in camps and displaced from their home countries have limited opportunities to imagine or enact civic behaviors (Dryden-Peterson, 2020). Accordingly, those concerned with civic engagement upon resettlement, must recognize that "parents and youth may be coming from countries where they did not have rights as citizens nor the education to be civically engaged" (Beghetto, 2021). A sense of agency for affecting change can then be further compromised because of long school absence or trauma (Dryden-Peterson, 2020). Coming from countries with highly unstable infrastructures means limited or highly interrupted formal schooling prior to resettlement is common, known in the research as SLIFE: Students with Limited or Interrupted Formal Education (WIDA.org) As a result, it is entirely possible for a refugee student to enroll in ninth grade in the US having never learned to read or write in their home language (Robertson & Breiseth, n.d.). So, while citizenship is finally within reach upon resettlement in the US (applications for naturalization can be submitted five years after admission), the motivation and know-how for engaged citizenship cannot be assumed. For resettled refugees, the journey to integration, well-being, and becoming active citizens can be an uphill battle, especially when still contending with that third strand of the triple trauma paradigm in post-flight. Barriers to full participation in the life of one's community are substantial for refugees.

Despite these challenges, agencies like the Migration Policy Institute assert the "urgent need to create alternative ways for socially isolated populations to participate meaningfully in their host communities" (Banulescu-Bogdan, 2020, p. 1). Refugee youth

reflect one key sub-set of this population for which the hurdles are great, but so too is the potential. These newcomers bring an untapped reservoir of strength and capacity, so it is important to not allow challenges and deficit narratives to override public perception and sense of self (Weng & Lee, 2015). There is a great cause to focus efforts on civic engagement and leadership early in resettlement with refugee youth, as it leads to benefits for both them and the broader society. As Ziebarth (2021) argues "Integration into civic affairs and political participation is an integral aspect of achieving, or at least working toward, the vision of participatory democracy that is representative of the diversity of backgrounds and perspectives inherent to the American patchwork" (pp. 735–736). Not limited to the US, scholars in countries of resettlement including Germany, Canada, and New Zealand note that civic engagement enhances social integration and overall life satisfaction of refugees, revealing a positive correlation with their subjective well-being (Barreto et al., 2022).

WELL-BEING AND CIVIC ENGAGEMENT

Critical to the premise of this chapter, is the growing body of research that suggests well-being and civic engagement are interrelated and/or mutually reinforcing for youth more broadly (Borgonovi, 2008; Hayhurst et al., 2019; Wray-Lake et al., 2019), for immigrant women (Li, 2020), and refugee youth (Carlton, 2015) more specifically. Well-being may enhance civic engagement and civic engagement can lead to increases in the areas of well-being, resilience, human flourishing (Hayhurst et al., 2019), and leadership (Carlton, 2015). Researchers cite "identity, sense of belonging in communities and society, purpose, positive relations to others, feelings of mastery, and personal growth" (Hayhurst et al., 2019) as central elements that reveal the ways well-being and civic engagement intersect across populations. For immigrants, further research suggests that civic engagement is critical for the development of social capital, both bonding and bridging. Li (2020) draws on the scholarship of both Putnam (2001) and Berry and Hou (2016) in confirming that, "Bonding capital refers to an individual's networks with people in the same group, while bridging capital means networks that connect individuals to the broader society" (p. 52). While refugee youth researcher Carlton (2015) uses the term volunteering over civic engagement, her scholarship highlights the importance of refugee youth possessing agency and the ability to contribute to society as critical to their sense of belonging and well-being.

While becoming a citizen or engaging in core practices like voting is significant, the range of possibility for refugees becoming civic actors is far greater in scope. Refugee-serving organizations like Unbound Philanthropy (2021) assert that when refugees learn to find their voice and lead, they can educate the public about who refugees are, debunk myths and misunderstandings, and help shift the broader narrative about refugees and immigration. A focus on the civic engagement of adolescent refugees in high school is particularly potent because they are on the cusp of attaining the legal rights and responsibilities that come with adulthood. For teens writ large, "adolescence represents a last formal opportunity to utilize social resources before high school graduation after which, paths diverge and there is no clear institution that engages young adults"

(Finlay et al., 2015, p. 279). If schools are "the main public institutions through which young people are recruited into public life" (p. 279), the urgency for focusing on refugees who resettle as teens becomes evident. The timetable for structured support provided by high school is far more abbreviated than for younger peers and siblings who have more time for social adjustment and English acquisition before being thrust into the workforce and adult expectations. Additionally, research indicates that more than parents, teachers play a critical role in the civic development of immigrant youth, so limited time for taking social studies courses "may restrict exposure to teachers' civic expectations and result in the unrealized civic potential of immigrant youth" (Callahan & Obenchain, 2016, p. 36).

ARTS, YOUTH CIVIC ENGAGEMENT AND WELL-BEING

The *Animating Democracy Initiative*, a program of Americans for the Arts, published a series of case studies and conversations advancing the role of the arts in civic engagement, including programs with youth. Notably, the authors offered that "through artmaking and civic dialogue, young people can gain a greater sense of self-worth, develop critical thinking abilities, and find a 'sense of place' within their communities, their country, and the world" (Korza et al., 2005, pp. 276–77). These same researchers (2005) assert the arts as a natural container for young people's perspectives where the arts become a motivating force that helps them express their ideas while also hearing and considering others. When opportunities are provided for young people to be:

> Valued for their insights and for their roles as "knowledge producers," their voices are given a place within the broader civic discourse of their communities. Such efforts nurtured a sense of civic responsibility and engagement that is not only valuable in the present, but vital for the future.
>
> *(Korza et al., 2005, p. 277)*

A 2017 Irving Foundation report on arts and civic engagement further notes that those with a strong civic identity often credit arts experiences as central to their development, offering that art experiences during adolescence are particularly influential. Especially relevant to this chapter is the assertion that "art *making* [emphasis added] experiences appear to encourage civic engagement more so than experiences as an audience member" (Rabkin, 2017, p. 5).

Meaningful connections between the arts, public health, and well-being become clear when considering the social determinants of health established by the US Department of Health and Human Services which argues "health is more than the absence of disease; it requires the presence of such factors as opportunity, access, agency, and narrative control" (Sonke et al., 2019, p. 8). The nature of the arts, which place primacy on personal choice and self-expression, has led to its increasing value as a perfect tool for assuring person-centered care and care for the whole person (Rollins, 2015). Art therapists who work specifically with refugees offer that through art, one can construct, deconstruct, and reconstruct their knowledge by creating visual

symbols and gradually telling and retelling their stories in ever more empowering ways (Adnams Jones, 2018). Telling stories through art in community, allows us to tell ourselves into "being" and in claiming an identity or position, we create true agency (Adnams Jones, 2018). The UNHCR actively advocates for the arts as transformative for the lives of refugees by providing a universal language to tell the world their own stories (Parater, 2015).

YOUTH ARTISTS AND ALLIES TAKING ACTION IN SOCIETY: REFUGEES, CONNECTIONS, ARTMAKING

The preceding literature review provides a critical framing for the goals and possibilities that drove the creation and evolution of YAAAS. YAAAS was an innovative arts-based collaboration between refugee youth resettled in the US as high school students, co-creating and co-learning alongside local teachers enrolled in a graduate program focused on arts-integrated learning, a program I designed and directed at Towson University, just north of Baltimore, Maryland. Ours was a responsive and iterative process that evolved as each of the three Fall semesters unfolded between 2017 and 2019. Prioritizing reciprocity, our collaboration focused on social adjustment and English support for youth participants, and global competency and arts-based learning strategies for the teachers. Our curriculum and pedagogy quickly evolved to embrace social-emotional learning (SEL), becoming increasingly trauma-informed (Souers & Hall, 2016) and culturally sustaining (Paris & Alim, 2017). Dialogical aesthetics, where artists become facilitators of communication and catalysts of change (Kester, 2004) was also a major point of exploration for the graduate students and a form of practice embraced throughout.

YAAAS involved a partnership with Patterson High School in Baltimore which has long had one of the highest immigrant and refugee populations in our city school system. Weekly evening meetings were held at the high school over the course of eight weeks. The project was designed to be non-hierarchical and highly relational, emphasizing dialogue, care, play, experimentation, storytelling, and humanization. These choices allowed us to prioritize both learning and well-being. Highly process-oriented, weekly collaborative artmaking experiments embraced theatre, music, movement, visual arts, and creative writing, which supported different interests, strengths, and levels of comfort. Arts education scholar Elliot Eisner (2002) reminds us, "The tools you work with influence what you are likely to think about" (p. 9). By being multi-disciplinary in our approach our collective created pathways for many ways of knowing, thinking, and engaging. Our efforts each year led to the creation of culminating works involving visual arts, poetry, and performance that were shared publicly, but given our process-oriented nature, these works could be best described as artifacts of our process, rather than an end-product goal. For the first two years, these public works were titled *Conversation Pieces*, partly as an homage to Grant Kester's (2004) book with the same title, always framed as a vehicle to invite further dialogue with viewers.

As with most cities of resettlement, the countries of origin for the refugee student participants tend to shift every few years. Those who participated in YAAAS from

2017 through 2019 were primarily from Sudan, Eritrea, and the Democratic Republic of Congo. YAAAS averaged around 17 refugee student participants each year where the majority were 18 years of age or older, with a small handful who were 16 or 17. The amount of time in the US ranged from a few months to just about three years, so experience with speaking and learning English varied greatly. Most refugee students in this group spoke two or three languages with English being the newest. Each year between five and twelve teachers (graduate students) participated. There was significant variation in years of teaching experience, age, subject area, and grades taught, as well as racial/ethnic background. All but one identified as women.

FINDINGS

Major findings from an action research study (Collins, 2020) conducted during the second year of the YAAAS program revealed just how transformative and "life changing" participants on both sides of the project found the experience. In analyzing student and personal observations about the project design and curriculum, noteworthy findings included the *humanization* that was fostered by prioritizing play and embracing student languages as assets from the start. These aspects of the pedagogy and curriculum were vital for establishing equal footing and trusting relationships. The *strategic scaffolding* of our activities was valued for the many ways varying levels of conversation, dialogue, and choice through artmaking were intentionally woven into each of our weekly engagements, making communication and our artistic journey as important if not more important than our destination. *Reciprocal capacity-building* was observed and felt in the many opportunities embedded throughout this project that advanced the cultural competency of the graduate students while expanding and highlighting the agency and efficacy of our high school student partners who grew evermore excited about contemplating their identities, articulating their goals, and imagining their future.

THREE GENERATIVE ASPECTS OF YAAAS

By pairing these findings about the transformative aspects of YAAAS with the growing body of scholarship that connects arts, civic engagement and well-being, the remainder of this chapter seeks to examine how civic potential can be further supported. Given that the word *action* is embedded in the very name of this project (Youth Artists and Allies taking Action in Society), this chapter seeks to imagine how to expand upon the civic potential that is so clearly interconnected with well-being for resettled refugee youth. Through this reimagining, I aim to enhance future iterations of YAAAS as well as support like-minded arts educators and arts organizations that may wish to tap into and support this tremendous potential of refugee youth. Three generative areas I explore as they pertain to resettled refugee youth, include: (1) how the YAAAS project conceives of civic engagement, (2) how YAAAS launches into civic engagement, and (3) how YAAAS sustains civic engagement by further expanding social capital. In all three areas, artmaking and collaboration prove vital.

Concepts of Civic Engagement

How one conceives of civic engagement matters. Too often, notions of civic engagement are limited to the single act of voting. While voting rights as participation in democracy cannot be overestimated, for refugee youth at the early stages of resettlement, voting may not yet be relevant or even possible. That does not mean that civic engagement needs to wait, especially given its interconnectedness with well-being. Belonging and human connection are age-appropriate and relevant concerns, as is the desire to feel helpful. Tapping into those thoughts, feelings, and needs through collaborative artmaking with others can be potent. During the early months and years of resettlement and language acquisition, a focus on storytelling through multiple artforms is vital and creates space for nuance and complexity. Well-being is further enhanced when students' home languages and cultures are welcomed into these processes and embraced as assets.

Through artmaking and storytelling, refugee youth can enhance their own wellness and civic potential by exploring and shaping their identities, crafting and recrafting their narratives, gaining a sense of agency to imagine new futures for themselves, and advocating for their families and the refugees who resettle after them. Furthermore, the processes of collaborative artmaking provide vital skills for civic engagement including problem-solving, building the imagination, honing communication skills, building tolerance of ambiguity, and working across differences. When creative efforts and stories are shared publicly or even just amongst teachers and peers, refugee students can enhance their own sense of agency and recognize their own potential. They emerge as advocates actively working against the pervasive invisibility of refugees, while challenging limited understandings and damaging stereotypes. In these ways, arts-based practices reveal the multifaceted landscape of civic engagement and lay the groundwork for significant actions such as voting.

In reimagining future iterations of the project, I will look to make more explicit our broad conceptualization of civic engagement to our young partners *and* their families. In doing so, all can appreciate the skills, knowledge, and values that are supported through our collective efforts and how they are vital to youth participant learning, well-being, entrance into higher education, and future as engaged citizens. For youth and families still encountering the initial shock of resettlement and acculturation, the importance of these opportunities isn't always apparent. Being explicit can help support consistent attendance in programming. Furthermore, I will work to ensure that our young participants appreciate how they are helping their teacher-partners become better teachers for future refugee and immigrant students, so they and their families can recognize their vital contributions to their new host country.

Launching into Civic Engagement

A very specific approach is required for launching into arts-based civic engagement with newly resettled refugee youth. Given our time limitations, the newness of the group to each other, and the varying levels of English acquisition, social adjustment, and trauma, there was a genuine need to start slow, tread lightly, and focus on relationships. Starting with play, creative experimentation, scaffolded risk-taking,

and prioritizing care was essential for a culturally sustaining, trauma-informed approach. These practices allowed us to move at what Adrienne Maree Brown (2017) refers to as "the speed of trust" (p. 42). Still, considering the urgency and potential revealed over three years of studying YAAAS in concert with the supporting scholarship, I recognized the need and potential for more intentionality related to civic engagement.

Brown (2017) asserts, "what we pay attention to grows" (p. 19). In reimagining future iterations of YAAAS, I believe the project can have a greater impact if *more attention is paid* to the teachers who are recruited. While it seems evident that all teachers could benefit, what would happen if a priority was placed on the engagement of teachers from the schools that are seeing the greatest growth in enrollment of refugee and immigrant students in our city? So often, the teachers starting the YAAAS graduate course would share how under-prepared they feel for supporting these learners. Global Education Monitoring Reports (2019) like the one issued by the United Nations Education, Scientific and Cultural Organization (UNESCO) validate this as a pervasive struggle. By necessity, YAAAS is small in scale, and to uphold the integrity of the highly relational design, it should stay that way. By zeroing in on the recruitment of teachers from schools that have significant English Learner enrollment, YAAAS could support educators who will be among the very first to engage and support refugee youth on a daily basis upon resettlement and starting school. In making this choice I can magnify the impact of this project and equip teachers who need it the most with global awareness and arts-based strategies to create more inclusive classrooms that are trauma-informed and culturally sustaining. At the same time, the ripple effect extends to a greater number of refugee youth whom these teachers encounter throughout their careers. Such a model also allows artists and art institutions to play a critical role in further supporting and enhancing the civic engagement of resettled refugees, in part, by supporting their teachers.

Sustaining Civic Engagement

In reimagining YAAAS, the third generative area asks how to effectively sustain the benefits of our civic engagement and well-being efforts over time. Maintaining relationships and expansion of the social capital of our refugee youth is at the heart of this sustainability. "Positive relationships are related to higher well-being" (Ryan & Deci, 2017) and particularly, relationships characterized by democratic climates where youth have positive bonds and feel heard and respected, have been linked to greater civic engagement (Campbell, 2008 as cited in Wray-Lake et al., 2019). Social isolation can be particularly intense in the early weeks and months of resettlement and can continue for years for some individuals and families. Opportunities beyond school hours to build genuine bonds with peers within and beyond their own ethnic groups who are encountering similar challenges were deeply valued and developmentally appropriate for our young partners.

Unique to YAAAS, is the intergenerational nature of the project which sought to combat traditional student/teacher hierarchies by inviting refugee youth to work alongside teachers as co-learners and co-creators for the duration of the project. Coming

into the project on equal footing from the very start is invaluable as Banulescu-Bogdan (2022) reminds us, "the quality and context of the contact between groups are critical determinants of success" (p. 2). For all parties, encountering weekly creative challenges, risk-taking, and vulnerability together through self-disclosure was deeply humanizing and fostered trust. These bridging relationships opened communication between teachers and English learners that often cannot happen in a typical classroom with 30 students and 1 teacher. Consequently, the opportunity for humanization and authentic connection for both sides of the partnership was critical. In fostering competency and agency for the refugee youth, it was quite potent for them to dispel stereotypes and see themselves as helping their teacher partners to become better, more inclusive teachers for future refugee youth. At the same time, youth participants received much-needed individual attention and support that they might not otherwise receive in the early stages of resettlement.

With a desire to further deepen the social capital of the refugee youth participants, and in anticipation of a relaunch of YAAAS as a summer intensive, I will seek to lengthen the program to enhance the relational element that proved so valuable. In addition to furthering the bonding and bridging social capital, *linking* social capital will be prioritized as advanced by Elliot and Yusuf (2014). "Linking social capital refers to the connections refugees and refugee groups have to state structures and institutions" (Elliot & Yusuf, 2014, p. 102). It is through "relationships at this level, that refugees can gain access to power, resources and greater opportunities to participate meaningfully in civil society" (p. 102). In appreciation of this possibility, future iterations of YAAAS will dive more deeply into fostering linking social capital with anchor institutions such as museums, libraries, and universities. One possible approach involves monthly meetups for the year following the summer intensive program so that peer and teacher relationships formed through YAAAS can continue to grow.

PIVOTING TO ARTS SETTINGS BEYOND UNIVERSITIES

Important to the potential of this third generative area is that the YAAAS program is portable. My professional setting has shifted away from directing a graduate program and I am newly based at the Baltimore Museum of Art instead of Towson University. Given this, monthly reunions can now be a chance to reconnect with young partners for new art exhibitions and continue cultivating a strong sense of belonging to the cultural institution of a museum. Additionally, linking social capital can be further extended by also meeting up at an array of anchor institutions around town to expand the network of relationships and sense of connection to the broader community. Emphasis will be placed on entities that are free or inexpensive, easy to reach, and of value to families for providing needed public resources and opportunities for entertainment, cultural enrichment, and respite. Extending a relationship like this can be labor intensive, but with careful partnering work, budgeting, and advocacy, these efforts can magnify and extend the elements of civic engagement and well-being in critical ways. In doing so, the gains from a shorter intensive program are sustained,

the network of relationships for youth participants is meaningfully expanded, and a sense of belonging reaches beyond our small group to the broader city these young people now call home.

CONCLUSION

In conclusion, research tells us that if current conditions prevail, two-thirds of the world's refugee population will likely never make it to high school (UNHCR, 2021). Building the well-being and civic engagement of the very small fraction of refugee youth who find themselves starting life anew as high school students in the US is urgent. The need is only increasing. At the time this chapter was written, the plight of Afghan evacuees, displaced Ukrainians escaping war, and masses of Venezuelan migrants at the US-Mexico border seeking asylum have been filling the daily newsfeed. Months or years from now, the countries of origin may shift, but history tells us this devastating mass displacement of people will continue. In the face of this, Eisner (2002) eloquently reminds us why the arts must be at the center of any efforts to support these populations when he states "A culture populated by a people whose imagination is impoverished has a static future. In such a culture, there will be little change because there will be little sense of possibility" (p. 5). Contemplating the impact of the triple-trauma paradigm on the futures and civic potential of resettled refugee youth can be daunting, but arts-based models like YAAAS can powerfully combat social isolation, enhance belonging, and support refugee youth in finding their voices. Highly relational, linguistically responsive, and asset-based collaborative art processes like YAAAS make abundantly clear that the civic potential of these young people is substantial and within reach. It makes evident the potent roles to be played by arts educators, teaching artists, university arts programs, community arts centers, and museums in supporting the well-being and civic engagement of resettled refugee youth. By taking up such responsive practices and possibilities and by pursuing creative cross-sector partnerships the network of engagement and support can be meaningfully extended while ensuring more vibrant, hopeful futures. By reimagining YAAAS, this chapter asserts that the arts have an important role to play in the civic engagement and well-being of refugee youth.

NOTE:

1 Boyte (2013) connects "do good to do well" to the Leather Apron Club founded by Benjamin Franklin and others in Philadelphia in 1727.

REFERENCES

Adnams Jones, S. (2018). *Art-making with refugees and survivors*. Jessica Kingsley Publishers.
Banulescu-Bogdan, N. (2020). *Beyond work: Reducing social isolation for refugee women and other marginalized newcomers*. Migration Policy Institute.
Banulescu-Bogdan, N. (2022). *From fear to solidarity: The difficulty in shifting public narratives about refugees*. Migration Policy Institute.

Barreto, C., Berbée, P., Gallegos Torres, K., Lange, M. & Sommerfeld, K. (2022). The civic engagement and social integration of refugees in Germany. *Nonprofit Policy Forum*, *13*(2), 161–174.

Beghetto, R. (Host) (2021, April 27). Dr. Sarah Dryden-Peterson – Refugee education: From uncertainty to creative futures (S2:E5) [Audio Podcast Episode]. In *Learning futures podcast*. Mary Lou Fulton Teachers College, Arizona State University. https://learning-futures.simplecast.com/episodes/dr-sarah-dryden-peterson-refugee-education-from-uncertainty-to-creative-futures-uWaGVnqh

Berry, J. W. & Hou, F. (2016). Immigrant acculturation and well-being in Canada. *Canadian Psychology*, *57*(4), 254. https://doi.org/10.1037/cap0000064

Borgonovi, F. (2008). Doing well by doing good. The relationship between formal volunteering and self-reported health and happiness. *Social Science & Medicine*, *66*(11), 2321–2334. https://doi.org/10.1016/j.socscimed.2008.01.011

Boyte, H. C. (2013). *Reinventing citizenship as public work: Citizen-centered democracy and the empowerment gap*. In Policy File. Kettering Foundation.

Brown, A. M. (2017). *Emergent strategy*. AK Press.

Callahan, R. M. & Obenchain, K. M. (2016). Garnering civic hope: Social studies, expectations, and the lost civic potential of immigrant youth. *Theory and Research in Social Education*, *44*(1), 36–71.

Campbell, D. E. (2008). Voice in the classroom: How an open classroom climate fosters political engagement among adolescents. *Political Behavior*, *30*(4), 437–454. https://doi.org/10.1007/s11109-008-9063-z

Carlton, S. (2015). Connecting, belonging: Volunteering, well-being and leadership among refugee youth. *International Journal of Disaster Risk Reduction*, *13*, 342–349. https://doi.org/10.1016/j.ijdrr.2015.07.006

Center for Victims of Torture. (2005). *Healing the hurt: A guide for developing services for torture survivors*. https://www.cvt.org/sites/default/files/u11/Healing_the_Hurt_Ch3.pdf

Collins, K. (2020). *Refugee youth and educators transform learning through collaborative artmaking* [Unpublished Manuscript].

Dryden-Peterson, S. (2020). Civic education and the education of refugees. *Intercultural Education*. https://nrs.harvard.edu/URN-3:HUL.INSTREPOS:37364795

Eisner, E. W. (2002). *The arts and the creation of the mind*. Yale University Press.

Elliot, S. & Yusuf, I. (2014). 'Yes, we can; but together': Social capital and refugee resettlement. *Kōtuitui: New Zealand Journal of Social Sciences Online*, *9*(2), 101–110. http://dx.doi.org/10.1080/1177083X.2014.951662

European Commission. (n.d.) *Forced displacement fact sheet*. https://civil-protection-humanitarian-aid.ec.europa.eu/what/humanitarian-aid/forced-displacement-refugees-asylum-seekers-and-internally-displaced-persons-idps_en

Finlay, A., Wray-Lake, L. & Flanagan, C. (2015). Civic engagement during the transition to adulthood: Developmental opportunities and social policies at a critical juncture. In L. R. Sherrod, J. Torney-Purta & C. A. Flanagan (Eds.), *Handbook of research on civic engagement in youth* (pp. 277–305). Wiley Press.

Global Education Monitoring Report Team. (2019. Global education monitoring report summary 2019: *Migration, displacement and education: Building bridges, not walls*. UNESCO.

Hayhurst, J. G., Ruffman, T. & Hunter, J. A. (2019). Encouraging flourishing following tragedy: The role of civic engagement in well-being and resilience. *New Zealand Journal of Psychology*, *48*(1), 75–94.

International Rescue Committee. (n.d.) *Refugees in America*. https://www.rescue.org/topic/refugees-america.

Kester, G. H. (2004). *Conversation pieces: Community + communication in modern art*. University of California Press.

Korza, P., Schaffer Bacon, B. & Assaf, A. (2005). *Civic dialogue, arts & culture: Findings from animating democracy*. Americans for the Arts.

Li, Y. (2020). Civic engagement and wellbeing among female immigrants in Canada. *Canadian Ethnic Studies*, 52(1), 49–72.

Michultka, D. (2009). Mental health issues in new immigrant communities. In F. Chang-Muy & E. P. Congress (Eds.), *Social work with immigrants and refugees: Legal issues, clinical skills and advocacy* (pp. 135–172). Springer Publishing Company.

Nelson, C. & Chandra, A. (2020, February 4). RX civic engagement: Keeping the public engaged in public health. *The Rand Blog*. https://www.rand.org/blog/2020/02/rx-civic-engagement-keeping-the-public-engaged-in-public.html

Parater, L. (2015, September 18). 7 art initiatives that are transforming the lives of refugees. *UNHCR Innovation Service*. https://www.unhcr.org/innovation/7-art-initiatives-that-are-transforming-the-lives-of-refugees/

Paris, D. & Alim, H. S. (2017). *Culturally sustaining pedagogies: Teaching and learning for justice in a changing world*. Teachers College Press.

Putnam, R. D. (2001). *Bowling alone: The collapse and revival of American community*. Simon and Schuster.

Rabkin, N. (2017). *Hearts and minds: The arts and civic engagement*. The James Irvine Foundation.

Robertson, K. & Breiseth, L. (n.d.) How to support refugee students in your school community. *Colorín Colorado*. https://www.colorincolorado.org/article/how-support-refugee-students-ell-classroom

Rollins, J. (2015). Arts, health & wellness. In C. Lord (Ed.), *Arts & America: Arts, culture, and the future of America's communities* (pp. 79–175). Americans for the Arts.

Ryan, R. M. & Deci, E. L. (2017). *Self-determination theory: Basic psychological needs in motivation, development, and wellness*. Guilford Publishing.

Sloan, J., Nelson, C. & Chandra, A. (2019). Examining civic engagement links to health: Findings from the literature and implications for a culture of health. RAND Corporation. Retrieved from https://policycommons.net/artifacts/4835839/examining-civic-engagement-links-to-health/5672549/ on 05 Jun 2024. CID: 20.500.12592/kg4w0j.

Sonke, J., Golden, T., Francois, S., Hand, J., Chandra, A., Clemmons, L., Fakunle, D., Jackson, M. R., Magsamen, S., Rubin, V., Sams, K. & Springs, S. (2019). Creating healthy communities through cross-sector collaboration [white paper]. University of Florida Center for Arts in Medicine/ArtPlace America.

Souers, K. & Hall, P. A. (2016). *Fostering resilient learners: Strategies for creating a trauma sensitive classroom*. Association for Supervision and Curriculum Development.

Stern, M.J. + Seifert, S. C. (2009). Civic engagement and the arts: Issues of conceptualization and measurement. Americans for the Arts. Retrieved from http://animatingdemocracy.org/sites/default/files/documents/reading_room/CE_Arts_SternSeifert.pdf

Unbound Philanthropy. (2021). *From resettlement to belonging: Opportunities for refugee leadership and civic participation*. https://unboundphilanthropy.org/wp-content/uploads/2021/07/From-Resettlement-to-Belonging.pdf

United Nations High Commission on Refugees. (2021). Staying the course: The challenges facing refugee education. *2021 Refugee Education Report*.

United Nations High Commission on Refugees. (2022). Global trends: Forced displacement in 2021. UNHCR Global Data Service. https://www.unhcr.org/refugee-statistics

United Nations High Commission on Refugees. (n.d.) *What is a refugee?* https://www.unrefugees.org/refugee-facts/what-is-a-refugee/

Weng, S. S. & Lee, J. S. (2015). Why do immigrants and refugees give back to their communities and what can we learn from their civic engagement? *International Journal of Voluntary and Nonprofit Organizations*, 27(2), 509–524.

Wray-Lake, L., DeHaan, C. R., Shubert, J. & Ryan, R. M. (2019). Examining links from civic engagement to daily well-being from a self-determination theory perspective. *Journal of Positive Psychology*, 14(2), 166–177. https://doi.org/10.1080/17439760.2017.1388432

Ziaian, T., Puvimanasinghe, T., Miller, E., DeAnstiss, H., Esterman, A. & Dollard, M. (2021). Identity and belonging: Refugee youth and their parents' perception of being Australian. *Australian Psychologist*, 56(2), 123–136. https://doi.org/10.1080/00050067.2021.1893601

Ziebarth, D. (2021). Making a difference in the community: Local civic engagement efficacy among immigrants and refugees in King County, Washington. *Local Government Studies*, 47(5), 735–758. https://doi.org/10.1080/03003930.2020.1794846

CHAPTER 12

AMP!ify | Agitate | Disrupt
Civic Engagement and Political Clarity in Art Education

Joni Boyd Acuff, Courtnie Wolfgang, and Mindi Rhoades

> **INSTRUCTIONAL QUESTIONS**
>
> 1. In what ways can grassroots DIY[1] forms of artmaking aid in developing the critical language necessary to engage in meaningful, civic engagement?
> 2. How might zine-making support pre-service teachers in the development of political clarity during a politically and socially hostile moment in history?
> 3. How might zine making and other forms of grassroots DIY artmaking support pre-service teachers in sharing ideas that shape the future of arts education?
> 4. What are the limitations of traditional scholarly publication and how might creation and distribution of independent publications (zines) expand possibilities for authorship in art education? How do we create more pathways for shared knowledge in the field?

In the United States, schools across the country have been met with politically driven challenges that aim to destabilize any missions related to social justice, including the diversification of knowledge creation. Across the country, policies have been drawn up to silence education and educators who value diversity, inclusion, equity, belonging, and justice. In September 2021, House Bill 322, the "Critical Race Theory Ban," was introduced on the Ohio House floor. As written, the bill would have prohibited K–12 educators addressing topics such as systemic and institutional racism, meritocracy, and white[2] privilege. The bill also stated that teachers may deny the humanity of gender variant, gender fluid, multiple, or non-binary identifying students by refusing to affirm their identity if teacher believes it goes against their "sincerely held religious or philosophical convictions" (H.B. No. 322, 2021, p. 12). In 2021, the Heritage Foundation blamed Critical Race Theory (CRT)[3] for the 2020 Black Lives Matter protests, as well as allowing LGBTQIA+ student groups in schools, Diversity, Equity and Inclusion (DEI) training for state and federal agencies, and culturally responsive

DOI: 10.4324/9781003402015-17

curricular reform, claiming it "rejects the fundamental ideas upon which our constitutional republic is based" (Sawchuck, 2021).

By fall 2021, 12 states had banned CRT's "divisive content," with an additional 14 states introducing bans or other restrictions on the teaching of social justice topics that erroneously became identified as CRT[4] or the discussion of racism and sexism, continuing to erase and now attempting to criminalize efforts centering historically marginalized experiences. For example, teachers and librarians face threats of termination if they do not comply with restrictions on reading materials that have been targeted by book bans in the United States. These books ban disproportionately target books which feature characters of color or LGBTQIA+ characters. While Ohio House Bill 322 failed to pass, by the summer of 2023, 36 states, including Ohio the state where the authors work, were either still considering bans on CRT or had already passed bans on CRT in schools (WiseVoter State CRT Ban Map, 2023) and the American Civil Liberties Union (ACLU) was tracking 228 anti-LGBTQIA+ state bills specifically targeting schools and education. Forty similar bans had been proposed in 22 other states which prohibit or restrict colleges and universities' initiatives relating to DEI (Chronicle DEI Legislation Tracker, 2023).

POSITIONALITY: US, OUR RELATIONSHIP, HOW WE COME TO THIS WORK

We, the three authors (a Black cisgender, heterosexual woman, one white cisgender, queer woman, and a white non-binary queer person who have been colleagues, friends, and collaborators for a decade and a half), are art educators working in higher education whose research and pedagogy are guided by identity theories, specifically Critical Race Theory (CRT) (Ladson-Billings & Banks, 2021), Black Feminist Theory (Collins, 1991), and Queer Theory (Wolfgang & Rhoades, 2017; Zacko-Smith & Pritchy Smith, 2010). These liberatory theories of historically marginalized communities support teaching pedagogies that actively disrupt varying forms of oppressions by attempting to unmask legacies of racism in political, educational, and social spaces; to center the experiences of Black/women; and to create safe and affirming living and learning spaces for queer communities. As Black and queer women navigating academic spaces and working in education, we carry critical examples of how racism, homophobia, and sexism affect the professional experiences of teachers and students. As professors who prepare future K–12 art teachers, we are acutely aware of how these bans impact our pre-service art teachers' K–12 curriculum upon entering the teacher workforce—recent graduates from our respective institutions report that administration censor classroom materials like rainbow flags, books about Black hair, student clothing and gender expression and more. We also understand how this ban will deeply shift what and how we teach pre-service teachers. We acknowledge how the bans restrict access to full histories in some classrooms and therefore our pre-service teachers' full capacity to create learning environments where all students feel seen. As these bans specifically seek to erase the histories and experiences of the authors, our students, our families, and communities, we feel a professional and personal responsibility to support pre-service art educators in developing civic engagement-seeing oneself as part of

a community working toward collective justice—and political clarity—recognition of and development of capacity to resist and transform socio/political phenomena.

We see the arts and art education as particularly well-suited for justice pedagogies: artists have historically used visual media to communicate ideas, to build coalitions, to challenge power and oppression, and to inspire change. Therefore, this chapter discusses a cross-institutional collaboration illustrative of such responsiveness: we begin by discussing our positioning and our collegial and personal relationships to one another; then a brief section discussing the what and the why of using zine making with pre-service teachers; followed by a description of the project, our conclusions, and ongoing provocations.

Our arts-based, pedagogical collaboration prioritized civic engagement (Barnes, 2021) and activated political clarity (Bartholomé, 2002; Kraehe & Acuff, 2021) to support pre-service art teachers' awareness of education's political aspects, including ways schools reproduce social inequalities (Bartholomé, 2002; Beauboeuf-Lafontant, 1999). We posit that intentional cultivation of political clarity and civic engagement in pre-service teacher preparation—to provide students with the tools to decipher the political and social landscapes of teaching in the United States and to act in solidarity with efforts to provide equitable and just learning experiences for students—is essential. We acknowledge, however, the risks associated with occupying "divisive" (according to some) positions and of encouraging students to consider these perspectives. To be clear, the authors do not consider justice work to be inherently divisive; we use "divisive" here to describe the aforementioned state legislation restricting content or even language related to racism, sexism, or heterosexism in schools (and thereby, we argue, creating hostile learning environments for many students and hostile teaching environments for educators). Therefore, we embarked on a collaborative and student-centered endeavor to include historical, social, and pedagogical research for pre-service art educators through the creation of a series of critical and social theory zines.

Using the CRT bans and anti-LGBTQ+ legislation as impetus for action, our arts-based intervention enabled a cross-university cohort civic engagement—seeing oneself as part of a community working toward collective justice—and political clarity recognition of and development of capacity to transform socio/political phenomena of pre-service art teachers to "see themselves and their teaching as part of a larger historical struggle for racial and social justice in the arts and through arts education" (Kraehe & Acuff, 2021, p. 152). This chapter illustrates how political clarity can be actualized in art education programs. We share pedagogical decisions and an approach to art education that encourages pre-service art teachers to see themselves as amplifiers/agitators/agents who can help artfully disrupt power structures that continue to harm and traumatize BIPOC and queer communities.

THE WHAT AND WHY OF ZINES AS A PEDAGOGICAL AND CURRICULAR TOOL FOR CIVIC ENGAGEMENT

Zines (pronounced "zeens" like magazine) have been a part of the cultural landscape for centuries. Non-commercial tracts and pamphlets could be considered early predecessors for contemporary zine practice. Chapbooks, a 19th-century term, were

small-production booklets with plagiarized summaries of published works made available to populations of people for whom the original works were difficult to obtain or for whom the summaries were more accessible in language or length. Like chapbooks, zines are non-commercial, small production, do-it-yourself (DIY) publications personal in nature and tend to be diaristic or political (Thomas, 2018). Thomas suggests that the use of zines in coursework in higher education encourages political activism, saying that it "gives participants to write and publish based upon their motivations and desire to make issues public outside of mainstream publication" (p. 746).

Other benefits, according to Thomas's research, include student development and "Zine creation allow[ing] students to think outside of the box about social issues. [Zine-making] fosters engagement with material that is beyond textbook learning. It breaks down barriers of the 'right' way to think about a social problem" (p. 747). Thomas adds that students develop agency, subjectivity, are politicized, and enjoy learning through the production of zines. One participant in Thomas's study noted that students kept "critical journals contextualizing how the content of the class influenced their [zine] work" (p. 747).

As faculty working with pre-service teachers, we often present historical, political, philosophical, and critical scholarship to our students. However, we also acknowledge that deep understanding of that scholarship requires an academic as well as experiential engagement with texts. For many of our students, they encounter critical theory for the first time in our coursework and are being asked to apply that knowledge to the craft of teaching and learning in and through the arts. Other arts education scholars have spoken to the pedagogical implications of using zines in the teaching of art, employing aspects of postmodernism like pastiche and parody (Congdon & Blandy, 2015); with pre-service teachers (Klein, 2010); and documentation of art teacher identity (Weida, 2020). Like these scholars, we understand zines as a site of creative, non-authoritarian, scholarly authorship through which pre-service teachers and arts educators can critically and playfully immerse themselves in dialogue with ideas. Additionally, we see zine production as a way to subvert the gatekeeping of academic or commercial publications in order to distribute resources related to current social and politicizing events to readers more quickly. Finally, co-authorship and collaboration between pre-service educators, artists, scholars, and researchers in higher education through zine production encourage political engagement in issues that directly impact teaching and learning in the 21st century, such as book bans, the forced removal of all flags in classrooms, and budget reductions that support DEI learning.

The production and distribution of zines shared knowledge through short form, easily reproducible tracts, can be understood as a form of civic engagement: consideration of the language, content, and audience situates the author or authors in conversation with their community around matters of interest or importance. Therefore, we posit the use of zines in the development of political clarity in pre-service art education as an act of civically engaged teaching. To produce a body of research or writing in a college-level course is often to write for an audience of one, the instructor. However, the use of zines as a teaching tool requires students to develop clarity of concept for a broader audience: the public. Zines are often created collaboratively, unlike formal research papers in higher education. This subtle but significant shift, we argue, is an element of this pedagogical practice that creates conditions for civic engagement and political clarity in classrooms.

AMP! INCEPTION

During the fall of 2021, the fears of retribution for teachers in states banning CRT, the banning of books, and anti-LGBTQIA+ legislation affecting school-aged students reached a crisis point. The first *AMP!* Zine, titled *WTF is CRT?*, [Figure 12.1] made by Courtnie Wolfgang—a lifelong zine enthusiast and zine maker—was the result of ongoing conversations between Courtnie and Joni around the need for art education alternatives to traditional academic publications to bridge the gaps between critical theory and practice, impacting art educators' pedagogy/praxis at all levels, in classrooms and other arts educational spaces. The first issue of *AMP!* was specifically related to content supporting arts educators navigating the political right's weaponization of CRT and LGBTQIA+ affirming practices in school spaces. As indicated earlier in the chapter, we saw the potential of *AMP!* as a pedagogical tool for working with pre-service teachers to contribute scholarly contributions to the justice movements in education: for educators by educators. To facilitate this, we created a zine template with a structure for each issue that uses a minimum

1. WTF is...?!

CRITICAL RACE THEORY (or CRT)

CRT is an ACADEMIC and SOCIOLOGICAL frame through which one can examine systems of privilege and oppression IN RELATIONSHIP to race. It emerged from a framework for LEGAL analysis in the 1970's.

CRT includes INTERSECTIONAL investigations of race and gender, sexuality, class, religion, disability, nationality, indigeneity, etc.

Notable early CRT scholars:
Derick Bell
Kimberle Crenshaw
Richard Delgado
Gloria Ladon-Billings

FIGURE 12.1 *AMP! Critical Race Theory* (Issue 1).

of three pages of standard letter copy paper, folded and each printed double-sided. The three authors also created a zine "specs" document to share with other authors [Figure 12.2], outlining the general format and providing links to zine archives like *Queer Archive Work* in Providence, Rhode Island, and the *DC Punk Zine Archive* for zine reference and inspiration.

NOTE: planning your zine content pages in groups of 4 (four) is best. For instance, 8, 12, or 16 page zines (2, 3, or 4 8 ½ x 11 pages, folded in half and printed front and back)

Your content contribution should be **ready to reproduce in black and white** (photocopier).

You can use InDesign stock templates to create your pages or create your own template... I made the above template in InDesign just using text and the draw box tool.

If you don't have access to InDesign, here are some free alternatives to InDesign if you want to design digitally!

OR can go old school and analog cut and paste. Make sure if you go analog with a glue stick to leave a small margin around all 4 edges of the page so your text/images don't get chopped during reproduction (½" will suffice). Here is a recent collage I made for a zine about Edmonia Wildfire Lewis and her cohort of other "confirmed bachelorettes" in Paris.

Here are some zine archives for INSPIRATION...
Queer Art Archive (zine library) & Downloadable Library
Here are some examples of the zines I cut my teeth on when I was a teenager!
Here is an archive of digitized zines held by the Ontario College of Art and Design

FIGURE 12.2 *AMP!* Planning FORMAT document shared with students and *AMP!* Participants.

AMP! was envisioned as a collaborative project always under collective development. While the three authors adapted the template and framework specifically for this class, these are deliberately malleable for any art education students, art teachers, or other interested parties as a way to ask critical questions and offer pragmatic ideas for action. Our initial overarching goals for *AMP!* as a process and a product are as follows:

- Make critical theory understandable/accessible/meaningful to art educators and pre-service teachers.
- Minimize gatekeeping/maximize inclusion (ideas, voices, perspectives, authors).
- Include contemporary critical artists/artwork.
- Include contemporary critical (art) educators.
- Operate collectively—decentralize the process/distribution.
- Develop a collective process of working with authors to produce/print/publish/distribute their own issues of *AMP!*

THE INTERVENTION

The *AMP!* Zine and template as a classroom project was introduced to pre-service art education students enrolled in a course titled, "Pedagogies of Critical Multiculturalism in Teaching Visual Culture," taught by Joni Acuff, in the Department of Arts Administration, Education & Policy (AAEP) at The Ohio State University where Joni and Mindi both teach. Pre-service teachers (PSTs) are required to take this course within the first semester of being admitted to the art education major in AAEP. Joni has taught this course for seven years as it evolved from a multiculturalism course to one that centers race more pointedly. The course takes a critical race theory stance and explores the interrelationship of social and cultural issues, visual culture, philosophies of teaching, and the construction of democratic spaces of learning building on theories of multicultural education. Through a simultaneous exploration of contemporary and historical visual culture (including art and popular culture), and educational and critical theory, this course emphasizes not only questions related to content in the art classroom, but also how social and cultural issues inform the construction of diverse teaching practices.

The course is framed by essential questions and learning outcomes. The ones listed below directly align with the zine project.

Essential Questions:

- How does the sociopolitical and sociocultural context of students' and teachers' experiences and schools influence theory and practice about art education?
- How can we be informed by social and cultural issues to actively participate in the construction of diverse teaching practices in the field of art education?

Learning Outcomes:

- Develop a critical language through which to speak about racial, social, and cultural issues informed by current theories of art, art education, and critical/cultural studies.
- Apply critical art pedagogy by engaging in art-making and inquiry-based studies.

For this course, the authors collectively customized the zine-based approach to feature anti-racist pedagogy in a class-produced set of *AMP!* issues.

In fall 2021, the semester in which the zine project was introduced, this course enrolled 15 undergraduate and licensure-only PSTs, with all but two self-identifying as white and American. This transition was natural but also seemed necessary to fit the contemporary social context. With the hyper-visible, public murders of teenage Black boys like Trayvon Martin, Tyre King, Tamir Rice, and Michael Brown, the PSTs became increasingly and acutely aware of the need to be able to support students of color in their classrooms. They also recognized their role as potential agents of change, given anti-racist pedagogy is grounded in political clarity. Kraehe and Acuff (2022) describe political clarity as "an awareness of the political aspects of education and the ways schools reproduce social inequalities" (p. 152). They continue, "Political clarity enables art teachers to see themselves and their teaching as part of a larger historical struggle for racial and social justice in the arts and through arts education" (p. 152). Introducing zines as an interventionist tool allowed Joni to model political clarity and also teach PSTs ways to develop their own pedagogy around political clarity.

Joni employed zines to enable PSTs to be active in their own knowledge-making and the teaching of others. Further, the aforementioned essential questions and learning outcomes support the pedagogical principle of political clarity. Many of the essential questions and learning outcomes communicate that what and how we teach must be responsive to real-world conditions (Kraehe & Acuff, 2021). Using zines making as an intentionally justice-centered learning activity is illustrative of the ways critical pedagogy can guide the reimagining of teachers as change agents both inside and outside the classroom. While zines are not intrinsically anti-racist, we propose a critical use of zines as an equity-based venue for producing and sharing anti-racist, anti-oppressive content.

The zine-making process was collaborative from beginning to end. After initial planning meetings among all three authors, Courtnie and Mindi visited the PSTs on multiple occasions to discuss the zine conceptualization process. The historical context and the social justice orientation of the origin of zines were new to students. Courtnie zoomed into the class twice and Mindi visited the PSTs in person, bringing multiple hardcopy examples of the first issue of *AMP!*, copies of the *AMP!* template, and a wide range of other zines for PSTs to read, share, and discuss. Mindi also facilitated a zine workshopping session where she brought in materials for the PSTs to use to craft their zine.

PSTs were placed in groups of three and each group was assigned a pedagogical framework to create a zine around. The frameworks included Critical Multiculturalism (May & Sleeter, 2010), Antiracist Pedagogy & Teaching (Thompson, 1997), Culturally Responsive Teaching (Gay, 2010), Abolitionist Pedagogy (Love, 2019), and Afrofuturism (Dery, 1994). Over 12 weeks, the PSTs were introduced to each pedagogy through readings, lectures, and class activities. The PSTs learned how these pedagogical frames looked and functioned in an art curriculum and classroom. Then they were responsible for sharing this information out to the world through the construction of their zines.

Across the zines, we see several ways these PSTs demonstrate an awareness of *the sociopolitical and sociocultural context of students' and teachers' experiences*.[5] In

AMP! Anti-Racist Pedagogy (ARP), the zine authors (referred to as "authors" from here on) note such pedagogy is necessary "to explain how the myth that white people are superior is ingrained into American history as well as media, curriculum, and daily life and it continues to shape unequal opportunities to learn and for students to feel welcome in school." The authors have a clear awareness that schools need active and proactive frameworks for ensuring equitable treatment for all students. In the same zine, the authors demonstrate an awareness that white people are the ones most in need of education that exposes racism, its prevalence, and its persistence. They feature educator Jane Elliott, a white educator known primarily for her work with white people on ant-racist pedagogy. In the Critical Multiculturalism zine, the authors use Dr. Bettina Love for their Educator Profile, acknowledging that she is a Black scholar known for her work with primarily Black populations and aimed at anti-racist reform in education and prison, yet simultaneously focusing on the idea and potential of Black joy.

In another zine, the authors acknowledge Afrofuturism [Figure 12.5] as a response to oppressive sociopolitical and sociocultural contexts. The authors note that Afrofuturism is "the insistence that people of color have a future," because in most current "mainstream visions of the future… people of color are practically, and sometimes quite literally nonexistent." In *AMP! Culturally Relevant Pedagogy* [Figures 12.3 & 12.4], the

FIGURE 12.3 Cover art and page 1 of *AMP! Culturally Relevant Pedagogy.*

FIGURE 12.4 Pages 2 and 7 of *AMP! Culturally Relevant Pedagogy.*

authors reflect the importance of recognizing the "inequalities in the U.S and in the art world and show their students the possibilities for a more equitable future."

For them, incorporating culturally responsive pedagogies not only "creates more equity in their classrooms and fulfilling the goals of multicultural education theories," but it helps transform art education into a more inclusive, sustaining environment for all students. The AMP! Abolitionist Teaching explicitly names multiple current equity issues related to race and education. The authors describe current conditions, including acknowledging racial injustice, noting problems not only in the United States but globally. Collectively, the zines present an awareness of the complexities around the kinds of sociocultural and sociopolitical discourses that operate and dominate currently.

Another essential question from Joni's class the zines addressed was how we can be informed by social and cultural issues to participate actively in ***the construction of diverse teaching practices in the field of art education.*** While other AMP! format sections also address this question, the "why are we talking about..." and "lesson plans" sections address it most directly and thoroughly.

AMP! Afrofuturism, titled *Back to the Afrofuturism*, fully engages with the social, cultural, and political issues around Black identity and representation across media and proposes diverse art education teaching practices. Afrofuturism openly embraces pop culture media as a means for disrupting and escaping "Western" (white supremacist) beliefs. The authors note that an Afrofuturist approach "embraces the

FIGURE 12.5 Cover page and page 8 of *AMP! Afrofuturism*.

future as a window for change," as a way to mitigate racial inequities. The authors caution against exoticizing African history and culture, instead urging a focus on "futuristic ideas combined with technology, imagination, and Afro-Diasporic art making processes."

The *AMP! Critical Multiculturalism* zine highlights Bettina Love's encouragement to be informed by sociocultural issues and to participate actively in the "construction of diverse teaching practices in the field of art education." The *AMP! Anti-Racist Pedagogy* centers accessible and equitable teaching practices, insisting that it isn't racist to teach anti-racism and anti-racist pedagogy. Instead, they stress Love's work with "activists, communities, youth, families, and school districts to build communal civically engaged schools rooted in abolitionist strategies that love and affirm Black and Brown children." They emphasize the need for diverse teaching practices as a desirable outcome. The *AMP! Critical Multiculturalism* zine authors affirm this approach because it can achieve multiple positive outcomes: lessening cultural misrepresentation, awareness of unfair power relations in and out of school settings, and to be inclusive and welcoming to everyone.

In the *AMP! Abolitionist Teaching* zine, authors explicitly call for us to "reframe education in order for Black and brown students to feel welcome," to employ teachers "who work in solidarity with their school's community" in order "to achieve incremental changes" in the present and working toward a more equitable educational system.

The *AMP! Culturally Relevant Pedagogies* zine's "LESSON ideas!" section presents a three-part plan for having students: (1) Research the Jim Crow Era's laws and oppressions; (2) Use this research to create new inclusive signs with anti-racist slogans and images; and (3) Post signs and host a school gallery walk to share and discuss their work. Afrofuturism work contributes to this shift by cultivating, desiring, rewarding, and reinforcing new media and methods. As *AMP! Afrofuturism* zine notes, Dr. Acuff's recent work provides a roadmap for using Afrofuturism as "an advanced art curriculum for Black existence," though she encourages educators to proceed with careful consideration when introducing and engaging these materials as curricula.

One of the primary goals for this course is to ***develop a critical language through which to speak about racial, social, and cultural issues informed by current theories of art, art ed, and critical/cultural studies***. This resonates fully with the purposes of *AMP!*: to make theory accessible, understandable, and useful to art educators. Each *AMP!* issue centers, explains, and develops a contemporary theory or theoretical concept in the context of art education. Two of the *AMP!* zines, *AMP! Critical Multiculturalism* and *AMP! Culturally Relevant Pedagogy*, suggest a broad, overarching theoretical approach to art education that values and honors the diversity of individuals, groups, and communities. *AMP! Critical Multiculturalism* espouses an educational approach "with opportunities to investigate and determine how cultural assumptions, frames of reference, perspectives, and the biases within disciplines influence ways knowledge is constructed." Further, it defines a critical multicultural art educator as someone who "works to educate students on the unfair power structures that have led to inequalities and inequities in our world," and who "provides students with opportunities to investigate and determine how cultural assumptions frames of reference, perspectives, and the biases within disciplines influence ways knowledge is constructed." *AMP! Culturally Relevant Pedagogy* provides another broad introduction to intentionally inclusive education, this time focused on its theory and practice. The other three zines focus more specifically on aspects of race within the context of art education.

First, in *AMP! Anti-Racist Pedagogy*, authors emphasize its academic benefits, arguing that anti-racist pedagogy "fosters [students'] critical analysis skills and their critical self-reflection." For them, being anti-racist goes beyond the informative and academic nature of critical multiculturalism and culturally relevant pedagogy. Instead, anti-racist pedagogy "means you have to have an active state of mind and actively oppose and identify racism" as an educator. As an example of implementing this approach, *AMP! Anti-Racist Pedagogy*'s artist profile highlights artist/educator Jen Bloomer who uses her own artmaking practice for reflection, educational, and activist purposes, publicly communicating explicitly anti-racist messages.

A key feature of *AMP! Abolitionist Teaching* is its insistence on wide-ranging relevance, echoing Bettina Love (2019), that "abolitionist teaching is not a teaching approach: It is a way of life, a way of seeing the world, and a way of taking action against injustice" (p. 89). This zine matches complicated concepts like abolition, the educational survival complex, and intersectionality with clear, concise definitions and a limited, streamlined set of useful resources for students and teachers. By combining these aspects, the zine creates a very accessible venue for students to develop their critical language through which to speak about racial, social, and cultural issues.

Finally, analyzing *AMP! Afrofuturism* provides a sense of progression along a continuum, from general to more specific and now to possibilities. *AMP! Afrofuturism* introduces the concept of blending fictionalized histories, science fiction, fantasy, and superhero narratives to "erase the past and reimagine the future through the eyes of Black liberation utilizing technology and artistic practices" and media. Of the zines, *AMP! Afrofuturism* defines more terminology, develops further explanations, and offers more examples than the others, perhaps given its flashy-sounding name, perhaps given its dynamic focus on creating expanded visions and images of possible futures that decenter whiteness and white supremacy. Collectively, these zines provided a flexible construct for students to engage with current theories, even complex ones, with the purpose of distilling them into understandable, manageable, and applicable components that can provide us with tools and processes to make progress around racial, social, and cultural issues in art education.

One of the most prominent ways the *AMP!* zine project complements the course goals is also its most practical: application. How do we take these theoretical ideas and do something with them? Why do they matter? Each zine presents a section with related lesson ideas to support this process. In *AMP! Critical Multiculturalism*, each author offers a lesson idea focused on self-reflection and introspection as a way students can begin to process their awareness of sociocultural and sociopolitical issues as they exist on global, local, and personal levels by producing an object that represents their intersections with aspects of their identities. *AMP! Culturally Relevant Pedagogy* offers a three-part lesson plan starting with inquiry into racist imagery and signs prevalent during the Jim Crow era in US history, then designing inclusive broadside signs in response, and then hosting a gallery walk for discussing their research and creations with others. *AMP! Anti-Racist Pedagogy* also employs a reflective process. In the zine, the authors offer a literacy-integrated lesson plan using the children's book *All Are Welcome*. The book serves as a catalyst, first for conversations and then for the imaginative student creations around inclusion, belonging, and community: creating welcoming spaces.

The *AMP! Abolitionist Teaching* lesson plan proposes collage as an inquiry-based method for gathering, organizing, and processing materials. In this way, the zine positions the featured artist's critical collage-making practice as a starting point and a model for students' own research and subsequent creative artistic/activist productions. *AMP! Afrofuturism* provides the most extensive set of lesson plan ideas and inspiration, and the most explicit grounding of these in art education literature. Quoting Acuff (2020), these authors offer Afrofuturism as a productive framework, a way for students "to not only see themselves in the art curriculum but also be able to imagine and develop their futures through the art curriculum" (p. 15). Acuff (2020) further suggests that an Afrofuturist foundation for art curriculum enables students "to use art to affirm their existence, as well as envision a world where colonialism and its effects are no longer a limitation to creating a Black-centric future," for Black students or anyone else (p. 20). The authors' lesson plan ideas provide offer a range of projects and activities, from studying the fictional land of Wakanda from the Marvel Cinematic Universe's Black Panther film to producing original 2D future cityscape drawings to creating art based on work from the three featured Afrofuturist artists (Wangechi Mutu, Osborn Macharia, and Laolu Senbanjo). These lesson ideas also

feature research, collecting images and objects, and combining these to create visual collages, fictionalized characters, imaginative landscapes, and futuristic worlds with sweeping narrative storylines. The lessons encourage a hybrid approach to blending media in layered, complex, and sophisticated ways to create imaginary universes of possibility that inspire and motivate us to make progress—for everyone—toward these more utopian aims. Overall, analysis of the set of *AMP!* zines demonstrates that it provides a flexible and inclusive format that enables students to address the essential questions and course goals. The *AMP!* zine format itself also remains flexible and open to revision and modification and for specific classroom, educational, or activist purposes. Several zines in this collection also explicitly provide information about the specific state and/or grade-level arts standards they cover, offering further evidence of their curricular and pedagogical flexibility and applicability.

CONCLUDING REFLECTIONS

Echoing the findings from Thomas's (2018) survey, which state that many teaching faculty recount the value of zines in the history of a political movement or subculture, we posit that zines are an important pedagogical intervention supporting pre-service student identity construction as creators of critical content and media. As ephemeral objects, zines allow students to "materially embody the fluidity" (p. 746) with which we hope students encounter political clarity through civic engagement, particularly during moments of social unrest. Zines are possibility spaces (Elkin & Mistry, 2018) for the development of student agency so that they become "proactive drivers of their learning, art making and other transdisciplinary inquiries they are pursuing" (p. 110).

One foundational key to the success of this undertaking is that *AMP!* is a collaborative, grassroots effort intended to be by and for art educators. The concluding tagline on *AMP!*'s back cover speaks to this: *AMP! Collaborative Since Forever*. Consequently, where *AMP!* became active was in Joni's classroom when she and her students used it as a critical-creative and collaborative artistic, educational, and activist tool with her students. AMP fostered an arts-based approach for coalition building that transcended institutional restrictions and prepared students to become art teachers who have the tools to resist, disrupt, and transform injustices in their varying permutations.

NOTES:

1. DIY refers to Do-It-Yourself and is just as much a state of mind as it is using one's skills to complete projects. DIY refers to self-organized, grassroots efforts that rely on the resources of individuals, instead of institutions.
2. We are following the guidance of the Associated Press in the decision to capitalize Black and keep white lowercase when referring to group and individual identities.
3. Critical Race Theory is a study of the ways racism has shaped policy, practice, and social constructions globally.
4. CRT is not part of the K–12 curriculum in the United States, but a theory through which systemic racism might be better understood.
5. The italicized and bolded phrases are to signal that we are quoting the aforementioned essential questions and learning outcomes aligned with the zine project.

REFERENCES

Acuff, J. B. (2020). Afrofuturism: Reimagining art curricula for Black existence. *Art Education*, 73(3), 12–21.

Barnes, S. (2021). Black sociologists and civic engagement. *Journal of Economics, Race, and Policy*, 4, 91–103.

Bartolome, L. (2002). Creating an equal playing field: Teachers as advocates, border crossers, and cultural brokers. In Z. F. Beykont (Ed.) *The power of culture: Teaching across language differences*. Cambridge, MA: Harvard Education Publishing Group (pp. 167-192).

Beauboeuf-Lafontant, T. (1999). A movement against and beyond boundaries: Politically relevant teaching among African American teachers. *Teachers College Record*, 100, 702–723.

Chronicle DEI Legislation Tracker (2023). https://www.chronicle.com/article/here-are-the-states-where-lawmakers-are-seeking-to-ban-colleges-dei-efforts

Collins, P. H. (1991). *Black Feminist Thought: Knowledge, Consciousness, and the Politics of Empowerment*. Routledge.

Congdon, K. G., & Blandy, D. (2015). Zinesters in the Classroom: Using Zines to Teach about Postmodernism and the Communication of Ideas. *Art Education*. https://www.tandfonline.com/doi/abs/10.1080/00043125.2003.11653501

Dery, M. (1994). Black to the future: Interviews with Samuel R. Delany, Greg Tate, and Tricia Rose. In M. Dery (Ed.), *Flame Wars: The Discourse of Cyberculture* (pp. 179–222). Duke University Press.

Elkin, T., & Mistry, A. (2018). The accordion book project: Reflections on learning and teaching. In Du, X., & Chemi, T. (Eds.). *Arts-Based Methods in Education Around the World*. Macmillan Publishers.

Gay, G. (2010). *Culturally Responsive Teaching: Theory, Research, and Practice*, Second Ed. Teachers College Press.

H.B. No. 322 As Introduced. (2021). 134th Generally Assembly. 1–26. https://search-prod.lis.state.oh.us/solarapi/v1/general_assembly_134/bills/hb322/IN/00/hb322_00_IN?format=pdf

Klein, S. (2010). Creating zines in preservice art teacher education. *Art Education*, 63(1), 40–46. https://doi.org/10.1080/00043125.2010.11519052

Kraehe, A. M., & Acuff, J. B. (2021). *Race and Art Education*. Davis Publishing.

Ladson-Billings, G., & Banks, J. (2021). *Critical Race Theory in Education: A Scholar's Journey*. Teachers College Press.

Love, B. (2019). *We Want to Do More than Survive. Abolitionist Teaching and the Pursuit of Education Freedom*. Beacon Press.

May, S., & Sleeter, C. (2010). *Critical Multiculturalism: Theory and Praxis*. Routledge.

Sawchuck, S. (2021). What is Critical Race Theory and why is it under attack? *Education Week*.

Thomas, S. (2018). Zines for teaching: A survey of pedagogy and implications for academic librarians. *Portal: Libraries and the Academy*, 18(4), 737–758. https://doi.org/10.1353/pla.2018.0043

Thompson, A. (1997). For: Anti-racist education. *Curriculum Inquiry*, 27(1), 7–44.

Weida, C. L. (2020). Zine objects and orientations in/as arts research: Documenting art teacher practices and identities through zine creation, collection, and criticism. *Studies in Art Education*, 61(3), 267–281. https://doi.org/10.1080/00393541.2020.1779570

Wolfgang, C., & Rhoades, M.. (2017). First fagnostics: Queering art education. *Journal of Social Theory in Art Education*, 37(1).

Zacko-Smith, J. D., & Pritchy Smith, G.. (2010). Recognizing and utilizing queer pedagogy. *Journal of Multicultural Education*, fall, 2–9.

The Landscape is Turning
Narrative Collage as Sites of Civic Engagement

Amy Pfeiler-Wunder

> **INSTRUCTIONAL QUESTIONS**
>
> 1. What stereotypes exist around the identity of teacher – How do you address this as a future professional?
> 2. How do personal factors such as class, race, gender, and/or other identities (age, "disabilities", sexual orientation/identity, etc.) inform your professional identities?
> 3. How has the political, social, and cultural landscape of teaching/education impacted how you see your role as a current or future educator?

I technically entered 24 "classrooms and homes" during the pandemic – dorm rooms, living rooms, family kitchens, cars, and hotel rooms. This came with a keen awareness that being at "home" for others (and myself) brought new possibilities and new challenges. Prior to the pandemic, although I studied how learner and teacher stories entered the classroom, "being at home" with my learners via zoom transformed my orientation and definition of a "classroom." I felt closer to and farther away from my students' lives. Was home for my learners: Warm? Welcoming? Inviting? Safe/unsafe? Distant? Confining? Challenging? Home may encapsulate memories of safety, connection, and love. Home is also complicated and complex.

Home, in the myriad of ways it is defined, lived, and experienced, is often an early site of learning democratic principles. As conversations over headlines unfolded, what topics are on the table? Off the table? What rules exist for these discussions? If disagreements existed, how are relationships fostered between siblings, caregivers, occupants in the home? What tensions are present and how are those negotiated? For example, who in the home makes decisions on the news program viewed, downloaded, and streamed? I recall one student sharing

DOI: 10.4324/9781003402015-18

her deep fear of writing about her liberal views related to an upcoming election. These views went completely against the political leanings of her family. So much so, that to reveal these, meant being ostracized by her family, from her home.
(personal notes on teaching during the pandemic, March 2019)

FOSTERING CRITICAL ENGAGEMENT IN EDUCATIONAL SETTINGS

Conversations on critical civic engagement recognize the entanglement of place, of home, of one's culture in understanding democratic principles. Notions of "home" are foundational in conversations on civic engagement. Civic engagement adheres to civic wisdom, "the central idea of bringing out discussion and solution of public problems" (p. 3), ensuring all citizens "make use of their civil and political rights" (p. 3). Civic wisdom is also guided by civic intelligence rooted in facing challenges through learning, adapting, reflecting, and imagining (Navarro, 2017).

For my students, knowing themselves to better understand others became a place to develop civic intelligence (White, 2012). They reflected and imagined fostering a classroom community where challenges in society and culture could be discussed through dialogue and artmaking. To model this, students engaged in making paper dolls as a site of their own inquiry composing personal narratives through the form of artist statements on what it meant to be a teacher, specifically a teacher committed to amplifying voices of historically marginalized students and responding to challenges faced in communities.

Narrative inquiry recognizes that stories are impacted by temporality, place, and sociality – the social, political, and cultural landscape (Clandinin, 2016). Temporality means ongoing examination, "we are composing and constantly revising our autobiographies as we go along" (Carr, 1986, p. 76). Individuals have a past, present, and future that affects how they tell their stories and listen to others' stories. Sociality recognizes that there are social, political, and cultural conditions that affect the process of how narrative informs us and our hopes, dreams, and desires (Clandinin, 2016, p. 40). Pre-service students desired and dreamed of educational settings where their identities were welcomed, and their classroom settings were inclusive and fostered a sense of belonging. Temporality is focused on place, and therefore, what was revealed about their teacher's identity was impacted by the place in which they were studying and the communities in which they would teach. As they snipped, cut, and collaged, their dolls took shape, simultaneously being shaped by the current educational landscape. In this case, the impact of Covid-19 on teachers, schools, and learning. School felt more isolating, new economic challenges unraveled, and they reflected on the impact of Covid on school communities they would enter upon graduation. Clothing and accessories emerged representing the political and social landscape as news media and conversations unraveled during the death of George Floyd and the Black Lives Matter movement. Finally, place mattered as where each of us worked and lived impacted our stories.

In this chapter, I begin with a discussion of the place surrounding the students' lived college experience. I then highlight the paper dolls of three pre-service students as examples of artmaking as site of civic engagement, as evidenced by how pre-service

students rewrote/disrupted narratives of what it means to be "teacher" through their choices in clothing, accessories, and personal reflections as artist statements. Finally, I discuss how their lived experiences and autobiographies reveal the importance of understanding stories told by educators, with keen attention story types that can foster educational settings committed to civic engagement.

How Place Impacts One's Identity and Civic Engagement

My pre-service students attend college in a borough of 5,000 surrounded by the rolling hills and farmland where I also make my home. As a product of Iowa farmland, this place is feels known, comfortable. My childhood home was surrounded by corn fields, winter wheat, rolling hills, and farms passed from one generation to the next. I also recognize it creates a bucolic scene. Today, the land I live on is the land of the Lenape, who are also present in the community, yet seen as invisible given the occupation and colonization of land by Whites.[1]

My community is also 90% White. The university where I teach is also predominantly White, while increasing in students of color. The pre-service students I teach are also "in the midst of" (Clandinin & Connelly, 2000, p. 20) a political landscape with significant barriers in education that include school board meetings heated due to (mis)interpretations of critical race theory[2] (Ladson-Billings & Tate, 1995); challenges inherent in a testing culture (Ravitch, 2016); concerns for school safety due to gun violence and political polarization. These are not unique to the US; public schools in the UK are also faced with inequalities related to school funding, over testing, and teacher shortages. These challenges are often exacerbated depending on the school location – and the funding allocations for each school site. My students and I not only see political and social unrest every time we listen or stream the news: for some of my students and myself, shootings are becoming closer and closer to home as evident in the local newspaper headlines:

> State police say they have arrested the suspect involved in a shooting that left one man dead near the Kutztown University campus.
>
> *(Muniz, 2022)*

For many of my students, the college campus was their home during their studies, and a microcosm of the larger society. This community, this place, was shaping their teacher storylines. Students discussed fears of what it meant to be a teacher of color in rural community, fears of how they would be accepted in a conservative school or community setting, worries about how school funding, choice, and gun violence may impact them in their future careers. Given the intersections of time, place, and the social and political landscape, pre-service students reflected on what it means to be change agents with a desire to amplify their educator voice and the voice of their students with the "goals of democracy and unity through the education of its citizens" (Banks, 2004, 2016, as cited in Howard, 2019, p. 44).

The paper doll project was created as a site of identity de/construction to provide a method to facilitate a critical examination of the how lived experiences impacted their teacher identities, how they viewed learners, and the type of classroom environment

they wished to create. We started by unpacking identities and positionalities building a democratic "home" within the classroom, deeply listening to understand each other's stories with empathy and care (Kay, 2016).

Identity and Positionality as Platforms for Civic Engagement

Identity encompasses how one defines self, some fixed, some more malleable, while positionality are enacted identities in discourses, practices, and experiences (Tien, 2020). Identities and positionality shape one's narrative landscape and storytelling. I related to many of my student's narrative landscape as first-generation college student. I also empathized with their personal experiences of financial insecurities. As a product of a rural area, my family faced and still does financial instability. I am also a White educator in a still predominantly White teaching field (Emdin, 2016; Spillman, 2015). I was raised Christian. These privileged positionalities matter. Could I really be an ally or accomplice within these privileged identities (Reyes, 2018)? Even if I felt I created a space for open discourse on the role of teacher identity within culture and society, I could not hide nor ignore the place of privilege in these conversations given parts of my identity aligned with most of the teaching force in the country. "Thinking narratively is risky business", as Clandinin (2016) shares, "It calls me to be attentive to my own unfolding, enfolding, and the lives of those with whom I engage" (p. 23). It calls us as teachers to recognize how positionality can be acted, enacted, concealed, and performed that can support democratic principles or keep them at bay.

COLLAGE NARRATIVES: PAPER DOLLS AS SITES OF CIVIC ENGAGEMENT

The paper dolls and artist statements explored their past, present, and identities as future educators, spaces of reflection in the form of "collage narratives". "Collage narratives" (Garoian & Gaudelius, 2008) acted as sites of tension and becoming; the "interplay between curriculum and pedagogy" or the "*what* we teach and *how* we teach it" illustrated through the intersection of collaged elements from visual culture and their narrative artist statements. These paper doll layered and narrative collages as artist/teacher represented the tensions and possibilities within education as a form of civic engagement. Using the paper dolls as a site for revealing layers of identity also required understanding the history, use, and challenges of this form of visual culture.

Background on Paper Dolls

Paper dolls appeared in an 1810 London chapbook called "The Little Fannie Figure" which was aimed at the upper classes as teaching tools and used for play focused on "appropriate behavior" for young girls (as cited in Pfeiler-Wunder, 2017). They were also used as teaching tools in women's magazines such as *Good Housekeeping* and *McCall's*. Paper dolls were also widely available in many purchased goods viewed as "prizes" such as those that came in coffee and flour products (Johnson, 1999).

Before creating their own paper dolls, paper dolls from pop culture were distributed in small groups and students discussed stereotypes perpetuated by the dolls. For example, "Dress Up for the New York World's Fair" doll was meant as a multicultural teaching tool in the 1960s, including "paper doll cutouts with costumes from many different lands" (Spertus Publishing, 1963, p. NA). Illustrated with "traditional" clothing and costumes from other parts of the world, these dolls were interpreted by the students as a form of propaganda to understand other cultures and places different than one's own. Here race, ethnicity, and culture are viewed as "other".

Discussion followed by also reveals which dolls attempted or included new narratives (on gender, race, class, and other identities). For example, a paper doll focused on the stages of pregnancy did not solely focus on the "warm glow" of pregnancy. The challenges with hormonal changes were also illustrated in a tongue and cheek manner as the doll held a large knife in one hand and one of the accessories also included antacids and a frying pan. The description on the page even reads "She's pissed-in fact she's peeing every five minutes" (Imagineering Company, 2005). Critical conversation on how paper dolls have been used in visual culture ran parallel to their discussion of pervasive stereotypes of "teacher" and "art teacher" in visual culture by placing these key words via a Google search. Here the art teacher was typically female, White, always bubbly, and joyful wearing colorful clothing and fun earrings! Students then created paper dolls that pushed on teacher stereotypes or embraced while showing nuisances in identity and positionality to visually create counter narratives to how culture views, uses, and even plays with paper dolls. Pre-service students embarked on the creation of collage paper dolls with the following questions to inform their initial sketches:

- What clothes and accessories reflect identities most important to you at this moment in time?
- What clothes or accessories will you include to illustrate tensions between your personal and professional identity and identities placed on educators by society, school, other educators?
- What stereotypes exist around the identity of teacher – How do you address this as a future professional?
- How do personal factors such as class, race, gender, and/or other identities (age, "disabilities", sexual orientation/identity, etc.) inform your professional identities?

In the following images, I provide three examples of pre-service student's paper doll narrative collages. Excerpts of students' storylines illuminate their process of becoming educators and engaged citizens.

PAPER DOLLS COLLAGE NARRATIVES

Look closely at the accessories included in Anthony's paper doll such as the T-shirt with the logo: Black Lives Matter, "I voted" pin, and gay pride banner, all against a New York skyline. What do these clothing selections and accessories reveal about Anthony's teacher identity and positionality? How does revealing these identities

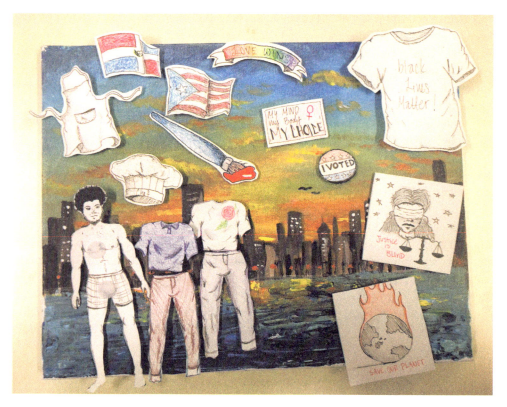

FIGURE 13.1 Anthony: Paper Doll in New York City.
Photography by Amy Pfeiler-Wunder.

impact the type of classroom culture he desires to create? In the next section, narrative threads from the pre-service students are in italicized, followed by my reflections. My reflections are the interpretations of the interplay between the visual elements and their writing. In Anthony's examples, he composes new narrative story threads on what it means to be a teacher coupled with his desire to amplify the voices of his future students.

He shares,

> the parts of my own identity that I value the most are my ethnicity, my beliefs, my queerness, my recreational hobbies, and my geography. I tried to incorporate all of these intersecting identities into my paper doll (see Figure 13.1). For my ethnicity I incorporated a Dominican flag and a Puerto Rican flag. This represents the pride found in my ethnicity. Doing this allows me to pay tribute to the culture that raised, encouraged, supported, and corrected me. My culture and ethnicity are also heavily responsible for my values and beliefs. This facet of my identity was translated through signs and banners I created to represent my activism and passion for equality and inclusivity. This is something I hope to bring to the classroom. By bringing my passion for inclusivity into my classroom, and "engaging in the study of gender, race, class, and/or sexual orientation" (Bolin & Hoskings, 2015), I can foster

an environment free of judgement, therefore allowing my students to reflect on their own individual experiences through creativity and self-expression. Geography is a huge part of my identity and my future. This is translated through the backdrop for my doll, which I chose to be the skyline of New York City, my home.

For Anthony, his culture and ethnicity were key elements of his identity. He had a deep desire to give voice to his future students, as a teacher of color who also identifies as gay. For many of my students, their first encounter with Ed Check's work (2002) resonated with them when Check wrestles with revealing his sexual orientation identity in the classroom. From my interpretation, Anthony's story was one of resistance in naming his identity outside of teaching as "White and female". He also desired a classroom where emerging stories would occur through his statement focused on bringing inclusivity and a judgment free zone into his classroom. He desired for student to reflect on their own experience and express their ideas freely. Here Anthony created space for democratic intelligence through providing space for reflection and change. He also touched on the importance of home, naming he lives in New York City, implicitly making note that he is not from the same state as many of the classmates or even a small town. Place matters and is folded into his identity as a preservice teacher of color studying in a predominantly White community.

In this doll, take note of the carefully crafted accessories. What is revealed through skinned knees, holding one's cell phone, and a rainbow striped bag (see Figure 13.2)?

FIGURE 13.2 Rosie's Doll: "Being Myself". (1) Rosie with skinned knees, (2) Rosie with a cellphone, "Teaching in a Digital Age" and (3) Rosie with a rainbow bag.

Photograph by Amy Pfeiler-Wunder.

As Rosie shares in the following excerpt, her stance of standing and looking outwardly are examples of the deep care she wishes to bring to her future classroom. She shares:

> I am very caring towards my friends and loved ones but if I feel in any malicious intent from people, I am not afraid to standup for what I believe and defend the people I care about. I usually almost never get angry or yell, however I do know that I can come across as mean looking when I am focused, so I try to be mindful. Another major part of my identity is being a creative open-minded person, who will listen to both sides of the story and not make judgement. I hope that with these identities and parts of my identity and the new information I am learning and the experiences that are to come, these will create a solid foundation as a teacher. When I read resource of Engaged Pedagogy by bell hooks, I had never heard about this type of teaching formally by its names and the principle that made it up. After reading about Pedagogy, I realized many of the morals such as the relationship developed between students and teacher being more equal and both considered learners and the group and community of teachers working together to help each other succeed.

For Rosie, her work also spoke to creating a classroom where civic engagement emerged through resistance stories (Bell, 2020). This occurred through listening to understand, avoiding judgments, but also resisting and pushing against "malicious intent from people". As shared in her artist statement and illustrated through physically and metaphorically bruised knees, "I am not afraid to standup for what I believe and defend the people I care about". And "being a creative open-minded person, who will listen to both sides of the story and not make judgement". Here she alludes to creating space for emerging transforming stories based on reading the work of bell hooks. She desires a civically engaged classroom evident in her discussion of teacher and student being equal, working together to help each other succeed. The rainbow bag symbolizes acceptance of all people. The cell phone, a nod to the visual and media forces at her fingertips. She also employs the ideas of civic engagement, where standing up means making change in how groups are defined and by whom. Community engagement, working in relationship, is also paramount to being civically engaged.

In Andrea's doll, a course reading inspired her to reveal more openly here experience as someone who identifies as gay and how this identity would support amplifying students who identified as gay in her future classroom. As Andrea shares:

> I like that in Ed Check's article he talks about sexuality in the classroom. Some people will always think it belongs and be liberated by seeing themselves represented while others want nothing to do with it. In my opinion love is not a political matter and it does belong in the classroom. I had no queer teachers growing up and I would have infinitely benefited from seeing representation in my school and classrooms. Queer people belong everywhere, and they deserve to be visible while belonging, so setting a positive example and advocating for my learner is very important to who I am and who I want to continue to be.

In Andrea's dolls where the inclusion of a KU Pride shirt openly shared her identity and strong belief that love is not a political matter (see Figure 13.3). Love is a part of

FIGURE 13.3 Celebrating Pride: Andrea's Doll. (1) Andrea's Blank Paper Doll and (2) Celebrating Pride Clothing Choices.

Photograph by Amy Pfeiler-Wunder.

teaching. "In my opinion love is not a political matter and it does belong in the classroom". Love and care of one's students *does* belong in a classroom, the kind of love where one is honored for who they are. "Queer people belong everywhere, and they deserve to be visible while belonging, so setting a positive example and advocating for my learners is very important to who I am and who I want to continue to be". The kind of love where one feels a sense of belonging. When one feels at home in the classroom, space opens for sharing varying perspectives. Feeling at "home" in your space, in what you voice, and with those you develop relationships become platforms for democratic classrooms, school, and communities. These are acts of civic freedom. A sense of belonging to group that seeks a common goal and solution is critical to these acts of civic freedom. This can be modeled through the dialectic between making, conversing, and imaging something new.

DISCUSSION: THE ROLE OF STORIES IN CIVIC ENGAGEMENT

Knowing self to better understand others through narrative collage became a place to develop civic intelligence fostering and envisioning a future educational community where challenges in society and culture could be discussed through dialogue and making. The pre-service students desired to make a difference. For the pre-service students, the paper dolls became spaces where they simultaneously broke with the

dominant storylines told through paper dolls (e.g. gender being most obvious in thinking about dolls as for girls) while disrupting these stereotypes through creating new teaching narratives illustrated in the choices of clothes and accessories. To see where civic engagement emerged, I examined the themes in their artists statements through story types (Bell, 2020) using stories as an analytic tool. Stories reflect the personal ways in which individuals learn about the world; the use of language as a way of understanding the world; and as "evocative" sources of knowledge both individually and collectively (Bell, 2020, p. 13). In my interpretations of their work, three story forms emerged when students critically engaged with the making of the dolls as cites to re-compose and negotiate stories to impact practice (Clandinin, 2016, p. 30). As students who have experienced marginalization and underrepresentation, they pushed against "stock stories" or stories told by the dominant group and celebrated in public ritual, law, and education and embraced the following storylines (Bell, 2020, p. 18):

a. Concealed stories: Stories that co-exist alongside stock stories but remain in the shadows. These are stories told by those in the margins to give voice and honor the marginalized and stigmatized (Bell, 2020, p. 19) such as the use of rainbow clothing choices or accessories by the three pre-service students to highlight gay pride.
b. Resistance stories: Warehouse stories, not often told in schools that demonstrate how people are resisting racism (Bell, 2020, p. 20). Here as gay person of color, normalized identities of a White teaching field are resisted.
c. Emerging transforming stories: Stories intended to challenge the stock stories, to "interrupt the status quo and energize change" (Bell, 2020, p. 20). We see Rosie, bringing care into her teaching, in a school culture that can still be focused on hierarchies between teacher and students.

All three-story types align with civic wisdom (Navarro, 2017), where one reflects on the stories you know, then resist repeating, retelling, and claiming certain storylines that avoid democratic principle of engaging *all* citizens. Educators, instead, invite, rewrite, and tell stories that are resistant and transformative. This means creating a classroom culture driven by learner voice, shared dialogue, and the creation of community policies, as a microcosm democratic intelligence and engagement in the larger society (Navarro, 2017). Using narrative collage, pre-service students' stories worked in tandem with their collaged dolls to became a site of "critical pedagogy" that allowed for challenging "oppressive regimes of spectacle culture" and opened space "for creative and political intervention and production-a kind of educational research that exposes, examines, and critiques the academic knowledge of institutional schooling" (Garoian & Gaudelius, 2018, p. 92). As an iterative process, narrative inquiry created a site for reflecting on how professional identities could contribute to instilling democratic voice in future educational settings. As educators alongside our current pre-service students, this non-linear journey of resistance, and transformation to foster engaged citizenry, involves criticality in recognizing the stories educators tell, especially as White educators of pre-service students.

Moving Beyond Stock and Concealment Stories

The use of narrative collage illuminates how educators and I attempted to negotiate teacher identities through dialogue and the stories we chose to tell (Akkerman & Meijer, 2011; Hall, 2000; Hanawalt, 2015; Pfeiler-Wunder & Tomel, 2014, 2017; Rao & Pfeiler-Wunder, 2018), working to move beyond stock stories. Within the stories told, given 80% of the profession is White, I think it imperative White educators have these conversations while also examining the intersections of identity, including, but not limited to, race, class, gender, and sexual orientation *alongside* our pre-service students as critical colleagues. Through interrogating the intersection of identities, concealed stories are revealed. Concealed stories are the places where individuals marginalized or stigmatized by mainstream narratives share their strengths. Being White and a female educator is a dominant narrative, which needs to be critically noted; however, moving between working-class and middle-class ideologies and language use continues to be a space of concealment. Many of the pre-service students also worked to amplify identities that are often concealed as part of the teaching field, such as identifying as part of the LGBTIA+ community.

Resistance and Transformative Stories

Pre-services students also desired amplifying the voices of marginalized students during field observations but sometimes struggled with what they could say in a school environment where they were guests, or they knew their identities were marginalized depending on the school culture and surrounding community. A challenge for pre-service students is navigating democratic teaching in an undemocratic society, already structured by centuries of racial oppression and social order (Tien, 2017, p. 108). However, in their paper dolls, they *did* find a place for voice, and a reimaging of their future classrooms through the choice in clothing and accessories that were markers of *resisting* certain storylines in education and educational spaces along with a desire to change and *transform* educational spaces.

This is essential to narrative collage and inquiry, where these sites of tension become a space to reimagine what and how they would create a classroom setting where all voices were heard. This is the power of knowing the stories we tell. Through the process of counter storytelling (Bell, 2020) using the three-story types previously mentioned, students, along with myself, used narrative inquiry as an approach to fostering a transformative community where we recognized, appreciated, honored and complicated the individual stories of their future classrooms (p. 112). Creating this type of "home" in their pre-service program established a backdrop for students to model civic wisdom with their future students. Civic wisdom includes both civic intelligence and civic engagement (Navarro, 2017). Civic wisdom, reflection on the stories one tells coupled with civic intelligence, reflecting and imagining differently provides avenues to solve challenges through civic engagement. With pre-service students this can begin with challenges they see in the classroom and then move out to their school community, and larger community. Here the focus moves to collaborative and participatory change (Brooks, 2017).

CONCLUSION

What did this project reveal to me as an educator and mentor of pre-service students about fostering civic engagement? If notions of home are foundational in conversations on civic engagement, paper dolls were the site of civic intelligence where pre-service students could learn, adapt, reflect, and imagine (Navarro, 2017) critical discourse and civic engagement in their future classes. For civic engagement to emerge in their future classrooms, a sense of "home" needed to first be created in their pre-service teaching experiences. Due to the entanglements bound in one's identity positioned by others culture and society, educators must begin by creating a safe and brave space for these conversations (Pfeiler-Wunder & Berg, 2023). Educators cannot always guarantee a safe space for dialogue due to the multiplicity of individual's lives, impacted by cultural, historical, and contemporary forces. Learners from PreK–12 through higher education must feel a sense of belonging and connection (Thatte, 2017) forming a "nest and safe place" at school (Noddings, 2002). Brave spaces emerge when students share with vulnerability and ideas are challenged (Boostrom, 1997 as cited in Pfeiler-Wunder & Berg, 2023). The paper dolls were the sites of both seeing the stereotypes and stock stories perpetuated in paper dolls, and reimaging the identities the paper dolls could represent.

Critical voice, a movement away from stock stories, unfolded through this visual language by holding space "toward multiple, related literacies, or [multi-modal epistemologies]...collapsing and disorienting pasts, presents, and futures" where individuals are marginalized (Kuby et al., 2019). As individuals who have and do experience marginalization, the dolls became the platform to express these identities as disruptions to the status quo on how teacher identity has been defined (White and female) to envision their role in changing the teaching demographic. This again is where resistance and transformative stories emerged. For the White students in the class, listening to understand the multiplicity of experiences also created space for possibilities, with a deeper awareness that the stories told in and about education maintain White, heteronormative positionalities. Here is where the "in between spaces" of civic wisdom and engagement take root.

Education setting becomes sites of tensions and possibilities to barriers fostering democratic principles of fairness, justice, and equity. Here the heart of a democratic society, the pursuit of happiness, means being fully true to one's identity in their pre-service programs in turn imagining and creating a classroom home for their future students to do the same.

NOTES:

1. Being White or Whiteness in education is acknowledging how Whiteness "acts as the standard by which all other groups are compared". Being White and Whiteness is normalized and taking for granted in culture and society, and therefore, White people rarely need to consider their racial identity. See https://nmaahc.si.edu/learn/talking-about-race/topics/whiteness
2. Like Spillman (2015), in the process of my work, I knew I was failing at fully interrogating my Whiteness and inability to see how my work might very well be perpetuating "White

property" (Kraehe et al., 2018 p. 1). Recognizing my own lack of using critical race theory in my lens and the importance of CRT as an "analytic tool for understanding how race operates in varied local and institutional contexts in connection with societal structures of racial power" (p. 5).

REFERENCES

Akkerman, S. F., & Meijer, P. C. (2011). A dialogical approach to conceptualizing teacher identity. *Teaching and Teacher Education*, 27(2), 308–319.

Barthe, R. (1974). *S/Z: An Essay*. R. Miller (Trans.). Hill & Wang.

Bell, L. A. (2020). *Storytelling for justice: Connecting narrative and the arts in antiracist teaching* (2nd ed.). Routledge.

Boling, E., & Hoskings, K. (2015). Reflecting on our beliefs and actions: Purposeful practice in art education. *Art Education*, 68(4), 40–47. https://doi.org/10.1080/00043125.2015.11519330

Boostrom, R. (1997, March 24–28). "Unsafe spaces": Reflections on a specimen of educational jargon [Conference Session]. Educational Research Association, Chicago, IL. https://files.eric.ed.gov/fulltext/ED407686.pdf

Brooks, G. M. (2017). *Civic engagement: Perspectives, roles, and impacts*. Nova Science Publishers, Inc.

Carr, D. (1986). *Time, narrative and history*. Indiana University Press.

Check, E. (2002). In the trenches. In Y. Gaudelius, & P. Speirs (Eds.), *Contemporary issues in art education* (pp. 51–60). Prentice Hall.

Clandinin, D. J. (2016). *Engaging in narrative inquiry*. Routledge.

Clandinin, D. J., & Connelly, F. M. (2016). *Engaging in narrative inquiries with children and youth*. Taylor & Francis.

Emdin, C. (2016). *For White folks who teach in the hood...and the rest of y'all too: Reality pedagogy and urban education*. Beacon Press.

Hall, S. (2000). Old and new identities: Old and new ethnicities. In J. Solomos (Ed.), *Theories of race, racism: A reader* (pp. 143-153). London, UK: Routledge.

Garoian, C. R. & Gaudelius, Y. M. (2008). *Spectacle pedagogy: Art, politics, and visual culture*. Suny Press.

Hanawalt, C. (2015). Reframing new art teacher support from failure to freedom. *Journal of Social Theory in Art Education*, 35, 69–81.

hooks, b. (1994). *Teaching to transgress: Education as the practice of freedom*. Routledge.

Howard, T. (2019). *Why race and culture matter in schools*. (2nd ed.). Teachers College Press.

Imagineering Company & Lynn Chang-Franklin. (2005). *Pregnant paper dolls*. The Imagineering Company.

Johnson, J. (1999). History of paper dolls. In OPDGA The Original Paper Doll Artist Guild. Retrieved from https://www.opdag.com/history.html

Kay, C. (2016). Constructing, modeling, and engaging in a successful educational partnership. *Art Education*, 69(5), 26–30. https://doi.org/10.1080/00043125.2016.1202025

Kraehe, A., Gaztambide-Fernandez, R., & Carpenter, S. II (Eds.). (2018). The Palgrave handbook of race and arts in education. In *The arts as white property: An introduction to race, racism, and the arts in education* 1–31, Palgrave Macmillan.

Kuby, C., Spector, K., & Thiel, J. (Eds.). (2019). *Posthumanism and literacy education: Knowing/becoming/doing literacies* (1st ed.). Routledge.

Ladson-Billings, G., & Tate, W. F. (1995). Toward a critical race theory of education. *Teachers College Record*, 97(1), 47–68.

Muniz, V. (2022, December 5). *Arrest made in deadly shooting near Kutztown campus*. PAHomepage. https://www.pahomepage.com/state-news-2/arrest-made-in-homicide-shooting-near-kutztown-campus/

Navarro, F. M. (2017). Civic engagement as a component of civic wisdom in public life. In G. M. Brooks (Ed.), *Civic engagement: Perspectives, roles, and impacts* (pp. 1–15). Nova Science Publishers, Inc.

Noddings, N. (2002). *Starting at home : Caring and social policy.* University of California Press.

Pfeiler-Wunder, A. (2017). Dressing up: Exploring the fictions and frictions of professional identity in art educational setting. *Journal of Social Theory in Art Education, 37*, 28–37.

Pfeiler-Wunder, A., & Bergh, M. K. (2023). Let's talk: Engaging in critical conversations in the art room. In C. Stewart, E. Burke, L. Hochtritt, & T. Northington (Eds.), *Cultivating critical conversations in art education: Honoring student voice, identity, and agency.* Teacher's College Press.

Pfeiler-Wunder, A., & Tomel, R. (2014). Playing with the tensions of theory to practice: Teacher, professor, and students co-constructing identity. *Art Education, 67*(5), 40–48.

Rao, S., & Pfeiler-Wunder, A. (2018). Intersections, identities, and the landscape of preservice education, *Art Education, 71*(1), 32–37. https://doi.org/10.1080/00043125.2018.1389590

Ravitch, D. (2016). *The death and life of the great American school system: how testing and choice are undermining education.* (3rd ed.). Basic Books.

Reyes, G. T. (2018, March 3). Cross this out: Community mobilizing through a pedagogy of disruption and healing. [keynote] Kutztown University's 8th Annual Commission of Human Diversity Annual Conference, Kutztown, PA.

Spertus Publishing. (1963). *Dress up for the New York world's fair.* Spertus Publishing.

Spillman, S. (2015). The failure of Whiteness in art education: A personal narrative informed by critical race theory. *Journal of Social Theory in Art Education, 35*, 526–550.

Thatte, A. (2017). *The learning home: An ethnographic case-study of curriculum place, and design.* Marilyn Zurmuehlen Working Papers in Art Education.

Tien, J. (2017). "Democratic" for whom? Teaching racial justice through critical pedagogy. In B. Picower, & R. Kohli (Eds.), *Confronting racism in teacher education: Counternarratives of critical practice.* Routledge.

Tien, J. (2019). Teaching identity vs. positionality: Dilemmas in social justice education. *Curriculum Inquiry, 49*(5), 526–550. https://doi.org/10.1080/03626784.2019.1696150

White, E. (2012). *Whiteness and teacher education.* Routledge.

Engaging the Next Generation of Citizen Artists

How a Museum of Contemporary Art and Chicago Public High School Partnered to Foster Informed and Activated Youth

Lynne Pace Green, Damon Locks, Maria Scandariato, and Andrew Breen

INSTRUCTIONAL QUESTIONS

1. How does an art museum engage young people and underserved communities in authentic dialogue around civic issues?
2. How can we create a sense of power and civic agency in high school students who do not see themselves represented in civic structures?
3. Can the tools and strategies used by contemporary artists be employed by high school students to investigate social problems that impact their lives and their communities?
4. Can teachers of two distinctly different subject areas develop a year-long, integrated curriculum and co-teaching model in a Chicago Public School?
5. What happens when a practicing artist establishes a studio practice inside a Chicago Public High School and in collaboration with teachers and students at the school?

The Learning Department at the Museum of Contemporary Art (MCA) Chicago has a long history of investment in youth agency. The education program at the MCA prioritizes programming which recognizes the power of youth perspectives and life experience as a set of critical viewpoints when considering contemporary art. When presented with the challenge by a loyal funder to leverage their programming to address critical needs in the Chicago educational landscape, the learning team brainstormed

DOI: 10.4324/9781003402015-19

programming ideas that would both extend and deepen their school partnership program and enrich the Museum's commitment to becoming an agent of civic change. At this time, there were several prominent issues facing the Chicago Public School (CPS) system around issues of equitable access to arts education. Becky Vevea, Education Reporter for the local National Public Radio station WBEZ, produced a piece claiming that "Most of the majority African American neighborhoods in the city are essentially arts education deserts" (Vevea, 2014, para.2). On a national level, the President's Committee on the Arts and Humanities in its report: *Reinvesting in Arts Education: Winning America's Future through Creative Schools* (Dwyer, 2011) recommended that arts organizations who were committed to developing creative schools consider the following strategies:

1. Build robust collaborations among different approaches to arts education.
2. Develop greater opportunities for the arts to be integrated in learning.
3. Expand in-school opportunities for teaching artists. (pp. 48–52)

At this same time, the state of Illinois was rolling out a new initiative calling for an increased focus on civic instruction. For the first time in decades, Illinois high school students would be required to complete at least one semester of civics in order to graduate. The MCA team became curious about the intersections of civic study and contemporary art practice. Recognizing the need for civic curricula that would help initiate curiosity around civic and social systems and motivate students to become engaged citizens, CPS educators were looking for new models. According to a study conducted by the Center for Information and Research on Civic Learning and Engagement (CIRCLE) at Tufts University's Tisch College, "About 30% of urban and suburban residents ... see themselves living in civic deserts, and low-income youth of all backgrounds are widely disconnected from civic life. This is a caustic environment in which to come of age as a citizen, and the results are evident in young people's civic engagement" (Levine and Kawashima-Ginsberg, 2017, p. 3).

In considering how to enhance traditional models of civics curricula through an integrated arts approach, the MCA began to identify an intersection between the call for participatory action research with the practices used by contemporary artists to stimulate community dialogue around civic issues. The Center for American Progress, a non-partisan policy institute, seemed to reinforce this thinking in their 2019 report, *Strengthening Democracy with a Modern Civics Education* (Jeffrey and Sargrad, 2019), with the following statement: "Once students garner a robust civics education, it's important that they are able to transform that knowledge into civic engagement inside or outside of schools through strategies such as youth participatory action research (YPAR) and youth-led activism." Because these civic values and strategies for engaging communities in civic discussion mirrored the practice of contemporary artists, the MCA seized upon the opportunity to develop a program that would integrate an innovative approach to civics instruction with real-life practices used by contemporary artists in a new pilot program called School Partnership in Art and Civic Engagement (SPACE).

WHAT IS SPACE?

SPACE was conceived as a multi-year partnership with CPS in high schools designed to empower teens to create meaningful change in their communities using contemporary art strategies and expanded civic understandings. Over the course of a full year of study, students would explore the dynamic intersection of civic study and contemporary art practice. This grand experiment was designed as a pilot to unfold consecutively in three select Chicago public high schools over the course of five years. The MCA identified local contemporary artists whose practices aligned with the values and goals of the program and asked these artists to set up practice in a studio space built in partnership with the school administration. The intention was to make the role of a working artist visible to the school community. Two teachers were identified to partner with the resident artist to design an integrated, contemporary art-based, civics curriculum. The core strategy of the program was to use contemporary art-based practices to research local civic issues and mobilize student and community action to address these issues. Ultimately, the goal was to present opportunities for student-driven, positive, change-making action that would result in young people who saw themselves as agents of change in their communities.

THE FRAMEWORK

In order to ensure the course would properly meet standard requirements for both art and civics, it was important to establish a framework that would hold participants accountable. Working with the Illinois standards for Social Science and Visual Arts, the MCA engaged a set of curriculum experts to help develop a guiding curricular map to identify a set of four outcomes for the program. These outcomes matched those identified by CPSs to compose an essential civics curriculum. They resulted in a SPACE framework (see SPACE Curriculum Framework in Appendix) intended to guide teachers as they developed curriculum to meet the unique needs of their students. A set of steps was developed that mirrored a contemporary art practice and that correlated with each outcome. The outcomes and steps were as follows:

- Research Outcome = The World We're In: inquires, identifies, and analyzes relevant local issues
- Pathways of Change Outcome = The Bigger Picture: identifies different ways people affect change in their community
- Planning for Action Outcome = Radical Imaginings: defends and promotes a process toward the realization of positive community change
- Action and Change-Making Outcome = Acting for Change: works as a change agent

THE SCHOOL

In this chapter, we will focus on one of the three SPACE school sites. Comments by the team at Sarah E. Goode STEM Academy inform our discussion below. This site ultimately arrived at a model that included awarding dual credit for a year-long course

in civics and art and was team-taught by a civics teacher, art teacher, and the resident artist. Goode is a high school located in Chicago's Ashburn neighborhood, which is on the southwest side of Chicago, approximately 16 miles and a 40-minute drive from the MCA. According to a 2022 school snapshot from Illinois Report Card, the student demographics were composed of about 60% Latinx, and 40% African American students. Goode was a lottery school which means that although anyone can apply, priority is given to those within the attendance boundaries. Most students enrolled in SPACE had not taken any art courses prior to their junior year.

THE TEAM

Each SPACE team consisted of two distinct, subject area teachers: a certified art specialist, and a civics teacher, plus a practicing contemporary artist. At Goode STEM Academy, this team was Andrew Breen (art teacher), Maria Scandariato (civics teacher), and Damon Locks (Artist in Residence). In addition, Lynne Pace Green served as the MCA project manager for SPACE and oversaw the program at all three SPACE schools. While each SPACE team and school provided unique context and manifested in different ways, the Goode teachers worked consistently together for the longest time. Throughout this collective partnership, they were able to make great strides and advanced the program concept in consecutive iterations to achieve impressive results. Throughout this chapter you'll hear perspectives from each of the on-site team members and you'll see how the individual roles expanded and strengthened when woven together as part of a collective approach. Civics teacher, Maria Scandariato, captures the unique nature of this program with the following:

> SPACE was a course like no other our students took, or would take in their high school experience. Having two teachers and a resident artist working together, team teaching, gave us a unique ability to reach students with all ability levels, at different entry points and support their learning …. We modeled collaboration and compromise, by supporting and valuing each other's area of expertise and asking questions of one another in front of students.

INTRODUCING A NEW LENS ON TEACHING ART AND CIVIC ENGAGEMENT

Relevancy Builds Engaged Citizens

Guiding students to believe they are part of a civic society is challenging. Most often they learn about civic issues as a result of what they consume as passive observers in the world around them. They don't see themselves as part of the system. Within the larger educational landscape, students also learn to become passive consumers of their own education. This disengaged condition further extends to their role in a civic society when the laws and governance surrounding them makes little space for youth voice and often

does not include representation from their communities. In making civics personal and relevant, an opportunity is created to engage students in conversations around action and solutions. When students are directly impacted by failing systems and incidents of violence or injustice, either personally or by extension to their friends, family, and neighborhoods, they are eager to engage in conversations about these issues. Centering civic curriculum around these issues creates a sense of agency. When they understand legal systems and civic structures and learn the history that has informed and shaped current conditions, they become empowered with knowledge to fight for change. The SPACE program starts from the place of inquiry and student discovery around conditions that are negatively impacting their immediate community. Students are simultaneously exposed to the work of artists whose work stimulates and engages communities in dialogue and that is grounded in personal relevance. The MCA supplements this education by bringing students to the museum for extended visits twice a year. These field trip experiences exposed students to an active exploration of groundbreaking artists and helped support the relationship between the program and the museum. Students were introduced to contemporary artists from all over the world, like Howardena Pindell, Jay Lynn Gomez, Arthur Jaffa, Tatyana Fazializadeh and Candy Chang, as well as nationally recognized artists who come from Chicago, like *Virgil Abloh*, *Kerry James Marshall*, and *Nick Cave*. In addition to touring the galleries, students would participate in workshops led by the museum's artist guides who modeled best practices by asking questions rather than providing answers and engaging students in dialogue that required them to form opinions about the artwork. The museum field trip experience helped students embrace the idea that engaging in art is a process, an expansive view, something that can be participatory not dictated by adults or the "experts" at an institution.

An Integrated Approach to Expand Learning

Combining an art class, civics class, and an outside artist in one course presented a list of challenges: *How does it all fit together? Will it be cohesive? How do we introduce the project and approach so that it makes sense to students?* To truly integrate two disparate courses, it becomes imperative to connect area specialists and provide them time to develop, teach, and modify curriculum. By engaging content specialists who are experienced and accountable to their subject area, this integrated approach produces outcomes that meet the national, state, and local requirements for both subject areas. When successful, arts integration helps to develop critical thinking across course content. SPACE educators utilized various strategies to support student learning and practice. The two content specialists played off one another, asking what the other thought, modeling academic conversations that focused on intersections in the content areas. The SPACE educators asked students to take risks, but the students knew the adults were also taking risks when they saw their art teacher discovering intersections with civics and their civics teacher learning about art techniques and contemporary art practice. They were transparent about their struggles to integrate the concepts and celebratory when the intersections were seamless and rich.

Damon Lock's role as resident artist was to propose a project rooted in questions raised by the students. Together, Damon and the teachers would brainstorm how to

execute these projects with the students. An illustration of this practice was a project launched during the second year of SPACE: *Futuristic Radio Plays*. Students were asked to develop their own original radio plays. The concept was challenging to the teachers as they had never created radio plays before. And it was even more challenging for the students because in addition to being unfamiliar with the radio play art form, most students had never been exposed to art in a vinyl album form. Nevertheless, students were introduced to 1940s radio plays and asked to imagine a future world where social justice issues in our current world were addressed and resolved. The goal was to get the civically engaged content into the format of a sci-fi radio play. Creating and recording was the hard part. Originally, the vintage radio plays were presented to the students via vinyl, so Damon found a way to get their plays pressed onto vinyl to close the artistic and creative loop. According to the teachers, this successful project was exactly what the students needed. It was different from anything they had ever done and required them to take risks, write, record, and edit to tell a story that referenced policy issues, root causes, and explored solutions.

SPACE thrived by taking all team members outside of their normal routine and comfort zone to create an organic, student-responsive curriculum. This process of expanded thinking was required of the students but also for the artist and teachers. Artist Damon Locks captured his own growth and development with the following:

> In many ways my art practice is political, community-oriented, and civically grounded... I think I was a strong choice for the program. Even with that, I had to learn a lot about bringing ideas to the classroom. This process of integrated learning was what benefitted me most when looking back at the project. When it was at its most successful, it was the richest experience for us all (myself, the teachers, and the students). We were learning alongside the students while building the scaffolding for a civically minded, creative, process for us all.

Student Agency

To help students understand their role in this dual course model, we developed the term *Citizen Artist* to help establish themselves as both an engaged citizen and an artist equipped for change making. This term emphasized their activated role in society and helped encourage them to think like an artist in imagining radical change. If the idea of activating the students as citizen artists was to be a reality and not just a conceptual framework we needed to create space for student agency. True student agency means that the students get to define the parameters in which they work. They then make decisions inside those parameters by asking questions and drawing conclusions. This approach involved designing structures that required students to investigate, research, and dig deep into the root causes of an issue they cared about. As facilitators of their learning, we needed to provide them the space to work through ideas and problems. We needed to operate with flexibility and be prepared to shift directions allowing students to take ownership of their learning. We prioritized a reflection process so that students were able to identify what was needed to improve their project and we responded accordingly. Our goal was to empower students to engage with the

community. We wanted to make them think, feel, act, and to utilize various platforms to begin the conversation; to not only bring awareness to a situation but bring about change.

Building Intentional Community

At the end of each summer, SPACE teams came together to reflect, share practice, and set goals for the upcoming school year. SPACE program manager Lynne Pace Green asked the Goode team how they wanted to approach building community with the upcoming class. Most educators agree that the first week of class should focus more on building community than academic content. But this best practice is always ongoing even after the first few weeks and the SPACE team wanted to craft a strategy that aligned with the values of the program. After some exploration, resident artist Damon Locks suggested creating a manifesto that would craft and articulate a shared set of beliefs and values. The team decided to engage the students in the process of creating a manifesto that would both build community and help students identify priority areas for action and change. They thought this exercise might take two weeks. In reality, the process extended over the course of two months and layered in foundational concepts in democracy and contemporary art with terminology and definitions that students would be required to understand and apply in their work. Introducing these core principles (see Principles of Contemporary Art and Principles of Democracy in Appendix) alongside the construction of their manifesto helped to establish a deep foundation in both civic and art concepts. These first two months, steeped in an extended manifesto process produced the most focused and engaged student collective in all three years.

Identifying Values and Priorities in a Collective Manifesto Process

Damon started the manifesto process by sharing several examples of manifestos by artist collectives (e.g. Guerrilla Girls) and political organizations (e.g. The Black Panthers) illustrating how creating a manifesto helps to root these groups in common struggle by building a list of shared concerns. We examined and studied examples of manifestos to show the intersection of art and civic action and how those goals can come together and bring awareness to a cause. In small groups and as a whole, Damon facilitated brainstorming sessions to help students identify what they cared about. By creating a class manifesto the students declared what they stood for and by doing so framed what they would not stand for. They did this collectively. They painstakingly crafted each sentence so its meaning was direct and clear. As they analyzed recurring themes, final statements began to emerge. Through frequent revisions, they came up with clear, specific language they could all agree on. They identified the issues that they most wanted to address in order to create the world they wanted to live in. As Damon said,

> Once this was accomplished we were not a group of individuals working on our own separate trajectories, we were indeed a community, a community centered around this joint agreement, this jointly penned manifesto. The citizen artists of SPACE now established their community. All that was left was doing the work!

Students designed posters to share their manifestos, creating dialogue with other students, defending their positions, making connections, and influencing their peers. The project was not complex but the level of understanding and the collective effort was a high benchmark in student agency. We produced t-shirts with icons of the issues identified in the manifesto and manifesto declarations on the back. The idea was to have these value systems extend outward from our classroom to the rest of the school community. We accomplished this through the posters on display, student speeches in shared spaces of the school, and through the visibility of the t-shirts and buttons produced and worn by students. These visible, outward acts of community engagement became talking points for the project and set the stage for the whole year. This process established parameters for discussion and created a communal understanding of values and negotiated agreement. Ultimately, it created a stage to present student demands for a better world. Consider for example the following statement by Josiah, one of the student participants:

> When we did the Manifesto statements we looked at other manifesto statements and why they were being made throughout history and what they were hoping to achieve and what we could hope to achieve with ours. … A lot of the students in the classrooms were politically shut off or they weren't really focused on these issues because it was above them, it was beyond them, but when (we) sat down and had time to go into these details and look into what was actually happening in our communities … I feel like it lit a fire in a lot of the teenagers including me. It was kinda like an awakening experience at the same time. I feel like we really carried that throughout the whole school year.

Community Extended Outside the Classroom – *Ten Days of Change* Project

While the manifesto project was intended to build community, the *Ten Days of Change* project fulfilled our commitment to creating experiences that extended outside the classroom walls. It fell in line with our goal to move away from keeping art contained in the classroom and rather, creating experiences that were public facing. Instead of developing large-scale projects that took a full semester to produce as we had done in the past, we wanted to allow our citizen artists the opportunity to create more small-scale, iterative artmaking. This mirrored what we were exposing students to in Damon's *Artist of the Week* case studies. On a weekly basis, Damon introduced students to civically engaged contemporary artists and projects to expose them to the work of countless artists who were exploring social, political, and economic issues in society. Artists such as *Jenny Polak*, *Amanda Williams*, *Glenn Ligon*, *Alexandra Bell*, and *Tatyana Fazlalizadeh* were introduced in order to provide a reference point for how artists approach their art by drawing from contemporary issues in society and bringing exposure to and dialogue around these issues. Most of the artists highlighted in that weekly lesson didn't put aesthetics and design as the main driver for their work but rather valued process over product and audience activation. All of those artists, and ours, were interested in leveraging the social impact art can have on a school community.

A required project in the civics curriculum is the soapbox speech. In this unit, students must identify an issue they care about and dig deeper for the root causes. They must research the issue and create a short 2-minute speech that identifies the problem, why we should care about it, and create a call to action. These soapbox speeches became an anchor for *Ten Days of Change*. Students brainstormed civically engaged activities related to their soapbox speeches and worked in small groups to design activities around the concepts in their soapbox speeches. These activities ranged from gallery walks, polling, sound collaborations with Damon, button exchanges, and presenting their soapbox speeches in public spaces. Every morning, students took over announcements to share one of the highlighted soapbox speeches and bring the school community's attention to the *Ten Days of Change*. Students were required to develop a script, purpose, and roles for these engagements as part of a process in creating something engaging and relevant for the school community.

Despite this preparation, our first few days in the *Ten Days of Change* were a mess. Some students prepped their materials last minute, others hadn't fully nailed down a script, while others were frustrated by not knowing what to expect. On the third day, students debriefed about how they could improve. Students noticed that the visitors (students from other classrooms whose teachers brought them to explore these civic action stations) were unclear on the purpose and role in these socially engaged art practices. Fellow students arrived in the *Ten Days of Change* space, with no direction and many were reluctant to wander and talk. This debrief was a particularly memorable and teachable moment because it forced students to reflect and rethink their purpose and how to effectively engage with others. Eventually, students decided to assign liaisons who would go to classes first to provide context for the event and the purpose of SPACE at our school. Students also spent time revising their activities based on feedback they received. This act of sharing the process and outcome of the work with other students helped to cement the experience for each student. Not only were students able to raise awareness and create dialogue through art, their deep reflection on the public interactions was even more impressive. This peer-to-peer sharing of ideas and opinions illustrates conviction and purpose taking root in both parties. At the conclusion of the *Ten Days of Change*, students had connected with the entire school community. Between daily student announcements and the engagement events, they impacted over 1000 people which was beyond any previous attempt at engaging the public outside the SPACE classroom.

IMPACT

Civically Engaged Students

Initially, art teacher Andrew Breen thought that the presence of a well-known cultural institution (the MCA) and a local artist would naturally allow young people to engage in this evolving, cross-disciplinary curriculum. But student buy-in did not happen overnight. Most students had never been to the MCA or ever experienced artmaking that de-emphasized the lone studio artist. In the beginning of the year, many expressed preconceptions that this co-taught class was about aesthetics and techniques. From the

very beginning the teachers were upfront that SPACE was not a prescribed curriculum in the way the students usually experience a course in CPS. There would be no textbook or course guide; there were only loose ideas surrounding the academic journey for the year. Installing frequent exposure to artists and making projects outside the classroom walls was purposeful so that the students could drive the agenda and learn to navigate social issues through contemporary art.

Shifting the power structure to allow students to become the experts on issues they care about and requiring them to provide possible solutions with a call to action was key to creating meaningful impact. The teachers provided exposure to various artistic platforms, such as civic dialogue, murals, billboards, pop-up stations, marches, and other less traditional forms of artmaking, allowing students to start conversations about how to bring about the change they wanted to make. They spent the entire course emphasizing the process, and therefore allowing students to create powerful final projects in which they were deeply invested.

Students shared the following statements illustrating this impact the course had:

- SPACE helped me see that art can be a voice for anyone to use.
- Learning about art and civics together made me realize that sending a powerful message isn't always about speaking or even writing or even yelling at the top of your lungs. It made me realize that sending a powerful message is made up of substance, purpose, and intent.

The impact was not contained to the student learning experience. Both the SPACE teachers and the artist noted how challenged they were and spoke at length about the myriad of growth and discovery opportunities they experienced as a result of this project. It was, in essence, an expanded and on-going professional learning program for everyone.

Compounded Professional Learning Model for Teachers

SPACE teachers participated in peer-to-peer learning, allowing for cross-disciplinary learning and opportunities to develop new strategies around teaching their content. The teachers speak to this impact. Civics teacher, Maria Scandariato, observed that

> Working, learning, growing as a teacher and a human took place during this time. During our time together I learned so much from our partnership with the MCA, our resident artist Damon, and co-teaching with an art teacher, Andrew. My SPACE experience has transformed my teaching practice and now, art is always incorporated in my social studies courses and through that exploration students learn more about content, build more skills, and are able to think creatively and critically about issues that matter to them.

Art teacher Andrew Breen acknowledged that

> As my role as an educator grew, I saw the MCA as a local space to learn and experience art that was challenging. Looking back on SPACE it really was the

collaboration with so many people that made all of this feel so special. This giant 3-year professional development made me slow down, be more intuitive and honest with others when I didn't know something.

Expanded Practice for the Artist

Artists are often brought into public school settings for short-term projects and programs. Relationships are introduced but not necessarily sustained and built upon. In SPACE the artist was embedded in the school community for a three-year period. This is rare and creates a unique opportunity.

Resident artist Damon Locks addresses this:

> The image of the artist has traditionally been one of solo genius, separate from the world around them. The idea of the artist retreating into their art studio and developing work then presenting it to people with the expectation that people will appreciate it feels antiquated to me. It seems that a more contemporary vision of this would flip the idea upon its head with the artist being outside the studio having conversations with people then developing work in or out of their studios based on these conversations so there is a community interested or invested in the work because it is born in dialogue.
>
> It is this dialogue which was particularly compelling about the SPACE Program. Creating work within the context of a CPS classroom in conversation about the world at large with students, teachers, and the school curriculum itself was challenging. This is the role of the artist, to be navigating spaces, generating conversations, and instigating work based on all of the above. The artist is not beyond the world but of it and their job is to amplify and investigate and when that is done in community, notes become chords and voices become choruses and the work takes on greater significance and has potentially greater impact. For me, this was a place for growth as an artist who likes to collaborate.

WHAT TO CONSIDER WHEN DEVELOPING SUCCESSFUL PARTNERSHIPS

The SPACE program was developed as a pilot project. It was funded for five years with a commitment to developing a "scalable, replicable program." The vision for this project was to incubate a model that might be replicated at other schools throughout the district. When it started at the first school, Curie Metropolitan High School in the Archer Heights neighborhood of Chicago, the resources and staff were focused on supporting this incubation with all it needed to succeed. Even with this level of support, there were significant challenges in that first year which would need addressing in order to move successfully into the second year. To complicate matters, the museum was committed to an expansion plan that required it to fold in a new school community in each of the first three years, with new teachers, artists, and administrators. This second school was Sarah E. Goode, and as they started planting seeds for their

eventual success, the MCA was now focused on supporting two very different school communities while laying groundwork for an eventual, third school to roll into the SPACE model the following year. This growth model for the first three years of the five-year pilot program for SPACE illustrates the complexity of establishing successful public school/professional arts institution partnerships in school settings. It also illustrates the importance of a pilot structure that allows space for reflection, iteration, cultivating relationships, and clear goals, rooted in reciprocity for both the school partners and the arts organization.

Space for Reflection and Iteration

While significant time was spent researching and designing the program in the first year of a five-year grant, there was little time built into the model for the reflection and refinement of each site model. Because there are so many variables at each school location, it became increasingly difficult to manage the unique needs of each school as the program compounded. As a result of these increased demands, codifying a successful program model overall took the back seat. In retrospect, it would have been better to either spend the first three years crafting the structure and model at one school site before rolling it out at other schools or to have folded in new schools more slowly with definition and refinement being the driving goals rather than rapid replication.

Crafting Relationships and Clear Goals

The key to successful community partnerships is establishing clear goals that are mutually agreed upon and provide clear value to all partners. The SPACE program was approached as a pilot project with the goal being to transform art and civic education models and to create civic agency in the youth involved. These goals were mutually agreed upon and would certainly benefit all stakeholders. However, the project would have benefitted from identifying clear outcomes and agreed-upon timelines. While there were clear learning outcomes identified for the project, the programmatic outcomes were a bit more vague. Although the project was designed as a three-year program for each school site, nothing was determined in regard to what happens after three years, or what conditions were required of the school in order to keep the program viable after the funding ran out, or what the relationship with the museum and the artist might look like after the project concluded. The lack of structure around these programmatic outcomes proved to be challenging for the sustainability of this project.

CONCLUSION

In many ways SPACE accomplished its goals above and beyond what was originally imagined. The program at Goode demonstrates this. It was a truly integrated curriculum and co-teaching model that went beyond the original vision for the program. Students were undeniably transformed in their understanding of art and civics as well as their sense of agency in the world. The school principal spoke eloquently about the

power of having an artist embedded in the community. The MCA viewed the project as a showcase program that truly exemplified its commitment to becoming a civic institution. But SPACE was ultimately "paused" at the end of six years. While a major factor in this decision to pause was indeed the pandemic, it was ultimately not the only factor. From the MCA's perspective, the schools had not yet arrived at a sustainable model that was independent of the MCA's management and funding. Additionally, SPACE had not arrived at a "scalable and replicable" model. These factors, combined with the transient nature of teachers and administrators in a large, metropolitan school district, proved challenging for a model heavily rooted in relationships.

Was the SPACE project a success? Were teachers, students, artists, administrators, and institutions forever transformed as a result of this program? The answer is absolutely yes. But the decision to prioritize building a "scalable, replicable" program model is perhaps where the MCA might choose to shift thinking. Any form of contemporary art practice or social justice initiative should be approached from a place of honoring the unique perspective of the artist and community it represents. While a public school system may present a set of constraints, uniformity should never be the goal. If SPACE were to be resurrected, the next iteration should be approached with a commitment toward crafting a community-specific model that grows into a project template that the school community must ultimately claim, shape, and invest in in order to make it their own.

REFERENCES

Dwyer, M. C. (2011). *Reinvesting in arts education: Winning America's future through creative schools*. President's Committee on the Arts and the Humanities. http://files.eric.ed.gov/fulltext/ED522818.pdf

Jeffrey, A., & Sargrad, S. (2019, December 14). *Strengthening democracy with a modern civics education*. The Center for American Progress. https://www.americanprogress.org/article/strengthening-democracy-modern-civics-education/

Levine, P., & Kawashima-Ginsburg, K. (2017, September 21). *The republic is (still) at risk and civics is part of the solution*. A Briefing Paper for Democracy at a Crossroads National Summit. https://hasbrouck.org/draft/FOIA/25c.Kawashima-GinsbergWritingSample.pdf

Vevea, B. (2014, July 9). *Schools on south, west sides left behind in CPS arts plan*. WBEZ. https://www.wbez.org/news/2014/07/09/schools-on-south-west-sides-left-behind-in-cps-arts-plan

APPENDIX

- SPACE Curricular Framework
- Contemporary Art Principles
- Principles of Democracy

SPACE CURRICULUM FRAMEWORK

SPACE deploys a flexible curriculum framework that supports students in becoming creative change agents with the confidence, knowledge, and skills to confront real-world issues. This framework is adaptable for arts and social studies courses

of varying lengths, and can be used as a yearlong investigation or intensive unit of study.

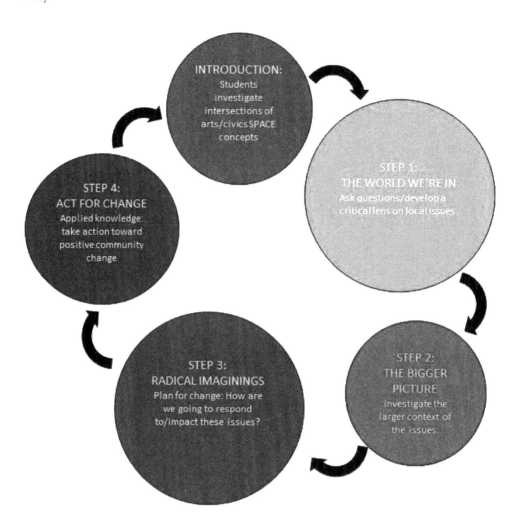

SPACE Student Outcomes and Indicators, and Standards Alignment

RESEARCH OUTCOME 1: Inquires, identifies and analyzes relevant community issues.

Indicator 1A: Questions, researches, and identifies current local controversial issues.
Indicator 1B: Identifies root causes of issue through research and analysis.
Indicator 1C: Makes connections between research, personal background, and own viewpoints on community issues. Standards alignment:

- **IL Social Science.Inquiry Skills.4.9-12:** Gather and evaluate information from multiple sources while considering the origin, credibility, point of view, authority, structure, context, and corroborative value of the sources.
- **IL Visual Arts Anchor Standard Creating 1.1.III:** Visualize and hypothesize to generate plans for ideas and directions for creating art and design that can affect social change.

PATHWAYS OF CHANGE OUTCOME 2: Identifies different ways people affect change in their community.

Indicator 2A: Identifies key stakeholders and investigates and analyzes multiple points of view to explain the actions of individual groups; and different ways people affect change in their community.
Indicator 2B: Facilitates community conversation; seeks input from range of community members and museum Standards alignment:

- **IL Social Science.Inquiry Skills.5.9-12:** Identify evidence that draws information from multiple sources to revise or strengthen claims.
- **IL Social Science. Civics.5.9-12.** Analyze the impact of personal interest and diverse perspectives on the application of civic dispositions, democratic principles, constitutional rights, and human rights.
- **IL Social Science.History.3.9-12:** Evaluate the methods utilized by people and institutions to promote change.
- **IL Visual Arts Anchor Standard Creating 1.2.III:** Choose from a range of materials and methods of traditional and contemporary artistic practices, following or breaking established conventions, to plan the making of multiple works of art and design based on a theme, idea, or concept.

PLANNING FOR ACTION OUTCOME 3: Defends and promotes advancement toward realization of positive community change.

Indicator 3A: Identifies potential in-roads for change, as vetted by instructors, community members, fellow students.
Indicator 3B: Uses multiple artistic strategies and modes to prototype action plan. Standards alignment:

- **IL Social Science.Inquiry Skills.7.9-12:** Articulate explanations and arguments to a targeted audience in diverse settings.
- **IL Visual Arts Anchor Standard Creating 2.3.I:** Collaboratively develop a proposal for an installation, artwork, or space design that transforms the perception and experience of a particular place.
- **IL Visual Arts Anchor Standard Creating 3.1.I:** Apply relevant criteria from traditional and contemporary cultural contexts to examine, reflect on, and plan revisions for works of art and design in progress.

ACTION + CHANGE-MAKING OUTCOME 4: Works as a change agent.

- **Indicator 4:** Launches action plan(s) to create change in the community. Standards alignment:
- **IL Social Science.Inquiry Skills.9.9-12:** Use deliberative processes and apply democratic strategies and procedures to address local, regional, or global concerns and take action in or out of school.
- **IL Visual Arts Anchor Standard Connecting 10.1.III:** Synthesize knowledge of social, cultural, historical, and personal life with art-making approaches to create meaningful works of art or design.
- **IL Visual Arts Anchor Standard Presenting 6.1.I:** Analyze and describe the impact that an exhibition or collection has on personal awareness of social, cultural, or political beliefs and understandings.

INTRODUCTION

OVERVIEW

Students will be introduced to key concepts of the SPACE curriculum, which include an understanding of contemporary art practice, and the ways in which artists are engaging with civic issues. Students will be introduced to contemporary art practice through direct engagement with the Embedded Artist (artist models their practice), through in-class dialogue about works of art and connections to class concepts (democratic values, etc.), and through a student visit the Museum of Contemporary Art Chicago. Through this unit, students will develop visual literacy skills, and understand the value of raising critical questions about our world.

KNOWLEDGE

Students understand:

- Qualities of contemporary art practice
 - Contemporary art is created at the same time and in the same social and historical context in which it is viewed; it's the art of *our* times
 - Contemporary artists raise critical questions about the world through their work, and ask us to engage with their responses.
 - The idea behind a contemporary artwork (concept) is often more important than what it looks like (aesthetics).
 - We as the viewers play an active role in the process of constructing meaning about the work of art.
- Contemporary artists use multiple strategies to comment on and make change to civic issues
- Contemporary art strategies can be used as tools for civic engagement

SKILLS

Students

- Define contemporary art, civic engagement, and cite examples of civically engaged artist projects.
- Read/describe/analyze a work of contemporary art as a text; make observations, inferences, inquiry, interpretations.

KEY ACTIVITIES

- Artist talk/workshops by Embedded Artist
- Use museum art objects/exhibitions as exemplars of differentiated ways to communicate social issues (Museum study visit).
- Dialogue and inquiry via contemporary art: case studies, broad spectrum of socially engaged art practices

SHARED CONCEPTS/VOCABULARY

- Contemporary Art Practice
- Civic Engagement
- Socially engaged art
- Inquiry
- MCA as resource

ASSESSMENT

- Portfolio/journal entry: understanding of contemporary art/SEA/civic engagement

STEP 1: THE WORLD WE'RE IN

OVERVIEW

Develop a critical lens on local issues

KNOWLEDGE

Students understand:

- What community means and how students/individual define the communities to which they belong
- I am affected by and can affect issues in my local community
- To make change, start by identifying issues in the community; to do that, understand the larger civic context in which community members live.
- APPLICATION: By learning to question the world around you, you can change it.

SKILLS

Students:

- Identify issue(s) of local importance to self, classroom community, and local community
- Develop a critical lens: learn to look, question, and analyze (ask why, who, how, what, when around issues)
- Make connections between research, personal background, and own viewpoints on community issues/conflicts

KEY ACTIVITIES

- Look at and talk about contemporary art
- Define an issue of importance to the smaller community of the classroom before moving on to larger context of whole community
- Neighborhood walks (move outside walls of classroom and school to look at issue as it exists in neighborhood)

Assessment:

- Written: Portfolio/journal entry: personal connection to issue: what and why this matters to me
- Arts-based: to be developed by core team with MCA input

SHARED CONCEPTS/VOCABULARY

- Community
- Built environment
- Mapping
- Research
- Dialogue

STEP 2: THE BIGGER PICTURE

OVERVIEW

Understand the larger context of the issue: Who is impacting the issue? Who is being impacted by the issue?

KNOWLEDGE

Students understand: The Ecology of the issue(s): what is the bigger context around this issue

- Why does this issue matter to/in the community
- Who is doing the work on these issues and how?

SKILLS

Students:

- Identify root causes of the issue through research and analysis.
- Identify key stakeholders and investigate different ways people affect change in their community.
- Facilitate community conversation; seek input from range of community members and museum
- Document community engagement through arts-based approaches
- Articulate a point of view that is different from their own

KEY ACTIVITIES

- Look at and talk about contemporary art: participatory / dialogic artistic practices
- Identify and develop specific documentation strategies for community engagement
- Facilitate community interactions that represent some diversity of perspectives, including public polling, interviews, and/or surveys
- Create arts-based representation of the issue and learnings from community dialogue

Assessment:

- Written: Portfolio/journal entry: evidence understanding of the issue has changed and why – I used to think and now I know or now I wonder: more sophisticated understanding and articulation of the issue
- Arts-based: to be developed by core team with MCA input

SHARED CONCEPTS/VOCABULARY

- Root cause analysis
- Public engagement
- Facilitation
- Point of view

STEP 3: RADICAL IMAGININGS

OVERVIEW
Plan for change: How are we going to impact/respond to this issue?

KNOWLEDGE
Students understand:

- Multiple perspectives around a central issue.
- What impact students want to have as a classroom community.
- How artists and other change agents plan for change
- How artistic and civic strategies explored in prior units can inform their own proposals for change

SKILLS
Students:

- Identify potential in-roads for change, as vetted by instructors, community members, fellow students
- Use multiple artistic strategies and modes to prototype action plan toward positive community change
- Identify artistic choices, and articulate reasons for those choices

KEY ACTIVITIES

- Look at and talk about contemporary art: prototyping/charrette examples
- Develop proposal for art-based project/event that addresses community issue, uses contemporary arts practice, and directly activates / involves the community
- Artists and community partners who visited return to give feedback
- Prototype to test/trouble-shoot implementation

Assessment:

Rubric for proposal (conceptual and aesthetic criteria), to be developed by core teams with MCA input

SHARED CONCEPTS/VOCABULARY

- Collaboration
- Synthesis
- Presentation
- Revision
- Aesthetics

STEP 4: ACTING FOR CHANGE

UNIT OVERVIEW

Apply knowledge: take action toward positive community change

KNOWLEDGE

Students understand:

- The process of project planning, execution, and completion
- Their ability to have impact on the world around me – empowerment
- Their own learning trajectory

SKILLS

Students:

- Launch action plan(s) to create change in the community.
- Reflect critically on their own learning

KEY ACTIVITIES

- Launch action in community (ranging from performance, festival, convening, workshops, etc.) that addresses community issue, uses contemporary arts practice, and directly activates/involves the community
- Share-out at museum/with school community about public action
- Document action(s)
- Project forward: articulate possible next steps toward sustaining or creating change

Assessment:

- Rubric on project implementation (conceptual and aesthetic criteria), to be developed by core teams with MCA
- Portfolio/journal entry: reflection on action; projected future actions/civic engagement; reflection on how understandings changed over this process.

SHARED CONCEPTS/VOCABULARY

- Change agent
- Social justice
- Leadership
- Reflection

ENGAGING THE NEXT GENERATION OF CITIZEN ARTISTS 235

PRINCIPLES OF CONTEMPORARY ART

Like the Principles of Democracy, the Principles of Contemporary Art practice can intersect, support and conflict with each other depending on the situation. As citizen artists collectively respond to the world, what new principles could be imagined?

Intertextual		When artists create new work from pre-existing text, which can range from images, video, words or sound. Using these sources to reference or transform allows the artist to challenge and shape the meaning of the original text.
Time		When a work is dependent on change, movement or the passing of time. Artists manipulate how moments of time are experienced through the viewing of their artwork.
Civically-Engaged		Aims to create social and/or political awareness or change through collaboration with individuals, communities, and institutions in the creation of participatory art. The discipline values the process of a work over any finished product or project.
Hybridity		Similar to Intertextuality, artists use hybridity through the blending of new or unusual materials (trash bags, led lights) with traditional mediums (painting, photo). The incorporation of these materials, such as recycled or industrial materials, plays an important role in the meaning of the artwork.
Text		Utilizing text as the main vehicle for their art, contemporary artists challenge the concept that text is only meant to be read. Some artists incorporate words and numbers to use as forms, narratives, instructions, and social/political commentary. Note: visuals, sounds or events can also be considered text.
Perspective		When an artist works with the real space surrounding the artwork itself. Through transformation or mimicking the environment, perspective can play a role in the way the viewer looks at the artwork or even the way the work is perceived.
Performance		Whether live or recorded, the present or absent artist is the focus for various approaches in engaging with an audience. The interdisciplinary form is extremely open and may incorporate speech, singing, audience members, acting, dance, props, multimedia or music. The performance can happen anywhere and for any length of time.
Obsessive		Some artists engage with repeated, meticulous or dense information to transform how viewers see an idea or issue.
Destruction		Destruction refers to when an artist uses strategies to show damage in or to their artwork. Many times, this destruction is documented as a process, which becomes the work itself.

PRINCIPLES OF DEMOCRACY

Accepting the Results of Elections

In elections there are winners and losers. Occasionally, the losers believe so strongly that their party or candidate is the best that they refuse to accept that they lost an election. Assuming an election has been judged "free and fair," ignoring or rejecting election results violates democratic principles. Democracy depends on a peaceful transfer of power from one set of leaders to the next, so accepting the results of a free and fair election is essential.

Accountability

In a democracy, elected and appointed officials are responsible for their actions and have to be accountable to the people. Officials must make decisions and perform their duties according to the will and wishes of the people they represent, not for themselves or their friends.

Bill of Rights

Most democratic countries have a list of citizens' rights and freedoms. Often called a "Bill of Rights," this document limits the power of government and explains the freedoms that are guaranteed to all people in the country. It protects people from a government that might abuse its powers. When a Bill of Rights becomes part of a country's constitution, the courts have the power to enforce these rights.

Citizen Participation

One of the most basic principles of a democracy is citizen participation in government. Participation is more than just a right—it is a duty. Citizen participation may take many forms, including running for office, voting in elections, becoming informed, debating issues, attending community meetings, being members of private voluntary organizations, paying taxes, serving on a jury, and even protesting. Citizen participation builds a stronger democracy.

Control of the Abuse of Power

One of the most common abuses of power is corruption, which occurs when government officials use public funds for their own benefit, or they exercise power in an illegal way. To protect against these abuses, democratic governments are often structured to limit the powers of government offices and the people who work for them. For example, the executive, judicial, and legislative branches of government have distinct functions and can "check and balance" the powers of other branches. In addition, independent agencies can investigate and impartial courts can punish government leaders and employees who abuse power.

Economic Freedom

People in a democracy must have some form of economic freedom. This means that the government allows some private ownership of property and businesses. People are allowed to choose their own work and to join labor unions. The role the government should play in the economy is debated, but it is generally accepted that free markets should exist in a democracy and the state (government) should not totally control the economy. Some people argue that the state should play a stronger role in countries where great inequality of wealth exists due to past discrimination or other unfair practices.

Equality

In a democracy all individuals are valued equally, have equal opportunities, and may not be discriminated against because of their race, religion, ethnicity, gender, or sexual orientation. Individuals and groups maintain their rights to have different cultures, personalities, languages, and beliefs. All are equal before the law and are entitled to equal protection of the law without discrimination.

Transparency

For government to be accountable, the people must be aware of the actions their government is taking. A transparent government holds public meetings and allows citizens to attend. In a democracy the press and the people are able to get information about what decisions are being made, by whom, and why.

Human Rights

All democracies strive to value human life and dignity and to respect and protect the human rights of citizens. Examples include, but are not limited to the following:

- **Movement:** Everyone has the right to freedom of movement and residence within the borders of his or her country. Everyone has the right to leave and to return to his or her country. (Article 13, Universal Declaration of Human Rights)
- **Religion:** Everyone has the right to freedom of thought, conscience, and religion. This right includes freedom to change his or her religion and to worship alone or in community with others. It also includes the right to not worship or hold religious beliefs. (Article 18, Universal Declaration of Human Rights)
- **Speech:** Everyone has the right to freedom of opinion and expression. This right includes freedom to hold opinions without interference and to seek, receive, and impart information with others. (Article19, Universal Declaration of Human Rights)
- **Assembly:** Everyone has the right to organize peaceful meetings or to take part in meetings in a peaceful way. It is undemocratic to force someone to belong to a political group or to attend political meetings or rallies. (Article 20, Universal Declaration of Human Rights)

Independent Judiciary

In democracies, courts and the judicial system are impartial. Judges and the judiciary branch must be free to act without influence or control from the executive and legislative branches of government. They should also not be corrupt or obligated to influential individuals, businesses, or political groups. These ideas are related to the rule of law and to controlling the abuse of power. An independent judiciary is essential to a just and fair legal system.

Multi-Party Systems

To have a democracy, more than one political party must participate in elections and play a role in government. A multi-party system allows for organized opposition to the party that wins the election. Multiple parties provide the government with different viewpoints on issues and provide voters with a choice of candidates, parties, and policies. Historically, when a country only has one party, the result has been a dictatorship.

Political Tolerance

Democratic societies are politically tolerant. This means that while the majority of the people rule in a democracy, the rights of minorities are protected. A democratic society is often composed of people from different cultures, races, religions, and ethnic groups, as well as people with viewpoints that differ from those of the majority. People who are not in power must be allowed to organize and speak out. If the people in the majority try to destroy the rights of people in minority groups or with minority viewpoints, then they also destroy democracy.

Regular Free and Fair Elections

One way citizens express their will is by electing officials to represent them in government. In a democracy, elections are held regularly, usually every few years. Democracy requires that elected officials are chosen by the people in a free and fair manner. Most adult citizens should have the right to vote and to run for office—regardless of their race, gender, ethnicity, and level of wealth. Additionally, obstacles should not exist that make it difficult for people to vote. There should be no intimidation, corruption, or threats to citizens before or during an election.

The Rule of Law

In a democracy, no one is above the law—not even a king, elected president, police officer, or member of the military. Everyone must obey the law and will be held accountable if they violate it. Democracy also insists that laws are equally, fairly, and consistently enforced.

CHAPTER 15

Reflective Conversations between Two Experienced Women Art Educators and Their Life-Long Involvement through Civic Engagement

Sharon Greenleaf LaPierre and Enid Zimmerman

> **INSTRUCTIONAL QUESTIONS**
>
> 1. What constitutes a successful aging process to maintain artistic involvement and in what way is it expressed through art making, teaching, mentoring, and research and/or community involvement?
> 2. What personal characteristics and forces drive aging changes and processes to continue creative growth and civic engagement over time?
> 3. What personal and individual experiences, over a lifetime, allow for unique authentication and verification of creative aging processes?

As two experienced women art educators, we explore ways of having our voices heard by being involved in community activities which represent civic-minded participation. We are Sharon LaPierre and Enid Zimmerman, who, after having reached seasoned and experienced ages, continue to be creatively and socially engaged in building more inclusive and equitable communities. We both are involved in individual and shared civic activities in which public involvement and our individual and collective actions address issues of concern through forms of activism, which may or may not be political, and include community engagement often through organizational involvement. In 1997, we co-edited the first National Art Education Association (NAEA) research book that had been published in many years. This previous collaboration brought us

together after 26 years with the purpose of documenting our recent conversations about our engagement with creative aging and how our art making influenced our public involvement. Finally, we propose the beginning of a future framework about creative aging based on these conversations and personal practices.

ART EDUCATION, AGING, AND CIVIC ENGAGEMENT

Research and practice in the field of art education that sets forth a positive consideration of art education, creativity, gender, aging, and civic engagement (Lindauer, 2003; Zimmerman, 2024) is currently needed. Often teaching and learning in art classrooms is where social justice activism is emphasized (Shields, Fendler, & Henn, 2020) and mature art educators, who are no longer engaged in full-time education practices, often are not included in the research conversation. There is some research that focuses on how, in creative aging contexts, activity that nurtures a sense of competence, purpose, and growth can support and encourage development of problem-solving skills (Fisher & Specht, 1999).

We both have taught art education in K–12 art classrooms and at the higher education level and are now 'retired' but actively participate in civic engagement through creating a variety of activities that focus on social action in diverse contexts and communities. Our experiences in teaching art education and practicing art making have allowed us to seek positive changes through creative problem-solving. LaPierre is involved in animal rescue and rehabilitation, as well as maintaining a working studio in which she creates and then exhibits her whimsical sculptures. Zimmerman recently has been mentoring art educators and developing art educational programs with a focus on self, political, and civic engagement.

In the following sections, we each will discuss our motivations for civic engagement, how our family backgrounds and educational experiences have influenced our choices, and how we think social values and skills can be fostered in higher education contexts today. In addition, we deliberate about any impediments related to being mature women and our civic engagement activities, publishing, and/or exhibiting our artwork. Using summaries from our conversational exchanges, we will summarize how conceptions we have formulated through experience might become resources for others in respect to art education teaching, learning, and practice. The wisdom and knowledge we both possess, therefore, also will be considered having potential to add to the field of art education in areas of feminist studies, creative aging, problem-solving, and community engagement.

We present summaries of our conversations focusing on our backgrounds, intentions, and actions we have taken during our careers resulting in our productive lives with creative aging undergirding our ongoing actions to engage productively in various communities in which we are involved. In the following sections, we each have linked our aging processes with our involvement in community activities at local, national, and international levels. These pursuits have developed as a reflection of our involvement in art education research and art making which ultimately have led us to problem solve through avenues of community engagement.

THE ART OF AGING BY SHARON LAPIERRE

In this section of the chapter, I explore factors that have influenced my evolutionary growth based on my background experiences as a child, an art educator, a production artist, and an activist. I will explore my unique artistic style and creative development through the years, as well as actions that I have taken to continue to live a productive life as I have aged.

My background and circumstances played a large role in my development. I was born into a family where my mother and grandmother cherished education and actively encouraged me to study and to use my talents every day. My mother was self-educated, but did have some nursing training, and read and wrote constantly about various subjects she researched. She gave me special tutoring lessons in mathematics, sewing, tailoring, and knitting, as well as swimming and piano lessons. In those days, neighbors served as mentors for neighborhood children. My mother would cook or clean homes as payment for lessons. She became a volunteer Chaplain for the veteran's hospital in Yountville, California. The lessons I learned from her spiritual passage forever guided and formed my purpose in life because she imparted her strength and courage to her children.

Our modest home was always full of books to read, including a complete *Encyclopedia Britannica* set. I was never at a loss for things to occupy my time and mind, and I was encouraged to research what I did not know. The public library was an important part of my learning to explore and generate ideas. I would visit often for fun. My family did not have much money because I came from people who originally picked fruit and vegetables in the fields of Washington and Oregon and who had little formal education on either side of the families. In fact, my father had a third- or fourth-grade education and was born in Canada. I learned to work hard and to save every penny I made so I could go to college, which was a driving force. I started working at odd jobs when I was eight years old and even maintained my own bank account which was promoted by my parents. As a young child, I picked prunes in the fields of California (eventually becoming the lead organizer in the fields), mowed lawns, and had an early morning paper route along with my brother. I remember sewing cloth aprons with my own design and going from door to door selling them for one dollar, adding to my savings. Being raised in a small agricultural town in California allowed for such activities.

Those days of growing up have served me well in striving to share my talents as a teacher and my art as an artist. I wrote about my migrant days in detail in an article published in the *Journal of Multicultural and Cross-Cultural Research in Art Education* (LaPierre, 2000). Those early life experiences drove me to develop a unique style of whimsical art making, as well as my social commitment to animal rescue and women's rights. I recognized early in life that my artistic thinking process as a young girl was a form of spatial intelligence that was not fully understood or recognized in my opinion (LaPierre, 1993).

My art style began to evolve from years of drawing faces and looking at people's expressions (see Figures 15.1 and 15.2). These elements intrigued me and made me laugh at times. My creative inspiration came from the love of color and the wonderful

FIGURE 15.1 *Pinheads*, 22″ × 16″ steel sculpture on found object, acrylics by Sharon LaPierre.
Permission of the artist.

diversity of expressions seen in faces. Faces showcase the human spirit and speak of an inner truth like a window to the soul as delineated in eyes, cheeks, mouths, and hair. So, I developed a whimsical face style using various media such as loom weaving and fiber techniques (tapestry and basketry), drawing, and steel sculpture. I became known for this whimsical style, exhibiting extensively and writing about my craft. My work appeared in many publications and on the cover of magazines. It all seemed natural to me to share this style of creating, as well as the thinking process, as I lectured at various colleges and juried art exhibits. My love of the "art of whim" brought laughter, joy, and energy to my life.

As the years have progressed, I wanted to share what I learned in life about my thinking process from being a production artist, specifically artistic spatial intelligence (LaPierre & Fellenz, 1988), so I went on to get my Ph.D. in Curriculum Development

REFLECTIVE CONVERSATIONS **243**

FIGURE 15.2 *White Faced Basket*, 9.5″ tall by 8″ in diameter, coiled basket with handmade paper, wool, acrylics, relief eyelashes, mixed media by Sharon LaPierre. *Permission of the artist.*

and Research Methods. My research was solidified as a Kellogg Post-Doctoral Fellow in Adult Learning Research at Montana State University. Also, my journey led me to Stanford University where Elliot Eisner was a mentor for a short time. I was lucky enough to be a part of the NAEA which helped to hone my research skills, my presentation, and teaching abilities, and to clarify my theories regarding artistic thinking as a particular form of spatial reasoning, as well as my administrative abilities as president of both United States Society for Education through Art (USSEA) and Seminar for Research in Art Education (SRAE).

As I sit and write this section of the chapter, I realize how diversified my background has been through the years. This has allowed me to enter many areas of active endeavors, all requiring creative solutions just like an artist. To me such active endeavors are no different than making art. It requires me to problem solve and to develop an outcome in my mind, looking at all possibilities for success. Thus, this becomes a model for civic-minded engagement because it offers a method for reform.

One of my biggest loves has been to rescue animals in need. I was licensed by the Colorado Division of Wildlife as a full rehabilitation specialist for 11 years and apprenticed at a sanctuary in California for deer fawns. My love of wildlife spurred me to co-found the Wildlife Legacy Trust where grants were given to nonprofits to help rescue animals through the Community Foundation Serving Boulder County. My activism in this area of animal rescue really started in my 50s when I came upon a large herd of Peruvian Paso Horses in my county that were being systematically starved to death. I sat in my truck for four days and nights to document their lack of food, knowing my mission was to set them free. To get it started, I contacted the owner and brought 90 bales of hay in exchange for the lead mare whose face was covered with cancer. I loaded her into the trailer and as I was doing that, a young foal with rickets jumped into the trailer as well. The owner said, "Take them both," as he waved his hand. The lead mare lived her life out at a sanctuary and "Caramela de Raza" became the love of my life. She was wild because of no human contact and sick with parasites because of no decent food. I learned to train a horse and kept her until she passed years later. I worked with a national rescue group to obtain legal custody and placement of all the other horses in the field, including many stallions in the barn. My love for horses led me to rescue many in need during my lifetime. If I could not place them, I kept them, trained them, and showed them. Many have won national titles along with my husband as the owner/rider. To me this is no different than making art. It requires me to problem solve and to develop an outcome in my mind, looking at all possibilities for success from a spatial perspective.

Another example of how my animal rescue impacted my creative and research directions in the arts was when I was president of the SRAE for NAEA. The story was recounted in *NAEA News* (LaPierre, 1995). At that time, I rescued a five-year-old pit bull mix from a research hospital setting. My intent was to place him in a home. However, he had been so damaged with lung transplants, and they had electrified his testicles, that he could not be placed. He lived to be 15 years old with us, but for the first 2 years, he shook violently in the corner and would only eat dry dog food thrown on the floor. I had to learn to desensitize his behavior to help him live outside of a cage. He could not be touched. Every time he went to eat at the research center, he was zapped by electricity attached to his testicles. I was told that the studies dealt with food deprivation and how much pain could be tolerated. He endured this kind of treatment for the first five years of his life. My intolerance for this kind of methodology drove me to become an advocate for ethical animal research, allowing me to serve on the Northern Arizona University Research Board later, helping to set standards and practices that were honorable towards a living being. I began to teach my graduate students the purpose and ethics of research methodologies. This experience spurred me to work with Enid Zimmerman to co-edit a research anthology (LaPierre & Zimmerman, 1997) focusing on diversified research approaches. Solving problems, observing issues to be studied, and using research methods to match the intent became a passion for me and another way to actively express my creative acts.

The following summation details my active civic participation throughout the years regarding women's issues by remembering the 1960s, 1970s, and 1980s.

- When I married in 1967, I assumed that I could use my own name (maiden name) without a problem. My name on my social security number was changed without my permission to my husband's last name. I learned this was tradition and not a law. To retain my own name, I had to go to court in the State of Colorado and apply for a name change in front of a judge because it had already been changed through marriage records. This I did on December 27, 1974, setting a precedent for other women to use their own names (County of Arapahoe, State of Colorado, Civil Action No. 24956). A notice was placed in the *Littleton Independent* newspaper, and I retained my name through court order which allowed others to do the same. This legal action allowed me to change my social security back to my own name as legal with a copy of the court order.
- I went to purchase a U.S. Savings Bond, which was the thing in the 1970s. In order to buy a bond, I had to list on the bond either "Miss" or "Mrs" or I could not buy it. I enlisted the help of the ACLU and lawyer, Peter Nay. I was allowed to buy a federal U.S. Bond without these designations using my own legal name. This allowed other women to do the same.
- The tax forms in Colorado at this time required a signature from the woman if filing jointly which read "Taxpayer's Wife's Signature." This was offensive to me since I worked and put my husband through graduate school. So, I was influential in changing this designation to "Taxpayer's Spouse's Signature."
- Financial credit for women in the 1970s was difficult because it was tied to their husband's name and credit rating. Buying property or obtaining credit cards in one's own name was not a usual practice. I wrote constant letters and finally won the fight to retain my own individual credit cards, which resulted in my own credit rating. When I graduated from college, I was sent credit cards from various gas companies as a standard practice. When I married, my credit became that of my husband with his name on the card and a different starting date reflecting my name change.
- The National Organization for Women (NOW) was just being formed in the 1970s. During graduate school, I was the "Convener" in San Diego, CA. We met initially in my apartment and then in a private home in La Jolla.
- The first group for Lutheran Medical Center in CO was formed as a volunteer rape counseling unit in the early 1980s. We became the chain of evidence for the victim while being examined by a doctor instead of a male police officer being present in the room. It was a new concept at the time, and volunteers were trained to understand the issues. I played a role in this process change.

The expression of creativity does not cease with age. On the contrary it expands because of background, experiences, activities that one develops over time. It just takes on various forms of manifestation derived from past learning, and that learning over time becomes wisdom … how to think outside of the box to solve a problem

or give purpose to existence outside of an aging body and the belief of deterioration, bringing joy and fulfillment. These active participations as noted in this section of the chapter set the stage for an existence that have made a difference for me and others. It is uniquely defined as expressed in my developed art style which sees the joy in life. Throughout my lifetime I have competed in swimming and horse showing, maintained a daily workout schedule of walking, biking, or lifting weights. To me, this is a necessary ingredient to maintain my ability to be productive. Wisdom from growing old can only serve to enhance creative action because art is the energy of life and to me all of life activities require creative thinking and purposeful living. It is the same as art making. This insight has led me to appreciate all the twists and turns in my life's journey. I have learned to appreciate the creative spirit as the deep-down life force to express and have a reason and motivation to continue to exist. Creating art brings that inner satisfaction for me as nothing else can, allowing me to transfer the process to serve my community.

ENID ZIMMERMAN'S VIEW OF SUCCESSFUL AGING

I am writing about creative aging on June 24, 2022, the day the Supreme Court overturned Roe v Wade. On January 22, 1973, Roe v Wade passed and many people, I was one, who worked for its passage, rejoiced in the streets around the country. As a former President of the NAEA Women's Caucus from 1980 to 1982, I have been an activist for women's rights for almost five decades. I am saddened by this overturning event and think of its ramifications for equality, diversity, and inclusive policies that have been instituted and now may be in danger of being eradicated as well. This Supreme Court decision prompted me to recall activities that may have influenced my own pursuits beginning with my childhood background to my more current creative aging accomplishments. Understanding creative aging can be strengthened by explanations of early years that influenced adult choices that in some cases may have connected with political and social action in later life. My father and mother were important influences in my life. My mother served as a model for me as a woman who spoke up when she felt she was not being treated fairly. I often was embarrassed by her very aggressive stances related to how she felt about a variety of matters; however, she served as a model for being able to be an advocate for what I later thought was important in my life. My father was born in Polish Russia and came to the U.S. when he was 13 years old, thus making me first generation on his side of the family. In his youth, he lived an adventurous life and at one time was manager of the circus in Coney Island, New York City. My sister is four years younger than I, and my father often took me to places outside my home, such as the neighborhood bar, to give my mother some respite from a child who always was asking too many questions. When I was older, he and I spent many hours talking about societal matters as he was an active Democratic Socialist.

When I was eight years old and my sister was four, we both contracted polio and spent three months in the hospital. I had bulbar polio, the result of which is I have a paralyzed vocal cord and speak from my diaphragm not my voice box. At

this time, my father's business failed, and my parents often struggled with finances. When I was in middle school, my mother went to work as an accountant to help support the family. Both my parents supported me in all my educational endeavors and made me believe I could accomplish anything I set out to do. I attended schools in New York City: Music and Art High School, now in Lincoln Center, and City College where I was a fine arts major and received a teaching license. I always was determined to be active in both art teaching and engagement within the communities I was serving. I taught K–6 art in NYC from 1961 through 1966 and received an MFA in painting in 1967 from Hunter College with Donald Judd as my mentor. In 1972, I founded an art school in Ithaca, New York, and in 1977, I became a doctoral student at Indiana University School of Education and in January 1979 received a doctoral degree in Art Education. I then was on the IU faculty and eventually was promoted to Full Professor and became Head of the Art Education Program and High Ability Programs on the Indiana University campus. I always collaborated with art educators in countries from around the world by developing art programs that could be taught in the U.S., thereby focusing on global understandings. In 1980 I was President of the NAEA's Women's Caucus and participated, before retiring from IU, in international activities, a few highlights of which were in 1985 participating in a Fulbright-Hays Group Project in Malawi and Zimbabwe, in 1989 serving as a USSEA national consultant, and in 1991 as a delegate to the Art Education Association of Indiana's cultural exchange program in Japan. From 1993 through 1998, I was first Chair of the NAEA Commission on Art Education Research, and from 1993 I served as INSEA World Councilor. As a civically engaged higher educator, therefore, when I retired from IU, it was a natural transition to become an art educator in a variety of international and national settings.

When I retired from Indiana University in 2004, my priorities changed, yet I have continued to be actively involved in art education advocacy and research at the national level and have returned to creating artwork to nurture my own creativity that is inspired through a feminist lens. I am guided by a notion of *Tikkun Olam*, which often is translated in Hebrew as *repairing or healing the world*. In Jewish practice in contemporary times, it has been extended to also mean engaging in social action and the pursuit of social action (Rose et al., 2008). For the past 18 years, since my retirement from IU in 2004, I have been fortunate to have a healthy retirement income, grants, and paid remuneration from many organizations in the U.S. and abroad and have been privileged to have extra medical coverage, all of which allowed me to pursue local, national, and international activities.

In advance of retiring, I purposefully generated several projects so I could continue to be engaged civically in NAEA, IU, and other organizations. When I retired from IU, I wanted to continue being associated with NAEA and to assist other art educators as I have always supported advocacy for art education programs in schools, museums, and community settings. With this intent in mind, I established the NAEA Gilbert A. Clark and Enid Zimmerman Leadership Advocacy Award in 2020 that supports art educators whose contributions are not acknowledged or brought to public attention. I also have continued to mentor art educators at all levels both in person and through Zoom conversations.

In 2014–2015, I was an evaluator for NAEA's Summer Vision DC (SVDC), a museum-based program that focused on building a professional, learning community of art educators. From 2016 to 2021, I also was co-evaluator with Robert Sabol for the NAEA School for Art Leaders (SAL) program to support museum, school, and community art educators in development of their leadership skills and abilities. From 1993 through 1998, I was the first Research Commission Chair, and from 2012 through 2016 I served as a member of the new NAEA Distinguished Fellows.

After retiring from IU, several of our former students invited me and Gil Clark to teach for extended periods of time at their universities located around the world. Thus, I was able to extend my civic engagement to learning and teaching in international contexts. I was a Visiting Professor/Scholar at the University of New South Wales in Sydney, Australia and at National Chiayi University, Taiwan; Consultant to the Korean Research Institute for Gifted and Talented Students in the Visual Arts, Seoul, Korea; and Consultant to a Pilot Project on the Development of Gifted and Talented Students in the Visual Arts, Arts Education Section of the Education Department, Hong Kong. Also, for three years, from 2004 through 2007, I served as Senior Editor of the *Journal of Cultural Research in Art Education*, and from 2007 through 2010 I was a co-editor of the *INSEA Newsletter*. Since my retirement in 2004, I have continued to be engaged in art education activities at the national level and co-edited *Connecting Creativity Research and Practice* with Flávia Bastos (Bastos & Zimmerman, 2015) and co-edited *Cultural Sensitivity in a Global World* with Marjorie Manifold and Steve Willis (Manifold, Willis, Zimmerman, 2016).

At SVDC and SAL, visual journaling was introduced by Renee Sandell as a means of expressing visually by reflecting on what participants were experiencing and how they could use art making skills they may not have used for many years. For the past five years, I have created graphic visualizations in diaries that include images guided by social action and pursuit of social justice. These images depict reflections about self-care, the current political environment, and the natural environments. I have filled five diaries of different sizes with these images and have published several of them in articles and book chapters (for example, Cooper & Zimmerman, 2019a, 2019b; Sandell & Zimmerman, 2019, 2021; Zimmerman, 2019, 2024). As examples, one page was a collage created in 2017 from a photo taken five years before, when I retired and looked back at my office at IU and realized I had moved on to a future state and was pleased with my accomplishments (see Figure 15.3). In 2021 to 2023, as a means of coping through self-healing and discovering means to confront personal and political distress during COVID times, I took photos of masks I found in the street and linked them to my own feelings of despair and hopelessness; but finally, I chose to act and create new beginnings with optimism for the future as evident in the titles of these collages (see Figure 15.4). In addition, I have conducted workshops in both local and national contexts where I have worked with communities of people to create their own visual journals based on their visions of creating a better world for future generations. They then go back to their local communities and work with others to create new visions and hopes for the future. All of these local, national, and international journeys that I have described above have contributed greatly to what may be termed my creative aging process.

REFLECTIVE CONVERSATIONS 249

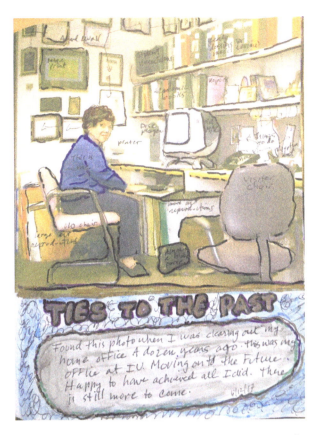

FIGURE 15.3 *Ties to the Past*, June 12, 2017, 9" × 11" mixed media work by Enid Zimmerman.

Permission of the artist.

FIGURE 15.4 *Difficult Road Ahead*, September 17, 2021, November 20, 2022, and February 18, 2023, 9" × 11" each, mixed media works by Enid Zimmerman.

Permission of the artist.

TOWARD A FUTURE FRAMEWORK FOR CREATIVE AGING

From our conversations and research explorations about productive maturing, we have created what could be viewed as a future framework toward creative aging. We view this future framework as a beginning and hopefully more investigators will use this conversational structure and revise and add to it based on their own reflections and life experiences. A major factor regarding our personal and professional lives is that our leadership skills allowed for changes and contributions in our chosen fields within the context of art education. This in turn allowed each of us to speak in our own distinctive voices nurtured by our background years as our parents played important roles encouraging us to develop our own skills and knowledge. Another factor that set the stage to age successfully was that each of us followed our own sense of purpose, including who we were and what we wanted to accomplish. We then developed art making and research skills that prepared us in our future lives as art educators and art makers. In our professional and organizational development, we both were inspired by our leadership in areas of feminist and political involvement activities. Finally, through experience, knowledge, and our creative aging activities, through purposeful actions, we found we could influence change by means of our current art making and publishing activities. In addition, through mentoring and activism in our local communities and beyond, we have motivated others to know enjoyment through active participation into their mature years which continues to result in creative aging.

REFERENCES

Bastos, F., & Zimmerman, E. (2015). *Connecting creativity research and practice in art education: Foundations, pedagogies, and contemporary issues*. National Art Education Association.

Cooper, Y., & Zimmerman, E. (2019a). Understanding visual conceptual frameworks and curriculum mapping for art education research and practice. In Y. Cooper (Ed., Trans.), *On 21st century arts and culture education*. Hung-Yeh.

Cooper, Y., & Zimmerman, E. (2019b). Concept mapping: A practical process for understanding and conducting art education research and practice. *Art Education*, 73(2), 24–32.

Fisher, B. J., & Specht, D. K. (1999). Successful aging and creativity in later life. *Journal of Aging Studies*, 13(4), 457–472.

LaPierre, S. D. (1993). *Issues of gender in spatial reasoning* (ED358016). ERIC. https://files.eric.ed.gov/fulltext/ED358016.pdf.

La Pierre, S. D. *Seminar for research in art education president's column*. NAEA News (NAEA is not spelled out). 1995 April (there is no day), vol 37, No 2, 14.

LaPierre, S. D., & Zimmerman, E. (Eds.). (1997). *Research methods and methodologies in art education*. National Art Education Association.

Lindauer, M. S.(Ed.). (2003). *Aging, creativity, and art: A positive perspective on late-life development*. Kluwer Academic/Plenum.

Manifold, M., Willis, S., & Zimmerman, E. (2021). *Cultural sensitivity in a global world: A teacher's handbook*. National Art Education Association.

Rose, G. N., Green Kaiser, J. E., & Klein, M. (Eds.). (2008). *Righteous indignation: A Jewish call for justice*. Jewish Lights.

Sandell, R., & Zimmerman, E. (2019). Using feminist advocacy, collaboration, and arts-based practices to heal ourselves and others. *Visual Culture and Gender*, 14, 7–12, Hyphen-Unpress.

Sandell, R., & Zimmerman, E. (2021). Feminist leadership: Revelations through data visualization mapping. In K. Keifer-Boyd, L. Hoeptner Poling, S. R. Klein., W. B. Knight, & A. Perez de Miles (Eds.), *NAEA women's caucus lobby activism: Feminism(s)+art education*. National Art Education Association.

Shields, S. S., Fender, R., & Henn, D. (2020). A vision of civically engaged art education: Teens as arts-based researchers. *Studies in Art Education*, 61(2), 123–141.

Zimmerman, E. (2019). Personal narratives using data visualization concept mapping and marking & mapping™ practices. In Y. Cooper (Ed.), *Aesthetic education: New trends in world arts education research* (pp. 65–73). Shanghai Educational Publishing House.

Zimmerman, E. (2024). A personal narrative about retirement: Continuing to pursue an active professional and creative life. In M. Davenport & M. C. Manifold (Eds.), *Art education and creative aging* (pp. 180–191). National Art Education Association.

CHAPTER 16

Utilizing Fugitive Pedagogies to Promote Civic Education in *De Facto* Segregated Schools

Debra A. Hardy

> **INSTRUCTIONAL QUESTIONS**
>
> 1. Many Black educators likely practiced fugitive pedagogies in their classrooms; however, due to the lack of a written record of their pedagogies, we may not know their stories. How can we study the narratives of pedagogies which are so often unrecorded?
>
> 2. In what ways might the work of educational theorists such as Woodson, who focused on the miseducation of students through a failure to teach accurate histories, still resonate today? What can be done about contemporary miseducation in a time of heightened surveillance of individual educator practices from administration, parents, and students?
>
> 3. How does the art classroom lend itself well to the teaching of the intersection of art, politics, and justice?

On the top floor of DuSable High School in Chicago's Bronzeville neighborhood, Margaret Burroughs'[1] classroom looked like any other art class in the all-Black school. Students worked diligently on still lives, landscapes, and portraits with their teacher helping strengthen their skills from her years of work as a practicing artist. However, when her student lookout gave the all-clear that no administrators were walking down the hall, Burroughs used her art room as a location in which to both bolster students' confidence within the arts and as a space to consider the power and possibility within their Blackness. As students drew and painted, Margaret discussed Black history and

moments within her own life that radicalized her toward equity and justice, and she encouraged her students to see themselves as part of a history and as change-agents. Burroughs believed in the power of education to provide her students with a Black historical foundation from which they could become fully engaged citizens in the United States. Through these acts, Burroughs politically and philosophically aligned herself with a lineage of Black educators engaged in *fugitive pedagogy* (Givens, 2021) and crafted her art classroom as a counter-public space of possibility.

While Burroughs' legacy today is predominantly remembered within Chicago as an artist, poet, and co-founder of the first Black history museum in the United States[2] (Cain, 2018), her work to impart and explore Black histories to Chicago's youth started during her 20-year career as an art teacher at DuSable High School. In the classroom, she began exploring the ways that she could help empower students, even when doing so was politically risky. Burroughs' integration of the work of educational theorists such as Carter G. Woodson into her classroom helps to underscore the ways that engaged Black educators saw art, politics, education, and civil rights as entangled subjects, all of which led toward Black liberation and further civic engagement. Burroughs' use of her classroom space as a civic space highlights the political acts of Black teachers, who were willing to risk their profession to involve students in counter-narrative conversations. The commitment of Black educators[3] like Burroughs to teach their students, even at great personal and professional risk from White dominant institutions, demonstrates the importance of active and engaged citizenship teachers imparted to their students through the teaching and centering of Black history in the curriculum throughout the twentieth century.

CITIZENSHIP, BLACK EDUCATION, AND CARTER G. WOODSON

As slavery in the Americas existed for over 150 years prior to the formation of the United States as an independent nation, the concept of *citizenship* for Black Americans has been a difficult topic of conversation since the days of the early republic (Spires, 2019). Black individuals were not given the same birthright to American citizenship that White male settler-colonists had before or after the American Revolution, and as such, conceptions of citizenship for Black individuals have gone beyond simple national identity. Dilworth (2004) defines citizenship education for Black Americans as "an ongoing process by which individuals acquire the knowledge and skills needed to execute new forms of political behavior and socialization" (p. 3). In a similar action-oriented definition, Spires (2019) notes that

> As state policies and public discourse around citizenship were becoming more racially restrictive, black activists articulated an expansive, practice-based theory of citizenship, not as a common identity as such but rather as a set of common practices: political participation, mutual aid, critique and revolution, and the myriad daily interactions between people living in the same spaces, both physical and virtual…Citizenship, in other words, is not a thing determined by who one is but rather by what one does. (p. 3)

Within these definitions, *citizenship* is not a passive trait that one simply attains through birth in a particular location; it is instead an active and ongoing political action with a focus on participation and liberation. Thus, education and civic engagement have been continuously linked for Black leaders and thinkers, as education became a location of possibility and transformation toward engaged citizenship (Dilworth, 2006; Woodson, 1933).

Education for Black Americans has similarly operated as a contentious battleground over power and agency, rather than a birthright (Mills, 2021). Education of Black individuals was outlawed in southern states such as South Carolina, even to free individuals, due to its possibility of inciting revolt against the enslavement of Black Africans (Givens, 2021; Woodson, 1933). Even after emancipation, education was exercised as a site of White control. The use of literacy tests to block Black voters in the Southern United States provided an opportunity for White Americans to wield education as a barrier to participation in citizenship. The disenfranchisement of Black Americans after the Civil War was similarly expanded by White Northern capitalists and missionaries, who saw education as a central factor in crafting a permanent underclass (Mills, 1997; Watkins, 2001; Woodson, 1933). Through the establishment of centers of education, capitalists were able to shift and mold education of newly freed Black college students to conform to White perspectives and eliminate the perspective of Black individuals from the curriculum. The state inflicted ideological violence through the erasure of history and accomplishments of Black individuals within education and crafting an education focused on a White and Western perspective that provided no room for Black accomplishment.

Through his experiences as an educator and his work as a historian, Carter G. Woodson saw the ways that failing to learn about Black narratives led to a population of educated Black individuals who struggled deeply with self-loathing and inferiority in comparison to their White peers. Even when individuals taught within these systems reached higher education and positions of relative power, they continued to believe in the inferiority of their own race, replicating these systems of educational violence to new generations (Woodson, 1933). Woodson's seminal work, *The Mis-Education of the Negro* (1933), articulated the ways that state-sanctioned education continued to control Black populations through cultural and historical erasure. Having worked as a teacher himself, Woodson highlights the structural ways that Black schools continued to operate through White supremacy. Mills (1997) ties this ideological violence of miseducation and erasure to the enforcement of the United States' *racial contract*, in which the subjugation of BIPOC individuals is intrinsically tied to the concept of citizenship. By "inculcating subjugation" (Mills, 1997, p. 89) through miseducation, the racial contract continues unimpeded as Black students do not learn about histories of resistance. To counter this cycle of educational violence, Woodson proposed challenging Eurocentric dominant narratives within education and to instead center the ways that Africans and Black Americans helped shape the world. Providing complete narratives which highlight the real histories of African contribution to the world and explored Black struggle against slavery, education could then create a "critical historical consciousness would contribute to civic competence" (Dilworth, 2004, p. 9). Doing this, in turn, would create space for Black

Americans to become full citizens and political actors who saw themselves as part of a lineage of opposition to White supremacy.

Woodson's work as an educational theorist and a historian through the creation of the Association for the Study of Negro Life and History (ASNLH) in 1915 and the subsequent development of Negro History Week in 1926 helped craft a network of Black teachers, leaders, and thinkers invested in providing civic-minded education to their students to counteract and challenge miseducation. Givens (2021) labels this work of Black teachers as *fugitive pedagogy*, as it became an active site for Black educators to fight against White dominant educational narratives. Fugitive pedagogies utilize education as a tool to craft liberation by freeing the minds of Black youth while embedded within a White supremacist educational space. Fugitive pedagogies emerged from Woodson's teaching as Black educators incorporated Woodson's philosophies and work with Black history into their classrooms. As the education of Black individuals "was a fugitive project from its inception" (Givens, 2021, p. 3) during the colonial era, those teachers who embraced the work of Woodson and taught against the normative Whiteness of the curriculum were continuing the legacy of full education of Black youth as a site of resistance, in turn providing opportunity for students to see themselves as political change-agents. Fugitive pedagogies demonstrate the everyday struggle and defiance of Black teachers within systems of White supremacy to teach full narratives to their Black students.

Throughout the first half of the twentieth century, Woodson's work became highly influential for Black educators, who took up his call for radical change in Black education and became scholars of the practice. Educators engaged in fugitive pedagogies shared a commitment to Woodson's work of challenging educational systems of White supremacy through their ability to teach with and through Black narratives. In line with Snyder's (2015) reading of Woodson as a progressive educational theorist, these affiliated educators were interested in a curriculum which could achieve social transformation through relevant teaching and through a focus on service to a greater good. Educators became involved with the ASNLH as affiliate members; they purchased, read, and contributed to the *Negro History Bulletin*; they enacted subversion in their classrooms to bring education to their students and championed Negro History Week's integration into the curriculum. Black teachers practiced Woodson's work and developed new generations of students as involved citizens.

MARGARET BURROUGHS AND FUGITIVE PEDAGOGY IN ACTION

Margaret Burroughs arrived in Chicago at age 6 from St. Rose, Louisiana, and remained rooted in the same South Side neighborhood until her passing at age 95. Like the over 200,000 Black migrants who moved to Chicago between 1910 and 1940, the young Margaret Taylor and her family relocated to Chicago's Black Belt, later reclaimed as Bronzeville (Baldwin, 2007. Within the confines of 31st and 67th to the North and South, and Cottage Grove to State to the East and West, thousands of new families arrived, moving into small kitchenette apartments for the hope of a better life outside of the Jim Crow South and the promise economic opportunity of Northern

cities. The confines brought on by restrictive covenants and racism developed a close community that Burroughs continued to support and highlight even as the neighborhood changed dramatically throughout the twentieth century.

Taylor's move as part of the first wave of the Great Migration provided the three daughters' education that they could not achieve in Louisiana, where the Black school Burroughs' mother Octavia led in a local church only extended to eighth grade and there were no high schools for Black students (Cain, 2018). In Chicago, Burroughs was able to attend private Catholic schools and an integrating Englewood High School, where she made strides both as an athlete and as an artist. Despite her access to education expanding dramatically, Burroughs (2003) would later write that her schools failed to teach her about Black individuals, and the moments they were brought up were memorable and she was interested and engaged. Almost all of Burroughs' teachers were White, and they often had little understanding of the experience of the migrant Black populations they now taught. Even with the expanded access to education that Northern cities provided and the founding of Negro History Week by Woodson and the ASNLH in 1926, Black narratives were not a part of the curriculum by the time Burroughs graduated Englewood High School in 1933. Burroughs would obtain her teaching credentiaCls from Chicago Normal School, as well as her BFA and MA in art education from the School of the Art Institute of Chicago in the mid-1940s, and became an art teacher at DuSable High School in 1946.

The internal classroom experiences of teachers are ephemeral, particularly when working from a space of subtle resistance where the lessons students may be taking away from the classroom are not simply the ones written in a lesson plan or within a formalized curriculum. Bey (2011) argues that for Black art educators, focusing on pedagogy and the how of teaching provides a deeper understanding of their pedagogical stance than the written curriculum. From accounts that Burroughs herself gave (Burroughs, 2003; Fleming & Burroughs, 1999) and those of her former students (Parker, 2005), it seems that Burroughs' classroom became a place for her to experiment with the teaching of Black histories. By covertly but actively challenging anti-Blackness within the curriculum, Burroughs used her position as an educator to encourage Black youth to see themselves as part of a historical narrative and a generative future.

Four major ideological pillars can be seen as aligning Burroughs' teaching at DuSable High School with Woodson and fugitive pedagogy: (1) that Black history is essential to the development of Black students' self-worth; (2) that challenging entrenched systems of White supremacy within education is a political act, but that not challenging systems is also a political act; (3) that defying those in power should be done through subversion rather than direct confrontation; and (4) that Black counter-public spheres can be used as sites of resistance. Each of these facets of her teaching highlights the ways that fugitive pedagogies aligned with Burroughs' beliefs in Black education, her politics, and her later desire to continue exploring and expanding access to Black narratives through the establishment of the DuSable Black History Museum and Education Center.

Initially founded as the New Wendell Phillips, DuSable High School opened in 1935 to alleviate overcrowding at the only other *de facto* segregated school in Chicago.

Prior to DuSable, Black children whose families migrated north to Chicago's South Side integrated other schools bordering the Black Belt, including Burroughs' own alma mater of Englewood High School. This expansion and integration of majority-White schools on the South Side over the previous decades exacerbated tensions between Chicago's poor White communities of Polish and Irish immigrants and newly arriving Black families. Burroughs herself recalled experiencing racist acts while attending Englewood, which forced her and the other Black students to walk to and from school together for protection (Burroughs, 2003). To curb further integration, Chicago Public Schools (CPS) founded DuSable on the southwest side of Bronzeville. While CPS did not have *de jure* segregation as existed in the South during Burroughs' childhood, Chicago used other means to separate White and Black students. CPS unequally enforced transfer requests for White students to attend White-majority schools, while keeping schools such as DuSable exclusive for Black residents (Daniel, 1980). This unequal enforcement led to majority-Black schools being overcrowded, while majority-White schools had a comfortable ratio of teachers to students. Three years after its opening, DuSable was already overcrowded, and an addition had to be built right after its initial opening to accommodate the expanding number of children in the Black Belt (Hardy, 2022).

While DuSable's students were exclusively Black, the school still operated within a culture of White supremacy as a part of the CPS system. Black teachers within CPS were often hired as long-term substitutes, which prevented them from accessing the benefits of the teacher's union (Ladson-Billings & Anderson, 2021). Without the stability of a full-time contract, many Black educators were simultaneously underpaid and unable to access the job security or the union benefits that White educators received. Burroughs spent five years of her career as a long-term substitute prior to securing her position and tenure at DuSable. Many of the administrators at the school were also White and did not live within Bronzeville, crafting a deep disconnect between administrators, educators, and students. While Woodson's work with the ANSLH and Negro History Week had begun two decades earlier, Black education in Chicago still suffered from underdevelopment and underfunding by the time Burroughs stepped into her classroom on DuSable's third floor in the 1940s.

Despite the limitations of funding and access brought on by CPS, Burroughs and other engaged educators in Bronzeville were able to tap into their community as a source of possibility for students. Burroughs had crafted herself a space within her community as an artist and organizer. In her teens and early twenties, Burroughs became involved with many of the individuals involved in the Chicago Renaissance—an artistic outgrowth that blossomed out of Bronzeville's tight quarters. Burroughs' friends and classmates, including Charles White and Gwendolyn Brooks, helped catapult Chicago's artistic achievements to the national stage. Burroughs also became the youngest founding member of the South Side Community Art Center (SSCAC) in 1940—a crowning achievement for many of Bronzeville's artists who finally had a dedicated space to display and create art. The SSCAC, created in collaboration with the Illinois Federal Art Project, remains the only art center founded by the Works Progress Administration (WPA) remaining in its original form (Hardy, 2018). Burroughs remained dedicated to the SSCAC throughout her life as a crowning achievement of community organization and Black and White collaboration.

Burroughs' life in Bronzeville and her involvement with the Chicago Renaissance also aligned her with the work of Woodson and the work of one of his champions, librarian Vivian G. Harsh. With the establishment of the Hall Branch Library in 1932 and the installation of Harsh as the first Black head librarian in the city, the Hall Branch became an important gathering space for Chicagoans interested in Black stories. The library's namesake, George Cleveland Hall, was one of the founding members of the ASNLH with Woodson (Burt, 2009). Harsh herself worked to gather Black archival materials and books for her audiences, often traveling throughout the United States to find books and materials she believed would serve her community. As Burroughs did not have access to Black history in her own educational journey (Burroughs, 2003), it is likely that the public library was one of the places she first was able to encounter the history of her people outside of the family stories shared in her home, and it would have been her first encounter with Negro History Week, which the library celebrated each February.

For Burroughs, working with Black youth meant the responsibility of being aware of and being dedicated to imparting the narratives of Black histories to students. Similar to Woodson's own philosophies of how the past impacts the future, Burroughs argued that "knowing one's relationship to the past was essential to understanding one's purpose in life" (Cain, 2018, p. 33) and she made sure her students had access that she was not afforded in her youth. She wanted her students to explore Black culture expansively and would often lend out books to them for further exploration. Burroughs believed teaching Black histories was an essential need for Black students for them to become active and engaged participants of the world. According to former students such as Ausbra Ford (2002), Jermikko Johnson (2002), and Daniel Texidor Parker (2005), Burroughs would teach about Africa, Black artists, and about Black culture while in the art room, and in particular the connections of African art to artists such as Picasso.

Burroughs, like many other women in Bronzeville, was also deeply involved and interested in politics and activism. Materson (2009) notes the ways that migrant Black women from the South were particularly vocal supporters of voting and politics. These women experienced the terror of living in the Jim Crow South where Black voters were harassed and unable to practice their citizenship. Women actively worked to become a part of the political system in the North and push for politics aligned with racial uplift. While Burroughs was younger than many of the initial Black women organizing for voting, her own interests in politics sprang from her involvement in civic actions. Her early involvement as a teenager in protests such as for the Scottsboro Boys radicalized her at a young age toward racial justice, and her involvement with many leftist and communist-adjacent organizations throughout the 1930s and 1940s, many of whom had meetings at the SSCAC, connected her with a legacy of Black revolutionaries. The concepts of art, politics, and education became aligned for Burroughs, as they were all involved in the struggle for racial liberation.

Woodson's work similarly aligned with Burroughs' own progressive politics. Woodson (1933) believed that teachers can and should "revolutionize the social order for the good of the community" (p. 145) and use their position as educators to help foster growth in Black students and to craft students toward an interest in

service to their community rather than toward individualism and goals of leadership. To both Woodson and Burroughs, Black teachers were political actors whose responsibilities were to leading their students to live lives of service to their communities. Education was seen as an expression of political action. As Collins (2009) notes, "it is no accident that many well-known U.S. Black women activists were either teachers or somehow involved in struggling for educational opportunities for African-Americans of both sexes" (p. 227). Black women educators saw the transformational power of education as a political act and saw their teaching as an extension of their activism.

Burroughs learned about the need to challenge through subversion rather than head-on as on at least one occasion, Burroughs' career was threatened due to her political activism and her openness to teaching her students Black history. In 1952, she was called in front of the Chicago Board of Education and questioned about her politics and her affiliation with communist organizations. Throughout the early 1950s, activists like Burroughs became targets as subversives through both official government channels and self-policing of communities by middle-class members. Burroughs did not separate herself as an activist from her work as an educator, and the crossover between her political interests and her career became an issue. After this encounter, Burroughs took a sabbatical from teaching and spent a year in Mexico City learning printmaking with her former roommate, Elizabeth Catlett, and the printmakers of the Taller de Grafica Popular, a leftist printmaking collective Catlett had become involved in. After returning from Mexico, Burroughs seemingly became more careful about making her politics known in the classroom context, while still challenging the White curriculum through acts of covert subversion.

Givens (2021) calls Black educators' classrooms "nodes of the black counterpublic sphere—restricted spaces, (mostly) beyond the surveillance of white authorities" (p. 178). With the door closed, Burroughs' classroom became a sanctuary space: a refuge for her Black students in the face of the constant barrage of anti-Blackness of the dominant school curriculum. Despite being situated in an all-Black neighborhood, DuSable was still impacted by the culture of Whiteness that permeated Chicago. Just outside the school's doors, the Bronzeville community shifted and changed. In 1948, the Supreme Court's ruling of *Shelley v. Kraemer* made restrictive housing covenants, which had restricted Black residents from purchasing property in particular neighborhoods, unenforceable. Black residents with the financial ability to do so moved into single-family homes in adjacent South Side neighborhoods, which had been abandoned by White homeowners in the post-war era moving en masse to the suburbs. Bronzeville, overcrowded from years of more migrants moving in without substantial development, suddenly dropped by 50,000 residents in only a decade. The destruction of what were deemed as "blighted" communities and construction of the Robert Taylor Homes and the Dan Ryan Expressway, both of which bordered DuSable's westside, continued to strip away the sense of community the South Side previously had in Burroughs' youth (Hardy, 2022). Instead of also leaving the neighborhood like so many others, Burroughs chose to use the counter-public space of her classroom to her advantage and crafted communities of safety and uplift for her students. She chose to craft a place within the school for her students where it was important to discuss

Black history and she could bolster their self-worth and help them envision the future they wanted.

The unique nature of the art classroom was also to Burroughs' advantage in crafting a counter-public space for her students. Rather than having a set curriculum that had to be taught, art students work independently and side-by-side. Burroughs was able to talk to her students as they worked on independent projects, exploring her own activist history and the history of important Black figures. She could use her classroom as a pulpit from which to tell stories which colored and shaped the experiences of her students. According to Burroughs' former student, Daniel Texidor Parker (2005), within her class, students "had more than an art class because she taught us about who we were. And she very much emphasized who we were" (1:07–1:20). With her experiences as part of the SSCAC and shaped by her time spent in Mexico City, Burroughs believed deeply that art could and should reflect social realities and likely imparted her desire for students to reflect their world through their art.

CONCLUSION

In 1961, Margaret and her husband Charles Burroughs founded the Ebony Museum in their home on South Michigan Avenue as a part-time installation to display art and artifacts that they picked up from their own travels around the world that showcased the African diaspora and Black histories. Interest in the museum expanded over the years and Burroughs operated as its educator, giving free tours to school groups (Burroughs, 2003). In 1969, Burroughs would retire from the classroom and take on her role at the museum full-time, and in 1973 the museum fully transitioned into its current home in Washington Park.

While she did not express the reasons for her departure in her writings or her interviews, it is likely that Burroughs experienced the limitations of fugitive pedagogy within her classroom and believed that she could spread her work further through her institution than while teaching in a public school. The covert nature of fugitive pedagogies means that only students who were in her classes were the ones who benefitted from her narratives, and they did not get to impact the broader Chicago community. Despite over two decades of work, by the time she left, DuSable's students were still struggling immensely as community demographics shifted (see Hardy, 2022; Parkay, 1983). Burroughs spent the rest of her life dedicated to championing Black histories, transitioning from a place of exploring in the shadows to openly discussing Black achievement to both Black and non-Black audiences throughout the city, nation, and world through the renamed DuSable Museum.

For Black educators engaged with the work of Woodson during the first half of the twentieth century, civic education and engaged citizenship were core components of their teaching philosophies and their mission in educating Black students. They saw the disempowerment of Black youth as an initial step in the system of state control, and by providing students with knowledge about Black history and agency, they challenged White normative assumptions about Black intelligence and possibility. For Burroughs, this was an extension of her leftist politics and her belief in the responsibilities of

being a Black educator. Burroughs took her work into the art classroom by integrating her work as a political actor, her teaching, and her beliefs about the power of Black art as a space for social commentary. She used the platform she had as an educator to encourage her students to think about themselves as part of the history of Black Americans and to consider themselves as political beings and change-agents. Despite the deep inequities of Black schooling and the continued cultural violence perpetuated through White-centric curriculum, Black teachers during the early twentieth century took it upon themselves to challenge norms and consider alternative ways of knowing and to inspire Black youth. Burroughs pushed against the miseducation she saw her students receiving by helping to encourage students to study what she loved and gain an understanding of their history and their place within the world. By doing so, Burroughs pushed much farther than simply teaching art; she taught her students to accept and love themselves and challenge the systems that continued to fail them.

Over 70 years after Burroughs began teaching Black and African histories in her classroom to push against the miseducation she saw her students receive, state legislation throughout the United States have been putting limits on the academic freedoms of teachers, particularly in regard to discussions of race (Sawchuk, 2021). Educators' now legal inability to call out race or to discuss racial topics in the K–12 classroom veer close to Woodson's observations of his own classrooms at the turn of the twentieth century. He remarked that "history does not furnish a case of the elevation of a people by ignoring the thought and aspiration of the people thus served" (Woodson, 1933, p. 24). As public K–12 classrooms are now a majority minority (National Center for Education Statistics, 2024), it is particularly of concern that classrooms filled with Black and brown students are told they cannot learn about racial inequity. Without providing space to discuss the structural racism that people of color and particularly Black Americans continue to face and the power of those who challenged it, educators once again perpetuate miseducation at the hands of the state. By studying the legacy of educators such as Burroughs, it is clear that Black education has, and continues to be, a labor of love in order to craft a future generation of engaged citizens. Contemporary art educators can consider the possibilities within their classrooms to engage students as individuals toward a more just society, and how they too can use their classrooms as counter-public sites of resistance through the teaching of and through the narratives of people of color and centering Black and brown student voices and perspectives.

Burroughs was not an outlier in her teaching of Black histories and her subversive teaching style; rather, she is an example of many other Black educators who took on the work to educate their students in important civic matters they identified as lacking within the general school curriculum,[4] even if the narratives of their subversion have not been recorded or expanded upon. While Burroughs is remembered today as a radical and trailblazer on Chicago's South Side, there were many other Black women educators taking on similar work whose narratives have yet to be shared or have been lost to time. Black art teachers' narratives often remain obscured. It is important, then, to recognize Burroughs' story as an example of how Black women teachers have been willing to risk their professional lives for the betterment of their students and continue the work of Black liberation for over a century.

NOTES:

1 This chapter refers to Dr. Margaret Victoria Taylor Goss Burroughs (1915–2010) as "Burroughs" throughout for consistency, despite her use of many different last names throughout her lifetime, as it is the name she is most remembered for today.
2 Initially opened as the Ebony Museum in 1961, Burroughs renamed the institution to the DuSable Museum of African American History in 1968. As of June 2022, the institution has renamed itself as the DuSable Black History Museum and Education Center.
3 A lineage of Black subversive teachers includes the *expanded pedagogy* (Bey, 2011) of Aaron Douglas and Hale Woodruff; Louisiana schoolteacher Tessie McGee, who Givens (2021) uses to highlight the work of fugitive pedagogy; and the teachers interviewed by Casey (1993), who "practice[d] a complex (re)interpretive pedagogy" (p. 153) within White-dominated education to focus on the needs of Black children. Woodson's deep influence on Black teachers (Givens, 2021; King et al, 2010) and the political nature of Black education (Collins, 2009) suggest also that many more Black teachers practiced subversive teaching than records for their teaching exist.
4 Givens (2021) notes that by the end of 1938, the ASNLH's publication, the *Negro History Bulletin*, which was specifically aimed at Black teachers, had surpassed 3500 subscribers. Despite limited records of educators practicing fugitive pedagogy exist, it is known that Woodson's influence on Black educators was strong, and many educators adopted practices that they found through Woodson's texts, the ASNLH, and the *Negro History Bulletin*.

REFERENCES

Baldwin, D. L. (2007). *Chicago's new Negroes: Modernity, the Great Migration, and Black urban life*. University of North Carolina Press.
Bey, S. (2011). Aaron Douglas and Hale Woodruff: African American art education, gallery work, and expanded pedagogy. *Studies in Art Education*, 52(2), 112–126.
Burroughs, M. T. (2003). *Life with Margaret*. Time Press.
Burt, L. (2009). Vivian Harsh, adult education, and the library's role as community center. *Libraries & the Cultural Record*, 44(2), 234–255.
Cain, M. A. (2018). *South side Venus: The legacy of Margaret Burroughs*. Northwestern University Press.
Casey, K. (1993). *I answer with my life: Life histories of women teachers working for social change*. Routledge.
Collins, P. H. (2009). *Black feminist thought*. Routledge.
Daniel, P. T. K. (1980). A history of discrimination against Black students in Chicago secondary schools. *History of Education Quarterly*, 20(2), 147–160.
Dilworth, P. P. (2004). Competing conceptions of citizenship education: Thomas Jesse Jones and Carter G. Woodson. *International Journal of Social Education*, 18(2), 1–10.
Dilworth, P. P. (2006). Widening the circle: African American perspectives on moral and civic learning. In D. Warren & J. Patrick (Eds.) *Civic and moral learning in America* (pp. 103–117). Palgrave Macmillan.
Fleming, J. E., & Burroughs, M. T. (1999). Dr. Margaret T. Burroughs: Artist, teacher, administrator, writer, political activist, and museum founder. *The Public Historian*, 21(1), 31–55.
Ford, A. (2002). *Ausbra Ford talks about his high school teacher, HistoryMaker Margaret Burroughs* [Oral history interview]. (Session 1, tape 3, story 6). The HistoryMakers Digital Archive. https://da.thehistorymakers.org/story/67171
Givens, J. R. (2021). *Fugitive pedagogy: Carter G. Woodson and the art of black teaching*. Harvard University Press.

Hardy, D. A. (2022). *"More beautiful and better": Dr. Margaret Burroughs and the pedagogy of Bronzeville* [unpublished doctoral dissertation]. The Ohio State University. Retrieved from http://rave.ohiolink.edu/etdc/view?acc_num=osu164116262131306

Johnson, J. S. (2002). *Jermikko Johnson remembers receiving career guidance at DuSable High School* [Oral history interview]. (Session 1, tape 2, story 10). The HistoryMakers Digital Archive. https://da.thehistorymakers.org/story/63296

King, L. J., Crowley, R. M., & Brown, A. L. (2010). The forgotten legacy of Carter G. Woodson: Contributions to multicultural social studies and African American history. *The Social Studies, 101*, 211–215.

Ladson-Billings, G., & Anderson, J. D. (2021). Policy dialogue: Black teachers of the past, present, and future. *History of Education Quarterly, 61*(1), 94–102.

Materson, L. G. (2009). *For the freedom of her race: Black women and electoral politics in Illinois, 1877-1932*. University of North Carolina Press.

Mills, C. W. (1997). *The racial contract*. Cornell University Press.

Mills, S. (2021). An African school for African Americans: Black demands for education in antebellum Boston. *History of Education Quarterly, 61*(4), 478–502.

National Center for Education Statistics. (2024). *Racial/ethnic enrollment in public schools*. National Center for Education Statistics. https://nces.ed.gov/programs/coe/indicator/cge/racial-ethnic-enrollment

Parkay, F. W. (1983). *White teacher, black school: The professional growth of a ghetto teacher*. Praeger.

Parker, D. T. (2005). *Daniel Texidor Parker remembers his high school art teacher, Margaret Burroughs* [Oral history interview]. (Session 1, tape 2, story 9). The HistoryMakers Digital Archive. https://da.thehistorymakers.org/story/638427

Sawchuk, S. (May 18, 2021). What is critical race theory, and why is it under attack? *Education Week*. https://www.edweek.org/leadership/what-is-critical-race-theory-and-why-is-it-under-attack/2021/05

Spires, D. R. (2019). *The practice of citizenship: Black politics and print culture in the early United States*. University of Pennsylvania Press.

Snyder, J. A. (2015). Progressive education in black and white: Rereading Carter G. Woodson's "Miseducation of the negro". *History of Education Quarterly, 55*(3), 273–293.

Watkins, W. H. (2001). *The White architects of Black education: Ideology and power in America, 1865–1954*. Teachers College Press.

Woodson, C. G. (1933). *The mis-education of the Negro*. Benediction Classics.

CHAPTER 17

Combating Racial Pandemic and Advocating for the Invisible through Art

Kevin Hsieh

INSTRUCTIONAL QUESTIONS

1. How and in what ways do contemporary artists use their works to fight for social justice?
2. What causes a racial pandemic and what can artists do?
3. How do young artists create art advocating for social and racial justice?

In response to the rising hate crimes toward the Asian and Pacific Island (AAPI) population in the United States (US) due to COVID-19 pandemic (Liu, 2021; Stop AAPI Hate, 2022), I conducted an art project with 36 pre-service art teachers and 64 Taiwanese youth during August 2020 and August 2022. One of the required graduate courses that I teach at my current institution since 2011, *Teaching Asian Art in K-12 Classrooms*, is for all pre-service art teachers in the Master of Arts in Teaching (M.A.T.) and the Master of Art Education (M.A.Ed.) programs. As the course instructor, I developed and incorporated Asian arts and history to the course content, as well as pedagogies that can be adopted by K–12 art teachers who want to incorporate Asian art into their teaching. Over the summer of 2020, seeing the increasing anti-Asian incidents reported on the news due to the COVID-19 pandemic and its origination from China, I implemented the Voice for the Voiceless[1] (V4Vless) project in this course for Fall 2020 and Fall 2021. In addition to working with pre-service art teachers for this project, I also implemented this project in a summer Taiwanese youth arts and culture training program, Formosa Association of Student Cultural Ambassadors (FASCA) between July and August 2022. These 64 students in grades 8–12 are from four different cities (24 from Seattle, 6 from San Francisco, 15 from Atlanta, and 19 from Houston). These youth are Taiwanese Americans, Taiwanese

DOI: 10.4324/9781003402015-22

immigrants, first-generation Taiwanese Americans, or have at least either one parent with Taiwanese ethnic background.

The V4Vless project is a two-hour lecture with discussion and an overnight take-home studio project. Guiding Taiwanese American youths to explore their identities and addressing the issue of anti-Asian racism through visual art are a critical task for building their sense of belonging, resistance, coalition (Shin et al., 2022), and advocacy for racial equality as well as social justice (Cooper et al., 2022). In addition, facilitating pre-service art teachers to explore different topics related to social issues is essential for their professional development and changes of attitudes in terms of empathy and further becoming an advocate (Buller, 2021; Learning for Justice, 2018) for Equity, Diversity, & Inclusion (ED&I) and anti-racism (Hsieh et al., 2023; Pollock, 2008; Stoll, 2014) initiatives. In the V4Vless project, I introduced three contemporary Asian artists' creative expressions because these working artists' creative outlets respond to the anti-Asian sentiment and anti-Asian racism (Acuff & Kraehe, 2020). These artists are Zhe Lin,[2] Ai Weiwei,[3] and Amanda Phingbodhipakkiya. As Hsieh and Yang (2021) pointed out, these artists were chosen because "art has the power to disrupt silence surrounding gender, race, class, and sexuality privileges" (p. 370). In order to challenge the status quo to critically examine the relationship between race, racism, and power (Hutzel et al., 2012), I adopted Buffington and Waldner's (2012) Critical Response Cycle (CRC) and Acuff and Kraehe's (2020) counter-visual strategies for deconstructing racial hierarchy as pedagogical approaches for Taiwanese American youth and pre-service teachers to address and respond to racial injustice, as well as become agents for change by advocating for social justice (Learning for Justice, 2018). As Buffington and Waldner (2012) affirmed, educators can "situate" students as artists, researchers, and assets in a community to create art pieces "as a response, a form of research, and a possible vehicle for change" (p. 146).

PEDAGOGICAL POSITIONALITY AND FOUNDATION

As an Asian American art educator who engages in critical multicultural art education[4] and teaches in an urban university, I often incorporate visual culture such as public art, murals, street art, posters, billboard designs, animations, or films into my classes for discussions on race, gender, and other social issues. To support participants in interrogating and conjugating arts created by contemporary Asian artists dealing with racial issues, I applied both Buffington and Waldner's (2012) CRC and Acuff and Kraehe's (2020) counter-visual strategies for deconstructing racial hierarchy. In Buffington and Waldner's (2012) CRC, they offered four phases to scaffold learners in understanding complex and possibly contradictory meaning of artworks: (a) identifying the art, (b) researching and interpreting, (c) responding with art, and (d) critiquing the response and planning future action (pp. 139–140). In addition, Acuff and Kraehe (2020) argued that, to cultivate students' competence and confidence in talking about race and racism, educators should guide learners "to uncover older meanings and construct newer ones through counter-visual engagement with popular culture [visual arts]" (p. 21). With these pedagogical foundations and my own

positionality, I explain below how I implemented both pedagogical approaches with discussions of the V4Vless project and student work examples. Five learning objectives for the V4Vless project are as follows: (a) understand the historical context of Asian immigrants, (b) identify and understand the current racial issues and challenges, (c) recognize the responsibility to stand up to injustice and racism, (d) develop and propose solutions, and (e) advocate for social justice.

THREE CONTEMPORARY ASIAN ARTISTS' WORKS

Because works created by Ai Weiwei, Zhe Lin, and Amanda Phingbodhipakkiya are easily accessible to the public both online or in person, and most importantly addressing social issues related to Asian populations, I first introduced Zhe Lin's multimedia work, "*Chinaman's Chance*" on Promontory Summit Golden Spike Celebration to the participants. This work brought participants' attentions to the missing recognition of Chinese immigrants' contributions to the transcontinental railroad construction in the US history (Cooper et al., 2022; Lin, 2018) and provided "a way for marginalized voices to be heard" (Buller, 2021, p. 37). With Buffington and Waldner's (2012) CRC, I guided participants' examination of historical photography, *East and West Shaking Hands at Laying Last Rail*,[5] by Andrew J. Russell (1829–1902), a 19th-century photographer of the American Civil War and the Union Pacific Railroad. This photography recorded the champagne ceremony celebrating the completion of the first transcontinental railroad at Promontory Summit in Utah on May 10, 1869 (Russell, 1869). With identifying art, the first phase of CRC, I gave participants time to share what they observed in the photography and had them conduct quick online research about this photograph. Soon after, participants recognized that railroad construction workers were not shown in the photograph. I then showed the video of Zhe Lin's multimedia installation, *Chinaman's Chance*, which offered different perspectives of people (more likely the railroad workers) viewing the champagne ceremony from the other side of the trains. To participants, Zhe Lin's work not only amplifies the importance of counter perspectives but also intentionally offers narratives purposefully missed from the railroad workers.

After introducing Zhe Lin's artwork, I then presented images of works by Ai Weiwei and Amanda Phingbodhipakkiya. Both Ai Weiwei's masks and Amanda Phingbodhipakkiya's murals respond directly to the social issues caused by the COVID-19 pandemic, more specifically the anti-Asian racism. Two months after the World Health Organization (WHO) declared COVID-19 a pandemic on March 11, 2020 (CDC Museum COVID-19 Timeline, n.d.), artist and activist, Ai Weiwei, collaborated with eBay for Charity, Human Rights Watch (HRW), Médecins Sans Frontières (MSF), and Refugees International for launching an art project, to raise funds for the COVID-19 humanitarian and human rights efforts on May 28, 2020 (Schwartz, 2020). Ai Weiwei uses one of his own iconic images (a fist with a straight-up middle finger) symbolizing his life-long campaign for individual rights and free speech on blue face masks. While there was a shortage of face masks worldwide in the beginning of the pandemic, Ai Weiwei created hand-printed face masks to address that "the

COVID-19 pandemic is a humanitarian crisis. It [pandemic] challenges our understanding of the 21st century and warns of dangers ahead. It [campaign for individual rights and free speech] requires each individual to act, both alone and collectively" (Schwartz, 2020, para. 5). With CRC, participants interpreted and responded to Ai Weiwei's *MASK* and most importantly generated dynamic dialogues about how political, social, cultural, and racial factors played roles in racializing global pandemic.

The third contemporary artist I introduced to participants is Amanda Phingbodhipakkiya. Her works created and responded to COVID-19 pandemic and anti-Asian hate shared strong purposes with stop AAPI Hate campaign. Amanda Phingbodhipakkiya is an Atlanta native and a public artist in residence with the New York City Commission on Human Rights. She describes herself as a "Brooklyn-based multidisciplinary artist and an AAPI and women in STEM activist" and her "work is about making the invisible visible" (World Wild Campus News & Entertainment, 2021). Her work, *I Still Believe in Our City*,[6] is the New York City's first public art campaign standing up for the AAPI community in responding to the anti-Asian racism due to COVID-19 pandemic. Many of the works in her series of the *I Still Believe in Our City* are on view at Atlantic Terminal and in other neighborhoods around New York City where anti-Asian bias incidents have occurred. As an activist for the AAPI community, her six poster designs featuring six different Asian female portraits (I Still Believe, n.d.) are free to download digitally for protests and rallies uses.[7] *Let Me Share the Sky with You* (see Figure 17.1), another mural by Amanda Phingbodhipakkiya, was installed in a display window at the 10 10th Street in Midtown Atlanta in January 2021. This work delivers a colorful, positive, and powerful statement while COVID-19 was still spreading, and people were isolated from their loved ones at that time. The mural label stated,

> In a time when being close to the ones we love is difficult or unsafe, this mural imbues viewers with warmth and comfort. The sky, ever present in the background, is a great canvas to imagine dreams, allay fears, and find courage.

After I showed participants Ai Weiwei's MASK and Amanda Phingbodhipakkiya's poster and mural works, I guided their conceptualizations of the artists' various responses to social issues through discussing the functions and purposes of art, the context of why these works were created, and analyzing the compositions with artist statements. Participants then had an overnight V4Vless project developing their own art as a response. This aligns with the CRC's phase three, Responding with Art (Buffington & Waldner, 2012).

RESPONDING TO RACIAL PANDEMIC AND ANTI-ASIAN RACISM THROUGH ARTS

In this project, all 100 participants (36 pre-service art teachers and 64 Taiwanese American youths) expressed frustration when they encountered social injustice, such as police brutality, anti-Asian hate crimes, and women's rights in recent years, and at

FIGURE 17.1 *Let Me Share the Sky with You*, 2021, public mural (partial) by Amanda Phingbodhipakkiya, photo taken by the author at 10th Street, Midtown Atlanta on August 31, 2022.

Note: This work is commissioned by the Midtown Alliance, Heart of the Arts program, Midtown Atlanta.

the same time felt helpless but motivated to voice for the voiceless through creating a studio project. I made the V4Vless project very open and allowed all participants to use any medium for their projects. All 36 pre-service art teachers and 12 Taiwanese American youths used traditional medium such as drawing and painting, collage, or sculpture, while 52 youths created 2–5 minutes short videos for their V4Vless project. From analyzing the content of all 100 participants' works in terms of personal experiences, stories, inspirations, motivations, and responsibilities, I generated the three points discussed below with examples of participants' works.

EXPRESSING INNER STRUGGLE AND SEEKING A SENSE OF BELONGING

All 36 pre-service art teachers examined the anti-Asian racism with a teacher perspective and agreed that it is important to include more Asian or Asian American artists' works in their art curriculum, especially contemporary Asian artists. Sharing the struggles of Asian or Asian American artists encouraged empathy by these young

FIGURE 17.2 Between the Red by Arianne Peiann Chen, painting with collage on canvas board, 8" by 11", with poetry.

learners who share a similar background and further strengthened their sense of belonging. Sense of belonging is a key cognitive and affective dimension of finding one's place or space culturally or psychologically (Prince & Hadwin, 2013).

Especially, Taiwanese youths from the FASCA arts and culture program shared their inner struggle about their racial identities and senses of belonging. One high school teen wants to share her work (see Figure 17.2) with a short statement expressing her inner struggle about her sense of belonging and navigating her identities between being Taiwanese and American.

> Taiwanese-American,
> But will never experience the life of growing up Taiwanese.
> American-Taiwanese,
> But will never understand
> The American ways,
> Of the American life,
> Lived by Americans
> Not Taiwanese enough
> But never just an American.
> *(Published with permission of the artist)*

Through using symbols (the Taiwanese and the American flags), materials from cultural practices (red envelope), and images (eyes), Arianne expressed her inner struggle and the challenges that she faces in seeking her sense of belonging. She wrote,

> I used the paper of red packets to make up the woman to represent the culture of the life that shapes the experiences and values of each person, the red packets [red envelop] being an integral part of Taiwanese culture. Taiwanese and American flags in the background symbolize the struggle in identifying nationality, as opposed, yet working forces together. Surrounding eyes show the judgment from others whether due to being a different race or resentment sowed from the COVID-19 pandemic.
> *(personal communication, August 7, 2022)*

Another teen used her own time-lapse drawing of her young self to address the confused and challenging childhood journey of her racial identity. She wrote,

> I designed and edited a video describing my experience with underlying racism at a young age. Although I'm sure the kids didn't mean it when they were younger, it still hurt me as a child. I can still remember feeling so lost, alone, stupid/silly, and overall confused. I can't even begin to imagine any more kids feeling like they don't belong because of their skin color.
> *(SH, personal communication, July 24, 2022)*

Not only youth face this challenge of finding racial identity, but also adults. As seven Asian art educators who migrated to the US and are currently teaching at different universities shared their experiences of struggling in searching their own identities, sense of belonging, and an alternative Asian Critical Pedagogy (Shin et al., 2022), their stories and counter storytelling (Kwon, 2022) offer students an alternative road map for navigating through the journey of constructing identity and finding a sense of belonging. I also found that participants were open to my class content and engaged in difficult discussions on topics such as racial-injustice and bi-racial identity through a reflective and critical lens. Some participants also found inspirations from the past, such as art history, and further connected and related current social issues (Acuff & Kraehe, 2020) to how ancient artifacts present social hierarchy and inequity at that time of their creation (Hsieh et al., 2023).

GIVING NEW MEANING TO THE ART FROM THE PAST AS AN ACTIVISM

To create *This Is Not Consent*, focusing on Asian women and women's rights, pre-service art teacher, Courtney Escorza related Chinese Tang dynasty (618–907 AD) women's rights to the women's rights in the US (see Figure 17.3). She explained,

> After learning about the Tang Dynasty, I felt inspired and saw a parallel between our times and theirs. It was interesting to think that feminism existed even thousands of

COMBATING RACIAL PANDEMIC 271

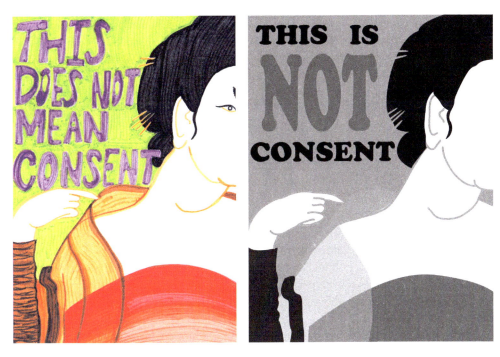

FIGURE 17.3 Sketch (Left, 17.3a) for the illustration *This Is Not Consent* (Right, 17.3b) by Courtney Escorza, poster design, 8″ × 11″, 2021.

> years ago despite it being a seemingly modern concept and to hear about what it might have looked like. I thought combining historical imagery with modern issues helped make a statement that we are still dealing with similar issues and that it is nothing new.
>
> *(personal communication, September 1, 2021)*

Escorza adopted a Tang women's image shown in historical murals and paintings, applied new meaning to it, and created an illustration for promoting women's rights. Her work is one of the many examples that art education scholars call activism art (Buller, 2021; Lentz & Buffington, 2020). Lentz and Buffington (2020) explained, "[the] important part of activism is people using their inherent power, voice, and creativity in ways that promote equity" (p. 52). Escorza's illustration activates not only her own art but also viewers' responses for addressing pressing social issues.

USING TECHNOLOGIES AND SOCIAL MEDIA FOR SPEAKING UP

Since there were not limitations on what format and medium the works of art should be, participants had total freedom to decide the medium for their V4Vless projects. Some used traditional medium such as drawing and painting, collage, or graphic design, and some created short animation or video clips.

While no pre-service art teachers (n=36) used social media or movie-making applications to create their works, 52 Taiwanese American teens (81.5%, n=64) used various digital applications such as iMovie, Movie Maker, or Powtoon to create short videos for their V4Vless projects. After analyzing these videos, I found three categories emerged.

PRESENTING EVIDENCE OF ANTI-ASIAN HATE CRIME

All videos included images or clips of anti-Asian incidents in historical or contemporary US history. This included examples such as the Chinese Exclusion Act in 1882, Japanese internment camps between 1942 and 1946, and anti-Asian hate crimes that occurred during the COVID-19 pandemic. Teens researched and found images or reports as evidence pointing out the urgent issue of racism and xenophobia in the US. While some images and clips were terrifying to watch, teens used them to identify current racial issues and the challenges they experience. One teen used the Japanese internment camps as his topic to advocate for the important inclusion of Asian American stories,

> [Japanese internment camp] story is crucial and important to the Asian American community and to the history of the United States. [Even though] this policy infringed on many of the most fundamental constitutional rights of Japanese Americans, the government justified it by citing national security concerns. Henry Glassie said that "history is not the past but a map of the past, draw from a particular point of view, to be useful to the modern traveler." … I used my video to express how I feel about recent and past situations. It not only shares the opinions of myself but also the opinions of other Asian Americans living in those situations.
> *(BF, personal communication, July 24, 2022)*

Another teen researched the Wyoming Rock Springs Massacre in 1885 and expressed that the anti-Asian hate crimes amplified by the COVID-19 outbreak "led to many anti-Asian racism [and] crimes, and it is important for everyone to know that this behavior hasn't changed since over a century ago" (IL, personal communication, July 24, 2022). In MT's video, she expressed,

> In this video, I included words Asian Americans said about living in America during pandemic. [They] shared their own experiences of being yelled at, shouted at, or harassed. People were scared and afraid to go outside. They don't think they were secured. I think no one deserved to be treated like this, especially being attacked just because you are an Asian. I think it is important to let the society knows what's actually happening to us.
> *(personal communication, July 24, 2022)*

Taiwanese teens actively engaged in finding evidence of anti-Asian incidents from the past and the current time which also motivated them to make connections between the facts and causes.

INVESTIGATING THE CAUSES

The content of the videos created by the Taiwanese teens also demonstrated their abilities and processes of investigating the causes of anti-Asian racism within historical and contemporary contexts. In AW's video focusing on woman of color and racism back in 1875, she shared what she found from her investigations on the causes,

> The Page Act of 1875 was meant to limit labor immigrants from China, Japan, or any Oriental countr[ies], yet the only ones who were regulated were East Asian women immigrants. The Page Act played a large role in the decline of East Asian immigrants in the United States during the Gold Rush. The Act also provided a platform for the passage of the Chinese Exclusion Act of 1882. ... The Page Act was a result of racism in the government, and sexism played a role in its burial in history. The lives of thousands of East Asian women immigrants were thrown horrendously off course by this Act and yet, few people have heard of this event. By presenting this event, I hope that everyone can understand that despite how much humans have progressed, we are still lacking in human rights, and it significantly impacts specific groups in society.
>
> *(AW, personal communication, July 24, 2022)*

Like Buffington and Waldner's (2012) project with the CRC framework, their students examined and re-evaluated the meanings of public Confederate monuments in Virginia. They guided their students to understand not only why these monuments were erected at that time but also how they are understood today. Likewise, Taiwanese teens' video projects also demonstrated the multi-layered of reasons why the anti-Asian racism exists in the past and how it still exists in the 21st century.

PROPOSING SOLUTIONS

In addition to presenting evidence and investigating causes, 36 of the 52 Taiwanese teens proposed their solutions as an advocate tool for combating anti-Asian racism in their videos. Three categories of proposed solution were identified, speaking out directly, using social media platforms, and forming coalition. Avoiding discussions about race and remaining silent when encountering racial injustice contributes to racism (Buller, 2021; Cooper et al., 2022). Acuff and Kraehe (2020) asserted that "race avoidance does not dismantle racial injustice but very likely contributes to more insidious forms of structural and microaggressive racism" (p. 21). One female teen communicated that "if ever faced with a microaggression comment don't let it slide, and let the person know the damage that is being done whenever one of those comments are being said" (ET, personal communication, August 7, 2022). A male teen expressed his solution and encouraged people to speak up and intervene when encountering racism in his video,

> One thing we can all do is speak up when we see anti-Asian hate crimes happening. Stop AAPI Hate, a nonprofit organization formed to track incidents of hate and discrimination reported that many respondents felt isolated and alone when they were targeted for their ethnicity or race, with no intervening to support the respondent or stop the perpetrator. This is known as the bystander effect, and many AAPI advocates strongly recommend people to take part in bystander intervention training. It's also important to understand and acknowledge the history of AAPI hate in order to work together towards a better future.
>
> *(AH, personal communication, August 7, 2022)*

Among these 36 proposed solutions, 86% (n=31) of them related to the uses of online social media platforms for sending their voices out, including Instagram, Twitter, and YouTube.

> As Asian Americans, we must stand up for ourselves. Instead of cowering away, we must use our words to fight back. Through social media and demonstrations, we can spread awareness to the unjust hate and rise up against the discrimination we face.
>
> *(LS, personal communication, August 7, 2022)*

In addition to the uses of social media platforms for letting voices be heard, 36% of the Taiwanese teens (23, n=64) addressed the importance of forming coalitions or participation in protest. One male teen wrote, "another effective way to not just help prevent microaggression but Asian hate as a whole is going to a nearby protest for the fight against Asian American hate (ET, personal communication, August 7, 2022)."

In addition to coalition-building, a female teen encouraged Asian women to advocate for political positions promoting social and policy changes,

> The recent deaths of the six Asian-American women in Atlanta spas are deeply felt by AAPI women across the country, leaving many afraid to even step outside their homes. By highlighting the struggles Asian women face, we can understand the impacts of these anti-Asian hate crimes on women and come together as a community to spread awareness and prevent more anti-Asian hate crimes against women from happening. In the long run, we can support Asian women who run for political positions and encourage more Asian women representation in our society.
>
> *(JC, personal communication, August 7, 2022)*

From the V4Vless project, Taiwanese American teens identified racism, researched facts, investigated causes, and planned actions for social changes. They agreed that they must speak up against harassment, exclusion, and racist behaviors, which is also indicated by the Learning for Justice's (2018) Social Justice Standards that learners "will recognize their own responsibility to stand up to exclusion, prejudice and

injustice" and "will plan and carry out collective action against bias and injustice in the world" (p. 3).

CONCLUSION: MOVING FORWARD AND BEYOND: WEAVING CULTURAL FABRIC AND CREATING NEW CULTURE

Our current society has grown more diverse and complex through the integration of various cultures. Different individuals bring their cultures into the society and weave them into a new cultural fabric. While the new cultural fabric is complex, the cloth is flexible yet expandable so that it welcomes newer threads.

During this project, I observed participants' emotions attached to the topics that they felt deeply related to. Through identifying, researching, creating, planning, and advocating, participants empathized with social injustices caused by anti-Asian hate due to the global pandemic and stereotypes toward Asians. Thirty-six pre-service art teachers expressed wanting to include a place for social justice in their future classrooms where resisting and transforming stories are explored for perseverance, empathy, inclusion, and courage for civic changes. Feeling empowered by the V4Vless project, 64 Taiwanese American youths not only associated racial injustice and racism with their own experiences, but they also engaged in the process of planning for taking actions, as well as advancing social changes.

NOTES:

1 The title of the project, Voice for the Voiceless, is credited to Dr. Yichine Cooper. She generated the title for one of our collaborative projects which is also accepted for publication by the Art Education Journal.
2 *Chinaman's Chance on Promontory Summit Golden Spike Celebration* [YouTube]: https://www.youtube.com/watch?v=00U4KTfd0Uw
3 Schwartz, E. (2020, May 28). *Ai Weiwei MASK:* https://www.refugeesinternational.org/reports/2020/5/28/ai-weiwei-mask
4 Critical multicultural art education that "call for a critique power and demands recognition that racism and other discriminations are enmeshed in the fabric of our social order" and it helps "teachers dismantle Western, normalized narratives and produce counter-hegemonic curriculum that contextualizes culture and reveals its fluidity" (Acuff, 2016).
5 https://www.nps.gov/media/photo/gallery-item.htm?pg=1914225&id=1440dfce-ee0f-4ef2-bd5d-bfbd43d8268f&gid=ED1DEB2C-FFE2-4E56-9EE6-A9696A313D3C
6 *I Still Believe in Our City* selected works can be seen at the artist's website: https://www.istillbelieve.nyc/gallery
7 Six posters are free to download for protests and rallies. https://www.istillbelieve.nyc/downloads

REFERENCES

Acuff, J. (2016). Being a critical multicultural pedagogue in the art education classroom. *Critical Studies in Education*, 59(1), 35–53.

Acuff, J. & Kraehe, A. (2020). Visuality of race in popular culture: Teaching racial histories and iconography in media. *Dialogue: The Interdisciplinary Journal of Popular Culture and Pedagogy*, 7(3), 1–24.

Buffington, M. & Waldner, E. (2012). Beyond interpretation: Responding critically to public art. In K. Hutzel, F. Bastos & K. Cosier (Eds.), *Transforming city schools through art: Approaches to meaningful K-12 learning* (pp. 138–147). Teachers College Press and the National Art Education Association.

Buller, R. (2021). Activism, art, and design: Bringing social justice to life in the higher education curriculum. *Art Education*, 74(1), 31–39. https://doi.org/10.1080/00043125.2020.1825593

CDC Museum COVID-19 Timeline. (n.d.). *CDC Museum COVID-19 Timeline*. CDC. Retrieved September 5, 2022, from https://www.cdc.gov/museum/timeline/covid19.html#:~:text=March%2011%2C%202020,declares%20COVID%2D19%20a%20pandemic

Cooper, Y., Hsieh, K. & Lu, L. (2022). Voice for the voiceless: Responding to racial pandemic through art. *Art Education*, 75(3), 18–23. https://doi.org/10.1080/00043125.2022.2027726

Hsieh, K., Cooper, Y. & Lai, A. (2023). No more yellow perils: Antiracism teaching and learning. *Studies in Art Education*, 64(2), 150–168. https://doi.org/10.1080/00393541.2023.2180248

Hsieh, K. & Yang, M. (2021). Deconstructing dichotomies: Lesson on queering the (mis)representations of LGBTQ+ in pre-service art teacher education. *Studies in Art Education*, 62(4), 370–392. https://doi.org/10.1080/00393541.2021.1975490

Hutzel, K., Bastos, F. & Coiser, K. (Eds.). (2012). *Transforming city schools through art: Approaches to meaningful K-12 learning*. Teachers College Press and the National Art Education Association.

I Still Believe. (n.d.). *For protests and rallies*. I Still Believe. https://www.istillbelieve.nyc/downloads

Kwon, H. (2022). Pedagogies of care and Justice: African American high school art teachers during the civil rights era in the segregated South. *Studies in Art Education*, 63(2), 256–274. https://doi.org/10.1080/00393541.2022.2080998

Learning for Justice. (2018). *Social justice standards: The learning for justice anti-bias framework*. Learning for Justice. https://www.learningforjustice.org/frameworks/social-justice-standards

Lentz, A. & Buffington, M. (2020). Art + politics = activism: The work of Ai Weiwei. *Art Education*, 73(1), 52–58.

Lin, Z. (2018). *Chinaman's chance on promontory summit: Golden spike celebration* [video]. YouTube. https://www.youtube.com/watch?v=00U4KTfd0Uw

Liu, W. (2021). Pandemic paranoia: Toward a reparative practice of the global psyche. *Psychoanalysiss. Culture & Society*, 26(4), 608–622.

Pollock, M. (2008). *Everyday antiracism: Getting real about race in school*. The New Press.

Prince, E. & Hadwin, J. (2013). The role of a sense of school belonging in understanding the effectiveness of inclusion of children with special educational needs. *International Journal of Inclusive Education*, 17(3), 238–262.

Russell, A. J. (1869). *East and West shaking hands at laying last rail* [photograph]. National Park Service. https://www.nps.gov/media/photo/gallery-item.htm?pg=1914225&id=1440dfce-ee0f-4ef2-bd5d-bfbd43d8268f&gid=ED1DEB2C-FFE2-4E56-9EE6-A9696A313D3C

Schwartz, E. (2020, May 28). *Ai Weiwei MASK*. Refugees International. Retrieved September 5, 2022, from https://www.refugeesinternational.org/ai-weiwei-mask/

Shin, R., Bae, J., Gu, M., Hsieh, K., Lee, O. & Lim, E. (2022). Asian Critical theory and counter-narratives of Asian American art educators in the U.S. higher education. *Studies in Art Education*, 63(4), 313–329.

Stoll, L. C. (2014). Constructing the color-blind classroom: Teachers' perspectives on race and schooling. *Race Ethnicity and Education*, *17*(5), 688–705. https://doi.org/10.1080/13613324.2014.885425

Stop AAPI Hate. (2022, July). *Two years and thousands of voices: What community-generated data tells us about anti-AAPI hate*. Stop AAPI Hate. https://stopaapihate.org/wp-content/uploads/2022/07/Stop-AAPI-Hate-Year-2-Report.pdf

World Wild Campus News & Entertainment. (2021, May 24). *Art for mural in progress with Amanda Phingbodhipakkiya* [Video]. YouTube. https://www.youtube.com/watch?v=XGrDAKbQo2I

CHAPTER 18

(Un)learning on the Sidewalk
Personal Reflections on Reclaiming Civic Engagement and Democracy in Public Art Making

William Estrada

> **INSTRUCTIONAL QUESTIONS**
>
> 1. What responsibility do we have in using art and teaching to serve as a radical space for dreaming together?
> 2. How can we reimagine where in the city and community art can exist?
> 3. What systems of trust and nourishment do we need to create to invite collaboration between artists that include the multiple stories present in historically marginalized neighborhoods?
> 4. How can we model being vulnerable in creating with people who usually aren't encouraged to make art?

It is important to center in community-based art-making that "every member of the community holds pieces of the solution, even if we are all engaged in different layers of the work" (brown, 2017, p. 63). Community-based teaching can be reimagined if as art educators, we consider teachers, students, parents, and community members, as collaborators; allowing for new ideas to be nurtured and creating learning spaces for culturally sensitive pedagogical approaches.

Growing up in Escondido, California, Guadalajara, Jalisco, Mexico, or the various Southwest Side neighborhoods of Chicago, Illinois, my family's experience and those of the people who lived in the communities I grew up in were hardly ever present in the books we read, in the lessons we were taught, or represented in the people we learned about. I grew up having very little access to art instruction in school, although I was surrounded by so much art in our neighborhoods. There was colorful graffiti on the walls, Black spirituals and Mexican regional music fill the air, stories were shared at every opportunity granted, neighbors would decorate their front lawns with

ornaments and religious iconography, and every Sunday turned into a runway as the neighborhood made their way to Church.

High school in Chicago was one of the first times I had access to art education, and the art room was one of the only places where the other students and I would dream about what could be possible. Mrs. Stallings, my art teacher, consistently celebrated our experiences and encouraged us to imagine multiple possible scenarios challenging our ideas, and at times asking us to figure out solutions to the problems that we wanted to address through our art. These experiences planted a seed within me that would be nurtured by many arts organizations and community artists whose arts practice centered on people's experiences. It is this pedagogical orientation that led me to what I came to know as social justice art education (Dewhurst, 2014). I learned that art could be a research tool and that participating in community-based art can lead to social change.

As a student, the art classroom was one of the only places where I had agency over the stories I represented about myself, about my family, and about my future. When I made the decision to pursue an arts degree and later an art education teaching certification, I made this decision because I wanted to teach art in neighborhoods that reminded me of the ones I grew up in. I wanted to teach art that celebrated peoples' complex and layered experiences and challenged historical narratives of who is an artist and where art can exist. In this chapter, I reflect on what informs my teaching and how my teaching has influenced my community arts practice. The figures associated with this chapter illustrate some of the projects associated with my artistry and teaching.

CREATING AND SUSTAINING DEMOCRATIC CLASSROOM ENVIRONMENTS

Over two decades ago I began my first teaching assignment at Telpochcalli, a public neighborhood elementary school in Little Village, a predominantly Mexican and Mexican-American neighborhood in Chicago. I began to learn from the classroom teachers and artists already teaching there about the importance of creating and sustaining democratic classroom environments that modeled engaging in difficult discourse, celebrating cultures, and inviting students to be their whole selves. I also learned about the importance of naming and acknowledging, as teachers and students, what each of us brings into the classroom. Ayers (Ayers et al., 2027) tells us that "teaching involves the courage and the imagination to give your energy and your time and *yourself* to others. It involves learning to talk with the hope of being heard, and, perhaps, more important, it involves listening with the possibility of being changed" (p. 25).

The people I teach with and learn from continuously influence me. They consistently provide new ways of looking at and understanding things and introduce approaches I had not thought of before. In this way, my students and I began to practice modeling what democratic and civic engagement looks like. This was particularly true when my students and I learned with and from each other what we wanted to enact in our communities. Democratic learning environments and culturally responsive

curriculum approaches create an opportunity to explore the various possibilities of addressing themes relevant to students, teachers, and their communities, and in the process, create art projects that have a deep impact on how we see our personal community arts practice. I have had the privilege of working with young people who have asked some of the most provocative questions I have ever been asked as an educator and community member. I also recognized that despite their thoughtful and strong opinions, they live in an adult world where they are told they have little to no agency. It was these powerful conversations with young people that first sparked my imagination and made me wonder why they believed it was so much harder for them to talk about issues affecting their lives with adults.

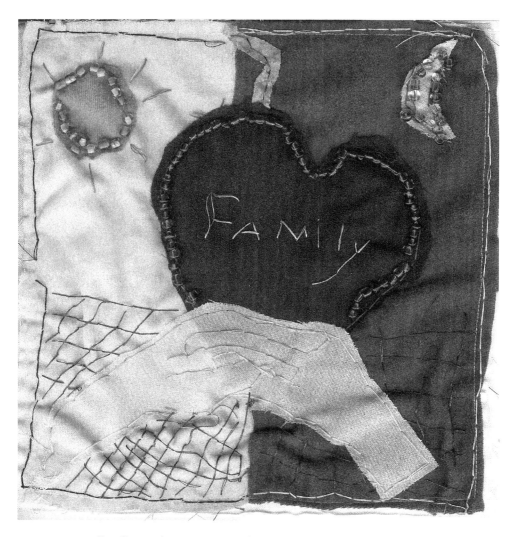

FIGURE 18.1 Family, student-generated Arpillera created as part of the Telpochcalli Artist in Residence Program in collaboration with Dana Oesterlin-Castellon as part of a social studies lesson on Latin American history and migration. Photograph by William Estrada.

THE RADICAL IMAGINATION

As an artist and art educator, I am constantly shifting my lessons and art projects based on the dynamics of the students' needs and their classroom teachers' interests. I have come to accept that my ideas, as important as I think they may be, are only a small part of the ideas that we generate in these collaborations. I have learned to embrace the discomfort of creating something with others that is not wholly mine. The most exciting projects I have co-developed in this way have been initiated from discussions with classroom teachers who are interested in approaching old lesson plans through new frameworks, students who are interested in working with artists who make public art, or, for example, parents who want us to address gender roles and ask that their sons be taught how to sew.

Curricula that are culturally relevant dynamically respond to issues happening in the classroom, in the community, and in the students' lives (see Figure 18.2). It is through critical discussions that challenge us as educators to model what democratic classroom practices can look like. Such discussions provide a choice between forcing preconceived ideas about what we believe students should be learning by offering agency over what they want to learn and imagining the application of that learning within their communities. In this way, I am reminded that "we [should] approach the radical imagination not as the thing that individuals *possess* in greater or lesser quantities but as a collective *process*, something that groups *do* and do together" (Haiven & Khasnabish, 2014, p. 4). It is this radical imagination work, the work of learning and creating together, that should be the most important practice we have as educators.

Throughout the last two decades, I have had the honor of working with amazing teachers and community artists who have guided and taught me how to be fluid in my teaching while applying pedagogical approaches that center students' experiences. Eventually, I understood these approaches as supportive of social justice art education, resulting in culturally relevant art projects that respond to the students' needs. Greene (2000) was instrumental in helping me identify that

> Community cannot be produced simply through rational formulation nor through edict. Like freedom, it has to be achieved by persons offered the space in which to discover that they recognize together and appreciate in common; they have to find ways to make intersubjective sense. Again, it ought to be a space infused by the kind of imaginative awareness that enables those involved to imagine alternative possibilities for their own becoming and their group's becoming. (p. 39)

I have discovered that uncomfortable friction is generated when educators refuse to acknowledge students' experiences and contributions. Relatedly, a lack of imagination inhibits moving toward new ways of thinking about what art education can be. Tapping "into imagination is to become able to break with what is supposedly fixed and finished, objectively and independently real. It is to see beyond what the imaginer has called normal or 'common-sensible' and to carve out new orders in experience" (Greene, 2000, p. 19).

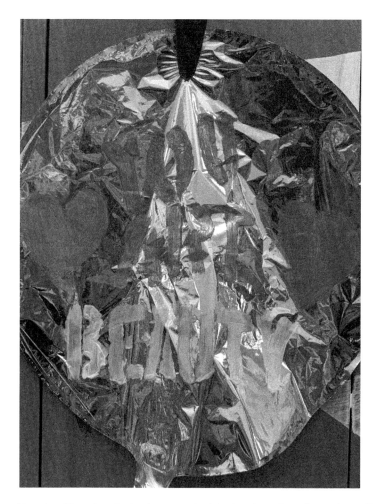

FIGURE 18.2 You Are Beauty, student-generated text using stencils and acrylic on mylar balloon in collaboration with Cognate Collective as part of a Chicago Arts Partnership in Education after-school program co-taught with Erin Franzinger Barrett.
Photograph by William Estrada.

A lack of flexibility on the part of educators obstructs the imagination. Too often, in my experience, it is the lack of flexibility we, as educators, hold onto as a result of being taught that our adulthood (or our academic degrees) grants knowledge and authority, leading to a belief that we know more than those we are teaching. This lack of flexibility, whether in the classroom or the community, does not encourage the participatory democratic structures inviting participation. Too many times over the course of my teaching career, I have witnessed students being asked to engage in art projects without question. Students are expected to be enthusiastic about what is being taught when their experiences are not incorporated into the curriculum. I have discovered that allowing myself to be vulnerable to the authority of my students creates a learning environment that allows students to build the curriculum with me. I do

not allow the fear of failure to limit these possibilities for collaboration. It is not knowing that new possibilities emerge, allowing for the imagining of possible paths and strengthening of relationships between teachers and students. In this way, my students and I model how to create collaborative learning spaces while navigating privilege, the lack thereof, biases, life experiences, and current circumstances emerging in what we teach and how we teach it.

Collaboration is hard, messy, and laborious. However, collaboration requires of educators embracing a pedagogy that provides "the context in which shared problems can be critically questioned and analyzed. It is a mutual process founded on reciprocity and humility that gets beyond the power imbalance of the traditional teacher-student relationship" (Ledwith, 2019, p. 102).

EMBRACING FAILURE

Above I mentioned resisting the fear of failure. So often we are so afraid of being transparent in our failures because we have been taught that failure is a sign of weakness, instead of framing failure as an opportunity to learn and reflect. There have been so many community-based art projects that I have planned as a teacher, but they have failed. The reason they fail varies widely, but it usually stems from not fully preparing for the unforeseen, or I have not allowed enough time to build relationships with students and other members of the community to generate meaningful partnerships that help us move through the parts of the art project that are still not fully developed. There is so much power in sharing that something has failed and in examining why that failure has happened. Being intentional in how we approach failure in the classroom can be powerful. Reflecting on what part of the art project can be saved? If we want to finish the project or abandon it, what projects would best follow this failure?

These questions have flooded the classrooms I teach so many times. I am confronted with the reality that, as an educator, I have to be transparent in our process and admit that something is failing. Inviting students to critically reexamine how we can move forward collectively and what lessons can be learned from what we have experienced as a class are democratic acts that invite students into conversations and include them in decision-making, promoting community engagement. Together, we continually practice how we might be able to solve a communal problem we have experienced as a class. It is in this process that we model democratic practices in the classroom. To this end my community-based arts and education practice stems from studying the community-based work of Taller de Gráfica Popular, Teatro Campesino, Bread & Puppet Theater, Guerilla Girls, The Yes Men, Theater of the Oppressed, Justseeds Artists' Cooperative, Asco Art Collective, AfriCOBRA, Tim Rollins and K.O.S., La Pocha Nostra, and Chicago Graffiti Crews to name a few. The performative aspects of the collectives who influence me are not lost on me. My teaching is rooted in activating classroom spaces as democratic learning environments where we are actors in modeling the worlds we want to build for ourselves (Boal, 1985).

ENGAGING WITH AND LEARNING FROM THE COMMUNITY

Teaching in the classroom taught me that young people are extraordinary problem solvers when given the opportunity. As adults, we should pay more attention to what young people are saying and how they navigate community-based problems that are not of their own making. Recognizing that if my teaching was to have a community impact, I needed to also engage with and learn from the community's adults. Taking the lessons, I was learning in the classroom and as described above, I wanted to explore engaging in conversations with adults in the neighborhoods that I teach and live in.

In 2002, I began to think about how I could invite adults in their communities to engage in difficult decisions through art making, just as students in my art classes have consistently invited me to have difficult conversations with them. In the process of having these conversations, I began to explore my own privilege, how we define freedom and expression, our power or lack thereof, what challenges we see in the places we live, and what role we may be able to play in thinking about the solutions to some of these questions. We must remember that "one does not have to agree with all the arguments for free expression to take the need to protect it seriously" (Palfrey, 2018, p. 82). I have learned that creating public art helps one to focus on thinking critically about what people in our communities pay attention to. Whether people are out for a stroll, running errands, taking their family members to school, or hanging out with friends – people out in public can be invited to make artwork in an intentional way.

The Mobile Street Art Cart Project

I do not always have opportunities to engage with adults from the neighborhoods I teach in. When I do public programming, adults, for the most part, assume only children and youth can participate in art-making activities. In 2016 I had the opportunity to facilitate The Mobile Street Art Cart Project (see Figures 18.3 and 18.4) through a 3Arts Project, "a unique crowdfunding platform with a built-in match that helps Chicago artists finance new creative work" (3Arts, n.d., p. 1). The Mobile Street Art Cart is modeled to emulate and honor the mobile vendors selling corn, fresh fruit, tamales, or ice cream in neighborhoods. It was created to invite people, including adults, to use art to mobilize and organize around issues affecting them. I know from personal experience that it is often through making and creating something that we slow down enough to listen to each other. In slowing down, we can ask questions about what is important to us, allowing us to unlearn and reimagine what a community can look like. This also challenges notions of what teaching can be and where it can take place. Landreman reminds us that "engaging in effective social justice education facilitation is more than applying techniques. It is a way of being in our day-to-day lives that is grounded in an understanding of the history and legacy of exclusion, discrimination, and oppression and a vision for social change" (Landreman, 2013, p. 19). As I have emphasized above, democratic learning spaces, like the Mobile Street Art Cart Project, provide a framework to engage in dialogue through art making.

FIGURE 18.3 People in their neighborhood making buttons through The Mobile Street Art Cart Photograph by William Estrada.

The Mobile Street Art Cart invites people of all ages to create through structured workshops or drop-in programming. I invite passersby to participate and take a moment to make artwork with me. I encourage participants to slow down and think about how we can use art as a tool to mobilize and organize in their communities. The rationale behind the Mobile Street Art Cart Project is based on my belief that holding these public art workshops out on the sidewalk lessons barriers to participation. Workshops were accessible to anyone walking by and people would be invited to engage in the art project as they passed. No one would have to make a choice to open the door, no one would have to question if the event was created for them, and people would not have the need to be invited into the workshop beforehand. Also motivating the Mobile Street Art Cart Project is that there are so many times that people in my community have been told making art is unimportant, or art is not for people in a particular neighborhood, or it is something for people who have a lot of leisure time. My intention is to question these ideas about who gets to make art. Who gets to call themselves artists? Who gets to enjoy leisure time and be celebrated for it? It was these questions that I was really interested in and engaging with.

The Mobile Street Art Cart Project was dreamed of as a tool to honor the mobile vendors that I've grown up with, the vendors that I see when I walk in the neighborhoods I teach in, and in the *tianguis* and *mercados* I grew up with in Mexico. The

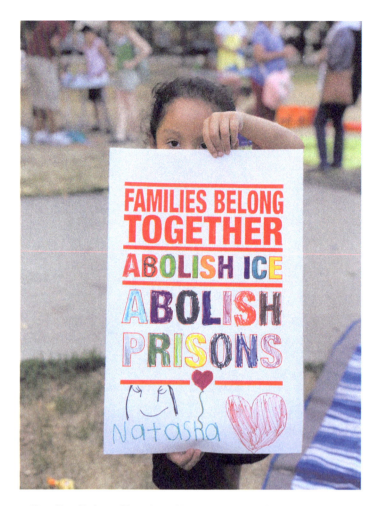

FIGURE 18.4 Families Belong Together, Natasha colored in a poster in a public workshop through the Mobile Street Art Cart Project in collaboration with the Mobilize Creative Collaborative.

Photograph by William Estrada.

Mobile Street Art Cart Project is a reminder of the cultural work mobile vendors do in connecting individuals to the places called home and to each other, of the civic engagement that happens every time people from different parts of a city come together to talk over delicious tamales, colorful goods, fruit covered in a combination of lime and tajin, or ice covered in flavored syrup. These cultural ambassadors weave experiences together through peoples' connections to the goods they sell. Interactions with these vendors can fill us with love and keep our connection to the places we call home. Like these vendors, my facilitation of the Mobile Street Art Cart Project makes connections with people, holding their stories, sharing resources found in the community, and connecting people to the organizing happening across the neighborhood. Sharing space as we create art and share the latest gossip from the neighborhood reminds us that "if you can settle your body, you are more likely to be calm, alert, and fully present,

no matter what is going on around you. A settled body enables you to harmonize and connect with other bodies around you, while encouraging those bodies to settle as well" (Menakem, 2021, p. 151). These moments when people are settled and come together ignite conversations and allow for deeper relationships to be formed.

Within community, The Mobile Street Art Cart Project attempts to emulate mobile vendors by creating spaces and "articulating and enacting a politics that is relevant across communities, while also facilitating an anti-capitalist basis of unity across struggles, we create a potentially important and revolutionary movement" (Walia & Smith, 2014, p. 142). It is this "direct support work [which] also encourages us to name and confront political systems in order to break through the psychological isolation that is intended to silence, blame, shame, and ultimately disempower people" (Walia & Smith, 2014, p. 104). Creating a temporary creative space that encourages sharing conversations with each other, similar to the ones I have been having in classrooms with young people. In this way, community members have insight into what I am doing in the school.

I am reminded by hooks that "to build community requires vigilant awareness of the work we must continually do to undermine all the socialization that leads us to behave in ways that perpetuate domination" (hooks, 2021, p. 36). It is through conversations about peoples' struggles, their love, and what resources they need that shared responsibility, resources, and mutual aid to support neighbors can be identified. The Mobile Street Art Cart Project evidences that

> Outreach should employ an array of strategies, and can take many forms such as posters, street theater, workshops, newsletters, and educational events. Whatever form of outreach we choose, the key is that it should be frequent and with the intent of engaging with people. movements tend to view outreach and popular education as separate. We assume that the people we outreach to are just passive receptacles of information, but outreach is most effective when it employs the popular education strategy of interaction. We need to stop and talk to people, ask them about their opinions while sharing our own, and invite them into spaces where they can expect not only to be talked at but can also provide their own thoughts.
>
> *(Walia & Smith, 2014, p. 181)*

I want to pause for a moment to highlight the importance of adults having time for joy, celebration, and critical art-making that amplifies the knowledge they hold. I want adults in historically marginalized communities to create art, be celebrated for taking the time to create and share the joy that is being nourished by building and sustaining brave spaces where their experiences are shared and integrated through collaborative approaches into the art projects we collaboratively implement in the places they call home.

Adults are constantly being consumed by the belief that their only value comes from the labor they produce, and because of that, they stop participating – our democratic process shames them for not doing enough while also excluding them because they do too much. Through artmaking, people slowly make connections, planting

seeds and nurturing our relationships with each new art workshop we share. Together, we weave and intersect our stories and experiences across neighborhoods and communities, ever so slowly creating a network of civically minded individuals who can use art to reimagine the democratic spaces in which we want to live. Through each conversation, each art project that we share, and community building, each relationship strengthens our ability to connect with each other. We share resources; we discuss strategies and issues happening across the different parts of the neighborhood. We begin to create a blueprint for coalition building that spans across experiences, neighborhoods, and race. With each seed we plant, roots grow and strengthen the ground we build on, so home can be claimed by many.

CONCLUSION

In this chapter, I have described how I use art making, prompts, and grassroots organizing to practice democratic and community-based engagement. Community-based art intertwines our experiences, connects singular stories, and helps us unlearn what we have been taught about art and who can make art. It helps us unlearn fear of each other and, in the process, grows our collective power.

My work as a community artist and educator is strengthened by the relationships, I get to form with community members that I may not have routine access to. Importantly, I am engaging with community members around some of the issues and themes I am teaching in the classroom. These community-based conversations are a significant resource generating future workshops for the Mobile Street Art Cart Project and questions I can bring to my classroom. My purpose is to repudiate that "We sometimes act as if we have to figure everything out perfectly before engaging in an action. This is a recipe for paralysis and insularity" (Dixon, 2014, p. 123). My interest in this work is to have more people in their neighborhoods use art to mobilize and organize themselves and their neighbors. I learn from the wealth of knowledge and experience people bring into our brief collaborations. I am inspired by Dixon's view that

> Developing plans that can somehow guide us past all contradictions, uncertainties, and narrows is simply impossible. It's also not desirable. A movement-building orientation helps us to see that successful fights for fundamental social change develop from long-term engagements with the lives and struggles of ordinary people. Such engagements, like anything worth doing in this beautiful and unpredictable world, are complicated and messy. (p. 123)

My teaching becomes more intentional and thoughtful in the classroom and, by extension, the community through these experiences. Relationships are slowly nourished with every public workshop I deliver. I get to grow with people in their neighborhood, and they see it, reminding me of the work they have created, asking me how new projects are coming along, reminding me of themes I should address, and seeking out more opportunities to engage with the work we get to do together.

As these relationships grow and I share why I believe art education is important in historically marginalized communities, participants invite others to join us so we can engage in various discussions about how we can use art to heal, engage in discussions, imagine possible futures, celebrate our stories, relax, reclaim our creativity, share space with each other, and of course, create art that we get to claim as our own. Our purpose is

> To put anti-oppression politics into practice in our groups, we have to wrestle with hard questions in an ongoing way: How do we remain consistently mindful of power dynamics and shift them? Who has the opportunity, capacity, and support to take initiative? How do we determine our priorities and develop strategy? Who gets recognition and for what work? How do we hold people accountable? These aren't just questions for discussion; we have to create practices to move on them.
>
> (Dixon, 2014, p. 99)

I have learned through my work in community that there are many questions we should ask ourselves and community members when developing public art projects because there is much to learn from people in the community. This is particularly true for community members who are disenfranchised from our democracy and may be disinterested in community engagement because of their experiences.

The artwork that we create becomes the artifact of the relationships that we are beginning to grow slowly, watering them, slowly spreading seeds, and building expectations of ourselves and of each other. It is these relationships that remind us of our actual worth, of the importance of our participation in this democracy, it is a reminder of our responsibility to be civically engaged, but most importantly, it is a reminder that what we say, what we think, and what we dream has value. It is these conversations, these small moments of creativity where we put a squeegee to a screen to reproduce a graphic, it is this moment where we put a gel pen or a colored pencil to a template to make a button, it is this moment where we take a marker to an adhesive paper that will later get turned into a sticker, it is this moment where we are creating for ourselves, for each other that we remind ourselves that the work that we are here to do has impact. That impact is larger than us. That impact creates ripples that expand outwards away from us. Those ripples become bigger, slowly disrupting, inspiring, and inviting others to respond to the work we're creating together as they attempt to readjust from our disruption of their everyday life. These interactions truly remind me of the power of art education. It is in the art classroom, and through community-based arts programming, we can dream of different possible futures together. In doing so, we must acknowledge the present so we may begin to create brave learning environments that will help us dream and practice building a civically minded society now. One that not only talks about democracy but models it in how we treat each other.

There is so much knowledge that exists in the communities we work in and we are at a disservice when we are not able to provide opportunities to learn from the people inside and outside of our classrooms or institutions. In developing and implementing community-based art education and culturally responsive curricula that critically

examine personal interests and community themes, artists, educators, students, and community members can radically reimagine the relationship between art and people in the places they call home. Together, we can weave experiences across time and space, reflecting on how prevalent issues affect us – creating opportunities to engage in critical thought, knowledge creation, and interrogating power relations.

REFERENCES

3Arts. (n.d.). https://3arts.org/projects/about/

Ayers, W., Kumashiro, K., Meiners, E., Quinn, T., & Stovall, D. (2017). *Teaching toward democracy: Educators as agents of change*. Routledge.

Boal, A. (1985). *Theatre of the oppressed*. Theatre Communications Group.

brown, a.m. (2017). *Emergent strategy: Shaping change, changing worlds*. AK Press.

Dewhurst, M. (2014). *Social justice art education: A framework for activist art pedagogy*. Harvard Education Press.

Dixon, C. (2014). *Another politics: Talking across today's transformative movements*. University of California Press.

Greene, M. (2000). *Releasing the imagination: Essays on education, the arts, and social change*. Jossey-Bass Publishers.

Haiven, M., & Khasnabish, A. (2014). *The radical imagination: Social movement research in the age of austerity*. Zed Books.

hooks, b (2021). *Teaching community: A pedagogy of hope*. DEV Publishers & Distributors.

Landreman, L. M. (2013). *The art of effective facilitation: Reflections from social justice educators*. Stylus Publishing.

Ledwith, M. (2019). *Community development: A critical approach*. Polic0y Press.

Menakem, R. (2021). *My grandmother's hands: Racialized trauma and the pathway to mending our hearts and bodies*. Penguin Books.

Palfrey, J. (2018). *Safe spaces, brave spaces: Diversity and free expression in education*. MIT Press.

Walia, H., & Smith, A. (2014). *Undoing border imperialism*. AK Press.

Engaging Circles of Relation
Indigenous Methodologies in Community-based Theatre

Theresa J. May

> **INSTRUCTIONAL QUESTIONS**
>
> 1. What kinds of guidelines were suggested by the students as a framework for conducting interviews? How did these guidelines safeguard the ownership of stories and the privacy of memories, and why was this important? Were these guidelines sufficient in light of the trauma of the fish kill?
>
> 2. Provide two examples of reciprocity demonstrated by the project as a whole. In what way did the give-and-take of learning together enhance the end product? Why was this way of working essential to the success of this project?
>
> 3. In what ways did the project described in this chapter constitute a personal journey of self-decolonization for the author? If you were to undertake a community-engaged project such as the one described, what might be your personal challenges?
>
> 4. Is there an issue or concern in your community that has been divisive? What stories would be important to tell about this issue? How might community-based theatre-making (such as *Salmon Is Everything*) be useful in bringing stakeholders into dialogue? Who in your community would you talk with first and how might you want to collaborate with them?

I am a non-Native artist-educator with 25 years' experience working in collaboration with regional Indigenous community members and students (Native and non-Native) on creative and theatrical projects. In what follows, I describe how my students and I collaborated with Native community members to develop the community-based play, *Salmon Is Everything*, a process that provided pathways for self-decolonization (May, et al. 2018). I discuss the central importance of applied Indigenous methodologies – relationship, respect, reciprocity, and reverence for interrelatedness – whenever

artist-educators aim to collaborate with Native American community members. More broadly, I hope to demonstrate how community-based theatre instills democratic values by exercising the imaginative, social, and cultural skills vital to civil society and a functioning democracy.

Theatre-making is at once imaginative, collaborative, embodied; it exercises civic engagement and practices democratic values in personal and palpable ways. As audience members and performers come together in the *willing suspension of disbelief* to share in the enactment of a story, they grant implicit validity to diverse and often conflicting experiences and world views. Community-engaged theatre praxis in particular has the potential to prepare students to learn skills crucial to the function of any democracy, including deep listening and empathy, the ability to hold more than one reality as true and valid, and to practice tolerance in the messy give-and-take of collaboration.

Community-based theatre was pioneered by Cornerstone Theatre Company of Los Angeles, a consortium of theatre practitioners that have defined their practice as theatre by, for, and about a specific community (Cohen-Cruz, 2005). As an applied use of playwriting, devising, and performance, skilled artists work in collaboration with communities in a process of telling stories that expresses the lived experience, histories, and cultural traditions of the community. Community-based theatre actualizes what Iris Marion Young called "communicative democracy" (Young, 1996, p. 121) in which the inclusion of varied and diverse voices from historically marginalized groups enhances democratic processes by resisting the aim of common ground in favor of pluralism. In practice, this publicly engaged theatre-making is more complicated. The artists involved may not always be members of the community they serve; and community members may have little experience in theatre-making.

Salmon Is Everything documents the historic 2002 fish kill on the Klamath River – which runs from central Oregon to Northern California – in order to call attention to the impact of the fish kill on Indigenous communities of the Klamath watershed. The play was developed in collaboration with the Karuk, Yurok, Hupa, and Klamath/Modoc tribal communities, whose traditional homelands lie within the Klamath River watershed. Humboldt State University Native and non-Native students gathered research materials, conducted interviews with regional Indigenous community members, and helped shape this source material into a theatrical performance presented to the wider watershed community. Documenting and amplifying the Indigenous voices in the aftermath for the 2002 fish kill was not merely an attempt to find common ground in a factious community but to represent voices and lived experiences that were not being heard in local or national media. In this way, the play became a space to envision a new watershed citizen.

Since its first production in 2006, the play has continued to have a life through readings, workshops, and community events.[1] *Salmon Is Everything* centers on three families – a Karuk/Yurok family of subsistence fishers, a ranching/farming family, and an environmental biologist and her partner. What follows describes how the creative team, including myself, students, and community both Native and non-Native, brought the stories of the watershed together. As activism-through-storytelling, *Salmon Is Everything* is an example of theatre that works to not only envision and

embody ecological justice and resilience on stage but also to demonstrate how citizens with oppositional self-interests might strive toward more inclusive communities through the practice of relationship-centered civic action. Over time, the play has continued to support awareness and a more inclusive citizenry within the Klamath River watershed. As of this writing, four dams on the Klamath River have been slated for decommissioning and deconstruction.[2]

Educational activism, as this project claims to be, must understand community collaboration as a process of decolonizing from the inside out. In *Research as Ceremony*, Shawn Wilson writes, "if your research does not change you, you're not doing it right" (Wilson, 2008, p. 83). The vignettes discussed below reveal some of the lessons I learned as a non-Native artist/educator, and they may be useful to others; but when collaborating with culture bearers and their communities, the best advisors and teachers are those people themselves. Thus, before I continue with the case study, and certainly before any suggestion of about how to go about educational collaborations with Indigenous community members, I must point out a crucial aspect of this work: it requires a willingness and commitment to self-decolonization. Every step of the project I describe below challenged me in immediate and sometimes uncomfortable ways. Consequently, what follows is not a how-to manual, nor a list of steps for a successful process. Even the phrase "best practices" is too presumptive of ways of thinking, being, and researching that are unsuited, and potentially harmful, to people who have lived with the generational trauma of settler colonialism. What I *can* provide is the story of my own experience, and the lessons that came along the way, in the hope that my story might be helpful to educators and artists who want to begin a similar journey toward decolonization. As I learned over and again, this work begins by coming into relation with history, working through one's settler-grief, and acknowledging the ways colonialism continues to show up in our everyday labors and relations. What I have learned I have learned because my Indigenous collaborators have been patient with me, and so I note my deep gratitude for their generosity here.

Community collaborations with Indigenous culture-bearers must surely provoke an ongoing examination of one's own world view and recalibrate one's sense of purpose as an artist or educator. Jo-ann Archibald encapsulates this process as story*work*: a journey not only of understanding but practicing the values of Indigenous methodologies, including relationship, respect, reciprocity, and reverence for the interrelatedness of all things (Archibald, 2008, p. 2). For non-Native educators and students, this means coming into relationship with our history. In *Decolonizing Methodologies*, Linda Tuhiwai Smith urges research and creative work that serve the forward-looking needs and goals of Indigenous communities. It is not enough, she argues, for scholars to name and narrate the injustices of the past. While such recognition "provides words, perhaps, an insight that explains certain experiences […] it does not prevent someone from dying" (Smith, 2006, p. 3). Awareness of the effects of colonialism must be followed by proactive work to undo – to *unsettle* – those effects. The central tenets of Indigenous methodologies – relationship, respect, reciprocity, and reverence for interrelatedness – are the guiding values that I will come back to throughout what follows.

COMING INTO RELATION

In "Communication and the Other: Beyond Deliberative Democracy," Iris Marion Young (1996) provides a distinction that sheds fresh light on the function of diversity in democracy. We are accustomed to "deliberative democracy" in which positions are laid out through debate, and decisions made by majority voices (Young, 1996, pp. 120–36). Indeed, education typically frames democracy as a deliberative process through which difference is something to be transcended in order to find so-called common ground. This quest for agreement, Young argues, re-inscribes majority privilege by dismissing knowledge represented by the experience of marginalized groups precisely because it is not commonly held. In this way, democracy can also function as a mechanism of exclusion. Theatre, storytelling, and art in general provide a context for learning communicative democracy in which difference is valued and disagreement becomes a source of new knowledge. When "each can tell her story with equal authority," allowing the community to access its "total social knowledge" (Young, 1996, p. 125). Stories preserve and disseminate wisdom, provide historical context, and transmit feelings that have the power to change the listener, easing long-standing social and political polarization.

In the Autumn of 2002, over 34,000 salmon died in the Lower Klamath River in Northern California – one of the largest fish kills in the history of the western United States (Department of Fish and Game, 2003). Ongoing environmental degradation of the river was exacerbated by a drought in eastern Oregon and precipitated a new battle in the region's water wars as farmers and ranchers demanded that agriculture take priority over fish. As autumn runs of coho and CHINOOK salmon entered the mouth of the Klamath River to spawn, tens of thousands died from gill rot caused by the warm water temperatures. Salmon corpses lay floating and putrefying along miles of riverbank. News of the fish kill spread through north coast Indigenous communities like wildfire. An ecological catastrophe that destroyed a primary source of first foods, it also caused lasting emotional, spiritual, and cultural trauma to Indigenous tribes that have depended on the river for economic and cultural sustenance since time immemorial.

In response, the president of Cal Poly Humboldt (where I taught at the time) held a conference where scientists and representatives from state, federal, and regional government agencies dealing with water, land management, and wildlife, as well as citizen and environmental groups and local tribal leaders gathered to discuss the underlying causes and to advocate plans of action. The room was electric with antagonisms, palpable through the veil of professional presentations, revealing that the issues of water rights and allocation, species protection, human economies, and cultural rights are thick with layers of contested history. Meanwhile, the back of the room was crowded with people from the tribal communities, who understood the fish kill as a threat to traditional lifeways. As scientists and government officials presented their theories while Native elders sat silent, I began to think about the voices in the larger story that were not being heard, and wondered if a play about the events, told from an Indigenous point of view, might be one way to tell the story of what was a profoundly personal trauma for the tribal communities in the region.

We are not immune to history. In community-based projects such as this one, history complicates the work and the relationships on which it depends in constant and sometimes subtle ways. From the first contact of Euro-American settlers with Indigenous residents, to the most recent cross talk at Klamath watershed conferences, history is alive and effects relationships and behaviors in the present. In order to reveal some of the potential pitfalls of community-engaged projects that seek Indigenous collaboration, I relate the inception of the project in detail below.

We held the first community meeting about the Klamath Theatre Project on campus, inviting members of the Native community including Native artists and representatives from Indian Health Services, as well as a number of Native and non-Native students. After introductions, I began to present my idea. A few sentences into my notes, one of the elders stopped me and said, "Who are you?! What are we doing here listening to you? What's all this talk about telling an Indian story when we're sitting in a classroom of a racist institution?"[3] I was brought up short. My Karuk collaborator, professor Suzanne Burcell, responded, explaining that this might be a way to express Native perspectives about the salmon through stories. I had come "with a good heart." Sue said that she was willing to give me the benefit of the doubt and see what developed. The moment passed and my embarrassment subsided, although I never did get back to my notes! Instead, I listened and took notes as elders, students, and other community members spoke for two hours about the recent fish kill, the need for Native voices to be heard, the importance of community involvement, and their fears of institutional control. At the end of the evening we asked if there was consensus that the project should move forward with community participation. Yes, the community members agreed, as long as the university would not own people's stories, and as long as Native people were involved and consulted throughout the process so that the end product reflected the values of the Native community.

The takeaways from this first meeting for me were many. I had stepped into the mode that Tuhiwai Smith warned against in which the academic authority positions themselves as expert and designs the research to serve their own vision (Smith, 2006). It did not matter that my intentions were "good" because the institutional structures – the very structures of racism and exclusion – were already present in the air we breathed. Indigenous community members were wary of the social, political, educational, and economic institutions that have been part of a long colonial history of appropriation. As a Euro-American settler descendant and an employee of an institution with roots in colonialism, I represented that history. I would need to proactively take responsibility for my privilege, to proceed with an awareness of my institution's history and the history of settler colonialism itself. Second, listening needed to be at the center of my work. I was the student and I needed to allow myself and the project to be led by the knowledge and expertise of the Indigenous community members, especially elders, but also my Native students who had experienced the fish kill and its aftermath first hand. It would not be the last time that I was brought up short by the subtle ways ongoing settler colonialism would show its face in inequities and implicit biases. Even when Indigenous methodologies and the values they represent are in practice, history too often pre-determines relationships between educators and communities.

Relationship, respect, responsibility, and reciprocity form the center of applied Indigenous methodologies. These tenets are not merely intellectual ideas; they are ways of working, living, and being that may, from time to time, require artist-educators to examine their own privilege, implicit biases, and to engage in a process of personal transformation.

Relationship, in the form of ongoing consultation with community partners, but also understanding my relationship with settler history; *responsibility* for that history and my inherited privilege, and for how the stories shared in the project would be safeguarded in future; *respect*, for the authority of the elders and the collective knowledge of their community; *reciprocity*, in listening to what outcomes community members want from the project so that the project gives back in a way that is consistent with Indigenous aims and values. *Consultation*, the practice of respect and reciprocity, would mean asking the community how to proceed. What form the project should take, and what outcomes they wanted to see? All project elements – rationale, ways of working, structure, focus, timeline, and final product – would involve consultation with my Indigenous collaborators, which included students, colleagues, and tribal knowledge-holders.

INTERVIEWS AND WRITING PROMPTS

The structure of collaboration with the students was simple and fluid. We met twice a week in the late afternoon and evening after work and classes. I brought food to sustain our energy and to help forge the bonds of community and exchange that we would need going forward. Our research and writing took three primary forms: research into the issues, events, and history of the watershed; creative or reflective writing through which students responded to that history and processed emotions about what had occurred; and interviews with community members. Writing exercises were often read aloud at our group meetings; more often than not these prompted personal stories, additional reflections, and pointed the way to the next step in the process. As the play began to take shape my students' stories became central; ultimately the narrative of the story would center on their lives, while, the politics and policies became secondary. Reflective writing allowed each individual to sort out her or his own thoughts and feelings about many aspects of the fish kill, and, as it turned out, what it meant to identify as a Native young person at this moment in history. Much of the story at the center of the play we developed emerged out of our day-to-day relationships as a collaborative group.

As part of our research, the students and I interviewed individuals and groups throughout the Klamath watershed. Native students interviewed family and extended family members; non-Native collaborators interviewed commercial fishermen, whitewater rafters, environmentalists, and agency personnel. As we prepared to conduct interviews with community members, I was again faced with the challenge of my own subject position as a non-Native faculty and outsider: what right do I/we have to gather the emotional artifacts of a collective trauma? My doubts seemed to call into question the very project of community-based theatre. Many celebrated theatre-makers

glean community stories as source material for fictionalized composites in their plays. But when the artists are not themselves part of that community, this process can be ethically suspect.[4] As a non-Native person, how could I ask students to conduct interviews with tribal community members about the fish kill? I am neither a relative nor someone directly impacted by the fish kill. What *is* my relationship to the fish kill and the river? I shared my doubts with my collaborators: would it be a good idea to talk to people upriver, to talk to your families and people in the tribal communities about what happened? How should we go about it? This juncture was an important lesson in Indigenous values. My admission that I did not know how to proceed allowed the students to advise *me*, to lead the way; it also opened dialogue with the wider watershed community and precipitated knowledge sharing, which is, after all, a central purpose of community-based work. The very act of turning to someone across the divide of culture, age, ability, or educational difference to ask "What would you do? What do you think?" is to say, in effect, "Teach me." This knowledge sharing not only affirms community, but it forges community.

"We can do interviews if we do them with respect," the Native students said. "It must be us doing the interviews, not you. I can ask my grandmother questions, or my uncle, and that makes sense, that's not disrespectful." This advice underscores the way in which community-based theatre grows out of and depends on long-term and ongoing relationships. I suggested that each of us make a personal list of people *in our own lives* that we might interview about the fish kill. A non-Native student complained she would have no one to interview, but when asked to think of people with whom she had a relationship or who were her peers who might have been affected by the fish kill, a light bulb went on. "I can interview the white-water guide from my river trip last summer!" In that moment, the project became personal to her. No longer merely an intellectual or artistic exercise, instead, it became *an investigation into her own life* and how she was connected to the river and the fish. Similarly, I made a list for myself that included colleagues at the university, health care workers, people from the environmental community, and government agency personnel. My self-doubt had helped decenter my status as project director, faculty, and artist; those doubts, honestly shared, gave rise to the very structure of our work together, a structure that had both integrity and efficacy.

The students advised that questions to elders needed to be quite general, the Native students told me, so that the person being interviewed could take the conversation in whatever direction felt right. If an elder answered a question about the fish kill by talking about a childhood memory or telling a story, that needed to be respected. "Elders don't always answer the question that you ask!" they warned. "They might think something else is more important." The Native students intuitively understood that a project like this must respond and adapt fluidly and generously to the unpredictable contributions of the community. Some of the Native students also had concerns that the topic might be too painful for their relatives and friends to discuss. "My grandmother might not want to talk about it. She was there and I remember her crying, and I don't want to make her remember it." However, many returned to report that their families and friends on the river were often eager to talk about the fish kill and its cultural, legal, and ecological ramifications. "My grandmother got going and then she

wouldn't stop!" one student exclaimed. Sharing my doubts with the students had two unexpected effect of bolstering their own courage to talk to their families: it was okay to be nervous, to not know how to speak about these things. And because interviews were conducted by individuals who already had a relationship with the person being interviewed, community trust in the project grew.

Relationship, in the form of understanding my subject position, and trusting my students; *responsibility* for my subject position as outsider, and for how to conduct the research in respectful way; *respect*, for the trauma that the fish kill caused and *reverence* for the relationship between my students and their communities, and between the tribes and the river; *consultation*, sharing my doubts, stepping back, and asking my students how to proceed; *reciprocity*, in carrying out the good counsel from my students, each of whom experienced that listening to their community's stories was a gift.

RECIPROCITY IN THE PROCESS

Throughout the development of *Salmon Is Everything* we engaged in ongoing dialogue with community members, which often took the form of a community reading, or share-back, of the play-in-progress. As Jan Cohen-Cruz has written, this "reciprocity" is one of the principles of community-based theatre and implies a kind of input loop from the community back into the creative process of the artists. Readings of the stories and interviews and ultimately the early drafts of the play took place in community setting – community, students, and faculty sitting in a circle reading aloud, followed by lengthy discussions of what the community heard and what suggestions they had for further development. As the play took shape, with composite characters and scenes, these share-backs took the form of concert readings using a stage and music stands. This phase helped the community begin to envision what they would like to see on stage, as well as the stories they wanted to hear. The conversations that took place after these community readings contributed to the further development of the play in ways we did not expect. In this way the community helped shape the play, but perhaps more importantly, the existence of the play – even in its rudimentary form – constituted a forum for communicative democracy.

The share-back attracted a diverse audience from the tribal community, students, faculty, and local environmentalists. Consensus indicated that the play-in-progress reflected a Native point of view, consistent with the original intent of the project. Hearing one another's stories, community members began to share additional memories and experiences, adding to a bounty of new information, feelings, and perspectives on the event and the politics it represented. "Yes, yes, it was just that way. It was at the Brush Dance out at Requa and we were fixing food and we hear someone calling from the river and my little son is walking up the bank with a dead fish in his arms! That's how we discovered what had happened. Then we all went down to the river and there they were, dead salmon floating and laying on the shore," one woman said. "The smell! You have to include the smell of the fish, the smell of death!" another said, adding that schools had been closed due to the smell. They gave us theatrical suggestions: "I hear the sound of Brush Dancing," and another chimed in, "We need images of the river, people fishing and dancing!"

Then an elder shifted the conversation: "We need the farmers' stories too! We need to invite them down for a salmon dinner after the play!" Others echoed agreement. "We need to have a big salmon bake and invite the farmers and ranchers from upriver to come down and share food at our table. Maybe then they'd understand." Choctaw playwright LeAnne Howe writes about the power of Native stories not only to communicate ideas but more importantly to create new worlds, new realities. "Native stories are power. They create people. They author tribes" (Howe, 1999, p. 117). As stories poured forth from the community, so did a creative force that would change the course of the project. "Farmers have to be in this play too," continued the cacophony of agreement. "The play needs to keep the Indian focus, because that's its purpose, to tell the story from our perspective, but we have to tell the larger story. If we could hear each other's stories, then maybe things could change because people would understand." The elders charged us to include the voices of the Upper Klamath community (including the Klamath Tribes) as elements of the play, and our next draft included voices from the wider watershed.

The *relationship* of the project and creative team with the community – to whom we were *responsible* – is expressed through the many concert readings. *Respect* is shown through organizing the readings in times and places convenient to the community. *Reciprocity* occurs in the way new stories, memories and experiences emerged from the share-back. *Reverence* for the new memories shared and the directive of the elders to widen the circle changed the course of the project.

CULTURAL KNOWLEDGE SHARING

Teaching moments were plentiful and often disarming. One Karuk culture bearer who worked closely with us brought basket-making materials to rehearsal; she explained how bear grass and willow roots were used; how Karuk women make colors from the black stem of the five-finger fern, and dye bear grass bright yellow by soaking it in wolf lichen. She explained other medicinal herbs and talked about Karuk beliefs in which everything has a spirit. Her collaboration made sure that the play represented Karuk traditions accurately and respectfully.

Much the same way that non-Native people might not understand the spiritual significance of the salmon, we may also miss the distinction between objects of material culture and our own everyday possessions. Cultural consultation insured that the creative team understood the objects of material culture – a brush dance skirt, basketry, and women's caps – are *living regalia*. Our Karuk consultant explains that because the skirt *has danced* only the woman who dances in it can touch it. This kind of cross-cultural knowledge sharing not only enriched every member of the group, it directly informed our creative product. Scenes were re-written and re-worked not only to be consistent with cultural values and protocol but sometimes to teach those values to non-Native audiences. One elder who performed in the play brought a cradleboard from home to use in certain scenes. During a break, the children began running around the stage, playing keep-away with the cradleboard. The elder rose to her feet and shouted, "Stop that! That is not a toy!" Her voice was filled with emotion as she

explained to me, "This is a cradleboard that we keep in our home, that our ancestors made, that we lay our babies in; that our grandbabies will lay in. It is a living object. It's disrespectful to treat it this way. It's not a theatrical prop!" This became an important learning moment for the diverse group of artists, including theatre and environmental studies students, and Native students and community members. We added a note in the production program explaining to the audience that some objects they see on stage are not "props" or "costumes," but rather living material culture, and that are not to be touched by anyone except the performer that handles them – a note we went on to recommend to anyone staging the play with regalia or other objects of material culture in the future.

EMPATHY AS POLITICAL ACTION

A frequent question about *Salmon Is Everything* is, "Did it make any difference?" The question whether theatre (or any art) matters is important not only because artists and activists want their work to contribute to social change but also because answering this question helps us understand *how* theatre participates in civic discourse – how it matters. In an article on the social power of theatre, Jill Dolan observes that the "actor's willing vulnerability perhaps enables our own and prompts us toward compassion and greater understanding. Such sentiments can spur our emotion, and being moved emotionally is a necessary precursor to political movement." Theatre's primary function is not necessarily to change laws or policies but to provide a forum in which people might imaginatively share in one another's experience. Witnessing a play, a person might ponder questions such as, what if that was my grandmother's experience? What if that happened to my child? What if I felt that humiliation, fear, or rage? Theatre is not merely a representational art; it takes place before our eyes, in and with our flesh-and-blood presence; theatre is a living forum. Because it is alive, theatre invites us not only to think about how others might feel but to *feel into* those possibilities in real time in the company of others. In this way it lays down new fibers of community in the form of relationships as well as stories. This is how the play mattered. Those fibers of relatedness include not only the diverse and complicated communities of the Klamath River watershed but all those who have worked or will work on productions of this play and its audiences.

CONCLUSION: WAYS OF WORKING

First Nations dramatist Monique Mojica affirms this envisioning potential of theatre in part because it is storytelling actualized through embodied, present-time performance:

> "[B]y performing possible worlds into being [...] by embodying that wholeness on the stage, we can transform the stories that we tell ourselves and project into the world that which is not broken, that which can be sustained, not only for Aboriginal people, but for all people of this small, green planet".

(Knowles and Mojica, 2009, p. 2)

When informed by Indigenous methodologies of relationship-centered discourse, the potential of theatre to leverage social change in the direction of tolerance, compassion and justice is heightened. In telling a complex community story, *Salmon Is Everything* became not only a play about an historic event, but a vehicle for cultural revitalization in the present. The play emerged from Indigenous knowledge, which includes Native languages in the form of prayer and songs, a connection to place that acknowledges the Indigenous history and culture, traditional cultural and ecological knowledge that is centered in your own personal lived history, and stories as the vehicles for sustaining spirituality and values. As it represented multiple points of view and maps how characters are changed by coming into relation with one another, it asked those who listened to change also.

Margaret Kovach observes that a tribal-based approach to study or creative work means "start where you are and it will take you where you need to go" (Kovach, 2010, p. 10). I hope that this case study demonstrates the unique ways that theatre-making engages civic dialogue, teaches cultural competency, and fosters generosity. In addition, I hope the chapter provides useful vignettes about how non-Native/allied artists and educators might work across cultural differences to honor, celebrate, and learn from those differences; and how they respond to the certain pitfalls that impede long-standing relationships between educator-artists and Native communities by suggesting the best practices that have served me in the past. Thomas King writes that once a story is told, it cannot be called back. Once told, it is loose in the world. King also reminds us that once we have heard a story we cannot pretend that we haven't heard it. "Do with it what you will [...] Just don't say in the years to come that you would have lived your life differently if only you had heard this story. You have heard it now" (King, 2005, p. 167). What will you do with it?

NOTES:

1. *Salmon Is Everything* was first performed in at Cal Poly Humboldt, and thereafter at community centers along the Mid-Klamath River. In 2011, the play was produced by the University of Oregon and continues to enjoy public readings in the Pacific Northwest. See, May, (2018), pp. 26–29.
2. In 2021, stakeholders of the Klamath watershed have agreed that four dams on the Klamath River will be decommissioned and removed. See, "US approves largest dam removal in history to save endangered salmon," (2022, November 17), *The Guardian*.
3. Quotations from students, community partners, and collaborators are paraphrased from my personal notes.
4. For further discussion of these considerations, see, May (2007).

REFERENCES

Archibald, J. (2008). *Indigenous Storywork: Educating the Heart, Mind, Body, and Spirit*. UBC Press.

Cohen-Cruz, J. (2005). *Local Acts: Community-Based Performance in the United States*. Rutgers University Press.

Department of Fish and Game. (2004). "September 2002 Klamath River Fish-Kill: Final Analysis of Contributing Factors and Impacts." California Department of Fish and Game.

Howe, L. (1999). "Tribalography: The Power of Native Stories." *Journal of Dramatic Theory and Criticism*, 14(1), 117–125.

King, T. (2005). *The Truth about Stories: A Native Narrative* (Vol. 1). University of Minnesota Press.

Knowles, R. & Mojica, M. (2009). "Creation Story Begins Again: Performing Transformation, Bridging Cosmologies," pp. 2–6. Armstrong, Johnson, K. L. & Wortman, W. A. (Eds.) *Performing Worlds into Being: Native American Women's Theater*. Miami University Press.

Kovach, M. (2010). *Indigenous Methodologies: Characteristics, Conversations and Contexts*. University of Toronto Press.

May, T. (2007). "Toward Communicative Democracy: Developing *Salmon Is Everything*," pp. 153–54. Kuppers & Robertson, G. (Eds.) *The Community Performance Reader*. Routledge.

May, T., Burcell, S. M., McCovey, K., O'Hara, J. E., Brown, K. & Bettles, G.. (2018). *Salmon Is Everything: Community-Based Theatre in the Klamath Watershed* (Second edition.). Oregon State University Press.

Smith, L. T. (2006). "Choosing the Margins: The Role of Research in Indigenous Struggles for Social Justice," pp. 151–173. Denzin, N. K. & Giardina M. D. (Eds.) *Qualitative Inquiry and the Conservative Challenge*. Left Coast Press.

"US Approves Largest Dam Removal in History to Save Endangered Salmon." (2022, November 17). *The Guardian*.

Wilson, S. (2008). *Research Is Ceremony: Indigenous Research Methods*. Fernwood Publishing.

Young, I. M. (1996). "Communication and the Other: Beyond Deliberative Democracy," pp. 120–36. Benhabib, S. (Ed.) *Democracy and Difference: Contesting the Boundaries of the Political*. Princeton University Press.

Conclusion and Final Remarks

Flávia Bastos and Doug Blandy

Editing *Promoting Civic Engagement through Art Education: A Call to Action for Creative Educators* is an extension of our career-long commitment to promoting civic engagement through art education. This work advances a tradition of interrogating conventions and established practices in art and in education to promote social justice and sustain democracy. Blandy and Congdon's (1987) *Art in a Democracy* confronted and critiqued extremely popular approaches to art education for their lack of inclusivity of diverse cultural perspectives and for privileging a universalized conception of art. One piercing theme of that book was that "citizens in a democracy have the right and should be given the freedom to learn in a way that will validate their own racial, ethnic, or occupational culture" (Holt, 1991, p. 119). Connecting art and education practices to the rights afforded to citizens, Blandy and Congdon, along with their book's contributors, charted a critique that paved the way to a growing desire for a more activist and civically engaged professional and scholarly field of art education that connects what happens in art and in education to widespread practices in society. Bastos was deeply influenced by this critical tradition, leading her to pioneer the integration of social reconstruction ideas from Brazilian educator Paulo Freire into the field of art education through her early work focused on transformative art education practices rooted in communities (Bastos, 2002). Presently, Bastos' work in collaboration with James Rees focuses on critical digital citizenship through the ongoing research of *Who Is American Today?* that examines the possibilities of media making in promoting civic engagement (Bastos & Rees, 2020). Our editing of this volume dovetails these earlier calls for activating the civic engagement potential of art and education, reflecting on the various artistic and cultural traditions that can promote a sense of belonging and warning against the potential harm of privileging only some cultural expressions, or the expressive works of a few, instead of honoring diverse voices and modes of creativity.

In *Promoting Civic Engagement through Art Education: A Call to Action for Creative Educators* we find kinship with the book's contributors in discovering inspiring works from artists, scholars, educators, and students that expand previous critiques and articulate the connections between art, education, and democratic societies. The authors in this volume testify to the possibility of facing the myriad sociopolitical issues of today with a sense of direction and support found in joint purpose. We believe that while art and education alone cannot fix the travails of, and assaults

DOI: 10.4324/9781003402015-25

to democratic societies worldwide, art and education are aligned in their orientation and fundamental purpose to promote greater understandings and insights from which voice, agency, solidarity, and transformation can take place.

We have crafted careers that explored the fertile possibilities of the art to inform empowerment and to model inclusive approaches to civic engagement. However, more than consolidating our scholarly legacies, editing this volume embodies our response to addressing the exigencies of today. It should be read as a call for action, a loud invitation to educators and students who feel similarly to those of us associated with this volume about the challenges democratic societies are currently facing. Since we started working on this project, we have been pleased to learn about many other recent publications that address the intrinsic connection between art, education, and civic engagement (Bae-Dimitriadis & Ivashkevich, 2024; Catlett & Landsman, 2022; Shields & Fendler, 2024). This book is part of a larger wave of responses to the issues examined through this project. We hope that by embracing this call for action, each reader and contributor can play a role in creating a chain reaction toward change that will help us move forward.

All of us associated with *Promoting Civic Engagement through Art Education: A Call to Action for Creative Educators* underscore the importance of art and creativity in unveiling an approach to social life that is reciprocal, just, and conducive to joy. The chapters in this volume share a view of the arts as a terrain of hope and possibility from which to envisage and impact change. Promoting, supporting, and affirming democracy has parallels to what Bettina Love (2019) calls *abolitionist teaching*:

> Art is a vital part of *abolitionist teaching* because it is a freeing space of creativity, which is essential to abolishing injustice (…). Art first lets us see what is possible. It's our blueprint for the world we deserve and the world we are working toward. Abolitionist teaching is built on the radical imagination of collective memories of resistance, trauma, survival, love, joy, and cultural modes of expression and practices that push and expand the fundamental ideas of democracy. (p.100)

Creating a just world is to practice freedom rooted in our shared humanity and striving to support the common good. Art and aesthetic experiences are an ideal foil from which to examine, understand, and critique our existence. Art and creativity have the potential to be catalysts of joy, fueling education's work toward change. Art advances civic engagement because it can frame questions, propose methods of investigation, articulate solutions, and facilitate dissemination of ideas conducive to democratic dialogue.

Returning to Liora Bresler's foreword to this volume brings us full circle. In her foreword, she is in solidarity with all of us, as writers, readers, and activists, in the necessity of responding to the global attack on democratic societies with the concurrent rise in authoritarianism. She reminds us that while these attacks are uppermost in our minds today, such attacks have historical precedence and that what we are experiencing is just the most recent iteration. Integral to this recognition is affirming the importance of education as crucial to civic education and by extension democracy. Bresler's recognition of educating for democracy requires striving for an "I-Thou-Us"

relationship with learners and educators recognizing a diversity of voices aspiring to come together around common concerns transcending the "tribal" or "national." Bresler's references to international examples coupled with her own international scholarship are convincing in this regard. Importantly Bresler cautions all of us, committed to this work in advancing civic engagement and democracy in education and art, that we must avoid the reification of curricular approaches in favor of creating ever-evolving innovative spaces inviting engagement with democratic processes, in and outside of the classroom, toward personal and communal engagement. All of us associated with *Promoting Civic Engagement through Art Education: A Call to Action for Creative Educators* invite you to join with us in making this commitment to current and future generations of students and educators.

REFERENCES

Bae-Dimitriadis, M., & Ivashkevich, O. (Eds.). (2024). *Teaching civic participation with digital media in art education: Critical approaches for classrooms and communities*. Routledge.

Bastos, F. M. C. (2002). Making the familiar strange: A community-based art education framework. In Gaudelius, Y. & Speirs, P. (Eds.), *Contemporary issues in art education*. Prentice-Hall.

Bastos, F. M. C., & Rees, J. (2020). Who is American today? Promoting critical digital citizenship with high school students. In Knochel, A. D., Liao, C., & Patton, R. M. (Eds.), *Critical digital making in art education*. Peter Lang.

Blandy, D., & Congdon, K. G. (Eds.). (1987). *Art in a democracy*. Teachers College Press.

Catlett, M., & Landsman, A. (2022). *The city we make together: City council meeting's primer for participation*. Iowa University Press.

Holt, D. K. (1991). Recent publications. *Studies in Art Education*, 32(2), 117–124.

Love, B. (2019). *We want to do more than survive: Abolitionist teaching and the pursuit of educational freedom*. Beacon Press.

Shields, S., & Fendler, R. (2024). *Developing a curriculum model for civically-engaged art education: Engaging youth through artistic research*. Routledge.

Index

Note: *Italicized* pages refer to figures, and page numbers followed by "n" refer to notes.

Abandor, N. 28
ableism and civic education 78–79
Abloh, V. 219
abortion 63–66
Abortion Access Front 59
Abram, D. 44
Abramo, J. M. 142, 149
The Accursed Share (Bataille) 110
actipedia 67
activism: art 163–168; concept of 50; educational 293; through storytelling 292–293
activist art, actions of 20–22
Acuff, J. B. 100, 154, 192, *193*, 198, 265, 273
Adbusters 39, 42n5
ads, create campaigns for 39
aesthetic ideologies, material culture of protest as 99
Afrofuturism 120, 194
After Roe Fell: Abortion Laws by State 61–63
aging: art education, civic engagement and 240; creative 250; LaPierre's art of 241–246, *242*, *243*; Zimmerman's view of 246–249, *249*
Ailey, A. 116
Ai Weiwei 265; artwork of anti-Asian racism and COVID-19 pandemic 266–267; masks 266–267
Akbar, N. 103–104
Akoto-Bamfo, K. 104
Alexander, E. 104
American Civil Liberties Union (ACLU) 187
American Sign Language 85
American Suffragette Movement 99
AMP!ify | Agitate | Disrupt 155, 186–199; Abolitionist Teaching 195, 196–198; afrofuturism 195–196, *196*, 198; ARP 194, 197; Critical Multiculturalism zine 196–198; CRT *190*, 190–192, *191*; Culturally Relevant Pedagogy 194–195, *194–195*, 197; overarching goals for 191, *191*
Anastasiou, A. 102–103
Anderson, B. 162
Animating Democracy Initiative 176
anti-Asian racism: creating new culture 275; evidence of 272; investigating causes of 273; issue of 264–265; pre-service art teachers perspective of 268–270, *269*; proposing solutions to 273–275; responding through art 267–268; Taiwanese youths and 269–270; technology and social media for speaking 271–272
anti-LGBTQ+ legislation 188
antiracism 99–100; art education and 99–100; for social justice education *101*
Apple Inc. 96
Archibald, J. 293
Arizona law (2022) 60–61
art(s): new meaning to, from the past as an activism 270–271; responding to anti-Asian racism through 267–268; for well-being 173; youth civic engagement and well-being 176–177
art activism 163–168
art+civic curriculum: high school thinkers with stories of oppression 21–22, *22*; students' as informed civic actors and 18, *19*; workshop 18–22, *19*, *22*
art education xvii–xviii; AAPI-related racism through 156; aging and civic engagement 240; antiracism 99–100; civic engagement amd political clarity in 155, 186–199; cultural citizenship in 13–14; for democracy 123–138; as political act 124–126; reproductive justice as 56–63; *see also* civic education; civic engagement
Art+Feminism wikistorming event 57
articulations 28
artistic activism 154

Artistic Activism as Radical Research 163–168
art pedagogy strategies 67–68
arts-based intervention 155
arts-based policy research 79, 91
3Arts Project 284–288, 285, 286
art teacher identity 189
art therapists 176
art + work practices 109–111
Asian American art educator: pedagogical positionality and foundation 265–266
authoritarianism 10
autobiographical comics 29, 29
Aviary 142
awareness and attending 49
Ayers, W. 279

Back to the Afrofuturism 195–196
Bakan, D. 149
Baldwin, J. 117
Banks, J. 129
Banulescu-Bogdan, N. 181
Barclay, J. 80
Barenboim, D. 146
Barrett, T. 31–32
Bastos, F. 9–10, 303
Bataille, G. 110–111
Bazelon Center for Mental Health Law (2020) 84
Beadie, N. 15
Beck, M. M. 3
behavioral empathy 102
Bell, A. 222
Benedict, C. 143–144
Berger, E. 96
Berry, J. W. 175
Better Citizenship through Art Training (Beck) 3
Biro, P. 3
Black Feminist Theory 187
Black Lives Matter (BLM) protests 2, 95, 186, 202, 205–206; art and material culture of 98–99; killing of Brown (2014) 95; killing of Martin (2012) 95, 99; murder of Floyd (2000) 95–96
Black Panther (film) 120, 198
Blandy, D. 9, 98–99, 303
Bolin, P. E. 98
Bourdieu, P. 3
Brailler in elementary school 85
Breen, A. 155, 218
Bresler, L. 304–305
Brown, A. M. 180
Brown, J. 119
Buber, M. xv
Bucura, E. 143, 150
buffer sizes 118
Buffington, M. 265, 273

Burkholder, Z. 15
Burroughs, M. 156
Burton, L. 121

"Call Me Maybe" 142
Cal Poly Humboldt 294
I Can't Breathe Mural 96–97, 97, 100–105; material culture of protest and 105–106
Carcasson, M. 46–47
Carey, A. 80
caring 168
Carlton, S. 175
Cascone, S. 71n13
Cave, N. 219
Center for Information and Research on Civic Learning and Engagement (CIRCLE) 216
Central Intelligence Agency (CIA) 125
Chang, C. 219
chapbooks 188–189
Chauvin, D. 96
Check, E. 207
Chicago Public School (CPS) 216
Chinaman's Chance 266
Chinese Exclusion Act of 1882 83
civic action, eco-conscious teaching as 50
civic common sense 79
civic curriculum 13–15
civic education 7–8, 44; ableism and 78–79; aim of 14–15; in relation to immigration policy 83–85; roadblocks of 15–16; policy 84; standards 14–15; textbook for naturalization 78; wicked problem for 46–47
civic encounters 91
civic engagement 5, 7, 8–9, 44, 154; in art education 70; art education, aging and 240; concepts of 179; in educational settings 201–204; European research project on 144–148; focus on 15–16; global music communities and 140–151; heroism and 140–141; identity and positionality as platforms for 204; launching into 179–180; music and youth 144–148; paper dolls as sites of 204–205; pedagogical and curricular tool for 188–189; place impact identity and 203–204; and political clarity in art education 155, 186–199; refugees, connections and art making 177–178; of refugee youth 174–175; for resettled refugee youth 173; role of stories in 209–211; sustaining 180–181; teaching art and 218–223; and well-being 175–176; youth, arts and well-being 176–177
Civic Health Assessment 79
Civic Health Index 79
civic responsibilities 84–85

308 INDEX

civic wisdom 202
Clandinin, D. J. 204
classroom, connecting to nature in 53; *see also* school(s); teachers; teaching
Clay, K. L. 15
cognitive empathy 102
Cohen-Cruz, J. 298
collective pedagogy 163–168
Collins, K. 155
communicative creative practice model 114–115
communicative democracy 292
community-based art practices 14
community-based engagement 283, 284–288
community-based theatre 292; communicative democracy in 294–296; cultural knowledge sharing 299–300; empathy as political action 300; Indigenous methodologies in 291–301; interviews and writing prompts 296–298; reciprocity in 298–299
community of like-minded souls 51
Community Soil Collection Project 18
concealed stories 210, 211
Congdon, K. G. 303
connecting with land in reciprocity 52
connecting with your community 53
constants 117–118
Constitutional Democracy Under Stress: A Time for Heroic Citizenship (Biro) 3
constructive creative practice model 113–114
consultation 296
contemplation 78
contemporary Asian artists' work 266–267
Conversation Pieces 176
cookbook: contemplating dough 91–92; making of perfect dough's shape 87–90, 87–91; overview of 75–79, 76, 77; preparation of dough 80–82, 81, 82
Copernicus 112
counter-visual strategies 265
COVID-19 pandemic 2, 18, 96, 148, 156, 264; anti-Asian hate crime and 273–275; as "Kung Flu"/"China Virus" 80; phingbodhipakkiya, A. and 266–267; responding through art 267–268
Crawford, M. 64
creative aging 250
Creative and Mental Growth 2–3
Critical Art Ensemble 166–167
critical digital making 124
critical discourse 52
Critical Multiculturalism zine 194
Critical Race Theory (CRT) 161, 187; AMP! *190*, 190–192, *191*
Critical Race Theory Ban 186
Critical Response Cycle (CRC) 265
critical self-reflection 52, 103–104

cultural citizenship: in art education 13–14; artistic practice and 17; in a middle school classroom 17–20; as a model for emergent civic practice 22–23; research project 18–22; as the term 16–17
cultural knowledge sharing 299–300
cultural production frames artmaking 17, 23

Dadaism 35
Data Feminism 71n11
data visualization 67
Data Visualization Working Group (DVWG) 71n11
"Declaration" (Smith) 86
Decolonizing Methodologies 293
delays 118–119
deliberative democracy 294
Democracy and Education: An Introduction to the Philosophy of Education (Dewey) 4
democracy, art education for 123–138
democratic classroom management xvi
democratic decision-making 15
democratic education 163–168
democratic teaching xv
Derrida, J. 110
Desai, D. 154
détournement: as curriculum 36–39, *37*; projects 38–39; Spiral Punk Process group and 38–39; teaching 38; various styles of *39*
Dewey, J. 4, xv
Dewhurst, M. 104–105
dialogical aesthetics 176
digital media literacy 135
DiQuinzio, A. 66
Disabled Upon Arrival: Eugenics, Immigration, and the Construction of Race and Disability (Dolmage) 83
divisive human knowledge systems 114
Dixon, C. 288–289
do-it-yourself (DIY) 189, 199n1
Dolmage, J. 78, 83–84
domestic labor 80–82, *81*, *82*
Don't Shoot PDX 97–98
Douglas, F. 121
Dred Scott v. John F. A. Sandford case 83
"Dress Up for the New York World's Fair" 205
Duncombe, S. 20
Durant, J. 96

East and West Shaking Hands at Laying Last Rail 266
ecocentric worldview: definition of 47; through teaching 49
ecological consciousness through teaching 50–51
ecological crisis 44
ecological disruption 44

educational activism 293
Education: Intellectual, Moral, and Physical (Spencer) 115
Education Week 15
educators' experiences: awareness and attending 49; concept of activism 50; freedom and invitations 49–50; personal impact, actions and reciprocity 48–49
educators, key concerns for today's 126
Eisner, E. 176, 182
Elliot, S. 181
Elliott, J. 194
emotional empathy 102
empathy 102–103, 106–107n5
empirical findings 14–15
environmental degradation 46–47
Equal Justice Initiative's (EJI) Community Remembrance Project 18
Escorza, C. 270–271, *271*
Estrada, W. 157
Ethics of Care (Held) 168
eurocentrism 115
evolution 120
experienced women art educators *see* LaPierre; Zimmerman
#ExposeFakeClinics 58
expressive culture 4

Faber, M. 33; Freire-inspired media arts curriculum 33–34; pitting slogans against slogans 35; situationist practices 35–36
Facebook 142
Fahandej, R. 21
failed citizenship 129
Father's Lullaby 21
Fazlalizadeh, T. 219, 222
Feierman, L. 59
feminist art coalition 66
Fendler, R. 7
Finkelstein, A. 166
The Fire Next Time 117
flexible creative practice model 116
Floyd, G. 2, 95
Formosa Association of Student Cultural Ambassadors (FASCA) 264
Foucault, M. 3, 162
Franklin, F. 172
Freirean dialogical pedagogy 34, 35–36
Freire, P. 27, 124, 168, 171n1, 303; coding and decoding 30–32, *31*; educational philosophy and methodology 125; education as cultural action 27; expanding and investigating themes 29, 29–30; Freirean tradition 125; identifying generative themes 27–29, *28*; inspired media arts curriculum 33–34; limit acts 32–35, *33*; limit situations 32; literacy methods 125

Frozen (film) 146
Futuristic Radio Plays project 219

Galileo 112
Garcia, A. 14, 16
Gauntlett, D. 135
Gaztambide-Fernández, R. 17
generative themes 27–29, *28*
global music communities: civic engagement and 140–151; social capital and 143–144; TikTokin' Bout a revolution 142–143
goals 120
Gomez, J. L. 219
Goode, S. E. 217
Good Housekeeping 204
Gorman, A. 67
Gouzouasis, P. 142, 149
Grant, E. 62
Greene, M. xvi, 281
Green, L. P. 155, 218
Griffith, D. 103–104
Gude, O. 8

Hallam, S. 143
Halloun, I. A. 112
Hall, S. 22–23
Hardy, D. 156
Hartman, S. 16
healthy democracy 79–80
Hebert, D. G. 10
Held, V. 168
heterogeneous creative practice model 115–116
Hickey-Moody, A. 20, 23
Hill, J. C. 143
Hine, L. W. 119
Historical Marker Project 18
Hoggan-Kloubert, T. 52
Holiday, B. 117
homophobia 155
Horton, M. 161
Hou, F. 175
How to Be an Antiracist (Kendi) 100
Hsieh, K. 156, 265
humanization 179

#IAmNotaVirus 80
identity, culture and ethnicity as elements of 207
Immigration Act (1882) 83
immigration policy, civic education in relation to 83–85
Indaba 142
Indian Removal Act (1830) 83
Indigenous methodologies: in community-based theatre 291–301; reciprocity 296; relationship 296; respect 296; responsibility 296
information access 119–120

Instagram 142, 274
interconnections beyond human control 48
interdisciplinary approach 7
intergenerational mentorship 51
International Movement for an Imaginist Bauhaus 35
interrelated complex system 47–48; beyond human control 48
intervention: for noncommunicative models 118–119; for nonconstructive models 117–118; for non-flexible models 120–121; for non-heterogeneous models 119–120
intransigent human knowledge practices 115
Irving Foundation (2017) 176
"I-Thou-Us" 304–305

Jaffa, A. 219
Jahner, E. 106–107n5
James, K. 219
The Janes (film) 58–59
Japanese tango 144
Jenkins, H. 143
Jepsen, C. R. 142
Johnson, D. 10
Johnson, M. C. 8
Jones, P. M. 143–144
Journal of Multicultural and Cross-Cultural Research in Art Education 241

K–12 art teachers 187
K–12 classrooms 156
K–12 public schools 26
Kabiito, R. 69
Kagan, R. 1
Karlsen, S. 144
Kaur, I. 64–65
Keifer-Boyd, K. 8
Kendi, I. X. 100
Kepler 112
Kester, G. 176
Killing Us Softly: Advertising's Image of Women (documentary film) 38
Kim, J. 78
Kinsella, C. 150
Klamath Theatre Project 294
Korza, P. 176
Kraehe, A. M. 100, 193, 265, 273

Lalami. L. 137
Landreman, L. M. 284
The Landscape is Turning 155, 201–210; civic engagement in educational settings 201–204
Lange, E. A. 44, 46, 47–48, 51
language as material 85
LaPierre, S. G. 156, 239–240; art of aging by 241–246, 242, 243; *Journal of Multicultural and Cross-Cultural Research in Art Education* 241

Lave, J. 143
Lawrence, J. 117
(Un)learning on the Sidewalk 157; reclaiming civic engagement and democracy in public art-making 157, 278–288
Lentz, A. 271
Let Me Share the Sky with You 267, 268
letters of law 85–86, 86
Lettrist International 35
LGBTIA+ community 211
LGBTQ+ rights 99
Ligon, G, 222
Limit Acts and Constructed Situations as Curriculum: Paulo Freire and the Situationist International 8
Linton, L. 30
Li, Y. 175
Locks, D. 155, 218, 219–222, 225
Love, B. 195, 197, 304
Lowenfeld, V. 2
Lummis, C. 5
Lynching in America: Confronting the Legacy of Racial Terror 104

Makerere University 69
manifesto process 221–222
Manyukina, K. 144, *145*
Marshall, K. J. 219
material culture 98–99
May, T. J. 157
McCall's 204
McTighe, J. 28
Meadows, D. H. 112–113, 117, 119
media techniques 26
memory, history and pedagogy 162–163
#MeToo movement 35
Mexican revolution xvi
Mezirow, J. 44–45, 50
Migration Policy Institute 174
The Migration Series 117
Mikseri 142
Mirra, N. 14, 16
Mobile Street Art Cart Project 157, 284–288, *285*, *286*
Mojica, M. 294–296
monocultural practice 116
Morrison, T. 104, 162
Mrnjavčević, K. M. 140
Mr's.' Nirbhaya 64–65, *65*
Ms. More Than a Magazine 62
Museum of Contemporary Art (MCA) Chicago 156, 215–216
music: experience in digital age 148–149; social capital and 143–144; web-based remote learning of 149–150; and youth civic engagement 144–148
Music Talks 141, 147–148

NAEP's Civics Assessment Framework 79, 84–85
National Academy of Education 7, 13
National Art Education Association (NAEA) 156; Committee on Multiethnic Concerns (COMC) 100
National Art Education Association's Research Commission 71n11
National Assessment of Educational Progress (NAEP) 79
National Memorial for Peace and Justice 103–104
National Organization for Women (NOW) 245
National Public Radio station WBEZ 216
National Women's Law Center 64
Naturalization Act of 1790 83
naturalization, civic education textbook for 78
nature connection and outdoor experiences 52
Nazi Holocaust 2
negative feedback loops 119
New England Small College Athletic Conference (NESCAC) coalition 58
Newton 112
New York University (NYU) 154
non-diverse/non-flexible human knowledge systems 116
Noteflight 142

Oakland Art Murmur 96
O'Donoghue, D. 78–79, 86
Ohio State University 192
O'Neill, S. 150
online musical communities, and Web 2.0 digital technology 144
Orr, D. W. 44, 47–48, 53
O'Sullivan, E. 44–45
The Oxford Handbook of Social Justice in Music Education (Benedict) 143–144

paper dolls: background on 204–205; collage narratives 205–209, *206, 207, 209*; as sites of civic engagement 204–205
participatory citizenship 129
Partti, H. 144
"Passport to the Past" project 154–155, 161–163, *169–170*; art activism, collective pedagogy and democratic education 163–168, *164–166*
pedagogy of memory and history 162
Pedagogy of the Oppressed (Freire) 27
Penn State University 69
Pfeiler-Wunder, A. 155
Phingbodhipakkiya, A. 265; *I Still Believe in Our City* 267; *Let Me Share the Sky with You* 267, *268*; murals 266–267

physical structure 118
Pindell, H. 219
place impact identity, civic engagement and 203–204
Planned Parenthood 66, 99
Plotkin, B. 47, 53
Polak, J. 222
political clarity 193
political engagement. 148
positionality, as platforms for civic engagement 204
positive feedback loops 119
Powell, R. 85
Power of Advertising project 32–33, *33*
power of art to communicate 30–31, *31*
practical elements of theory 7
pre-service teachers (PSTs) 192
President's Advisory 1776 Commission 161
principles of Contemporary Art practice 235
principles of democracy 236–238; accepting results of elections 236; accountability 236; Bill of Rights 236; citizen participation 236; control of abuses of power 236; economic freedom 237; equality 237; human rights 237; independent judiciary 237; multi-party system 237; political tolerance 237; regular free and fair elections 237; rule of law 237; transparency 237
Principles of Interpretation 31–32
private heroism 140
problem-posing art teachers projects 7, 35
problem-solving 7
project *see specific project*
public art-making: creating and sustaining democratic classrooms 279–280; embracing failure 283; radical imagination 281–283, *282*; reclaiming civic engagement and democracy in 157, 278–288
public heroism 140
Pussy Hats, Politics and Public Protest (Saltzman) 99
Putnam, R. D. 175
Putting Democracy Back in Public Education 3–4

Queer Theory 187

Race and Art Education 100
Raiford, T. 98
reciprocal capacity-building 179
reciprocity 44, 296, 298–299; connecting with land in 52
recognized citizenship 129
Reddit 142
Red RADs 64–65, *65*
Reed, T. V. 99

Rees, J. 124, 303
refugee 173; resettlement 173–174; status 173; youth, civic engagement of 174–175
Reinvesting in Arts Education: Winning America's Future through Creative Schools 216
relationship 296
remodeling paradigm 120
ReproAction 59
reproductive justice: art, coalitions, and collections 68; as art education 56–63; bioethical issue exhibition 69–70; *Blood Lines* exhibition 69; coalitions and collectives' art exhibitions toward 63–66; feminist art coalition 66; participatory art about 67–68; from pre-Roe 1972 to post-Roe 2022 58–63, 60–63; protest in 1989 61, 63; revoking (mis)carried abortion bans 66–70; SisterSong and 66; womb power informed action 66–70
Research as Ceremony 293
resistance stories 210, 211
respect 296
responsibility 296
Revelations 116
Rhoades, M. 155
Richardson, E. 8–9
Richardson, M. 127
Rife, E. 9, 106n4
Roe v. Wade 8, 58, 246
role of stories in civic engagement 209–211
Rolling, J. H. 9, 113–116
Rosler, M. 61
Rubin, B. C. 15
rules 120
Russell, A. J. 266
Russell, E. 78

Sagar, A. 85
Salmon Is Everything 291–301
Saltzman, R. H. 99
Sandell, R. 248
Sargent, F.P. 83–84
Scandariato, M. 155, 218
Schmidt, P. 150
school: democracy and 13–14; teaching détournement at 36–37; *see also* teachers; teaching
School Partnership in Art and Civic Engagement (SPACE) program 156, 216; building intentional community 221; crafting relationships and clear goals 226; curriculum framework 227–234; definition of 217; framework 217; Futuristic Radio Plays project 219; impact of 223–225; integrated approach to expand learning 219–220; manifesto process 221–222; outcomes 217; as a pilot project 225–226; points to consider to develop 225–226; for reflection and iteration 226; relevancy builds engaged citizens 218–219; school sites 217–218; student agency 220–221; teaching art and civic engagement 218–223; team 218; Ten Days of Change project 222–223
self-decolonization 157
self-expression 26
self-reflection 53, 100; empathy for 102
Seminar for Research in Art Education (SRAE) 242
Semlow, A. 103–104
sexism 161
Share, J. 135
Shields, S. S. 7, 91
Siberian beatboxing 144
silencing 85
Simulation Theory 102
Singh, A. A. 100
"Sing me in" program 147
SisterSong Women of Color Reproductive Health Collective 66
situationist-influenced art and culture 35–39
slavery 161
SLIFE (Students with Limited or Interrupted Formal Education) 174
Smith, L. T. 293
Smith-Shank, D. 57
Smith, T. K. 86
social capital and music 143–144
social-emotional learning (SEL) 176
social engagement 156
social isolation 180
social justice 144
social justice art education 104–105, 281; antiracism for *101*
social media *see specific media*
socially engaged art practices 14
socio-ecological connectivity 8
socio-ecological sustainability 44
SPACE teachers: expanded practice for artist 225; peer-to-peer learning by 224–225
Spanish Civil War xvi
Spencer, H. 115
Spillman, S. 212–213n2
Spiral Punk Process group 38–39
Spiral Workshop 39–40, *40*, 41n3
Spotify 151
Sprain, L. 46–47
Stanley, T. 169
Stein, L. 61–63
Stevenson, N. 16–17
Strange Fruit 116
strategic scaffolding 179
Strengthening Democracy with a Modern Civics Education 216

Student's Textbook: A Standard Course of Instruction for use in the Public Schools of the United States for the Preparation of the Candidate for the Responsibilities of Citizenship 77–78
Sturken, M. 162
supportive community networks, role of 50–51
surplus energy systems, art and multiverse of 112–116
surplus human energy 111
Surrealism 35
symbolic practices 23
Synder, T. 162
systemic inequalities 154
systemic racism 112, 155
systems approach to creative future 116–121
systems of inequity 114, 116

Taiwanese American youths 264–265
Taylor, B. 2, 95
Taylor, E. W. 51
teachers: Covid-19 impact on 202; current curriculum 40–41, *41*; *see also* teaching
teaching: arts and civic engagement 218–223; ecocentric worldview through 49; eco-conscious, as civic action 50; ecological consciousness through 50–51
Teaching Asian Art in K-12 Classrooms 264
Ten Days of Change project 222–223
"The Little Fannie Figure" 204
theoretical dimensions of practice 7
Thinking in Systems (Meadows) 112, 117
This Is Not Consent 270–271, *271*
Thomas, H. W. 104
Thomas, S. 189, 199
Thomson, P. 17
TikTok 142
Tobias, E. S. 149
transcendence 121
trans-disciplinary curriculum xvii
transformative citizenship 129
transformative civic learning theory: assumptions 45; for eco-consciousness and civic action 46–48; framework of 44–46; Lange revisioning of 46; meaning perspective 44–45; Mezirow formulation of 44–45; nature connection as 47; O'Sullivan and planetary philosophy of 45; phases of 44–45; role of supportive community networks 50–51; socio-ecological view of 45
transformative stories 210, 211
Trump, D. J. 1, 128, 161
Tucker, M. 126
Twitter 142, 274

Ukraine war 2
Ukrainian pianist *145*

Ukrainian violinist *145–146*
Unbound Philanthropy 175
Understanding by Design (Wiggins and McTighe) 28
Understanding Joshua series 30, *31*
United Nations Education, Scientific and Cultural Organization (UNESCO) 180
United Nations High Commission on Refugees (UNHCR) 173
United States Society for Education through Art (USSEA) 242
U.S. Constitution 3
US Department of Health and Human Services 176
US immigration policy 83
"Utilizing Fugitive Pedagogies to Promote Civic Education in *De Facto* Segregated Schools" 156

Van Duinen, T. 32
Vevea, B. 216
virtual music learning 142–143
visual art curriculum 26; art education strategies for 27
Visual Culture & Gender (VCG) 57
visualizations 28
"Visualizing Reproductive Justice: A Call to End Fake Clinics" 58
visual journaling 248
Voice for the Voiceless (V4Vless) project 264–265, 268
Vulnerability, Humility, Insecurity, Tenacity 59

Wahbe, D. 167
Waldner, E. 265, 273
Waldron, J. L. 142–143
Ward, J. 102
Washington Post 1
Watermelon Man (film) 104
Web 2.0 digital technology, and online musical communities 144, 149–150
well-being: arts for 173; arts, youth civic engagement and 176–177; and civic engagement 175–176
Wenger, E. 143
Westheimer, J. 15
Who Is American Today? project 124, 126–138, *127*, *130*, *134*, *136*; American identity 131–132; citizenship 133–135; digital making 132; personal voice 132–133
Wiggins, G. 28
Williams, A. 222
Wilson, S. 293
Wolbring, G. 79–80
Wolfgang, C. 155, 190
Wo/Manhouse 2022 project 59–60

women's domestic labor and civic participation 78
World War II 2

Yang, M. 265
Yes Men website 36, 41n2
Young, I. M. 294
Youth Artist and Allies taking Action in Society (YAAAS) project 155, 172–182; arts, youth civic engagement and well-being 176–177; concepts of civic engagement 179; definitions and statistics 173–174; findings 178; launching into civic engagement 179–180; refugees, connections and art making 177–178; sustaining civic engagement 180–181; three generative aspects of 178–181
youth participatory action research (YPAR) 216
YouTube 142, 151, 274
Yusuf, I. 181

Zamata, S. 61
Zelmerlöw, M. 140
Zhe Lin 265; artwork of anti-Asian racism and COVID-19 pandemic 266–267
Ziebarth, D. 175
Zimmerman, E. 156, 239–240; view of successful aging 246–249, *249*
Zimmerman, G. 99–100
zine-making process 193
zine project 188–189; AMP! inception *190*, 190–192, *191*; *AMP!* issues 193; intervention 192–199; public murders of teenage Black boys 193
zine "specs" document 191, *191*

9781032513973